WORN ON THIS DAY

THE CLOTHES THAT MADE HISTORY

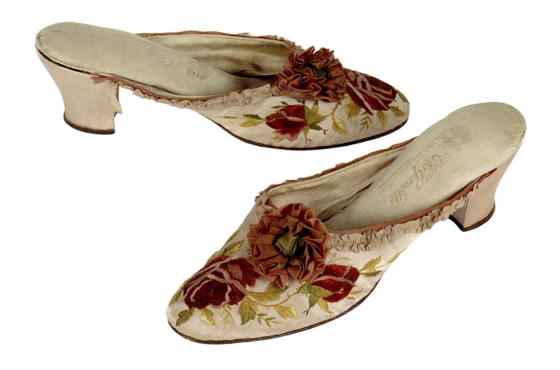

WORN ON THIS DAY

THE CLOTHES THAT MADE HISTORY

KIMBERLY CHRISMAN-CAMPBELL

RUNNING PRESS
PHILADELPHIA

Running Press

Hachette Book Group

1290 Avenue of the Americas, New York, NY 10104

www.runningpress.com

@Running_Press

Printed in China

First Edition: November 2019

Published by Running Press, an imprint of Perseus Books, LLC, a subsidiary of Hachette Book Group, Inc. The Running Press name and logo is a trademark of the Hachette Book Group.

The Hachette Speakers Bureau provides a wide range of authors for speaking events. To find out more, go to www.hachettespeakersbureau.com or call (866) 376-6591.

The publisher is not responsible for websites (or their content) that are not owned by the publisher.

Print book cover and interior design by Celeste Joyce.

Library of Congress Control Number: 2019943964

ISBNs: 978-0-7624-9357-9 (hardcover), 978-0-7624-9358-6 (ebook)

1010

10 9 8 7 6 5 4 3 2 1

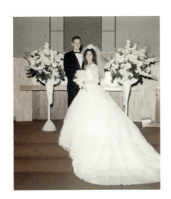

JULY 5, 1969

FOR MY PARENTS

TABLE OF CONTENTS

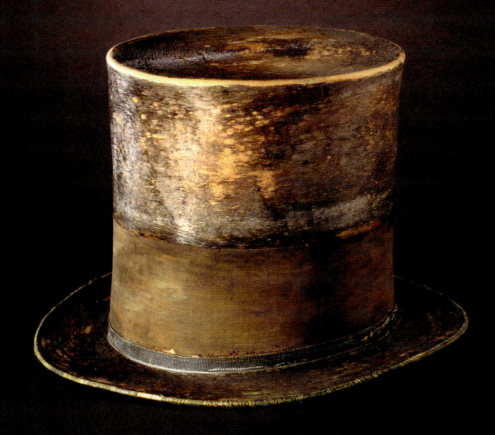

President Abraham Lincoln's
hat, worn on the night of
his assassination

PREFACE

Worn on This Day is a different kind of fashion history book. Instead of the usual linear chronology, it begins on January 1 and ends on December 31, looking at monumental occasions in different years from the first century A.D. to the present. And instead of documents and diaries, its source material consists of dresses, hats, ties, uniforms, umbrellas, and shoes. Rather than a predictable timeline of changing hemlines and hairstyles, the book is a revelatory mash-up of styles, stories, and personalities, and a journey of discovery through fashion's fascinating history, one day at a time.

Each day of the year is represented by a garment or outfit with a newsworthy narrative, whether famous and glamorous or anonymous and humble. The wardrobes of prominent figures like Abraham Lincoln, Marilyn Monroe, and Princess Diana are examined alongside those of ordinary people caught up in extraordinary events. Even seemingly mundane or unsightly garments are transformed by unique circumstances into priceless, totemic objects that illuminate humanity's historical relationship with clothing and culture.

While a traditional chronology might trace the evolution of fashion over decades and centuries, fashion also evolves through the seasons, bringing Easter bonnets, June brides, Fourth of July flag waving, Halloween costumes, and ugly Christmas sweaters. Events like the Oscars, the Met Gala, the Kentucky Derby, and the Olympic Games happen around the same time year after year, making their own highly anticipated fashion statements.

Measuring time by days rather than years creates surprising and thought-provoking juxtapositions. The onetime King Edward VIII's wedding to American divorcée Wallis Simpson and its inevitable consequence, Queen Elizabeth II's coronation, are only twenty-four hours apart. So are Olympic medalists Clare Dennis—who was almost disqualified for showing "too much shoulder blade" in her racerback Speedo swimsuit in 1932—and Ibtihaj Muhammad, who became the first American athlete to compete in a hijab in 2016. After their long and highly publicized trials, O. J. Simpson and Al Capone got their shocking verdicts in close calendrical proximity.

Clothes rarely survive for the reasons curators want or hope them to; that is, museum pieces are not often representative, well-preserved expressions of what everyone wore in a finite and clearly defined time and place. Linda Baumgarten, the longtime costume curator at Colonial Williamsburg, has written that "survival of . . . any artifact for hundreds of years usually favors the beautiful and the unusual," which is why museums are full of gorgeously beaded and embroidered formal garments but short on everyday clothing, especially that of the middle and lower classes. Additionally, more women's wear than menswear survives, because it usually went out of fashion faster and got less use. The clothes of small people were less likely to be reused or repurposed than those of large people, giving rise to the commonly held belief that everyone was smaller in the past. Bodices survive without their skirts, which were cut up and made into new garments; beautifully embroidered men's coats survive without their

breeches, which were less valuable and got more wear and tear. Indeed, many museum garments have been altered or damaged and may no longer look precisely the way they did on the day they were first worn.

While beautiful, exotic, and elite objects may be more likely to survive, choosing objects according to a single criterion—a precise date—levels the playing field, allowing clothes worn in a variety of times, places, and socioeconomic circumstances to rub shoulders with each other. In many ways, imposing this very narrow and somewhat arbitrary lens allows for a broader and more inclusive view of fashion history than a more traditionally structured book would, because it is not limited by time period, geography, or nationality. It gives equal footing to cultures and peoples traditionally underrepresented in museum collections: the poor and the working class; the marginal and the minority; the indigenous and non-Western cultures that are so often excluded from the story of mainstream fashion. Even encyclopedic museums seldom have the opportunity to make these kinds of narrative leaps, and most museums have collecting policies that dictate a narrow thematic, geographical, or historical focus, for lack of storage and display space as much as philosophical reasons.

It's true that this day-by-day approach does privilege the famous and infamous, especially in more distant periods of history. One could easily write a book about an entire year's worth of clothes worn by Jackie Kennedy or Princess Diana or Elvis. But celebrities come in many forms—statesmen, scientists, serial killers—and their clothes are not necessarily unique to the rarefied world of fame and fortune. During World War II, Princess Elizabeth wore the same uniform as the rest of the Auxiliary Territorial Service members. And even the most successful actors and athletes may come from modest beginnings. The main difference their renown or social status makes is that their garments have been preserved or photographed, while others haven't.

Museum curators use the word "provenance" to describe the critical background information that anchors a garment—or any other work of art—in a specific moment in history. In a nutshell, provenance is the ownership history of an object, from its maker onward. An object with a verifiable provenance is more valuable, both monetarily and educationally, and less likely to have been stolen, faked, or otherwise obtained unethically. Ideally, a garment's provenance would include who made it, who wore it, when, where, and maybe even how much it cost, but seldom is all that information straightforward or readily available. It requires curators to do intensive research, and to make educated guesses when the object's history simply cannot be reconstructed.

In the vast majority of cases, it's impossible to know who made or wore a decades-old garment, much less when. Designer labels have only been in use since the 1860s. Inventories, invoices, and wills sometimes contain valuable information about surviving garments, but it is rare for both an object and its documentation to be preserved. A trained curator can usually date a garment within five years or less based on stylistic and construction details, and narrow it down to a specific country or region. If it does have a designer label, it can often be dated to a single fashion season. Of course, most clothes are worn many times, over a few years if not longer, possibly by multiple people; moreover, it's generally not necessary to know the precise date or dates on which they were worn. A museum of decorative arts has much different collecting priorities than a local historical society, for example, and provenance may be less important or less likely to be recorded. But in those exceptional cases when a piece of clothing can be dated to a single day, there's usually a really, really good story behind it. These are the stories told in *Worn on This Day*.

Anthropologist Nicholas Thomas has pointed out that "objects are not what they were made to be but what they have become." Indeed, every garment in the book has two histories: its provenance—how it came to be—and what it came to mean. Wearing a garment gives it meaning beyond its material history or intrinsic worth. An antique textile dealer once told me about a woman who called her, wanting to sell a black dress worn by her great-great-grandmother, who had died in the 1850s. *Not another Victorian black dress*, the dealer thought, rolling her eyes. The caller continued: "My great-great-grandmother was a slave." The dealer nearly dropped the phone in shock, then invited the caller to name her price. Documented slave clothes are as rare as Victorian black dresses are commonplace. Sometimes, it's the man—or woman—who makes the clothes, not the other way around. In other words, every wedding dress is special to someone, but only Kate Middleton's wedding dress could bring in $15 million in ticket sales during just two months on display at Buckingham Palace.

Clothes reveal ineffable truths about not just individual lives, but also collective values and experiences. Garments act as totems and taboos and retain their power to impress or intimidate long after they were first worn. Things like Nazi uniforms and Ku Klux Klan robes are collected but rarely displayed by museums and historical societies, precisely because they so powerfully evoke events and emotions most visitors would prefer to forget. At the same time, old clothes may acquire new and problematic meanings over time. For example, many museums are reluctant to display fur garments because they offend animal lovers, even though fur has been an integral element of dress for thousands of years. In this book, you will find many ordinary and even ugly objects that never would have been saved if not for the profound meaning they acquired on one fateful day.

This book includes many "firsts." The first three-piece suit, worn by King Charles II on October 15, 1666. The first baseball uniform, worn by the New York Knickerbockers on April 24, 1916, and consisting of blue woolen pantaloons, white flannel shirts, and wide-brimmed straw hats. The first burqini, worn on February 4, 2007, by Lebanese-Australian volunteer lifeguard Mecca Laalaa Hadid in Sydney. It also includes a lot of "lasts." Many garments survive precisely because they were the last one someone wore before their life was tragically cut short by an accident, a natural disaster, or a bullet. Others were kept as souvenirs of having cheated death. These evocative objects are no longer mere garments but relics.

Beyond the fact that these pieces were saved for posterity, there is often evidence that the people who wore them realized that they were historically important, as they carefully signed, dated, or otherwise labeled them. And they have been speaking eloquently from the past to the present for hundreds of years. After visiting the National Maritime Museum in 1926, Virginia Woolf wrote in her diary: "Behold if I didn't burst into tears over the coat Nelson wore at Trafalgar. . . . [I] could swear I was there on the *Victory*."

These iconic clothes—many of them already imprinted on our collective consciousness—instantly transport us back in time, with a *you-are-there* quality that elicits powerful emotions and memories. Unlike birth dates or death dates, clothes take us to the moment when history was made, in an instantly relatable and tangible way that no mere headline can match. Many of these garments were worn on days that changed not just the lives of their wearers, but the lives of thousands, or even millions—days that unexpectedly split history into "before" and "after." These wearable time capsules transcend fashion to make up the fabric of history.

FROM MILLENNIAL MODES TO CHOCOLATE CHIP CAMOUFLAGE

JANUARY

1	2	3	4	5	6	7
Festive New Year's finery	Annabella Milbanke's wedding gown	General Hugh Mercer's sword	Rachel Ginsburg's wartime wedding suit	Grace Kelly's *sac à dépêches*	Lady Curzon's "Durbar" gown	Nana Akufo-Addo's inauguration robe
2000	**1815**	**1777**	**1949**	**1956**	**1903**	**2017**

8	9	10	11	12	13	14
Mark Zuckerberg's Patagonia onesie	Steve Jobs's trademark turtleneck and jeans	Denise Poiret's Queen of Sheba costume	Henry VIII's tournament armor	Rosalynn Carter's inaugural gown	Reba McEntire's star-spangled dress	Empress Eugénie's opera bodice
2016	**2007**	**1914**	**1540**	**1971**	**2002**	**1858**

15	16	17	18	19	20	21
Princess Diana's flak jacket and face shield	Clothing stolen from boxer Leon Spinks	A French missionary's Chinese clothes	Aviator Eugene Ely's leather helmet	First Lady Michelle Obama's state dinner dress	First Lady Jackie Kennedy's inaugural hat	Protest pink "pussy hats"
1997	**1981**	**1617**	**1911**	**2011**	**1961**	**2017**

22	23	24	25	26	27	28
Queen Victoria's lace-trimmed black fan	Marlene Dietrich's tuxedo and fedora	Humphrey O'Sullivan's patented heels	Queen Victoria's trendy dyed dress	Captain Cook's feathered cloak	Uniform of Auschwitz prisoners	Elvis's stylish television debut
1901	**1932**	**1899**	**1858**	**1779**	**1945**	**1956**

29	30	31				
The Beggar's Opera begins	King Charles I's undershirt	Dessert-inspired desert camouflage				
1728	**1649**	**1991**				

— **2000** —

New Year's Eve is always a cause for sartorial celebration, but the coming of the year 2000 demanded once-in-a-lifetime party clothes, suitable for saying goodbye to the old millennium while welcoming the new. This commemorative evening wear—hers by Escada, his by Jean-Paul Gaultier—was designed for staying up all night. The gown's geometric and floral motifs are augmented by stars, fireworks, popping corks, clinking glasses, and the date "2000." The silk suit is woven with a confetti-like metallic pattern, and the lining of the jacket is printed with "1999/2000"—a detail the wearer could reveal casually or in a dramatic striptease.

JANUARY 2

1815

Heiress Annabella Milbanke married the Romantic poet George Gordon—Lord Byron—in the drawing room of her family home wearing "a muslin gown trimmed with lace at the bottom, with a white muslin curricle jacket, very plain indeed, with nothing on her head," according to Byron's best man, John Hobhouse. The couple separated a year later, shortly after the birth of their daughter, the pioneering mathematician Ada Lovelace.

JANUARY 3

1777

The handsome sword General Hugh Mercer carried when he was wounded by a British bayonet in the Battle of Princeton was virtually obsolete as a weapon of war in the age of muskets; only high-ranking officers carried them in the American Revolution, as symbols of rank. Mercer died from his injuries days later and

WORN ON
THIS DAY

OPPOSITE: Escada evening gown and Jean-Paul Gaultier suit

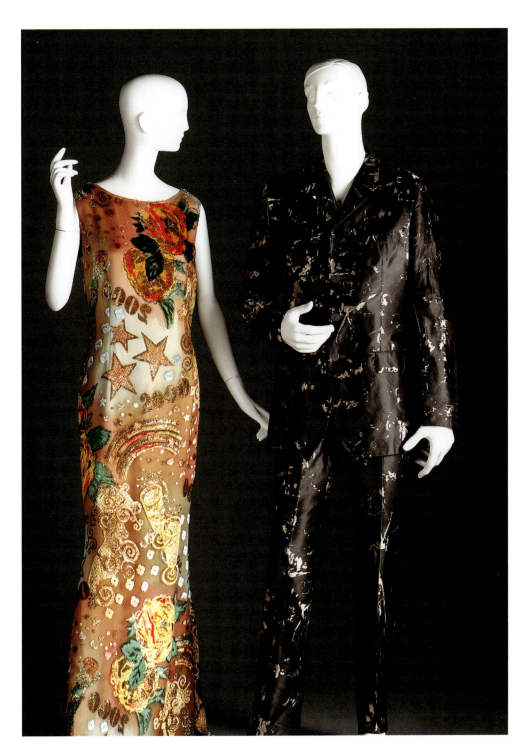

JANUARY / OI

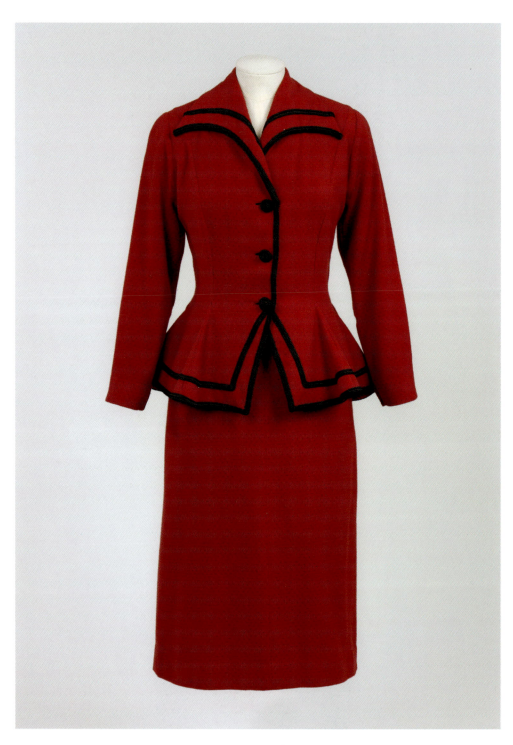

JANUARY / 04

received a triple tribute for his sacrifice: Charles Willson Peale's 1784 portrait of George Washington leading the Continental Army to victory includes a dying Mercer, and, in 1799, New York's Clermont Street was named Mercer Street after him—an honor subsequently referenced in the 2015 hit Broadway musical *Hamilton*.

JANUARY 4

1949

For her wedding to Walter Foster in London's Brondesbury Synagogue, Rachel Ginsburg wore a £22 wool and mohair suit, purchased at Liverpool's Bon Marché department store using clothing coupons donated by the couple's classmates at the London School of Economics (LSE). Due to the demand for uniforms and other military textiles during World War II, the United Kingdom rationed civilian clothing from June 1, 1941, to March 15, 1949—just weeks after Ginsburg wed. To buy clothes, you needed coupons as well as cash. Each type of clothing had a coupon value: eleven coupons for a dress, for example, or two for a pair of stockings. By the end of the war, the adult coupon allowance had shrunk to just thirty-six per year.

Clothes rationing hit brides particularly hard, and wartime weddings were often subdued affairs. Many war brides borrowed gowns from friends, made them out of unconventional materials like parachute silk, or chose day dresses or suits that could be worn again. When Princess Elizabeth married Philip Mountbatten in 1947, people across the country sent her their clothing coupons. She returned them all, using her own (plus 200 gifted by the British government) to purchase her satin and lace Norman Hartnell gown. Though Ginsburg's wedding garb was less traditional, it was equally evocative of joy and new beginnings—not just for the bride but for the nation.

Ginsburg had served in the Women's Auxiliary Air Force (WAAF), but found her domestic and secretarial duties "extremely boring," she confessed in a 2008 oral history taken by the Imperial War Museum. When the war ended, she seized the chance to study social science at LSE, funded by a modest government grant. Most of the students were fellow veterans. "That was a wonderful time, after the war," Ginsburg remembered. "You were still alive! For me, life was beginning." Ginsburg met her future husband, Walter, through the school's Jewish

OPPOSITE: Rachel Ginsburg's wartime wedding attire

Society. He had his own war stories: born in Vienna, he had come to England as a fifteen-year-old refugee in 1938. When war broke out, he was interned as an "enemy alien" before being allowed to enlist, serving as an interpreter in occupied Germany.

Like all demobilized servicemen and servicewomen, Ginsburg received a sensible "demob" suit. "You had to go to a depot, give back your wonderful uniform," she recalled. "You could choose from a rail of various rather disgusting-looking clothes"—in her case, "a brown tweed suit which Walter always hated. It wasn't very nice, but it was the only one I had." Small wonder, then, that Ginsburg selected this stylish, sophisticated, anything-but-sensible red ensemble for her wedding. The straight skirt and unlined jacket conform to wartime austerity regulations, and the black silk braid gives it a military air. But the shawl collar, pinched waist, and extravagant peplum betray the influence of Christian Dior's New Look, launched in 1947. Ginsburg had never seen anything like it. She wore this glamorous garb with a small net veil on her wedding day and on many days afterward.

JANUARY 5

1956

Grace Kelly carried one of her many Hermès *sacs à dépêches* (dispatch bags) to a luncheon at the Philadelphia Country Club, where her father announced her engagement to Prince Rainier of Monaco to friends and family. Thanks to the international publicity surrounding the fairy-tale union of Hollywood royalty and Monégasque royalty, the style acquired a new name, which it retains today: the Kelly bag.

JANUARY 6

1903

British-ruled India celebrated the coronation of King Edward VII with a "Durbar," a Persian term meaning a courtly ceremony. No expense was spared for the ten-day event, including the construction of an amphitheater, roads, railways, and an electrical plant. There were military parades, firework displays, dances, polo matches, banquets, concerts, and exhibitions. But the highlight of the Delhi Durbar was the State Ball in the Red Fort on January 6.

At 10 p.m., a fanfare of silver trumpets announced the arrival of the couple responsible for organizing the elaborate festivities: Lord Curzon, the Viceroy, and his wife. "The scene was a brilliant one," the *Washington Post* reported, not least because Lady Curzon wore one of the most magnificent gowns ever seen before or since: a Jean-Philippe Worth creation in cloth of gold entirely embroidered with

overlapping peacock feathers of gold thread and sequins, the eye of each plume set with an iridescent beetle wing. (Many guests mistook the sparkling blue-green carapaces—shed naturally by the aptly named jewel beetle—for emeralds.) Lace encircled her shoulders, and white silk roses bordered the hem of the trained skirt. It weighed more than ten pounds, not including Lady Curzon's tiara, stomacher, and necklace of diamonds and rubies. In the new electric lighting installed for the occasion, she sparkled like a one-woman firework display. As one guest declared: "You cannot conceive what a dream she looked."

Lady Curzon had been born Mary Leiter in Chicago; her father, Levi, co-founded the Marshall Field department store. She was one of many American "dollar princesses" who married into the British peerage in the late nineteenth century and one of the inspirations for Cora Grantham, the fictional mistress of *Downton Abbey*. As Vicereine, her role—like that of the Durbar itself—was not just ceremonial, but essential to promoting the fragile peace between Britain and its colonial subjects. Even her fashion choices were diplomatically motivated; while many British women in India went to great lengths to avoid assimilation, Lady Curzon wore Indian fabrics and worked with local weavers and embroiderers to help them adapt their wares to Western tastes. Though it was designed in Paris, her Durbar gown was embroidered by Indian women, and the peacock and beetles were native to India.

Like a firework, Lady Curzon's ascendancy was dazzling but brief. Lord Curzon resigned in August 1906, and the couple returned to England, where she died less than a year later, at the age of thirty-six. This portrait was painted after her death, based on a photograph taken at the Durbar. ("Keep the feathers picture of me," she told her husband. "That is the best.") But the gown itself was painted from life; the artist used it as a model for the portrait. It survives today at Kedleston Manor, but its glory has dimmed over time as the fragile fabrics have disintegrated and the metallic decorations have tarnished, and no mannequin can convey the impact it made on the beautiful Lady Curzon, who stood six feet tall.

JANUARY 7

2017

For his inauguration ceremony, Nana Akufo-Addo, the newly elected president of Ghana, wore a toga-like robe of kente cloth, a native fabric woven in four-inch wide strips on narrow horizontal looms that are then sewn or basket-woven together. ("Kente" means "basket" in the Ashanti dialect.) Hearts and flowers joined the traditional geometric patterns. Historically worn by royalty, kente cloth is today reserved for special occasions. The president's cheerful, colorful, draped garment (paired

with dark sunglasses) was a stark contrast to the British-style military uniforms of the Ghanaian troops he inspected as part of the event, with their tailored, white-belted red tunics and black trousers with red welts (or stripes)—a relic of Britain's ninety-year colonial rule of Ghana, which ended in 1957.

JANUARY 8

2016

Facebook founder Mark Zuckerberg posted a picture of himself—wearing one of his trademark gray Brunello Cucinelli T-shirts—holding his six-week-old daughter, Max, who was dressed in a colorful hooded Reversible Puff-Ball Bunting by eco-friendly, California-based luxury outdoor clothing label Patagonia, with the caption "Doctor's visit—time for vaccines!" The post was widely interpreted as a pro-vaccination statement to his 47 million Facebook followers.

JANUARY 9

2007

At the annual Macworld trade show in San Francisco, Apple CEO Steve Jobs introduced the first iPhone, wearing his habitual attire of Levis 501 jeans, gray New Balance sneakers, and black mock turtleneck custom-made by Issey Miyake, who designed the corporate uniforms for Sony that Jobs had admired on a trip to Japan. Many scientific and artistic visionaries have embraced the convenience and cohesion of a personal uniform; others include Mark Twain, Albert Einstein, Ray Eames, Tom Wolfe, and Mark Zuckerberg.

JANUARY 10

1914

Denise Poiret, wife of couturier Paul Poiret, scandalized guests at one of her husband's "Fête des Rois" parties by appearing as the Queen of Sheba in a gold lamé gown of his design, slit to the hips on both sides. The Festival of the Three Kings—also known as Epiphany or Twelfth Night— falls on January 6; Poiret traditionally threw a costume party during the week of Epiphany, allowing his guests to play king (or queen) for the day.

OPPOSITE: Lady Curzon's "Durbar" dress

JANUARY 11

1540

King Henry VIII bought armor the way some men buy flashy sports cars, and his passion for the dangerous sport of jousting often got him into just as much trouble. On March 10, 1524, he held a joust to test out a new suit of armor, "made to his own design and fashion, such as no armorer before that time had ever seen," according to courtier George Cavendish. The king forgot to close his visor, and his opponent's wooden lance struck him "on the brow" and broke; miraculously, Henry survived, his helmet "full of splinters."

On January 24, 1536, Henry was competing in a tournament at Greenwich Palace when he was thrown from his horse, which then fell on him. Both horse and rider were fully armored, and the king remained unconscious for two hours. The accident may have altered the course of history. Henry's second wife, Anne Boleyn, miscarried a few days later, delivering a stillborn son; he had her beheaded on May 19. It has been speculated that Henry suffered an undiagnosed brain injury, which would explain his increasingly erratic behavior; his leg was damaged to the extent that he could no longer exercise regularly. (In addition to jousting, he had been an enthusiastic hunter, wrestler, and tennis player.) His idleness led to weight gain, making exercise even more difficult.

This suit of armor—crafted in Greenwich by a German-born armorer, Erasmus Kyrkenar—was likely worn at the tournament celebrating Henry's wedding to his fourth wife, Anne of Cleves. The unconsummated union was annulled after just six months. But the armor clearly outlasted the marriage; Henry must have worn it over a period of several years, because it shows evidence of later alterations as the king's girth continued to expand.

WORN ON THIS DAY

JANUARY 12

1971

For her husband Jimmy's inaugural ball as governor of Georgia, Rosalynn Carter wore a gold-embroidered sleeveless blue brocade coat over a gold-trimmed blue chiffon gown by Mary Matise

OPPOSITE: Nana Akufo-Addo's presidential inaugural kente cloth

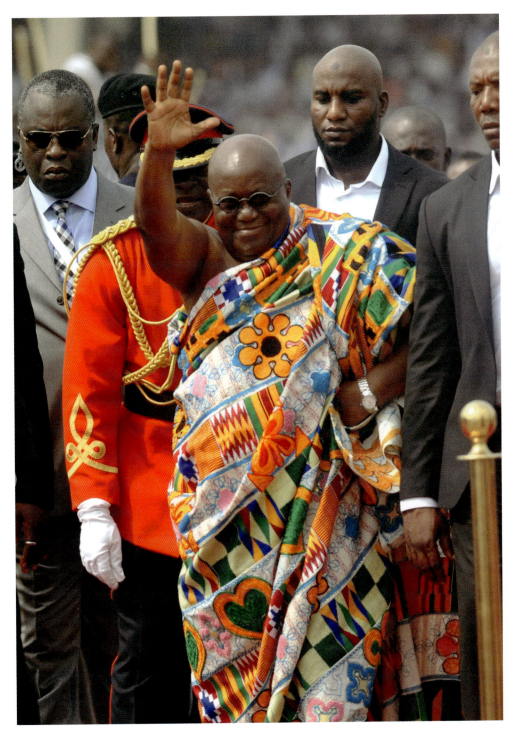

for Jimmae. She would rewear the same outfit at his presidential inaugural ball six years later, cementing her reputation as a First Lady more concerned with pinching pennies than following fashion.

JANUARY 13

2002

Four months after the September 11th attacks, actress-singer Reba McEntire wore a sequined American flag–patterned gown to the People's Choice Awards. Star-spangled clothing has long been a popular, if controversial, expression of patriotism; the US Flag Code states "the flag should never be used as wearing apparel."

JANUARY 14

1858

Empress Eugénie, the stunning, Spanish-born wife of Emperor Napoleon III of France, was the leader of style during the flowering of the French fashion industry in the mid-nineteenth century. Legendary dressmakers like Charles Frederick Worth, dubbed the father of *haute couture*, and the luggage-maker Louis Vuitton counted her among their best clients. Under Eugénie's example, the court of the Second Empire rivaled the elegance and extravagance of the reign of Queen Marie-Antoinette, whom the Empress admired and emulated.

Eugénie put on a white silk ensemble for a night at the opera with her husband—one of dozens of similar entertainments they enjoyed as France's First Couple. But that cold January night was like no other. As the Imperial coach drew up to the Salle Le Peletier, Felice Orsini, an Italian nationalist, and his accomplices threw bombs at it in an attempt to assassinate the Emperor. Though the Emperor suffered only scratches, the bombs killed 8 bystanders and injured 156, including Orsini himself. In a well-received show of fortitude, Napoleon and Eugénie proceeded to their box and enjoyed the performance of Rossini's *William Tell*. Orsini was apprehended, tried, and guillotined.

Her shoulder-baring bodice, which laces down the back, is trimmed with a wide collar of lace called a bertha; matching lace flounces and bands of ruching decorate the puffed sleeves. (In a fashion era that dictated bare shoulders for evening, Eugénie was famous for the beauty of hers.) The bod-

ABOVE:
King Henry VIII's tournament armor

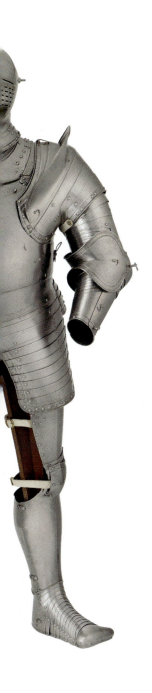

ice would have been worn with a matching full skirt supported by a crinoline, a cage-like dome constructed of steel or horsehair. It may have been part of a *robe à transformation*, which included two bodices: one for evening and one, more modest, for daytime. The skirt has not survived; inevitably, many of the era's vast, crinolined skirts were cut up and the precious textiles reused to make new clothes once the extreme silhouette went out of fashion in the late 1860s. Eugénie's lady-in-waiting, Madame Carette, recalled that "twice a year the Empress renewed the greater part of her wardrobe, giving the discarded ones to her ladies. This was a great source of profit to them because they sold them," either to secondhand clothes dealers or clothing rental shops.

Eugénie would be the last Empress of France. In 1870, Napoleon III was defeated and captured in the Franco-Prussian War, bringing the Second Empire to an ignominious end; he and Eugénie fled to England, where he died in 1873. She remained in England, but died on a visit to her native Spain in 1920, aged ninety-four.

Though the bodice is not labeled, it is likely by Worth, whom the empress called "the tyrant of fashion." His fashion house survived the collapse of the Second Empire, but Worth mourned the loss of the glittering court and remained loyal to Eugénie until his own death in 1895. Every year, he sent her a bouquet of Parma violets tied with a mauve ribbon embroidered in gold with his name.

JANUARY 15

1997

In Huambo, Angola, Princess Diana swapped her usual chic wardrobe for a flak jacket and face shield—worn over a plain, white button-down shirt, Armani chinos, and brown loafers—to walk through an active mine field. Her visit called attention to the work of the Red Cross and the Hazardous Areas Life-Support Organization (HALO) Trust, an anti-landmine charity working to remove the deadly detritus of Angola's thirty-year civil war.

JANUARY 16

1981

In the early hours of the morning, heavyweight boxing champion Leon Spinks was mugged while leaving a Detroit bar, he told the police. He woke up hours later in a motel room five miles away. "Missing, Spinks said, were

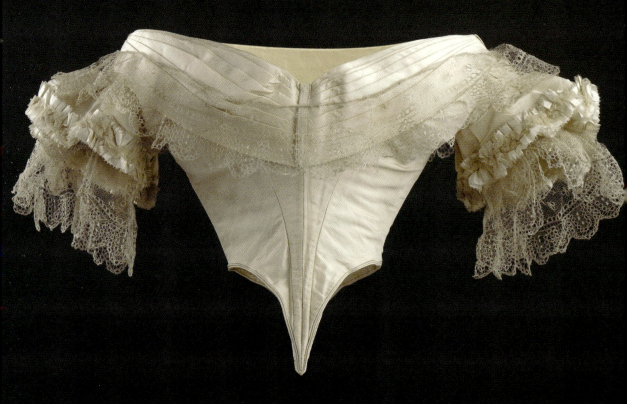

"THE TYRANT
OF FASHION"

his jewelry, his removable [gold] front teeth, and his clothes, including an expensive blue fox coat," the *New York Times* reported—$45,000 worth of goods in all. Three years later, Mr. T. revealed in his autobiography that Spinks had actually been "set up" by a woman while high on drugs. "He lied and told the police that he was robbed," he wrote. "He said someone hit him on the back of the head and took his money and dragged him to a hotel, where they took all of his clothes. I tell you, Leon couldn't even lie straight."

JANUARY 17

1617

Nicolas Trigault, a French Jesuit missionary, spent four years in China before returning to Europe in 1614, in search of funds and new recruits. Traveling in the Southern Netherlands, he met the Flemish artist Peter Paul Rubens. Rubens—who was fascinated by costume and kept many exotic and historic garments in his studio—made a drawing of Trigault, annotated with explanatory notes in Latin.

Trigault's rich garb was undoubtedly influenced by the Italian Jesuit missionary Matteo Ricci, who, when he arrived in Beijing in 1601, realized that the humble black robe of the Jesuit order would not win the respect of the Chinese. Instead, he assumed the dress of the Chinese literati, which he described in a letter as "a dress of purple silk and the hem of the robe and the collar and the edges are bordered with a band of blue silk a little less than a palm wide." He added: "The same decoration is on the edges of the sleeves, which hang open." A purple and blue silk sash around the waist completed the ensemble. Trigault wore a Korean cap with his Chinese robe, a hybrid costume that conveys the Jesuits' esteem for Chinese culture while, at the same time, acknowledging their otherness.

JANUARY 18

1911

Like many early aviators, Eugene Ely honed his daredevil skills in the automotive sector, racing and, later, selling cars. He assumed flying would be as easy as driving, but crashed the first plane he ever flew. Within a few months, though, Ely—who had only an eighth-grade

OPPOSITE: Empress Eugénie's opera bodice

education—had repaired the plane and learned to fly it. He found a job in the aircraft industry, which brought him into contact with the US Navy, then exploring military uses for aviation. Ely made the first ship-to-shore flight in 1910, taking off from the USS *Birmingham* in Virginia's Hampton Roads harbor.

On January 18, 1911, Ely made history again when he became the first aviator to land a plane on a ship, paving the way for the modern aircraft carrier. He took off from a racetrack near San Jose, California, and landed on the USS *Pennsylvania*, anchored in the San Francisco Bay. Ely probably helped design the plane's tailhook and the arrester cables on the ship's wooden landing strip; similar devices are still used on aircraft carriers today. During his flight, he wore a cotton-lined leather helmet. Adapted from a football helmet, it offered warmth as well as protection from the elements in the open cockpit.

Unfortunately, Ely was killed just a few months later, when his plane crashed at an exhibition in Georgia. He escaped with a broken neck, but died minutes later, at just twenty-four years old. Spectators scavenged the wreckage for souvenirs, making off with Ely's gloves, tie, and cap.

JANUARY 19

2011

First Lady Michelle Obama wore a red and black Alexander McQueen gown to a State Dinner at the White House in honor of the Chinese president, Hu Jintao. Though red symbolizes good luck in China, the Council of Fashion Designers of America issued a rare statement criticizing Obama for choosing a British designer instead of an American one.

JANUARY 20

1961

On a freezing January morning, thirty-one-year-old Jacqueline Bouvier Kennedy stood out among the fur-clad First and Second Ladies witnessing her husband's inauguration as president of the United States in an A-line coat and matching dress of beige melton wool by Oleg Cassini. Just a whisper of brown sable encircled her slim neck, and she carried a matching sable muff. But it was her simple hat of beige felt that started a fashion revolution.

At a time when hats were fading from fashion, the chic young First Lady

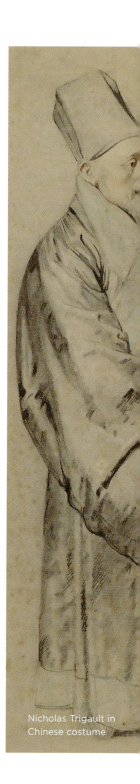

Nicholas Trigault in Chinese costume

made the brimless, unfussy pillbox her signature headwear, and singlehand-edly revived the millinery industry. (Ironically, her husband's distaste for hats is often cited as one of the reasons men stopped wearing them; he grudgingly donned a top hat—briefly—for the inauguration.) Of the many fashion trends Mrs. Kennedy set—A-line gowns, sheath dresses, bouffant hairstyles, over-sized sunglasses—the pillbox is the one indelibly associated with her.

The hat she wore to the inauguration was designed by Bergdorf Good-man's in-house milliner, Roy Frowick. The midwesterner would come to rule the New York style scene under his middle name, Halston—a sobriquet so dashing that no other was needed. But, in 1961, his name was known only to fashion insiders; he would not unveil his own ready-to-wear line until 1969.

Halston did not invent the pillbox style; simple, dome-shaped hats had appeared in Hubert de Givenchy's Fall/Winter 1959 collection, and other Paris couturiers including Christian Dior and Cristóbal Balenciaga offered their own interpretations. But Jackie made the style her own. To minimize her large head and downplay the hat's prominence, she wore it tilted to the back of her head, inadvertently setting a trend. The press christened the sud-denly ubiquitous chapeau the "Jackie Box."

JANUARY 21

2017

Women around the world donned hand-knitted pink "pussy hats" to march in protest of the inauguration of Donald Trump, who had boasted of grab-bing women "by the pussy." The Los Angeles–based Pussyhat Project was co-founded by Jayna Zweiman and Krista Suh. The pair created a simple knitting pattern evoking cat's ears—a humorous and heavily sanitized refer-ence to the president's vulgar comment—and shared it online, for free, with protesters around the world.

JANUARY 22

1901

When Queen Victoria died at Osborne House on the Isle of Wight, at the age of eighty-one, she was holding a large black fan edged with black machine-made lace with a daffodil motif. Since the death of her husband in 1861, she had eschewed colored clothes, setting a fashion for prolonged and conspic-uous mourning.

JANUARY 23

1932

Marlene Dietrich wore a tuxedo, white gloves, and a jaunty fedora to the premiere of *The Sign of the Cross* in Los Angeles. Her masculine attire raised eyebrows at a time when women still courted controversy by wearing pants, but, in 1933, *New Movie Magazine* would declare: "Marlene wins! Hollywood has at last succumbed to the trousers craze."

JANUARY 24

1899

Humphrey O'Sullivan obtained a patent on the rubber heel he had invented after his coworkers at a Lowell, Massachusetts, print shop kept stealing the rubber mat he used to cushion his aching feet. Finally, he cut two pieces out of the mat and tacked them to the leather heels of his shoes. He began manufacturing the heels and selling them to local shoemakers. The first "sneakers," so named for their silent rubber soles, would be sold by Keds in 1917.

JANUARY 25

1858

At the wedding of the Princess Royal, the mother of the bride—Queen Victoria—wore a gown in the trendiest shade of the time: mauve. Discovered in 1856 by Royal College of Chemistry student William Perkins, who was trying to synthesize quinine, mauve was the first chemical dye. By August 1857, the new hue was "the rage of Paris, where it is an especial favourite of the Empress Eugenie," the *Illustrated London News* reported. "Mauve mania" would persist until 1861. The queen accessorized the gown with the largest known diamond in the world at the time, the Koh-i-noor, a supposedly cursed Indian gemstone that would inspire Wilkie Collins's 1868 mystery novel *The Moonstone*.

OPPOSITE: Eugene Ely's aviator helmet, Jackie Kennedy's pillbox hat

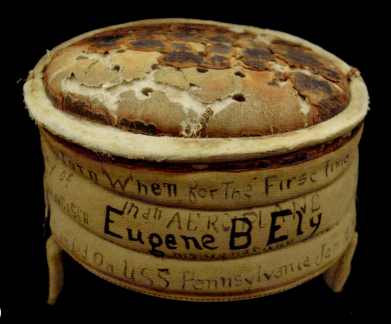

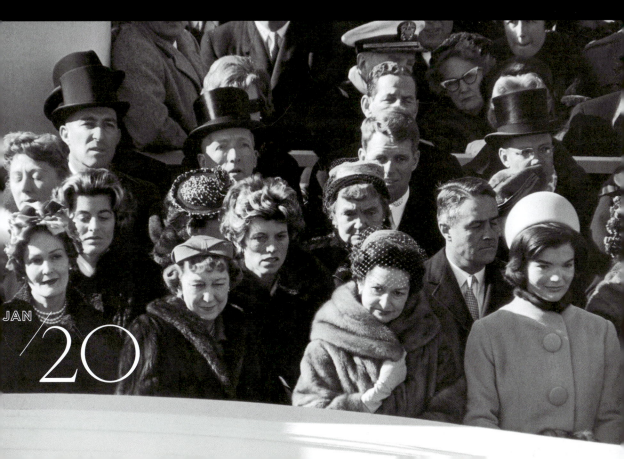

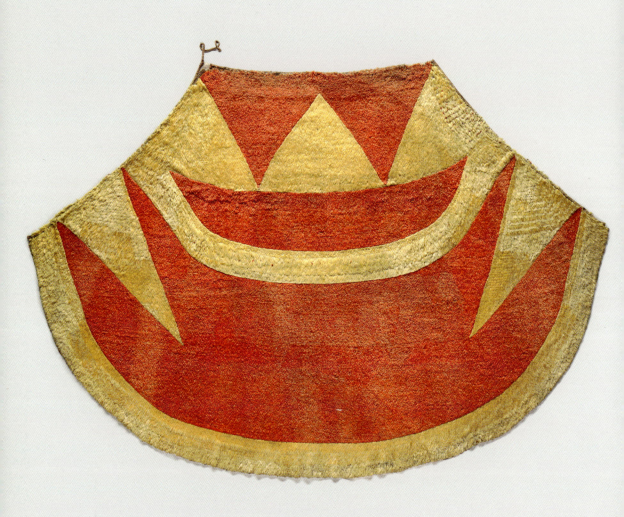

"EXCEEDINGLY
BEAUTIFUL, AND OF THE
GREATEST VALUE"

This feathered cloak or 'ahu 'ula was given to the English explorer, navigator, and cartographer Captain James Cook by Hawaiian high chief Kalaniʻōpuʻu. "The king rose up, and in a very graceful manner threw over the Captain's shoulders the cloak he himself wore, put a feathered helmet upon his head, and a curious fan into his hand," James King, one of Cook's officers, recorded in his journal. The chief "also spread at his feet five or six other cloaks, all exceedingly beautiful, and of the greatest value." In return, Cook "put a linen shirt on the king, and girt his own [sword] hanger round him," King testified.

It hardly seems a fair exchange for this magnificent artifact, among the most precious objects in Hawaiian society. Worn only by men of the highest rank, these cloaks were so culturally and materially valuable that they were often given names. They were constructed of a woven netting of plant fibers—similar to those used as fishing nets by the Hawaiians—with hundreds of thousands of feathers gathered into bunches and tied to the netting in a dense, velvety pile. Cook's is estimated to contain half a million feathers from twenty thousand birds. Just a few feathers were taken from each bird, so they could be released back into the wild; nevertheless, some of the birds represented in Cook's cape are extinct today.

The cloak advertised that its wearer had access to extensive lands as well as labor; its fabrication required the coordinated efforts of skilled bird catchers, weavers, and feather workers. King noted that "these cloaks are made of different lengths, in proportion to the rank of the wearer, some of them reaching no lower than the middle, others trailing on the ground"—signifying extremely high status. According to scholar Adrienne Kaeppler, Cook's cloak likely started as a shorter cape before being lengthened.

As well as conferring beauty and status, the cloak offered protection: the thick mat of feathers protected its wearer against blows, stones, and other weapons. The matching helmet (or mahiole) had a rigid wicker lining "capable of breaking the blow of any warlike instrument, and seems evidently designed for that purpose," King noted admiringly. The garments were also thought to provide spiritual protection: here, the red triangles (huinakolu) and crescent (hoaka) at the neckline form a sacred, defensive design. King called this traditional Hawaiian costume "in point of beauty and magnificence . . . perhaps nearly equal to that of any nation of the world."

Cook and his crew enjoyed similar hospitality wherever they went during

OPPOSITE: Hawaiian feathered cloak

JANUARY

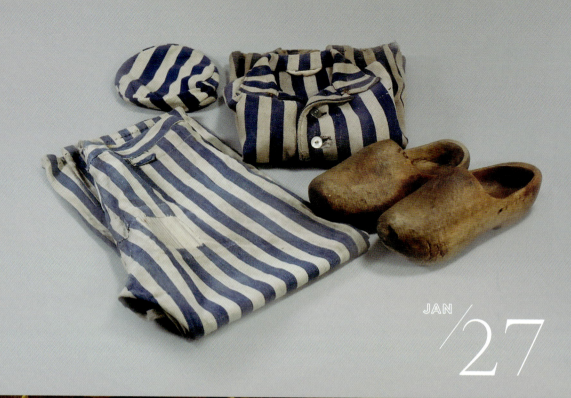

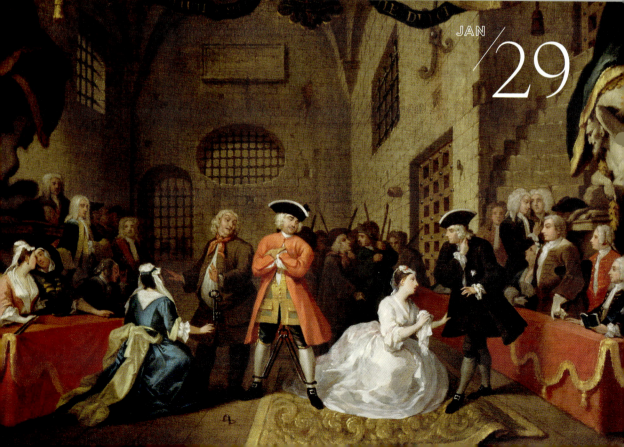

their month-long sojourn in the Hawaiian Islands. They were the first Europeans to visit the region, and their arrival during the Hawaiian harvest festival was welcomed as auspicious. However, relations soon soured when the natives realized that Cook and his men were not gods, as they had originally believed. Less than three weeks after receiving this cloak, on February 14, Cook was killed at Kealakekua Bay during a dispute with some Hawaiians.

JANUARY 27

1945

The first dehumanizing act the Nazis inflicted on prisoners arriving at Auschwitz concentration camp in Poland was taking away their clothing. Each inmate was given one blue-and-white-striped uniform and a pair of clogs, but no socks. Historically, striped textiles and parti-colored clothes have been used to stigmatize and exclude; they are both distinctive and high-contrast, making their wearers stand out. Sailors wear striped shirts because the repetitive pattern is supposed to make them easy to spot if they fall overboard; convicts are made to wear them to prevent escape. A prisoner at Auschwitz was wearing the uniform on page 22 the day the Red Army liberated the camp, freeing more than seven thousand prisoners—a fraction of the 1.1 million people estimated to have died there during the war. Today, January 27 is commemorated as International Holocaust Remembrance Day.

JANUARY 28

1956

The day after the release of "Heartbreak Hotel," Elvis Presley made his television debut on *Stage Show*, broadcast live from CBS Studios in New York. The then-unknown twenty-one-year-old wore a suit with a black shirt and a white tie carefully selected by Bernard Lansky, the owner of Memphis menswear shop Lansky Brothers—a favorite of the African American musicians who played the blues clubs surrounding it on Beale Street. "If Elvis had worn a white button-down Oxford cloth shirt, he would still be driving a truck," Lansky's son Hal once said. Elvis remained a faithful customer of Lansky Brothers—which celebrated its seventieth anniversary in 2016—until his death in 1977.

OPPOSITE: Auschwitz prisoner's uniform, William Hogarth's *Beggar's Opera* painting

1728

John Gay's musical entertainment *The Beggar's Opera* was the *Hamilton* of its time when it opened at the Lincoln's Inn Fields Theatre in London: a smash hit that winkingly inserted pop music, slang, and familiar, flawed characters into a medium previously dominated by Italian arias and Greek deities. In William Hogarth's painting on page 22, "A Scene from *The Beggar's Opera VI*," it's difficult to tell the actors from the audience members, many of whom sat onstage, a practice common in the English theater until 1763. The Latin proverb "*veluti in speculum*"—"as in a mirror"—seen in the background was often invoked as a reminder that the theater was a reflection of life; in this case, the likeness was especially accurate, right down to the clothes.

In the climactic scene, the show's antihero—the highwayman Macheath, better known as Mack the Knife—stands shackled in Newgate Prison, torn between his two lovers: his jailer's daughter, Lucy Lockit, in blue, and his lawyer's daughter, Polly Peachum, in white. Both women believe themselves married to Macheath and plead with their fathers to save him. It is one of the few scenes in which all the main characters appear onstage together.

Part of the show's appeal was the recognizable contemporary clothing of the actors. Macheath wore a red coat and a black tricorn hat trimmed with gold, his gold-laced waistcoat rakishly unbuttoned. A captain in the army before turning to a life of crime, he retained his martial flair. Macheath quickly became the archetype of the sharp-dressed, smooth criminal. Visiting Newgate—a real penitentiary—in 1763, James Boswell described one robber, Paul Lewis, who was nicknamed "Captain" because he had been in the Royal Navy. "He was just a Macheath," Boswell wrote. "He was dressed in a white coat and blue silk vest . . . and a silver-laced hat, smartly cocked."

Polly Peachum's white-gowned image appeared on fans, snuffboxes, and prints capitalizing on the show's success. The Duke of Bolton—portrayed seated in the box at far right, the silver star of a Knight of the Order of the Garter on his breast—fell in love with Lavinia Fenton, the actress who played Polly, and was a fixture in the audience throughout the season. When it ended, Fenton retired from the stage to become his mistress, eventually landing the role of a lifetime: Duchess of Bolton.

WORN ON THIS DAY

ABOVE:
King Charles's execution waistcoat

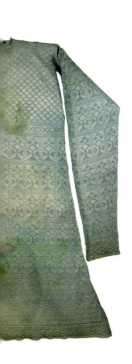

JANUARY 30

1649

When King Charles I was beheaded for treason in London, he was wearing a knitted silk shirt, called a waistcoat at the time—a rare extant example of an early seventeenth-century undergarment that has survived due to its grisly history.

An eyewitness to the king's death, Robert Cotchett, reported that "he putt off his hat and one of the executioners putt on his head a white capp and gathered upp his hair under it. Then he putt off his doublet and lay flatt downe on his belly with his neck on the block with his arms spread out giving the signe by spreading his hands wider." With one stroke, the executioner severed his head. "His mate took it upp and held it up to the spectators which was very many," Cotchett concluded. Both the executioner and his assistant wore masks with false beards attached to conceal their identities from angry Royalists in the crowd.

The waistcoat is constructed of five finely gauged hand-knit panels in a variety of patterns and stitches, possibly inspired by woven silk designs of the time. Wills and wardrobe accounts of the period indicate that women wore similar garments. Always a fastidious and fashion-conscious monarch, Charles set several trends in his lifetime; in death, he was no less dapper.

JANUARY 31

1991

When Specialist Melissa Rathbun-Nealy of the US Army's 233rd Transportation Company was captured in Operation Desert Storm, she was wearing her "chocolate chip" camouflage battle dress uniform—a six-color pattern developed in the early 1960s for arid environments, but not widely used until the 1980s. Expensive to manufacture and only effective in rocky, high-desert terrain, it was replaced in the mid-1990s by the subtler "coffee stain" camouflage, a three-color pattern matched to soil samples from Saudi Arabia and Kuwait. Rathbun-Nealy was the first female soldier held as a prisoner of war since World War II; she was released on March 4.

FEBRUARY

1	2	3	4	5	6	7
Helmet from Space Shuttle *Columbia*	Andre Agassi's Oakley sunglasses	Layering for the London weather	Burqini-style lifeguard uniform	Keeping kimono under control	Opera singer Nellie Melba's cloak	Beatles style arrives in America
2003	**1992**	**1763**	**2007**	**1683**	**1894**	**1964**
8	9	10	11	12	13	14
Prince Albert's diamond garter	Boat cloak worn by Franklin D. Roosevelt	Queen Victoria's white wedding gown	A vision of the Virgin Mary	Princess Liliuokalani's coronation gown	Susan B. Anthony's red shawl	Fancy pants of Norway's curling team
1840	**1945**	**1840**	**1858**	**1883**	**1898**	**2010**
15	16	17	18	19	20	21
Bodysuit worn by Olympian Franz Klammer	Susan B. Anthony's hated bloomers	Norman Hartnell's cash-covered couture	Rubber gloves worn by Acid Bath Killer	Queen of the Mystic Krewe costume	Handbag carried by Margaret Thatcher	Prime Minister Justin Trudeau in India
1976	**1854**	**1963**	**1949**	**1955**	**1985**	**2018**
22	23	24	25	26	27	28
First Lady Pat Nixon in China	Jennifer Lopez's Grammy Awards gown	Olympic "Miracle on Ice" jacket	Mourning Alexander McQueen	Hoodie worn by Trayvon Martin	The Snow Leopard's ski suit	Monica Lewinsky's blue Gap dress
1972	**2000**	**1980**	**2010**	**2012**	**2010**	**1997**

FROM SPACE SUITS TO SARTORIAL SCANDALS

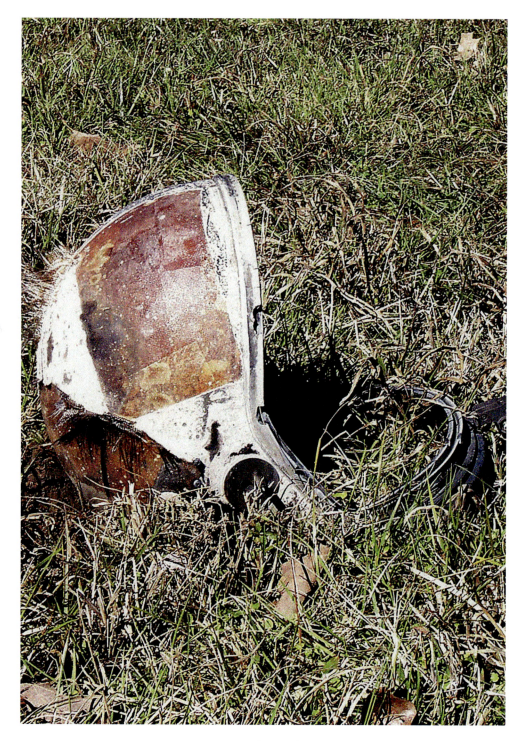

FEBRUARY / 01

01

— **2003** —

On its twenty-eighth mission, the Space Shuttle *Columbia* suffered a catastrophic breach and broke apart forty miles over Texas en route to landing at Kennedy Space Center. Debris showered down as far away as Arkansas and Louisiana, including the remains of this helmet worn by one of the seven crew members. It was found by an eleven-year-old boy on a cattle farm in Norwood, Texas, dented and stripped of its visor, hinge, and other hardware.

The helmet was part of an Advanced Crew Escape Suit (ACES). After the Space Shuttle *Challenger* exploded shortly after takeoff in 1986, killing all seven astronauts aboard, NASA required crew members to wear pressure suits instead of blue jumpsuits for launch and reentry. Nicknamed the "pumpkin suit," the ACES suit was bright orange to contrast with the blue ocean water where it would most likely be found in the event of an ejection.

A NASA report issued nearly six years after the *Columbia* disaster concluded that although the accident was not survivable, precious seconds were lost because of design flaws in the crew's seat restraints, pressure suits, and helmets. In the extreme turbulence, the restraints proved to be inadequate; as the astronauts' upper bodies were violently jostled, the helmets that were supposed to protect their skulls battered them instead, because they did not conform to the shape of the human head. The report also found that, at the time of the breach, one crew member had not been wearing a helmet, and those who were wearing them had their visors up, according to standard procedure; the cabin depressurized so quickly that they did not have time to lower them. Three crew members had not been wearing their gloves. Although the gloves were textured to allow basic manipulation of knobs, buttons, and switches, they were too bulky to perform certain

OPPOSITE: Helmet from Space Shuttle *Columbia*

FEBRUARY

reentry tasks. Without gloves or sealed helmets, the suits could not be pressurized. Thus, the astronauts were likely rendered unconscious before they could react to the ship's warning alarms.

NASA recommended several suit design changes for future missions. A former head of the Shuttle program, N. Wayne Hale Jr., told the *New York Times*: "I call on spacecraft designers from all the other nations of the world, as well as the commercial and personal spacecraft designers here at home, to read this report and apply these lessons which have been paid for so dearly."

FEBRUARY 2

1992

At the Davis Cup tournament in Hawaii, American tennis star Andre Agassi stayed out until 4 a.m. drinking with his teammate, John McEnroe, before facing Argentina's Martin Jaite. "To conceal my bloodshot eyes I play wearing Oakley sunglasses, and somehow I play well," Agassi wrote in his memoir, *Open*. "The next week I find myself on the cover of *Tennis* magazine, hitting a winner in my Oakley sunglasses. Hours after the magazine hits the newsstands . . . a delivery truck pulls up to the door." Inside was a red Dodge Viper sports car—a gift from Oakley founder Jim Jannard.

FEBRUARY 3

1763

In London, the winter of 1763 was so severe that parts of the Thames froze. Nonetheless, law student James Boswell "wrapped . . . well up in two pair of stockings, two shirts, and a greatcoat; and thus fortified against the weather, I got into a snug chair and was carried to Drury Lane."

FEBRUARY 4

2007

Twenty-year-old Mecca Laalaa Hadid became the first Australian lifeguard to wear a "burqini"-style uniform. The two-piece polyester suit in the North Cronulla Beach volunteer lifeguard patrol's colors of red and yellow had long sleeves and a hood to cover Laalaa's hair. It was designed by Leba-

nese-born Australian designer Aheda Zanetti, whose label Ahiida offers modest athletic clothing for Muslim women; she designed her first burqini in 2003 for her school-aged niece.

FEBRUARY 5

1683

In response to the sartorial excesses and blurring of class distinctions that characterized the Empo era, Japan issued a law forbidding the use of gold brocade, embroidery, and labor-intensive tie-dyeing techniques on kimono. The law also banned consumers from paying more than two hundred pieces of silver for a kimono. Like most sumptuary laws, or laws regulating consumption, this one backfired, encouraging kimono makers to develop eye-catching new methods of weaving, resist-dyeing, and stenciling and thus contributing to the unprecedented flourishing of the Japanese textile arts in the Edo period.

FEBRUARY 6

1894

While today's stage costumes rarely belong to the people who wear them, many leading ladies of the nineteenth century purchased their own designer costumes and wore them regardless of what everyone else onstage was wearing. Australian soprano Nellie Melba commissioned a show-stopping cloak from Paris couturier Jean-Philippe Worth, who dressed her on and off stage, around 1890. For many years, she wore it in the Act II wedding scene of Richard Wagner's medieval opera *Lohengrin*—the source of the tune now known as "Here Comes the Bride."

The cloak is embroidered with white fleurs-de-lis, its hem decorated with hand-painted angels set in roundels of velvet embellished with pearls, sequins, beads, and gold braid. "It was immensely heavy, and two stout pages were put on . . . to carry the train of this gorgeous garment in the wedding scene," one reviewer noted. "But, in spite of the two bearers, the movements of Madame Melba were much impeded as she moved about the stage."

When Melba was invited to perform at the Imperial Opera in St. Petersburg in 1891, the cloak almost didn't survive the journey. Customs officers stopped her train at the Russian border and searched Melba's luggage. To

her horror, she saw "an exquisite cloak which I had brought especially for *Lohengrin*, lying on the ground, perilously near the soldier's feet," she wrote in her memoirs. "I dashed outside and tried to explain, in a mixture of four languages, that the cloak was for the Opera, that it was a very beautiful thing, and that on no account must it be spoilt. All was useless."

Luckily, Melba found a Russian friend on the train. "A few words from him soon put matters right, and instead of indifference, the soldiers escorted me back to the train with many apologies," she remembered, adding: "I did not care for their apologies, but I cared intensely for my cloak, now safely reposing in my trunk."

She was not the only one enamored by the cloak. Tsar Alexander III and his wife, Maria Feodorovna, came to see her in *Lohengrin*. "They sent for me after the second act," Melba wrote. "One of the first actions of the Tsaritsa was to bend over my cloak and take it in her hands and to stroke it, saying: 'How perfectly lovely this is!'"

Melba sang her last *Lohengrin* at New York's Metropolitan Opera in 1894. On opening night—February 6—"the magnificence of her wardrobe was without a parallel as far as the local stage is concerned," the *New York Tribune* gushed. Even after she retired, Melba treasured her *Lohengrin* cloak, which still retains its show-stopping beauty.

FEBRUARY 7

1964

The Beatles descended from a Pan Am jet onto the tarmac at JFK Airport in New York—and into fashion history. It was their first visit to the United States, where they were appearing on *The Ed Sullivan Show*. Their identical mop-top haircuts, Chelsea boots, and slim-cut mod suits by London tailor Arnold "Dougie" Millings set trends worldwide.

FEBRUARY 8

1840

In the run-up to his marriage to Queen Victoria, Prince Albert was made a Knight of the Order of the Garter, England's oldest and most prestigious order of chivalry. Founded by Edward III in the fourteenth century, it was supposedly inspired by a wardrobe malfunction: a lady's garter slipped from

OPPOSITE: Nellie Melba's *Lohengrin* cloak

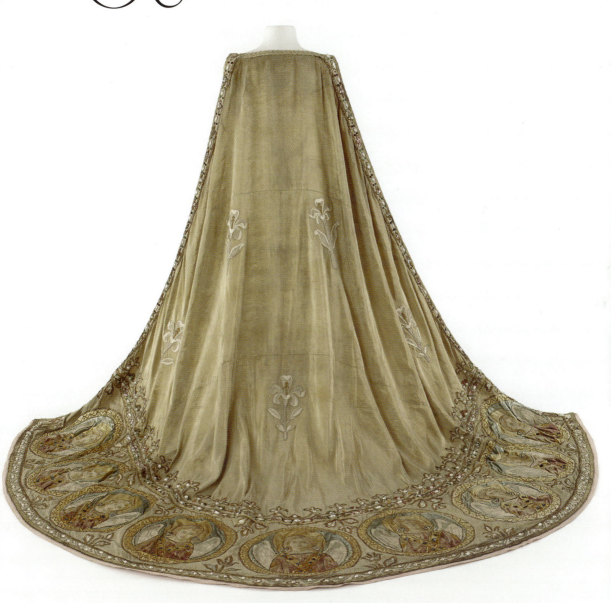

FEBRUARY / 09

her leg at a court ball and the king retrieved it. The order's Latin motto, *Honi soit qui mal y pense*—"Shame on him who thinks evil of it"—was his retort to those who made bawdy jokes about the incident. At the time of the order's founding, garters were practical, unisex accessories. Among other regalia, garter knights were entitled to wear special stars on their coats or cloaks and a blue velvet garter embroidered with the motto of the order in gold buckled around their left calves.

Two days before their wedding, Queen Victoria presented Albert with a diamond-studded star from her own collection and a velvet garter, its motto, edges, and buckle lavishly mounted with diamonds. The queen recorded in her diary that the prime minister, Lord Melbourne, "admired the diamond Garter which Albert had on, and said 'Very handsome.' I told him it was my gift." Prince Albert would wear the garter and star on his wedding day and on many occasions afterward until his death from typhoid fever in 1861.

FEBRUARY 9

1945

President Franklin D. Roosevelt wore a US Navy regulation officer's boat cloak at the Yalta Conference of Allied leaders in Crimea. Designed to keep the wearer warm and dry on the deck of a ship, the wool and velvet cloak fastened across the chest. The relative ease with which the cloak could be put on and taken off must have made it an attractive alternative to more conventional outerwear for the president, whose movements were hampered by the effects of polio. The long garment also hid his stiff gait and leg braces from view, while giving him a patriotic martial appearance at a time when many American men (and women) were in uniform.

By the time he left Yalta, Roosevelt had succeeded in convincing the Soviet Union to join the United Nations and fight against Japan. But his triumph was short-lived: he died of a stroke just two months later, having served an unprecedented (and since unmatched) twelve years in office.

FEBRUARY 10

1840

Queen Victoria was not the first bride to wear a white dress, lace, a veil, or orange blossoms. But she's the reason brides still wear them to this day. Her wedding gown of silk satin with lace flounces and a matching veil anchored by

OPPOSITE:
President Franklin D. Roosevelt's Navy cloak

a wreath of orange blossoms instantly set the standard to which all other brides aspired.

White was an increasingly popular choice for wedding dresses, but it was hardly the rule, and royal women typically wore cloth of gold or silver, or velvet robes of state. Victoria's only concession to her royal status was the court train she wore attached to her waist, ornamented with sprays of orange blossoms. Instead of a crown, she wore the sapphire and diamond brooch the groom, Prince Albert, had given her on the eve of the ceremony, which she pinned to her bodice, and an impressive necklace and earrings of Turkish diamonds.

Her gown was designed with patriotism rather than precedent in mind. It was probably made by her frequent dressmaker, Mary Bettans of Jermyn Street, from silk woven in the Spitalfields neighborhood of London. Her gloves were of English kid leather; her white satin shoes by Gundry and Son had gold trim and resembled modern ballet flats. Although Brussels lace was more fashionable, Victoria commissioned her wedding lace from the lace makers of Honiton, Devon, who had suffered from the advent of machine-made lace. She would continue to use Honiton lace on her own clothes and those of her children and insisted that her daughters and daughters-in-law wear Honiton lace for their weddings.

Handmade lace was as expensive as fine jewelry, and it was not unusual to rewear the same piece of lace with many different garments. The sentimental queen wore her wedding lace to the christenings and weddings of many of her children and grandchildren. When she died in 1901, her veil was buried with her.

FEBRUARY 11

1858

WORN ON
THIS DAY

As she was gathering wood on a riverbank in Lourdes, France, thirteen-year-old Bernadette Soubirous had a vision of the Virgin Mary. "She has the appearance of a young girl of sixteen or seventeen," Bernadette reported. "She is dressed in a white robe, girdled at the waist with a blue ribbon which flows down all around it. A yoke closes it in graceful pleats at the base of the neck. The sleeves are long and tight-fitting. She wears upon her head a veil which is also white. This veil gives just a glimpse of her hair and then falls down at the back below her waist." Bernadette would claim that the Virgin

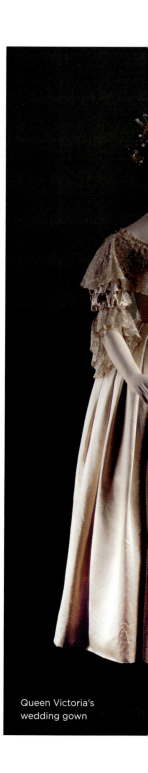

Queen Victoria's wedding gown

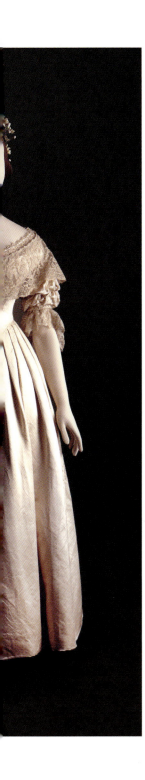

appeared to her a total of eighteen times; the site now draws six million pilgrims and tourists annually.

FEBRUARY 12

1883

King David Kalakaua's lavish coronation ceremony at Iolani Palace in Honolulu, Hawaii, blended Hawaiians' and westerners' traditions and regalia as Kalakaua asserted his legitimacy in the eyes of both groups. The king's sister, Princess Liliuokalani, had ordered "two elegant dresses" from Paris for the festivities, one of gold and white brocaded silk for the daytime ceremony, and one of crimson satin for the ball afterward. "Each costume was perfect itself, the lesser details being in harmony with the dress," she wrote in her autobiography. "Both were heavily embroidered, and were generally considered to have been the most elegant productions of Parisian art ever seen in Hawaii on this or any other state occasion." Each gown had two bodices, one for day and one for night, and the princess may have worn them again at other celebratory events held over the next two weeks, including regattas, fireworks, horse races, twenty-one-gun salutes, a giant luau, and nightly hula performances. (Kalakaua, a ukulele enthusiast, rehabilitated the hula, which had been banned by a pious queen in 1830.)

Kalakaua's lavish spending and king-sized ego did not endear him to the wealthy American settlers who were increasingly anxious to annex Hawaii; in 1887, he was forced at gunpoint to sign a new constitution, ceding most of his powers. In 1893, the United States overthrew Liliuokalani, who had succeeded her brother as Hawaii's last queen. Hawaii became a US territory in 1898 and the fiftieth state in 1959.

FEBRUARY 13

1898

Susan B. Anthony opened the Thirtieth National American Woman Suffrage Association (NAWSA) convention in Washington, DC, wearing her trademark red shawl. "It is silk crepe of exquisite fineness, with long, heavy knotted fringe," the *Evening Star* reported. "For full thirty years Miss Anthony's red shawl has been the oriflamme of suffrage battle. She wears it with the grace of a Spanish belle." Another paper quipped: "Spring is not heralded in Washington by the approach of the robin red-breast but by the appearance of Miss

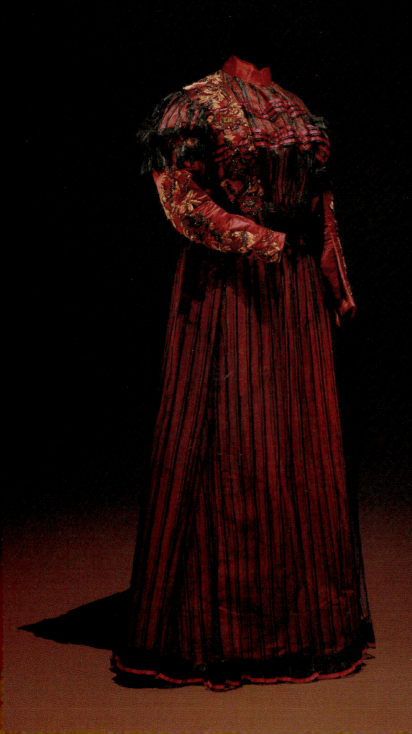

Anthony's red shawl." Anthony's shawl was her secret weapon in making the progressive feminism promoted by NAWSA palatable to a wider audience. At an appearance in Philadelphia in 1905, "the figure of Miss Anthony was simplicity itself," the Press reported "That bonnet, with the kind blue eyes beneath it, those spectacles, that plain dress and quaint red shawl, and above all, that sweet, gentle voice, spelled 'mother' as plainly as the fine word ever was written. Not a hint of mannishness but all that man loves and respects. What man could deny any right to a woman like that?"

FEBRUARY 14

2010

At the Winter Olympics in Vancouver, the Norwegian men's curling team shook up the staid, six-hundred-year-old sport by competing in colorful harlequin-print pants by California sportswear company Loudmouth Golf. They took silver—and launched an Olympic tradition.

FEBRUARY 15

1976

When Austrian downhill skier Franz Klammer won the gold by 0.33 seconds at the Winter Olympics in Innsbruck, Austria, he wore his own bright yellow bodysuit because his gold and black team uniform was so tight that he couldn't get into a crouch position.

FEBRUARY 16

1854

Although her friend Elizabeth Cady Stanton had "passed a most bitter experience in the short dress," Susan B. Anthony was determined to try out the daringly progressive combination of knee-length skirt and voluminous, ankle-length trousers, dubbed bloomers after her fellow suffragist Amelia Bloomer. But Anthony complained: "I have . . . been in the streets and printing offices all the day long; had rude, vulgar men stare me out of countenance, and heard them say as I opened the doors, 'There comes my Bloomer!' Oh, hated name!" Stanton responded: "We put the dress on for greater freedom, but what is physical freedom compared with mental bondage? By all means have the new dress made long."

OPPOSITE: Princess Liliuokalani's gown

Though Anthony ultimately rejected bloomers as an unhelpful distraction, she maintained "that women can never compete successfully with men in the various industrial avocations, in long skirts. No one knows their bondage save the few of us who have known the freedom of short skirts." It was not until bicycling became popular at the turn of the century that women would wear the pants again.

FEBRUARY 17

1963

In a publicity stunt, model Margot Greenfield presented a bingo prize at the Odeon Theatre in London wearing a ball gown crafted from one thousand £5 notes. Greenfield arrived in an armored car escorted by uniformed policemen. The dress was designed by Norman Hartnell, couturier to Queen Elizabeth II, whose face smiled out from the notes.

FEBRUARY 18

1949

Serial killer John Haigh—known as the Acid Bath Murderer—dissolved the bodies of his victims in sulfuric acid. After he killed his sixth and last victim on February 18 in Crawley, Sussex, Haigh was caught and sentenced to death. The rubber gloves he wore to protect his hands from acid were preserved in the "Black Museum," a secret room in Scotland Yard where grisly souvenirs from crime scenes have been kept since 1875.

FEBRUARY 19

1955

WORN ON
THIS DAY

Mrs. Richard West Freeman wore a silver satin gown patterned with gold leaves as Queen of the Mystic Krewe during Mardi Gras in New Orleans. The Mystic Krewe—or club, a members-only organization that puts on a Carnival ball or parade—was known for its extravagant tableaux depicting literary or historical scenes. Though the theme of the Krewe's 1955 coronation ball was "After the Battle of New Orleans," there is nothing particularly historic about the gown's design. But, like all Mardi Gras costumes, it is made to be seen: its reflective satin is embellished with rhinestones and sequins, and the puffed sleeves are adorned with wired and bejeweled

OPPOSITE: Mrs. Richard West Freeman's Mardi Gras costume

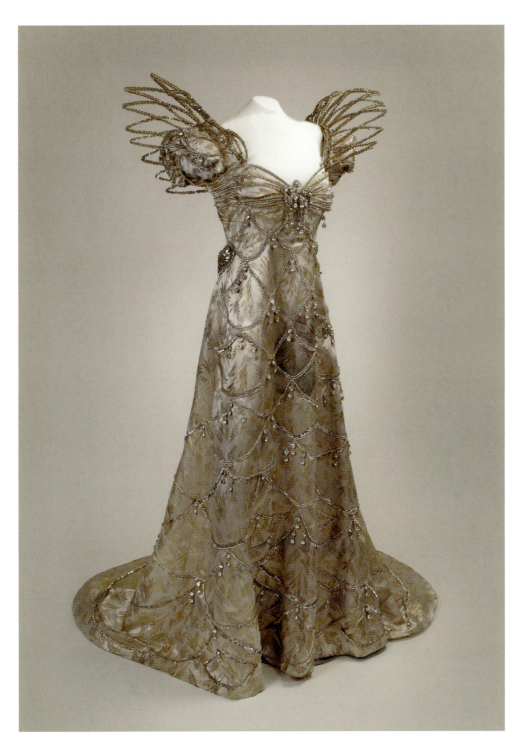

wings. The back forms a deep V crisscrossed with rhinestone-studded straps above a crescent of gold and silver sequins, so the queen looked equally regal after the parade had passed by.

FEBRUARY 20

1985

The black Asprey handbag Margaret Thatcher carried when she joined President Ronald Reagan and his dog Lucky on a walk in the White House Rose Garden on a crisp February day sold for $39,800 at a charity auction in 2011. As Britain's first female prime minister, Thatcher once described her handbag as the only safe place in 10 Downing Street. The accessory became a symbol of her feminine yet fierce leadership style. "She cannot see an institution without hitting it with her handbag," Julian Critchley, a conservative politician, complained in 1982. The verb "to handbag" subsequently entered the *Concise Oxford English Dictionary*, which defines it as "(of a woman) verbally attack or crush (a person or idea) ruthlessly and forcefully."

FEBRUARY 21

2018

Touring the Golden Temple in Amritsar on a visit to India, Canadian Prime Minister Justin Trudeau wore traditional Punjabi dress, including white kurta-pajamas and a saffron-colored headscarf. Throughout the one-week trip, he and his family were widely mocked on social media for their color-coordinated, Bollywood-style outfits, which were especially conspicuous because many of their Indian hosts wore Western clothes.

FEBRUARY 22

1972

When she joined her husband on his historic visit to the People's Republic of China—the first by a sitting US president—First Lady Pat Nixon dressed for diplomacy as well as the winter weather. She wore a tea-length red wool coat with beaver fur lining by Ritter Brothers of New York several times during the seven-day trip, including while touring the Summer Palace on February 22.

Red symbolizes good luck and happiness in Chinese culture, and it is the color of the Chinese flag, in use since 1949. At a time when most Chinese wore

OPPOSITE: First Lady Pat Nixon's red winter coat

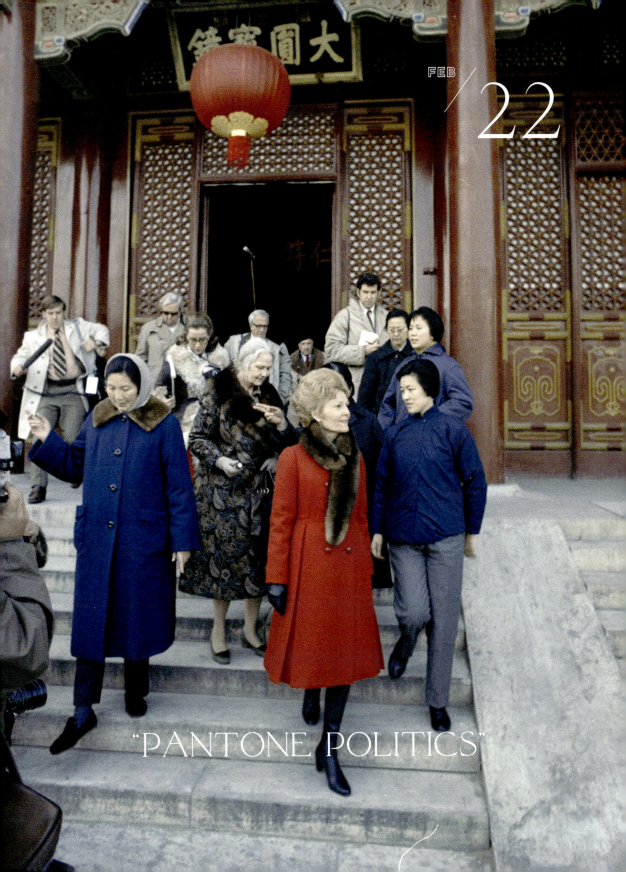

大圓寶鏡

"PANTONE POLITICS"

Mao suits—unisex pantsuits in drab navy blue and gray—Mrs. Nixon's coat stood out in every photo and newsreel of the much-publicized visit. But its repeated appearances served as a subtle reminder that even a wealthy capitalist might wear the same clothes every day.

The First Lady was a last-minute addition to the China trip, but her presence transformed it from a solemn summit into a public relations juggernaut. While President Nixon took meetings behind closed doors, "his wife did the important work," as *Chicago Today* put it. "She is establishing direct and friendly contact with the Chinese people on a normal human level; the level where children and families and food and service and health are the most important things." Clad in her red coat, the First Lady toured farms, factories, hospitals, temples, and schools, her every movement breathlessly chronicled by the massed international press.

In addition to putting careful thought into her travel wardrobe, Mrs. Nixon prepared for the trip by learning Chinese phrases and reading Chairman Mao's "Little Red Book." Carefully abstaining from either criticizing or endorsing the Communist regime, she played the role of the curious tourist, allowing Americans to discover the oft-misunderstood country through her eyes. The trip marked a turning point, not only for Chinese-American relations, but for the once seemingly aloof First Lady, whose popularity soared in its wake.

Today, this carefully calculated use of clothing symbolism to present a unified or sympathetic front is often called "Pantone politics" after the commercial color-matching system. Cynics may scoff, but fashion continues to be an eloquent international language.

FEBRUARY 23

2000

For the Grammy Awards ceremony in Los Angeles, Jennifer Lopez wore a plunging, translucent silk chiffon Versace gown held up by nothing more than a citrine brooch and double-sided tape. Google created Google Images due to the surge in search queries for photos of the dress.

FEBRUARY 24

1980

Two-time Olympian Herb Brooks coached the US men's ice hockey team to a gold medal at the Lake Placid Winter Games in one of the most famous upsets

in sports history. The "Miracle on Ice" took place in the semifinal match on February 22, when the American team beat the heavily favored Soviets—the four-time defending gold medalists—by a single point. It was not just "the greatest sports moment of the 20th century" (in the words of *Sports Illustrated*) but a major moral victory in the ongoing Cold War between the two countries. (The United States would boycott the Summer Olympics in Moscow later that year.)

On February 24, the United States played Finland for the gold medal. At the end of the second period, they were down by one point. According to team captain Mike Eruzione, Brooks—who was known for his colorful colloquialisms, or "Brooksisms"—told his players in the locker room: "'If you lose this game, you'll take it to your fucking graves.' He then walked towards the locker room door, paused and looked over his shoulder and said to us again: 'Your fucking graves.'" The team scored two points in the third period, winning the game and the gold.

For the medal ceremony, Brooks wore his red, white, and blue velour team jacket and matching pants, designed by Levi Strauss. The brand's label sits on the right breast above a patch of equal size reading "Ice Hockey." The back of the jacket proclaims "USA" in large letters. The choice of Levi's for the Olympic uniforms signaled a return to rugged Americana after Halston's subdued, businesslike uniforms for the 1976 games.

These youthful, patriotic warm-up suits were the perfect backdrop to ice hockey's Cinderella story. In contrast to the seasoned Soviet team, all of the American players were young amateurs at the time of the Olympics. But thirteen of the twenty would go on to NHL careers, and Brooks would coach the New York Rangers for several seasons before his untimely death in a car crash in 2003. His family auctioned his jacket along with other memorabilia in 2015; it sold for $23,900.

FEBRUARY 25

2010

At Alexander McQueen's funeral in London, his client and muse Daphne Guinness was a vision of Goth elegance in a billowing black parachute silk coat from his Fall/Winter 2002–2003 collection, heelless black platform Mary Janes, black lace gloves, and a horned black lace hat with a veil covering her blond hair, pulled back in a massive bun to reveal eighteenth-century diamond chandelier earrings.

FEBRUARY 26

2012

Seventeen-year-old Trayvon Martin was wearing a black hooded sweatshirt when he was shot and killed in Sanford, Florida, in what was later ruled to be self-defense. Broadcaster Geraldo Rivera was blasted for saying "the hoodie is as much responsible for [his] death as George Zimmerman," who claimed he mistook the unarmed teenager for a prowler. Though hoodies are a cheap, practical, and ubiquitous form of outerwear, they are also prone to be politicized and criminalized; hoodie-wearing teenagers were blamed for instigating riots in Paris in 2007 and London in 2011. Like balaclavas, bandannas, and burqas, hoodies can mask one's identity, making them convenient symbols of social alienation and lawlessness. But they have also been adopted as expressions of solidarity. In the wake of Martin's murder and the ensuing nationwide protests, African Methodist Episcopal Church Bishop John Bryant even wore one to the White House Easter Prayer Breakfast. The social media hashtag #HoodiesUp has become a rallying cry for social justice activists.

FEBRUARY 27

2010

Ghanaian skier Kwame Nkrumah-Acheampong wore a leopard-print bodysuit for his Olympic slalom event in Whistler, Canada. He was the first and only Winter Olympian from Ghana, where the temperature rarely dips below 70°F. Dubbed "The Snow Leopard," he favored leopard-spotted gear.

WORN ON
THIS DAY

FEBRUARY 28

1997

White House intern Monica Lewinsky, twenty-three, wore a blue Gap shirtdress to work, where she had a sexual encounter with President Bill Clinton. She later handed the dress over to the Office of Independent Counsel. Analysis in an FBI laboratory confirmed it was stained with the president's semen, precipitating impeachment proceedings.

OPPOSITE:
Olympic ice
hockey jacket

FROM BALLET SHOES TO DRIP-DRY BLUES

MARCH

1	2	3	4	5	6	7
Ballerina Marie Taglioni's pointe shoes	Converse shoes of Wilt Chamberlain	Reporter Nelly Bly's riding outfit	Caroline Harrison's inaugural gown	Ernesto "Che" Guevara's iconic image	Mary Todd Lincoln's inaugural gown	"Bloody Sunday" in Selma, Alabama
1842	**1962**	**1913**	**1889**	**1960**	**1865**	**1965**

8	9	10	11	12	13	14
Jockstrap of Joe Frazier, when he beat Muhammad Ali	Elizabeth Hurley's safety-pin dress	A walking royal wedding rosette	Gown worn by Jackie Kennedy to meet the Pope	Princess Anne's favorite vintage coat	Mata Hari's first scandalous striptease	Armbands worn by Jews in Krakow's ghetto
1971	**1994**	**1863**	**1962**	**2018**	**1905**	**1943**

15	16	17	18	19	20	21
Dress worn by Jackie Kennedy at the Taj Mahal	Masquerade costume worn by King Gustav III	T-shirt worn to 10 Downing Street	Suit of armor worn to a funeral	Windsor uniform designed by King George III	Violets worn to welcome Napoleon	She wasn't always a bridesmaid
1962	**1792**	**1984**	**1677**	**1789**	**1815**	**1883**

22	23	24	25	26	27	28
Uniform worn by actor Jimmy Stewart	Sharon Stone's white shirt on the red carpet	Goth gown worn by Gwyneth Paltrow	John Lennon and Yoko Ono's "bed-in" pajamas	Alice Vanderbilt's electric costume	Masks worn to commit murder	Dressed, drawn, and quartered in Paris
1941	**1998**	**2002**	**1969**	**1883**	**1905**	**1757**

29	30	31				
Gas masks for the whole family	Samuel Pepys's rented Indian robe	Aviator Geraldine Mock's drip-dries				
1941	**1666**	**1964**				

01

Ballerina Marie Taglioni wore this black satin shoe trimmed with white silk and narrow black ribbons when she performed for Tsarina Alexandra Feodorovna at the Anichkov Palace in St. Petersburg. She later gave it to one of her pupils. It is a rare surviving example of an early ballet shoe used for dancing *en pointe*—on the point of the toe. Modern pointe shoes are "blocked" to keep their shape and lend support, with a rigid toe box fashioned from tightly packed layers of paper and fabric and reinforced with a stiff shank. This shoe's only stiffening is the hand-darning under the toe and along the sides.

In 1832, Taglioni had become the first ballerina to achieve international celebrity when she starred in the world premiere of *La Sylphide* at the Paris Opéra. Her father, Filippo Taglioni, choreographed the ballet as a showcase for his daughter's unique talents. Although Marie was not the first to dance *en pointe*, *La Sylphide* was the first ballet to use the technique as a narrative device rather than an acrobatic stunt. In the story of a Scottish man haunted and seduced by a supernatural sylph, Taglioni's slow, ethereal rise onto the tips of her toes created the illusion of floating between heaven and earth. The ballet captivated audiences already enthralled by the Celtic-tinged romanticism of Sir Walter Scott's popular novels.

WORN ON THIS DAY

Taglioni's signature move may have looked effortless, but it required tremendous strength. To show off her footwork, she wore a short tulle skirt, ending just below the knee—a scandal at the time. Apart from the length, however, her sylph costume—designed by Eugène Lami—resembled a fashionable white evening gown, with a corseted bodice, short sleeves, and a wide, low neckline. Her satin slippers, too, were essentially street shoes. Thin fabric flats had replaced high heels after the French Revolution. Ballet dancers wore these lightweight, flexible shoes onstage. At the time, shoes did not have left

OPPOSITE: Ballerina Maria Taglioni's shoe

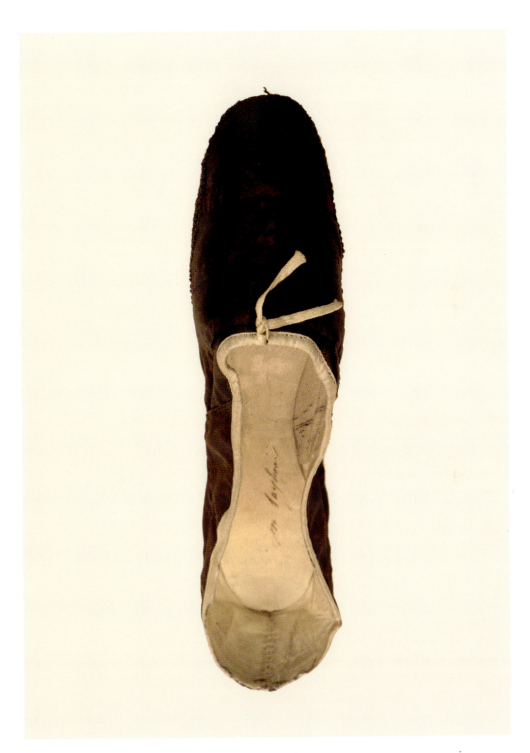

MARCH / 01

and right feet—a tradition still observed in ballet today. When, in the 1950s, actress and trained ballerina Audrey Hepburn began wearing Capezio ballet shoes as street wear, they came full circle.

Taglioni retired in 1847, having become so famous that her name and image were used to promote candies, cakes, and hairstyles. She has been credited with inventing modern ballet, with its blend of elegance and athleticism, as well as tutus and toe shoes. By 1856, Théophile Gautier noted, pointe shoes were lined with sturdy canvas, the toes reinforced with leather and cardboard. As dance shoes became increasingly supportive, the repetoire of steps expanded accordingly.

Curator Colleen Hill has observed that "ballet shoes are paradoxical objects: at once evocative of romance and femininity, as well as strength, discipline, and pain." Taglioni's fragile-looking shoes were so fetishized that a pair of her castoffs was purportedly purchased, cooked, garnished, and eaten by a group of Russian admirers after her 1842 performance.

MARCH 2

1962

Wearing high-top Converse Chuck Taylor All Stars, Philadelphia Warriors center Wilt Chamberlain became the first professional basketball player to score one hundred points in a single game. Promoted by and named for 1920s hoops star Chuck Taylor, All Stars are distinguished by their canvas uppers and waffle-patterned rubber soles. Tree Rollins was the last NBA player to wear them, in 1980; today, they are purely a nostalgic fashion item, replaced on the court by precision-engineered sneakers equipped with modern performance-enhancing technology.

MARCH 3

1913

On the day before Presidential Woodrow Wilson's inauguration, more than five thousand women from around the country marched on Washington, DC, demanding the right to vote. Pioneering journalist Nellie Bly covered the parade for the *New York Evening Journal* from a unique vantage point: astride a horse, in the midst of the procession. "I have stunning riding togs," she wrote. "They were of this new gray tweed, dotted all over with my favorite emerald green. The hat matched, and with the small feather on the side, was

quite fetching. Yes, of course, trousers, and a long coat, which just missed the top of my boots."

An estimated five hundred thousand spectators watched the parade; when some blocked Pennsylvania Avenue and hurled insults—and blows—at the suffragettes, the police did little to stop them and the cavalry had to be called in to restore order. A public outcry resulted, followed by a Congressional hearing and the resignation of the District's police chief. But a letter to the editor of the *New York News* blamed the "odious" suffragettes for the violence: "What, then, did we have in Washington? A parade of women, some of them decently clad, but some of them, if we believe the accounts, clad in a way in which no good father or mother would wish his daughter to appear in public."

MARCH 4

1889

When Benjamin Harrison was elected president, his wife, Caroline, chose an inaugural gown reflecting his "America First" economic policy. The silvery gray silk satin was designed by Indiana artist Mary Williamson, in a pattern of burr oak leaves honoring Harrison's grandfather, President William Henry Harrison. Burr oaks grew alongside Tippecanoe Creek, the site of the battle that had given the elder Harrison his nickname, "Old Tippecanoe." Williamson's design was woven by the Logan Silk Company in Auburn, New York, and the dress made in New York City by the dressmaking firm Ghormley of 45 East 19th Street. The gown had a fitted bodice with deep V neckline filled in by a high-necked dickey, three-quarter length sleeves with chiffon undersleeves, a pleated skirt, and a trained bustle. The silver-gray satin alternated with panels of apricot crepe covered with lace, and the gown was trimmed with gold, silver, amber, and pearl beads and crystal fringe.

Harrison's daughter, Mary "Mamie" Harrison McKee, wore a gown very similar in style, created by the same American artisans. For Mamie, Williamson designed a brocade incorporating goldenrod, her father's favorite flower. While the gown's color scheme was ivory and vibrant amber, its cut and trimmings mirrored Caroline's. In retrospect, it's fitting that Mamie's dress was so closely aligned with her mother's; she would step into the role of White House hostess when, at the age of sixty, Caroline died during Harrison's term in office.

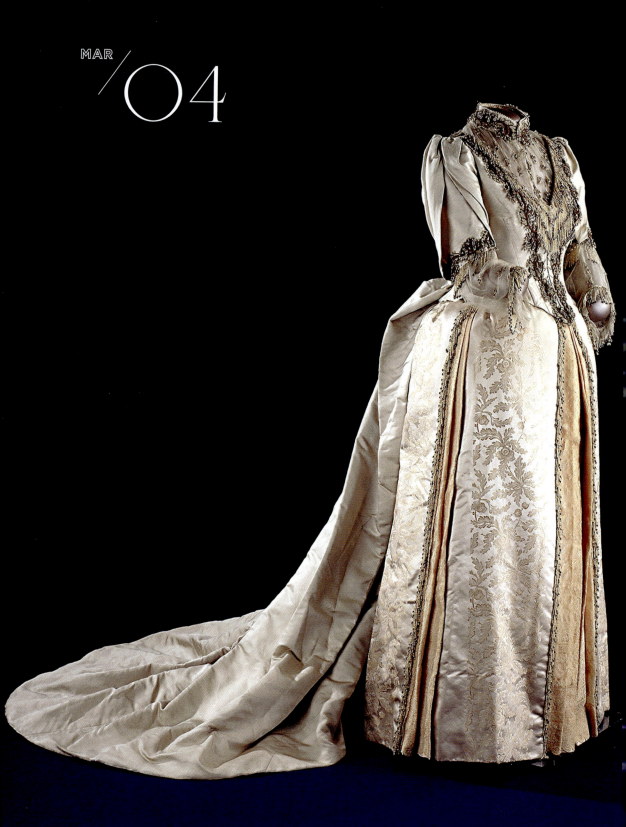

MARCH 5

1960

Ernesto "Che" Guevara wore a black beret emblazoned with a red Communist star and a green and black zippered leather jacket to a memorial service for victims of the *La Coubre*, a French freighter that had exploded under suspicious circumstances in Havana Harbor the previous day. The candid picture President Fidel Castro's official photographer, Alberto Korda, snapped of the Argentinian revolutionary was not published outside of Cuba until August 1967. The image, cropped and titled *Guerrillero Heroico (Heroic Guerrilla Fighter)*, instantly became a counterculture icon.

MARCH 6

1865

For her husband's second inaugural ball, Mary Todd Lincoln "looked extremely well, and was attired in the most elegant manner," the *New York Times* reported. "Her dress was made of white satin, very ample and rich, but almost entirely covered by a tunic or rather skirt of the finest point applique. Her corsage, which was low, and the short sleeves, were ornamented richly by a berthe made of the same material." A lace shawl and trimmings of narrow fluted satin ribbon and rosettes completed the ensemble, likely made by Elizabeth Keckley, a former slave who had become a successful seamstress and confidante to the First Lady. In contrast, President Lincoln wore "a plain black suit and white gloves." He was assassinated just six weeks later.

MARCH 7

1965

On what would become known as Bloody Sunday, six hundred civil rights advocates gathered in Selma, Alabama, to march fifty-four miles to the state capital in Montgomery in protest of racist voting laws—although none expected that they would be allowed to get so far. The future US representative John Lewis, who was among them, remembered: "Many of the men and women . . . had come straight from church. They were still wearing their Sunday outfits. Some of the women had on high heels."

OPPOSITE: First Lady Caroline Harrison's inaugural gown

Lewis wore a suit and tie, a raincoat, and dress shoes. "I was no more ready to hike half a hundred miles than anyone else," he noted. As the march neared Edmund Pettus Bridge (named for a Confederate general and Ku Klux Klan leader) at the edge of town, state troopers in helmets and gas masks blocked the bridge and attacked the marchers in their Sunday best with tear gas, clubs, and whips.

MARCH 8

1971

The unwashed Bauer & Black jockstrap boxer Joe Frazier wore when he defeated Muhammad Ali for the combined heavyweight title in the "Fight of the Century" at Madison Square Garden was auctioned for $10,200 in 2016.

MARCH 9

1994

Unknown model-actress Elizabeth Hurley, twenty-nine, became a household name overnight when she wore a revealing black and gold Versace gown—slit to the thigh and held together by oversized safety pins—to the London premiere of *Four Weddings and a Funeral*, starring her boyfriend, Hugh Grant. Versace, who knew Hurley through their mutual friend Elton John, had sent it to her fresh off the runway, without a fitting. "Liz has this intelligent face attached to that very naughty body," the designer explained. "So seeing a woman like her in this gown was a guarantee that everyone would go *pazzo* [crazy]."

MARCH 10

1863

WORN ON
THIS DAY

Excitement about royal weddings is nothing new, and neither is the impulse to merchandise and monetize that excitement. A red velvet dress with ivory satin piping and mother-of-pearl buttons—which could have been worn by a girl or a young boy—was undoubtedly made for a party celebrating the wedding of Queen Victoria's oldest son, Albert Edward, Prince of Wales, and Princess Alexandra of Denmark. The tails of the taffeta sash—whose shape mirrors that of the piping in front—are printed with the three ostrich plumes emerging from a coronet, the heraldic badge of the Prince of Wales, along with banners bearing his motto "Ich Dien" ("I Serve") and "Albert and Alexandra."

A hastily published souvenir book about the wedding records that "in order to help the distressed Coventry weavers, a rosette manufactured of white ribbon, intermixed with either blue or red, was universally adopted as the Prince of Wales's wedding favour." (Red and white were the colors of the Danish and English flags; the Union Jack was blue, red, and white.) The crowds of well-wishers who greeted Alexandra when she arrived from Denmark at Gravesend, three days before the wedding, wore these rosettes. Similar rosettes and other patriotic decorations adorned schools, churches, public monuments, and private homes in London. Many of the spectators who gathered outside St. George's Chapel at Windsor Castle—the same venue where Prince Harry married Meghan Markle in 2018—wore ribbon rosettes printed with portraits of the bride and groom. The red-and-white color scheme of this beribboned dress turned its young wearer into a walking wedding rosette.

MARCH 11

1962

To meet Pope John XXIII at the Vatican, First Lady Jacqueline Kennedy wore a floor-length black gown with long sleeves, paired with a black lace veil. To this day, papal protocol requires women to wear modest, formal black clothing and black veils for official audiences with the pontiff; however, Catholic royals may wear white instead.

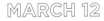

MARCH 12

2018

Princess Anne wore a knee-length white coat with navy trim to a Commonwealth Day service in London, nearly forty years after wearing it for the first time to Royal Ascot on June 17, 1980. The parsimonious princess has made headlines by rewearing this outfit (and others) several times over many decades.

MARCH 13

1905

Margarethe Zelle performed for the first time under her stage name, Mata Hari, in the library of the Musée Guimet, a private collection of Asian art in

Paris. Passing herself off as a Javanese princess, the Dutch-born Zelle wore, according to one review, "a casque of worked gold upon her dark hair—an authentic Eastern head-dress; a breast plate of similar workmanship beneath the arms. Above a transparent white robe, a quaint clasp held a scarf around the hips, the ends falling to the feet in front. She was enshrouded in various veils of delicate hues, symbolizing beauty, youth, love, chastity, voluptuousness and passion."

Of course, the true allure of Mata Hari's act was not what she wore, but what she took off; by the end, she was stripped down to her jeweled bra, which she always left on because she was self-conscious about her small breasts. During World War I, as her career as an exotic dancer declined, Mata Hari turned to spying for the Germans. She was caught and executed by the French on October 15, 1917; her famous body went unclaimed and was used for medical research.

MARCH 14

1943

In Krakow, Poland, Nazis forcibly removed eight thousand Jews from the city's ghetto and sent them to the Plaszow concentration camp. They identified them by the white armbands embroidered with blue stars of David that Polish Jews had been required to wear since December 1939.

MARCH 15

1962

WORN ON THIS DAY

Visiting the Taj Mahal in Agra, India, First Lady Jacqueline Kennedy wore a blue and green cotton shift dress in a large-scale stylized floral print—a rare departure from the solid-color pastels in crisp, shimmering silks that had characterized her wardrobe for her nine-day solo goodwill tour of India.

The dresses' designer, Joan "Tiger" Morse, was a New York socialite turned bohemian boutique owner, who traveled the world in search of exotic textiles and accessories for her Upper East Side establishment, A La Carte. Her dresses may have been crafted from flea-market finds, but they were carried by Bloomingdale's and Bonwit Teller and could cost up to $2,500. "I can't sew, drape or cut a pattern," Morse once said, "But I play with a piece of fabric and it comes up wild and it sells."

OPPOSITE: Child's costume celebrating the royal wedding

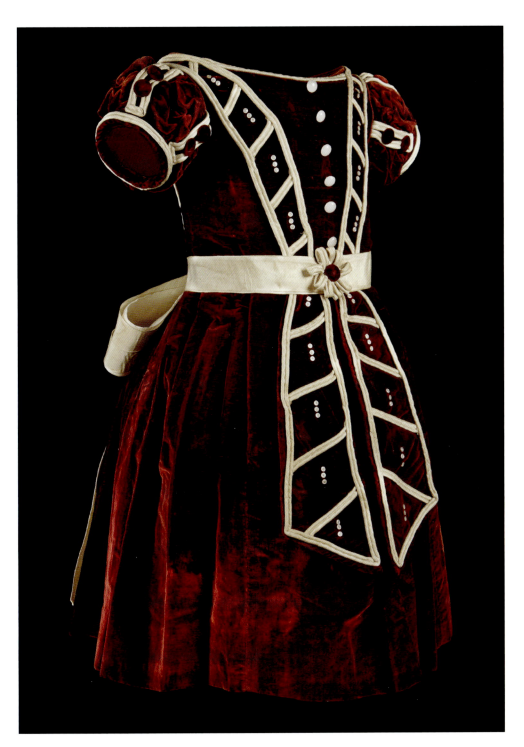

Though the first lady's press secretary had begged the media for "more than just a group of fashion stories," *Life* reported that Kennedy's "every seam has been the subject of hypnotized attention from the streets of Delhi to the Khyber Pass." It may not have been the kind of coverage the White House hoped for, but it was excellent publicity for Morse; the magazine would publish a twelve-page spread on the designer and her travels a few months later.

MARCH 16

1792

King Gustav III of Sweden was shot at a masquerade ball at Stockholm's Royal Opera House; the incident provided the inspiration for Giuseppe Verdi's 1859 opera *Un Ballo in Maschera (A Masked Ball)*. Though he wore a white mask of waxed cloth, a feathered tricorn hat, and a black cape over his silver costume—which was not really a costume at all, but one of the seventeenth-century-style suits the king had introduced as court dress—his assassins likely identified him by the star of the Royal Order of the Seraphim, Sweden's highest order of chivalry, conspicuously displayed on his breast. He died eleven days later.

MARCH 17

1984

Designer Katharine Hamnett attended a British Fashion Week reception hosted by Prime Minister Margaret Thatcher at 10 Downing Street wearing an oversized T-shirt of her own design reading "58% DON'T WANT PERSHING," referencing Thatcher's unpopular decision to allow American Pershing cruise missiles to be based in the United Kingdom. Hamnett—whose "CHOOSE LIFE" T-shirts would soon be made famous by the video for "Wake Me Up Before You Go-Go" by Wham!—said she "knocked up that T-shirt a couple of hours before the event" and kept her jacket closed until the moment she shook Thatcher's hand, surrounded by photographers.

MARCH 18

1677

When the Dutch naval hero Michiel de Ruyter was buried in the Nieuwe Kerk in Amsterdam, the funeral procession incorporated an old military tradition: a man in a full suit of armor. The suit, made more than a hundred years earlier,

OPPOSITE: Mata Hari in costume, Jackie Kennedy at the Taj Mahal

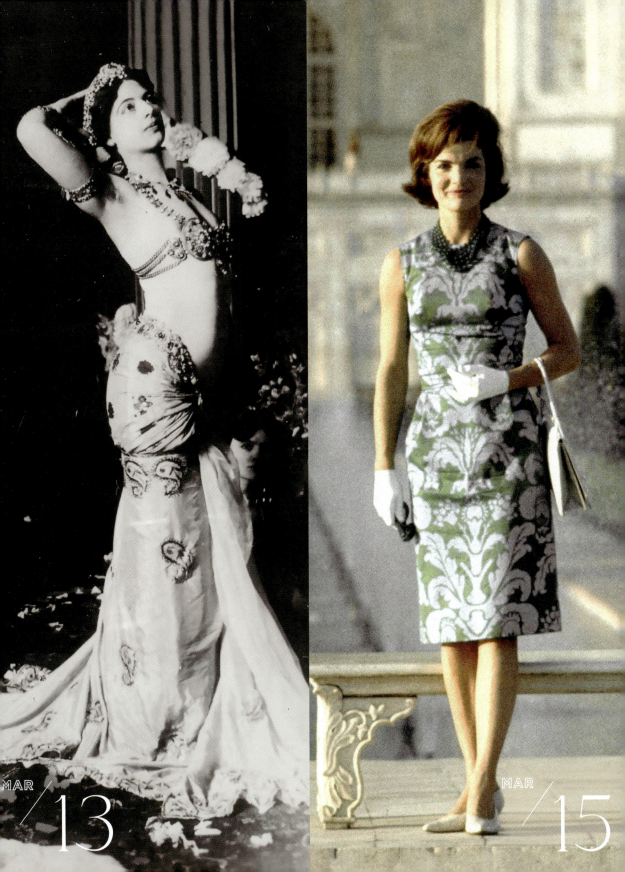

was rented for twenty-five guilders and worn by a man who was also hired for the ceremony, which lasted four and half hours. Several days afterward, he, too, died—of exhaustion from carrying the heavy metal.

MARCH 19

1789

In 1778, King George III designed the Windsor uniform for members of his family and household, male and female. The civilian uniform was a curious amalgam of fashionable dress and livery, intended for practical, everyday use, but with formal variations for ceremonial occasions. The king hoped it would alleviate the punishing expense of dressing for court. Fanny Burney, a lady-in-waiting to Queen Charlotte, described it as "blue and gold turned up with red, and worn by all the men who belong to his Majesty, and come into his presence at Windsor." The female version resembled a riding habit of dark blue wool with red collar and cuffs. A modified Windsor uniform is still worn by members of the British royal family today.

In October 1788, the king became physically and mentally ill with what is now believed to have been porphyria. When he was officially declared cured on February 26, 1789, his recovery became the talk of the court and the pulpits. After one service of thanksgiving, Burney recorded, "instead of the psalm, imagine our surprise to hear the whole congregation join in 'God Save the King.' Misplaced as this was in a church, its interest was so kind, so loyal and so affectionate, that I believe there was not a dry eye." The motto "God Save the King"—or the acronym "GSTK"—appeared on walls, ribbons, and commemorative medals. Ann Frankland Lewis painted this watercolor depicting the formal version of the Windsor uniform as worn to a ball at Windsor Castle on March 19, one of many events celebrating the king's recovery, accessorized with a headdress reading "God Save the King."

MARCH 20

1815

When Napoleon was exiled to Elba in 1814, he promised his supporters: "I shall return with the violets." The following spring, he escaped the Mediterranean island and made his triumphant return to the Tuile-

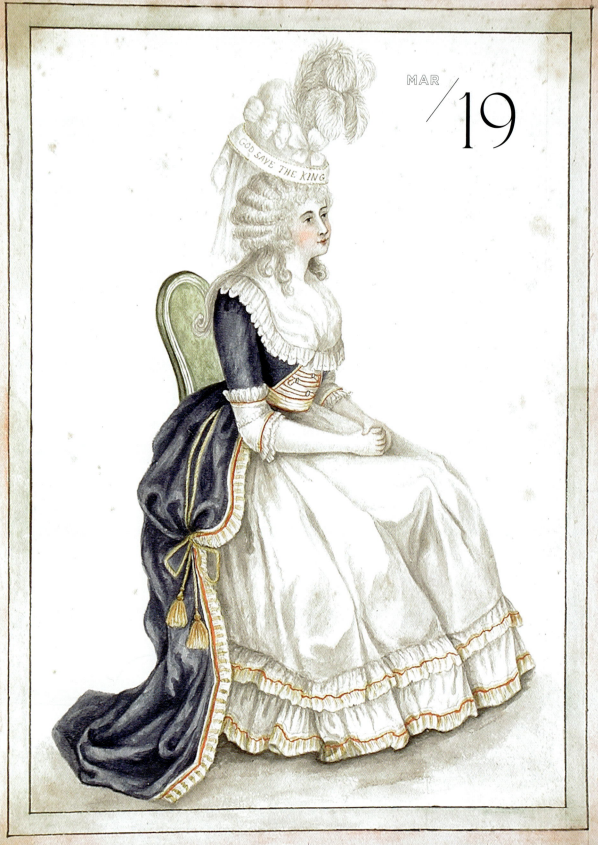

ries Palace in Paris. Instantly, palace officials and servants put on the Imperial liveries, uniforms, and tricolor cockades they had abandoned at his departure to welcome him back, "as if Bonaparte had made only a short journey," according to National Guardsman Alexandre de Laborde. Violets—fresh or jeweled—and the color violet were worn as Bonapartist emblems. So strongly were violets associated with Napoleon that they would be considered seditious for many years after his defeat at Waterloo and subsequent exile to another island, St. Helena, where he died in 1821.

MARCH 21

1883

The tradition of dressing bridesmaids in white—which persists today in many European countries, as Pippa Middleton famously demonstrated—derives from their original function as decoy brides, intended to fool evil spirits or thwart kidnappers.

This dress was worn by Isabella Cameron Murray, who served as bridesmaid to her younger sister, Mary, when she wed architect Varney Parkes in Sydney, Australia. Apart from the blue satin bow and underskirt, it closely resembled Mary's own cream-colored gown, with a fitted bodice embellished with glass pearl buttons, lace-trimmed high collar and cuffs, draped bustle, and luxurious materials.

But Isabella wasn't always a bridesmaid. When Mary died suddenly after only five months of marriage, Varney proposed to Isabella. They were married on Christmas Eve, 1884. But the union was not a happy one, and they eventually separated—a scandal at the time, made especially awkward by the fact that Varney's father was a prominent politician, and Isabella's widowed father had married Varney's sister.

MARCH 22

1941

Jimmy Stewart became the first major Hollywood star to wear a military uniform in World War II when he was inducted into the US Army Air Corps (later the Air Force) at Fort MacArthur in San Pedro, California.

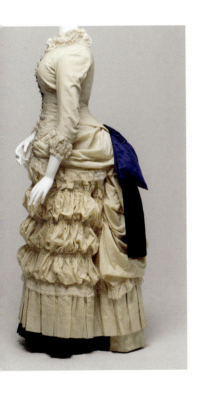

OPPOSITE, ABOVE:
Uniform designed by King George III, Isabella Cameron Murray's bridesmaid dress

MARCH 23

1998

Actress Sharon Stone made headlines by wearing her husband Phil Bronstein's white Gap shirt to the Academy Awards in Los Angeles, the sleeves rolled up and the buttons open almost all the way to the waistband of her floor-length lilac satin Vera Wang skirt. It was not the first time Stone had mixed high and low style on the Oscars red carpet; in 1996, nominated for her role in *Casino*, she had paired a short-sleeved black Gap turtleneck with a velvet Armani coat and a taffeta Valentino skirt.

MARCH 24

2002

Actress Gwyneth Paltrow wore a Goth-inspired Alexander McQueen gown to the Academy Awards in Los Angeles. Although the designer thought "she looked incredible," critics called the aggressively edgy look—featuring a transparent black mesh bodice, a messy milkmaid braid, and heavy black eyeliner—a fashion disaster for the usually chic star. Paltrow later admitted: "I should have worn a bra."

MARCH 25

1969

Honeymooners John Lennon and Yoko Ono invited the international press to witness their first "bed-in" for world peace in the Presidential Suite of the Amsterdam Hilton. Some reporters were disappointed to find the newlyweds fully clothed. "The bed was just an accessory," Lennon remembered. "We were wearing pyjamas, but they don't look much different from day clothes—nothing showing."

MARCH 26

1883

Costume parties were all the rage in Gilded Age New York. Men and women alike vied with each other to appear in the most spectacular designer disguises at the most extravagant balls. No ball was more extravagant than the one Alva Vanderbilt threw to christen her newly built Fifth Avenue chateau in

OPPOSITE: Alice Vanderbilt's "Spirit of Electricity" costume

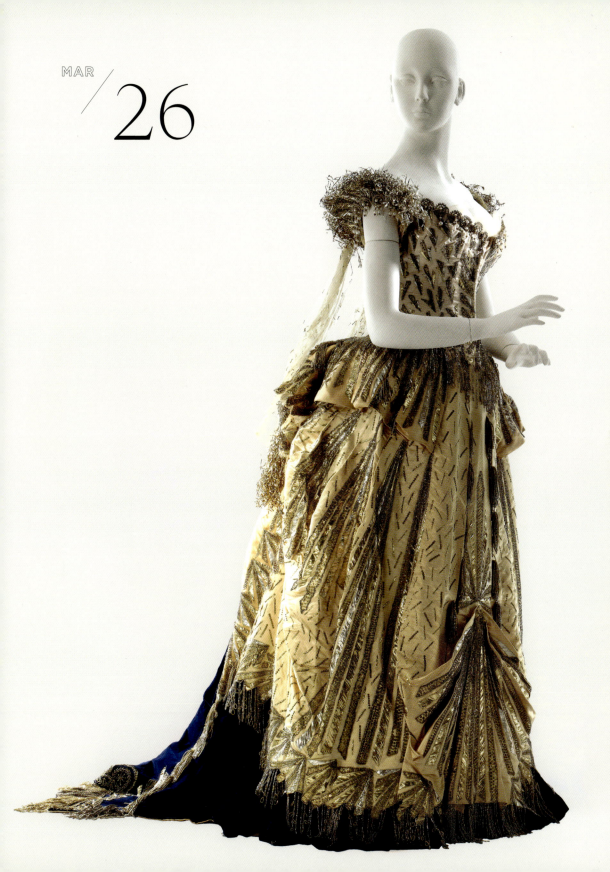

1883, and no costume more spectacular than the "Spirit of Electricity" gown worn by Alice Vanderbilt, the hostess's sister-in-law.

In 1883, electricity was a novelty in New York. Thomas Edison's commercial power plant, the Pearl Street Station, had opened the previous year at the southern tip of Manhattan. Electric lights had already replaced gas lamps on some city streets, and battery-powered lamps and electrical generators were sold for home use.

Alice's gown—created by Paris couturier Charles Frederick Worth—was made of gold and white satin embroidered with lightning bolts of pearls and faceted glass beads, with a deep blue velvet underskirt. The gown was equipped with concealed batteries, which lit a bulb Alice carried aloft like the Statue of Liberty's torch, casting beams of light over her glittering gown.

Alice literally outshone Alva, costumed as a Venetian princess of the Renaissance. Nevertheless, the ball succeeded in making the *nouveau riche* Vanderbilts the leading lights of high society.

MARCH 27

1905

When brothers Alfred and Albert Stratton robbed elderly Deptford shopkeepers Thomas and Ann Farrow, beating them to death, they left behind the crude masks they had fashioned out of ladies' black stocking tops, as well as a fingerprint on the shop's empty cash box. After eyewitnesses led police to suspect the brothers, Alfred's girlfriend, Annie Cromarty, testified that he had asked her for a pair of her old stockings. But it was the fingerprint that secured the brothers' convictions: the "Mask Murders" were the first murders in Britain solved by fingerprint evidence. The Stratton brothers were executed simultaneously two months later.

MARCH 28

1757

Robert-François Damiens, who had tried to assassinate King Louis XV, was the last man to be drawn and quartered in France—a gruesome, four-hour procedure witnessed by the Italian adventurer Giacomo Casanova, among other curious onlookers. Irish novelist Lady Sydney Morgan saw the tattered brown coat and rosary Damiens had worn in prison when she visited the Palais de Justice as a tourist in 1830. "Close to the papers of the trial of Damiens, in

an old box, was his coat, the coat he wore when he was dragged from his dungeon," she wrote in her memoirs. "What singular relics!"

MARCH 29

1941

During a tear gas drill, a mother and child in Southend, England, modeled correct gas mask protocol. Lethal gas had first been weaponized in World War I, bringing the fashion for beards to a premature end, because gas masks would not seal over them. In World War II, all British civilians—including babies—were issued gas masks to be carried at all times; brides carried gas masks along with their bouquets. The masks were distributed in cardboard containers with carrying strings, but enterprising merchants sold chic leather handbags equipped with concealed metal containers. At Bletchley Park, the top-secret government code-breaking facility, asthmatic mathematician Alan Turing wore his gas mask as he bicycled to work to protect himself from a more immediate danger: pollen.

MARCH 30

1666

Samuel Pepys went to the studio of the portrait painter John Hayls "and there sat till almost quite dark upon working my gowne, which I hired to be drawn in—an Indian gowne, and I do see all the reason to expect a most excellent picture of it." Sitters did not necessarily own the clothes they wear in portraits or studio photographs. Many painters and photographers kept collections of picturesque clothes and draperies in their studios; alternatively, clothes could be hired, a historical version of Rent the Runway.

The rented regalia Pepys described was called a banyan, a term alluding to the garment's Indian origins. European men adopted these loose, T-shaped garments for informal wear after they were brought back by the Dutch East India Company; locally made imitations were also available. Given the amount of (often imported) fabric they required, banyans could be extremely expensive. While Pepys had at least one banyan of his own, he may have hired a more costly or picturesque one that was otherwise beyond his means.

Trendy but timeless, exotic but comfortable, dignified and expensive without being stuffy, the banyan offered an attractive solution to the perennial problem of what to wear for posterity in a portrait. Resembling the flowing robes

worn by classical philosophers and medieval scholars, it was a popular choice among intellectual and creative types, who could not resort to uniforms or peers' robes. Banyan portraits frequently included props like books, globes, quill pens, maps, scientific instruments, and other accoutrements of intellect; Pepys holds the text of a song he composed.

Men rarely wore banyans outside the home, where they typically removed their wigs and replaced them with turbans or embroidered caps, to keep their closely cropped heads warm. But Pepys wears a wig, a fashion he had adopted in 1663, in imitation of Charles II. While his wig looks very natural, Pepys' wigs grew progressively more artificial-looking over the next twenty years, in line with fashion. The most expensive wigs were made of human hair, and Pepys, like many Londoners, worried about catching the plague from wigs made from the hair of the dead.

Pepys was highly conscious of the importance of keeping up appearances, however. "I must go handsomely whatever it costs me; and the charge will be made up in the fruits it brings," he rationalized. He undoubtedly applied this reasoning to his decision to rent his portrait attire. But dressing well was more than just a sound investment for Pepys. He confessed to finding "a great happiness" in "being in the fashion and in variety of fashions in scorn of others that are not so, as citizens wifes [sic] and country gentlewomen." Although Pepys had complained that "I almost break my neck looking over my shoulder to make the posture work for him," he was "well satisfied" with Hayls's portrait, completed in six weeks.

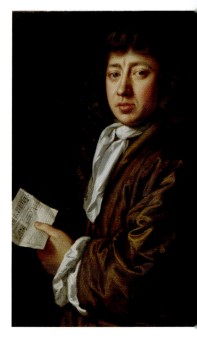

MARCH 31

1964

Halfway through her one-month voyage around the world—the first solo circumnavigation by a female pilot—Geraldine "Jerrie" Mock woke up in Bône, Algeria. "I dressed, putting on a white drip-dry blouse and blue cotton skirt that were destined to travel over deserts and mountains and oceans and be photographed so much that reporters would ask me, 'Mrs. Mock, we read that you're wearing a blue skirt every time you land. Do you just love blue?'" she wrote in her memoir *Three-Eight Charlie*. "And I would have to explain about American drip-dries—that you could wash them out overnight."

OPPOSITE, ABOVE:
Mother and child during a tear gas drill, portrait of Samuel Pepys

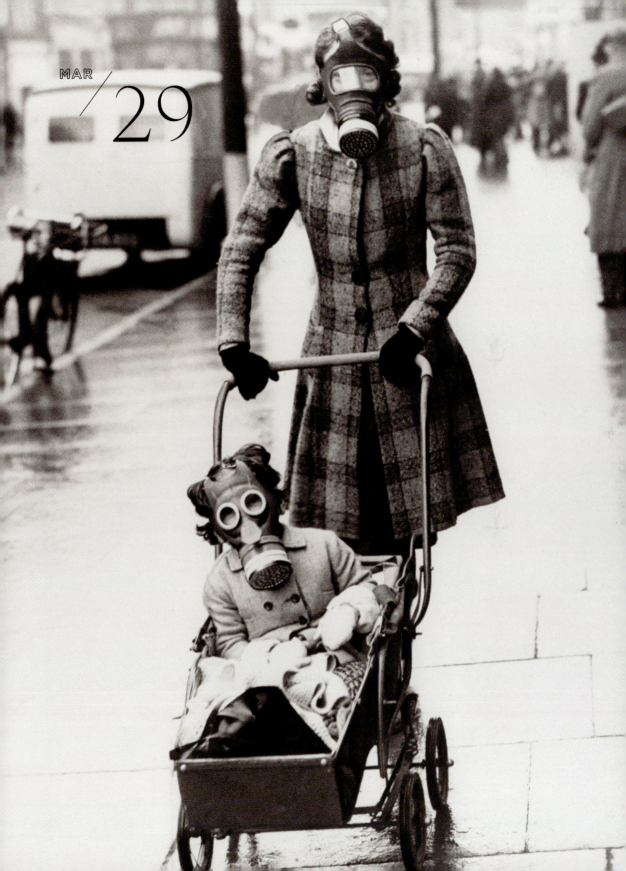

APRIL

1	2	3	4	5	6	7
Denise Poiret's opening night gown	Wedding train of Armandine-Marie-Georgine de Sérent	The Demon of the Belfry's victim	Sunday best at the Easter parade	Cecil Beaton's eccentric ocean liner attire	ABBA's Eurovision Song Contest costumes	Belt worn by Aushwitz escapee
1913	**1810**	**1895**	**1915**	**1930**	**1974**	**1944**
8	9	10	11	12	13	14
Queen Elizabeth II dazzles Paris	Marian Anderson's mink coat	Green jacket awarded to golfer Sam Snead	Shin guards worn by catcher Roger Bresnahan	White satin gown worn by Jayne Mansfield	Barbra Streisand's Scaasi sari gown	Top hat and coat worn by Abraham Lincoln
1957	**1939**	**1949**	**1907**	**1957**	**1970**	**1865**
15	16	17	18	19	20	21
Silk slippers worn aboard the *Titanic*	Tartan coat worn at the Battle of Culloden	Vest worn by Gene Kranz during *Apollo 13* mission	Lace suit worn by Grace Kelly	Grace Kelly's royal wedding gown	Air Jordans worn by Michael Jordan	White paper flowers worn in Tiananmen Square
1912	**1746**	**1970**	**1956**	**1956**	**1986**	**1989**
22	23	24	25	26	27	28
Coronation procession of King Charles II	Empress Elisabeth's bachelorette party dress	First baseball uniform worn by New York Knickerbockers	Jacob van Heemskerck's battle armor, minus one leg	When Anna Wintour met Andy Warhol	Hostess dresses worn during Expo '67	Princess Masako's royal wedding robe
1661	**1854**	**1849**	**1607**	**1981**	**1967**	**1922**
29	30					
Fascinator worn by Princess Beatrice to royal wedding	George Washington's inaugural suit					
2011	**1789**					

FROM THEATRICAL PREMIERES TO PRESIDENTIAL DEBUTS

04/01

— **1913** —

Couturier Paul Poiret designed this gown for his wife and muse, Denise, to wear to the premiere of Igor Stravinsky's ballet *Le Sacre du Printemps (The Rite of Spring)* at the new Théâtre des Champs-Élysées in Paris. An opening night was a social occasion as much as a theatrical one, an opportunity to see and be seen, and Poiret undoubtedly hoped to publicize his classically inspired gown, which perfectly suited Denise's slim figure. It was embellished with bands of rhinestones that accentuate its historicizing features, a high waistline and an asymmetrical hemline.

But the beautiful gown was undoubtedly overshadowed by the performance—one of the most infamous nights at the theater in history. With its jarring music, costumes, and choreography inspired by Russian folk traditions, *Le Sacre du Printemp*s effectively introduced modern dance and music to an audience expecting classical ballet. The reaction was swift and violent. "The theatre seemed to be shaken by an earthquake," Valentine Gross remembered. "It seemed to shudder. People shouted insults, howled and whistled. . . . There was slapping and even punching. Words are inadequate to describe such a scene."

The crowd booed, whistled, and heckled so loudly that the orchestra could hardly be heard. There were scuffles in the aisles between producer Sergei Diaghilev's supporters (to whom he had given free tickets) and those outraged by a performance they considered obscene. Artist Jean Cocteau recalled that the "smart audience, in tails and tulle, diamonds and ospreys were interspersed with the suits and *bandeaux* of the aesthetic crowd. The latter would applaud novelty simply to show their contempt for the people in the boxes." Choreographer Vaslav Nijinksy had to shout his cues to the dancers from backstage in order to be heard over the chaos. Finally, the police were called. If Poiret was disappointed, Diaghilev was delighted, knowing that there's no such thing as bad publicity.

WORN ON THIS DAY

OPPOSITE: Denise Poiret's premiere gown

74

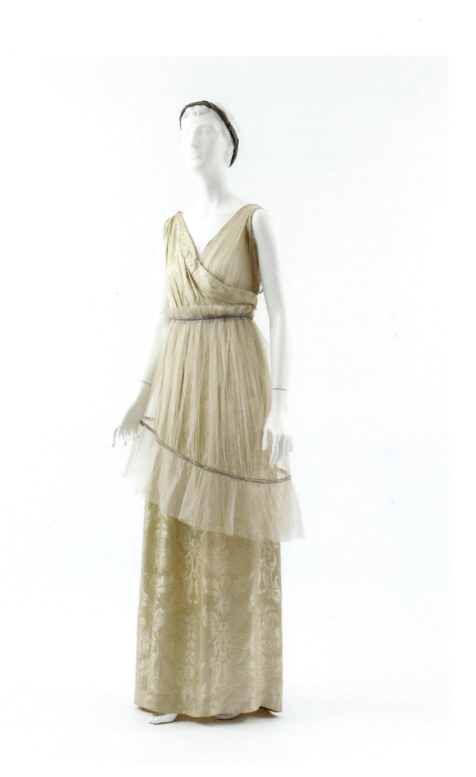

APRIL 2

1810

This court train was supposedly worn by Armandine-Marie-Georgine de Sérent at Emperor Napoleon's wedding to Marie-Louise, Duchess of Parma. It closely follows the etiquette for imperial court dress established for Napoleon's coronation in 1804.

With the proclamation of the French Empire in May 1804, the question of what to wear at court took on new urgency. King Louis XIV had introduced the concept of an exclusive court dress in the 1660s, but after the French Revolution of 1789 abolished the monarchy, court dress was no longer needed or wanted. The leaders of the new regime took pride in wearing informal and even slovenly dress. This was not only inappropriate for an imperial court, but disastrous for France's weavers, embroiderers, and lace makers, who had grown dependent on the income generated by court dress. The coronation gave Napoleon an excuse to resurrect court dress and, in doing so, to revive France's ailing textile industry.

While Napoleon favored a return to the opulent styles of the ancien régime, his stylish first wife, Joséphine, realized that for the new court dress to succeed, it would have to be fashionable and flattering as well as luxurious. Thus, imperial court dress was a compromise between tradition and modernity, formality and fashion. It combined a modern high waist—a classically inspired silhouette later dubbed the "empire" waistline—with traditional courtly accessories and opulence. As one courtier sighed with relief: "There was no question of resuming the hoop."

Although Napoleonic court dress was attuned to current fashions, it was equally dependent on the strength of tradition. Those competing impulses can be seen in the train. While it conformed to the fashionable high waistline, the train was so heavily weighted down with fine textiles and embroidery that it had to be secured by shoulder straps and belted at the front. It was likely worn over a white gown with historicized details like a Renaissance-style standing collar and classical embroidery motifs. But this impressive garment must have paled in comparison to the bride's ermine-lined train of crimson velvet entirely embroidered in gold with oak, laurel, and olive leaves; bees; and Napoleon's cipher, which weighed eighty pounds.

WORN ON
THIS DAY

OPPOSITE: Armandine-Marie-Georgine de Sérent's court train

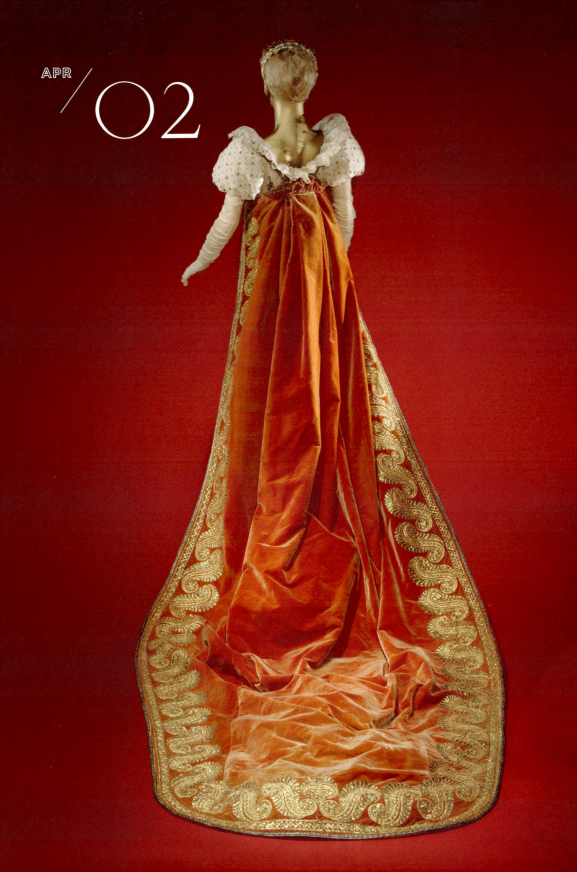

EASTER PARADE 1915 3434-15

APRIL / 04

APRIL 3

1895

Twenty-one-year-old Blanche Lamont wore a "black dress and large felt hat" when she was brutally murdered in San Francisco by Theodore Durrant, called the "Demon of the Belfry" because he hid Lamont's body in the belfry of Emmanuel Baptist Church, where he was assistant superintendent of the Sunday school. At Durrant's trial, Lamont's clothes were displayed in the courtroom on a dressmaker's dummy, "giving the gruesome effect of an effigy of the murdered girl," according to the court record. The defense protested that the lifelike dummy was not part of the evidence and should be removed, but the judge allowed it to remain. Durrant was convicted and hanged.

APRIL 4

1915

The tradition of parading around in new spring fashions on Easter dates back to the late seventeenth century, when wealthy Parisians flocked to the Abbaye de Longchamp in the Bois de Boulogne to hear the sung Holy Week services—one of the few entertainments available during Lent, when theaters were closed and balls were cancelled. Eventually, the Archbishop of Paris became so shocked by the extravagant clothes and carriages on display that he ordered the convent to shut its doors during Holy Week. Undeterred, the *beau monde* continued to parade from the city to Longchamp and back, showing off the latest hats and horse harnesses.

The Abbaye was destroyed during the French Revolution, but the promenade continued. In 1857, a racetrack was built near the ruins of the convent, providing the promenade with something it had been missing for several decades: a destination. Couturiers sent their models to the races to mingle with the spectators, advertising their wares. The Longchamp races inspired imitators around the world, including Royal Ascot, the Kentucky Derby, and the Melbourne Cup—events at which the fashion is as much of a draw as the horseflesh.

New York City's Easter parade began in the 1870s, when Fifth Avenue churches started decorating their interiors with beautiful seasonal floral displays. Churchgoers dressed in their Easter bonnets and Sunday best (often topped by fur coats in chilly years) would visit different houses of

OPPOSITE: Sunday best at the Easter Parade

worship to admire the flowers. While men wore sober black morning suits, for the ladies, "there was every color of the rainbow, and the view up the avenue . . . recalled an old-fashioned flower garden in full bloom," according to the *New York Times*.

As at Longchamp, the promenade was not linear but circular: pedestrians and carriages paraded up one side of Fifth Avenue, then turned around and paraded back down the other. It was a remarkably efficient way to see and be seen. Fashion reporters breathlessly chronicled the procession as a barometer of coming trends. The parade's impact on fashion only intensified with the advent of photography.

In 1915, balmy weather—coming on the heels of a blizzard—drew record crowds. The parade moved more slowly than usual thanks to the vogue for hobble skirts, which were not just tighter but shorter than their predecessors. Women's shoes, gaiters, and spats (short for spatterdashes) were suddenly on display. "Never were Easter paraders more painstaking in the matter of footwear," the *Times* reported. "New fashions in hats and in bonnets, in frocks and men's finery, were conspicuous, but the spectator who kept his eye close to the ground got his reward."

This New York tradition spread to Chicago, Philadelphia, and Los Angeles. In 1948, it was immortalized in the Fred Astaire–Judy Garland musical *Easter Parade*. Today, the Fifth Avenue version continues as a kitschy, family-friendly celebration with prizes for the most outlandish homemade bonnets.

APRIL 5

1930

On an ocean liner traveling from New York to London, twenty-six-year-old Cecil Beaton got fashion advice from a fellow passenger, playwright Noël Coward, who told him: "Your sleeves are too tight. . . . It limits you unnecessarily, and young men with half your intelligence will laugh at you." Coward continued: "It's hard, I know. One would like to indulge one's own taste. I myself dearly love a good match, yet I know it is overdoing it to wear tie, socks and handkerchief of the same colour. A polo jumper or unfortunate tie exposes one to danger." Despite Coward's warning, Beaton defiantly noted in his diary: "I still wear my plus fours on deck."

APRIL 6

1974

Clad in colorful satin culottes, sequins, and silver platform boots, ABBA won the Eurovision Song Contest in Brighton, England. Their performance of "Waterloo" made the unknown band the first Swedish act to win the competition and launched them to global pop stardom. In 2014, the group revealed that their flamboyant stage costumes were designed to be tax-deductible in their native country, as they clearly could not be worn on the street. "In my honest opinion we looked like nuts in those years," guitarist Björn Ulvaeus admitted. "Nobody can have been as badly dressed on stage as we were."

APRIL 7

1944

On the day he escaped from Auschwitz after twenty-one months in captivity, Rudolf Vrba wore a leather belt he'd inherited from a fellow prisoner, Charles Unglik, who had died on January 25. (Vrba wrote the date and Unglik's prisoner number on the inside of the belt.) It was an odd choice for a good-luck charm, as Unglik had worn the belt during his own thwarted escape attempt. Vrba's attempt was successful, however. He returned to his native Slovakia and continued to wear the belt when he joined the Slovak army to fight the Nazis.

APRIL 8

1957

For a State Dinner at the Elysée Palace in Paris, Queen Elizabeth II commissioned couturier Norman Hartnell to create a white satin evening gown, diplomatically embroidered in gold thread, pearls, and beadwork with Gallic emblems like daisies, poppies, fleurs-de-lis, crossed wheat sheaves, and Napoleonic bees. Hartnell named his creation "The Flowers of the Fields of France."

Though the embroidery may have been spectacular, the queen's made-in-England wardrobe looked stiff and old-fashioned next to the cutting-edge *haute couture* worn by her French hosts. The British ambassadress, Cynthia Gladwyn, confided to her diary: "Her

APRIL

clothes—though praised tremendously in the English papers with such remarks as 'Paris gasped' or 'The Queen in her Hartnell dress stole the show' (a silly remark, because she in fact *was* the show)—were not very beautiful, and did not compare with the French clothes." Nevertheless, the queen charmed the French public and politicians alike, drawing crowds wherever she went. As Cecil Beaton quipped: "The Queen triumphed over Hartnell's bad taste."

APRIL 9

1939

Denied permission to perform in Constitution Hall because of her race, African American contralto Marian Anderson gave a free concert for a crowd of seventy-five thousand people (plus millions of radio listeners) on the steps of the Lincoln Memorial in Washington, DC. She wore an orange jacket trimmed in gold with turquoise buttons and a floor-length black skirt of velveteen—one of the eye-catching formal ensembles the singer typically wore for concert performances, made from French materials and possibly purchased on one of her European tours. But it was her luxurious mink coat that took center stage on that chilly Easter Sunday, reminding the audience of the ugly racial prejudices that forced Anderson to perform outdoors, even as her elegant and expensive outerwear transcended them.

APRIL 10

1949

WORN ON
THIS DAY

Golfer Sam Snead was awarded the first green jacket at the annual Masters Tournament in Augusta, Georgia. Introduced for Augusta National Golf Club members in 1937, the distinctive blazers made the tournament organizers easily identifiable to visitors. For tournament winners, the jackets symbolize honorary membership in the club, though they do not confer actual membership. By tradition, the previous year's winner helps the new champion into his jacket (or the club chairman, in the event of a repeat win). But he shouldn't get too comfortable: the jacket must be returned to the club's premises after a year.

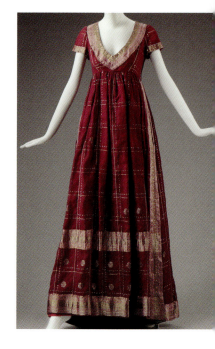

OPPOSITE, ABOVE:
Queen Elizabeth II's evening gown, Barbra Streisand's Vegas gown

APRIL 11

1907

Roger Bresnahan of the New York Giants became the first catcher to wear external shin guards in a major league baseball game when he donned cricket pads in the opening-day game against the Philadelphia Phillies, along with the mandatory mask and chest protector. Though mocked by fans and his fellow players, the bulky bulwarks deflected a foul ball in the fifth inning. Some other catchers tried them and complained that they could not run in them; owners campaigned to have them banned. However, they slowly caught on as more streamlined designs were introduced and are required equipment today.

APRIL 12

1957

Famously well endowed actress Jayne Mansfield upstaged guest of honor Sophia Loren at a dinner party in Beverly Hills, California, by wearing a white satin gown cut so low that Loren later said she feared "her nipples . . . are about to come onto my plate. I'm so frightened that everything in her dress is going to blow—BOOM!" Loren's epic side-eye was captured in a now-iconic photo.

APRIL 13

1970

When Arnold Scaasi opened his custom design salon in 1964, twenty-two-year-old singer-actress Barbra Streisand was one of his first clients. Streisand and Scaasi—whose real name was Arnold Isaacs—bonded over their shared Jewish heritage and love of bold colors and flamboyant materials. At the time, Streisand was still shopping in thrift stores; by 1968, she would be named one of the Ten Most Imaginative Women in Current Fashion, thanks to Scaasi's clothes.

WORN ON THIS DAY

In July 1969, Streisand was invited to be the first headliner at the new Las Vegas International Hotel. Today, lucrative Vegas residencies are customary for A-list performers; at the time, though, the size of Streisand's audience—and paycheck—was unprecedented. At twenty-seven, she became the highest-paid nightclub performer in history, with a contract estimated to be worth $1 million.

Streisand needed several outfits to wear over the course of the month-long engagement. Scaasi wanted to avoid stereotypical Vegas glitz. "One day the Gil sisters arrived at my salon with the most beautiful and luxuriously beaded saris

from their native India," he recorded in his autobiography. "The fabrics were gorgeous in the extreme—four-yard lengths of chiffon . . . that had borders on three sides of contrasting color, completely embroidered in gold tiny sequins and beads. Down the center of these marvels ran different designs, also heavily embroidered." He decided to dress Streisand in Western-style gowns made from these Eastern textiles.

Scaasi was particularly taken with one "very fine, almost transparent linen gauze—a pink plum color with a gold plaid design." He used it to make a gown, cut low to show off Streisand's "milky-white bosom." The gold border of the sari dovetailed down the bodice, forming a gilded frame for Streisand's assets. The full skirt "moved gracefully across the stage" and the high waist "hid the really tiny tummy Barbra was always worried about."

For each sari gown, Scaasi created a matching "tall pillbox" hat, which Streisand wore on the back of her head, her hair swept up beneath it—a silhouette that made the most of her famous nose. "In profile she did look like Queen Nefertiti," Scaasi quipped.

What happened in Vegas didn't stay in Vegas; Streisand continued to wear her sari gowns offstage. On April 13, 1970, Streisand wore the plum gown with its hat to a charity gala at New York's Plaza Hotel. One week earlier, she had worn a similar Scaasi ensemble—a pale pink high-waisted gown and hat, both embroidered with seed pearls and tiny mirrors—to the Academy Awards.

Scaasi called this ladylike look "the antithesis of 1969." In fact, ethnic garments and textiles were integral to the hippie aesthetic. The Peace Corps, established in 1961, encouraged a generation of young Americans to travel the globe, bringing back exotic sartorial souvenirs that combined luxury and authenticity in a colorful display of antifashion. Women wore caftans, ponchos, and djellabahs while men adopted Nehru jackets and dashikis, often mixing ethnic influences indiscriminately. (Debates on cultural appropriation were decades away.) By combining East and West, sophisticated and streetwise, Scaasi and Streisand hit upon a look that was evergreen.

APRIL 14

1865

It was supposed to be a relaxing night at the theater, and President Abraham Lincoln dressed for the occasion in his trademark top hat, a formal suit, and a favorite overcoat, all in his habitual black. The Lincolns and their guests arrived late to Ford's Theatre; the actors halted their performance of the farce

Our American Cousin while the orchestra played "Hail to the Chief" and the audience cheered. Lincoln doffed his hat as he bowed to acknowledge the welcome from the President's Box; he set it on the floor beside his chair, and the play continued. Before it was over, John Wilkes Booth would enter the box and deliver a fatal gunshot wound to the back of the president's head.

As Lincoln was carried out of the theater, his hat (pictured on page viii) was left behind. It became the property of the War Department, eventually being transferred to the Smithsonian. Because of the raw emotions surrounding the assassination—the first of an American president, and one inextricable from the painful aftermath of the Civil War—it was kept in storage for the next twenty-five years.

Lincoln began wearing top hats as a young lawyer in Illinois. At 6'4", he already towered over most people; his hats accentuated his unusual height. They were also useful for storing papers inside the crowns. The hat he wore that fateful night bears the label of Washington, DC, hatter J. Y. Davis. Its battered state suggests that the president wore it for several years, evidence of frugality in keeping with his everyman image. Lincoln added a black silk grosgrain mourning band in memory of his son, Willie, who had died in February 1862, at age eleven.

Lincoln had purchased his black wool overcoat trimmed with grosgrain piping from Brooks Brothers, the New York haberdasher, for his second inauguration weeks earlier. The hand-quilted lining bore a shield of stars and stripes and an American eagle carrying a banner reading "One Country, One Destiny"—a line from a speech by one of Lincoln's heroes, Senator Daniel Webster. After lingering through the night, unconscious, the president died on April 15, and Mary Lincoln gave the bloodstained coat to Alphonso Donn, a White House doorkeeper. Donn's family kept the coat for more than a century, allowing friends to cut off pieces as souvenirs.

Lincoln is the most collected president. His possessions and ephemera—photographs, letters, campaign literature, and autographs—were carefully saved and preserved, even before his death. By the centenary of his birth in 1909, "Lincolniana" was a recognized field of American antiquarianism.

WORN ON
THIS DAY

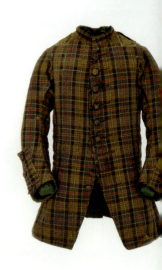

OPPOSITE, ABOVE:
Abraham Lincoln's quilted overcoat lining, Jacobite tartan coat

APR
/14

1912

Women's Wear Daily correspondent Edith Rosenbaum, thirty-four, was returning from a business trip to Paris when her ship, the R.M.S. *Titanic*, struck an iceberg and sank. She wore the shoes pictured on page ii when she abandoned ship—part of nineteen trunks' worth of clothes she'd purchased in Paris, which are now at the bottom of the Atlantic Ocean. Most of her couture-stuffed luggage was not her own; she had recently started a kind of personal shopping service for clients back in the United States. Before boarding the ship, she tried to insure her precious cargo, but she was told there was no need; the *Titanic* was unsinkable.

When the alarm was raised just before midnight on April 14, Rosenbaum locked up her bags (which had their own stateroom) and went to the ship's saloon. A ship's officer informed Rosenbaum that there was "no immediate danger," so she wandered around, wearing a light coat, silk stockings, and a hobble skirt, with no underwear. Backless embroidered silk evening slippers from the Avenue de l'Opéra shop À la Gavotte completed the utterly impractical ensemble. Finally, the White Star Line's Managing Director, Bruce Ismay, spotted Rosenbaum and hustled her into one of the last remaining lifeboats. Ismay was later excoriated for failing to go down with the ship and its 1,517 lost souls.

Naturally, Rosenbaum immediately wrote about her ordeal for *Women's Wear Daily*, in the effervescent language of early twentieth-century fashion journalism. London fashion designer Lucile was a fellow passenger on the *Titanic*, and Rosenbaum reported that she "made her escape in a very charming lavender bath robe, very beautifully embroidered, together with a very pretty blue veil." On the *Carpathia*, the Cunard steamship that picked up the *Titanic*'s survivors, the two women "exchanged compliments about our costumes and 'swapped' style information closely. . . . All her models, as well as my own, had gone to the bottom of the sea, and we both acknowledged that pannier skirts and Robespierre collars were at a discount in mid-ocean when you are looking for a ship to rescue you."

Rosenbaum sued the White Star Line for $14,569.50 in lost luggage, plus the $2,000 in cash she had left in the purser's safe; eventually, she received three cents on the dollar. It took her four years to repay her clients and recoup her losses.

WORN ON THIS DAY

ABOVE: Gene Kranz's vest, worn during *Apollo 13*'s emergency landing

1746

The Jacobite Rebellion of 1745 came to an ignominious end at the Battle of Culloden near Inverness, Scotland. It was not just the end of Scotland's dreams of independence but the end of the Highland way of living—and dressing. Tartan men's garments like kilts and the coat pictured on page 86, worn on the battlefield, were outlawed.

By banning Highland dress, the English government hoped to discourage the nationalist impulses that had led to Culloden. When he arrived from France in August 1745 with the aim of reclaiming his father's crown, Bonnie Prince Charlie embraced tartan as wearable propaganda, and he encouraged his fellow Jacobites to follow his example. The so-called Young Pretender rode into Perth wearing a suit of tartan trimmed with gold lace; in Edinburgh and Carlisle, he wore a short coat of tartan, a blue sash and bonnet, and red velvet trews (trousers). He seized control of Manchester in a tartan plaid belted with a blue sash. An English spy reported: "He is always in a Highland habit as are all about him. When I saw him he had a short Highland plaid waistcoat, breeches of the same." These visible emblems of Scottishness unified the ragtag Jacobite army, and helped Bonnie Prince Charlie's followers forget that the rightful, Catholic heir to the throne of Scotland had been born and raised in Italy.

Despite—or, perhaps, because of—the ban, some clan chiefs continued to wear Highland dress after Culloden, at least in their portraits. Never seriously enforced, the ban was lifted in 1782 to reward the heroism of Scottish regiments during the American Revolution. When Bonnie Prince Charlie died in Rome in 1788, any lingering threat of another rebellion was extinguished.

1970

NASA Chief of Flight Control Division Gene Kranz wore a white vest when he brought the crippled *Apollo 13* lunar module and its three astronauts safely back to Earth after four tense days. As leader of Mission Control's "white team," Kranz wore a different white vest for each mission. All of them were made by his wife, Marta.

When the Kranz family moved to a NASA-friendly neighborhood in Houston in 1962, "all the wives sewed," Marta remembered. "Gene wanted some kind of symbol for his team to rally around. I suggested a vest." He started wearing them during the *Gemini 4* mission. "It was an immediate hit," Gene recalled. "From then on, I put on a new vest on the first shift of every mission."

Gene's vests became his trademark; after he retired from NASA in 1994, "Gene became a motivational speaker, and when he gave speeches, people wanted him to wear the white vest," Marta explained. To paraphrase the title of Gene's autobiography, failure to wear a vest was not an option.

APRIL 18

1956

When actress Grace Kelly married Prince Rainier of Monaco, Monégasque law required two ceremonies: one civil and one religious. Her Hollywood employers at MGM Studios announced that both bridal ensembles would be their gifts to the departing star. For the forty-minute civil ceremony in the throne room of the pink-hued Prince's Palace, Kelly wore a full-skirted suit of pink silk overlaid with beige machine-made lace, its floral pattern outlined with dusty pink silk floss. It was designed by Helen Rose, who had costumed Kelly for four MGM films including her last, *High Society*. Rose would also design the more traditional gown Kelly wore for the religious ceremony the following day. The matching heels were created by New York shoe designer David Evins, nicknamed the "King of Pumps."

Later that evening, the couple attended a gala at the Monte Carlo Opera. Grace wore a white silk Lanvin-Castillo couture gown embroidered with eight hundred thousand sequins and fifteen hundred pearls and rhinestones, designed to show off the glittering decorations and orders that came with her new royal role.

APRIL 19

1956

The royal wedding of one of Hollywood's brightest stars and one of the world's most eligible bachelors was the television event of the year. An estimated thirty million people worldwide watched the ceremony in Monaco's Saint Nicholas Cathedral. Appropriately, the bride wore a gown created by

seasoned experts in onscreen style: the MGM Studios' wardrobe department.

Although Grace Kelly was technically still under contract to MGM, her new husband, Prince Rainier, had declared that she would no longer appear in films. The studio hoped to change his mind or, failing that, garner publicity for Kelly's two unreleased MGM films. But MGM also had a history of paying for the weddings (and providing the gowns) of actresses who got married while under contract, including Elizabeth Taylor and Jane Powell. It was a win-win for the studio, ensuring that its stars maintained their wholesome reputations while reaping free publicity.

MGM's Academy Award–winning head costume designer, Helen Rose, oversaw Kelly's gown. With its high neck, long sleeves, and fan-shaped train, it was appropriate for the solemnity of the Catholic service, but also camera-friendly. "Everything we do is with a view to how it will photograph," Rose told a reporter. The lace headpiece anchoring the lace-edged silk tulle veil was designed to keep the bride's face on view; it was decorated with wax orange blossoms, which would not wilt. In close-ups, tiny seed pearls and three-dimensional appliqué petals accentuated the pattern of the gown's antique rose point lace bodice, which disappeared into a high cummerbund of ivory silk faille encircling the bride's twenty-one-inch waist. Twenty-five yards of *peau de soie* and the same amount of silk taffeta went into the bell-shaped skirt and lace-inset train, gathered with three bows. The ensemble took the thirty-five wardrobe department employees six weeks to create, working in complete secrecy.

Kelly's shoes of silk, antique lace, seed pearls, and glass beads were made by David Evins, who was known for his lightweight, comfortable pumps with a flattering, low-cut profile. Although gossip columnist Walter Winchell reported that the shoes would be low-heeled "so His Serene Highness won't look like a shrimp at the altar," they actually had two-and-a-half-inch heels. X-rays reveal a lucky copper penny sewn into one sole. Kelly wore $150 pearl-trimmed stockings by Willys of Hollywood, hosiery maker to the stars, who had designed a similar pair for Princess Elizabeth's wedding. Even the prayer book the bride carried was decked in lace and seed pearls.

Princess Grace donated her gown to the Philadelphia Museum of Art in her hometown, where it went on display just weeks after the wedding on a mannequin made in Kelly's image. It remains one of the most influential wedding gowns ever worn. Its long-sleeved lace bodice and strapless underbodice provided inspiration for another instantly iconic royal wedding gown:

the Alexander McQueen gown Kate Middleton wore when she married Prince William in 2011.

APRIL 20

1986

Wearing Nike Air Jordan 1s, twenty-three-year-old Michael Jordan scored a record sixty-three points in a single NBA playoff game against the Boston Celtics. Though the Chicago Bulls lost in double overtime, Celtics captain Larry Bird complimented "God disguised as Michael Jordan" on his performance.

Nike had introduced the Air Jordan prototype in the 1984 preseason, but Jordan was initially banned from wearing them because their red and black color scheme did not meet the NBA's "51 percent" rule, requiring sneakers to be mostly white. Nike added a white upper just in time for the regular season. When the $65 shoes went on sale to the public in 1985, they made $130 million in their first year.

APRIL 21

1989

After several days of student-led pro-democracy protests in Tiananmen Square, the Chinese government announced that the Beijing landmark would be closed to the public the following day. American journalist Linda Javin, who was visiting friends at the Beijing Teachers' College, recalled: "At about 10:30 p.m. . . . thousands of students poured out of the dormitories. Many of them wore white paper flowers, symbols of mourning. They planned to get to Tiananmen before the police could seal it off." The increasingly tense standoff between protestors and police in the square ended in tragedy on June 4, with the massacre of an untold number of civilians by the Chinese army.

WORN ON
THIS DAY

APRIL 22

1661

Samuel Pepys woke up early to watch King Charles II parade from the Tower of London to Whitehall Palace ahead of his coronation in Westminster Abbey the following day. "It is impossible to relate the glory

OPPOSITE: Grace Kelly's wedding gown

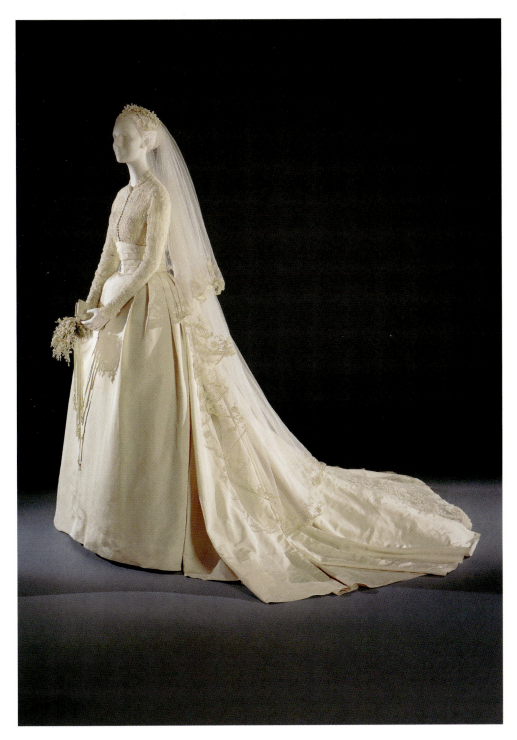

of this day, expressed in the clothes of them that [rode], and their horses and horses clothes," he wrote in his diary. "Embroidery and diamonds were ordinary among them. . . . The King, in a most rich embroidered suit and cloak, looked most noble. . . . So glorious was the show with gold and silver, that we were not able to look at it, our eyes at last being so much overcome with it."

APRIL 23

1854

Elisabeth of Bavaria wore her *Polterabendkleid* or "wedding eve dress" to the celebrations the night before her wedding to Emperor Franz Joseph I of Austria. *Poltern* is a German verb meaning "to crash" or "to make a racket"; a couple's *Polterabend* was (and still is) a noisy party, often involving smashing porcelain for good luck. The royal bachelorette's white organdy dress and its matching shawl were embroidered in green floss and gold metallic thread with floral motifs and Arabic characters chosen for their decorative effect rather than their meaning, reflecting Austria's deep historic ties to the Ottoman Empire.

APRIL 24

1849

The first baseball uniform was adopted by the New York Knickerbockers. It consisted of blue woolen pantaloons, white flannel shirts, and wide-brimmed straw hats. By the 1860s, straw hats would be replaced by billed caps, the forerunners of the modern baseball cap that came into wide use around the turn of the century.

APRIL 25

1607

Admiral Jacob van Heemskerck commanded the Dutch ships that soundly defeated the Spanish at the Battle of Gibraltar in 1607, during the Eighty Years' War—the first and greatest of his country's victories over Spain. Although he won the battle, he lost his life in

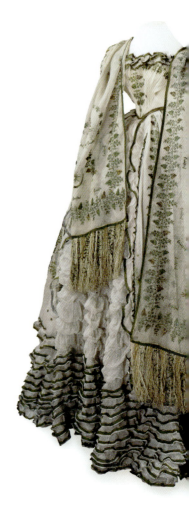

ABOVE:
Elisabeth of Bavaria's
Polterabendkleid

the fray after his left leg was shattered by a cannonball. When he was accorded a hero's burial in Amsterdam's Oude Kerk, his armor was hung above his tomb in keeping with tradition, minus one leg. It is now in the Rijksmuseum.

APRIL 26

1981

Andy Warhol, the pop artist and founder of *Interview* magazine, ran into an acquaintance at a restaurant in New York. "I couldn't remember her name at first, but then I did," he recorded in his diary. It was Anna Wintour. "She was just hired by *New York* magazine to be their fashion editor," Warhol continued. "She wanted to work for *Interview* but we didn't hire her. Maybe we should have, we do need a fashion person here, but—I don't think she knows how to dress, she's actually a terrible dresser." In 1988, Wintour was named editor-in-chief of *Vogue*.

APRIL 27

1967

At the opening of Expo '67 in Montreal, the fifty hostesses who staffed the American Pavilion wore mod A-line minidresses in white and navy, designed by Bill Blass. The futuristic fashions complemented Buckminster Fuller's geodesic dome, traversed by a monorail. Blass would go on to design uniforms for American Airlines as well as gowns for First Ladies Nancy Reagan and Barbara Bush. But at the time he was a relatively unknown, fledgling designer. How did he get the job?

Acting Chief of Design and Operations for the American Pavilion Jack Masey, who had hired him, couldn't tell anyone how he knew Bill Blass. The two had served together alongside other artists and designers in the army's camouflage unit in World War II. This top-secret tactical deception operation sent false radio transmissions, deployed inflatable tanks, and generally spread misinformation. But until 1996, the work of the so-called Ghost Army remained classified.

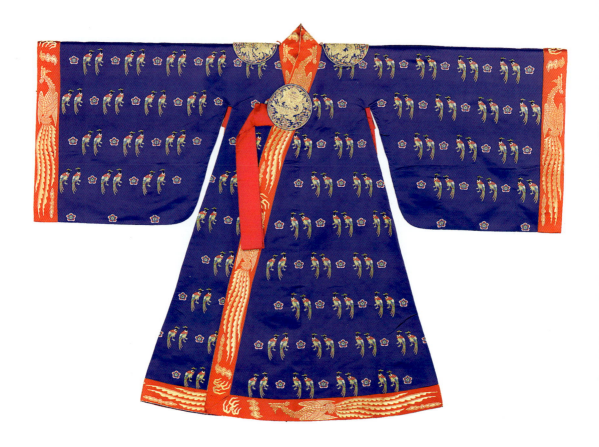

1922

The Japan-Korea Treaty of 1910 made Korea a colony of the Japanese empire, and the Korean emperor, Sunjong, was demoted to a mere king, micro-managed by a Bureau for Royal Affairs. In a bid to strengthen the fragile ties between the adversarial countries, his son, Crown Prince Yeong, was educated in Tokyo beginning in 1907, and married off to the Japanese Princess Masako in 1920.

In 1922, Masako and Yeong traveled to Seoul, where they participated in a Korean wedding ceremony on the second anniversary of their Japanese wedding. Masako wore a formal Korean court robe, or *jeokui*, of deep blue silk embroidered with 154 pairs of green pheasants, symbolizing love and longevity in marriage. They are rendered in five colors, representing the five virtues a queen was expected to embody: benevolence, righteousness, propriety, wisdom, and trust. Roundels embroidered with dragons decorate the breast, back, and shoulders.

On her head, Masako wore a triangular ceremonial wig decorated with ornate hairpins and jewels; nearly eight inches high, it was so heavy that a lady-in-waiting had to support it from behind as she walked. Yeong wore a *yongpo*, a court robe of red with a dragon design in golden threads, and the crown of the Yi royal dynasty. Their seven-month-old son, Jin, was dressed in a peach gown with black stripes and a ceremonial hood; during the ceremony, he was carried by a court chamberlain. A celebratory banquet followed the wedding. The next day, the couple visited Jongmyo, the Grand Ancestral Shrine of Joseon Kingdom, to ceremonially report their marriage to Yeong's ancestors.

But the happy occasion ended in tragedy. Masako and Yeong were scheduled to return to Tokyo on May 8, but the trip was postponed when little Jin became ill. He died on May 11; it was suspected that he had been poisoned. His funeral was held in Korea on May 17. As a woman, Masako was not allowed to participate. She returned to Japan the next day, accompanied by Japanese bodyguards amid fears that a similar fate might befall her.

OPPOSITE, ABOVE:
Princess Masako's wedding robe, Expo '67 hostess outfits

2011

The pink Philip Treacy fascinator Princess Beatrice wore to the wedding of Prince William and Kate Middleton evoked comparisons to a pretzel, an octopus, a toilet seat, and an IUD. (It was supposed to look like a giant bow.) The hat immediately spawned its own Facebook page and Twitter feed. She later auctioned it on eBay, raising $131,560 for UNICEF and Children in Crisis.

1789

George Washington, the hero of the American Revolution, took the oath of office in the first presidential inauguration in America's history. Held on the balcony of Federal Hall in New York City, in view of a large crowd, the inauguration set a number of precedents, among them how a president should dress.

Washington was adamant that his suit for the occasion had to be American-made, but by whom? The American textile industry was in its infancy, and it could not compete with European imports for quality or variety. In January 1789, Washington heard that a Connecticut wool mill might be able to produce the "superfine American Broad Cloths" he sought. The Hartford Woolen Manufactory had been founded the previous year by Jeremiah Wadsworth, a former supplier to the Continental Army. Washington dispatched his friend General Henry Knox to Connecticut to investigate. Knox sent back samples of cloth and sketches of buttons. Washington wrote approvingly on April 10: "The cloth & Buttons . . . really do credit to the Manufactures of this Country."

With only two weeks left before the inauguration, Washington settled on a velvety broadcloth in sober dark brown. The fabric was sent from Connecticut to New York, where Washington's tailor made it up into a double-breasted frock coat in the fashionable cutaway style and matching breeches. With the suit, Washington wore silk stockings, shoes with silver buckles, a steel-hilted sword, and a dark red overcoat.

Ironically, the suit was so successful that Washington was crucified by the press for wearing unpatriotic, foreign-made cloth at his inauguration. He had to produce proof that it was American-made. In a letter to the Marquis de Lafayette, Washington expressed hope that "it will not be a great while, before it will be unfashionable for a gentleman to appear in any other dress."

WORN ON
THIS DAY

OPPOSITE: George Washington's inaugural American-made suit

"SUPERFINE AMERICAN
BROAD CLOTHS"

FROM SPITALFIELDS SILKS TO SLAVE SHACKLES

MAY

1	2	3	4	5	6	7
Queen Victoria's Great Exhibition gown	Claire Danes's luminescent Met Gala gown	Lord Byron's swimming attire	Clothes worn at Kent State protest	Skirt celebrating the end of German occupation	Kangaroo leather cleats of Sir Roger Bannister	Camisole worn on the *Lusitania*
1851	**2016**	**1810**	**1970**	**1949**	**1954**	**1915**
8	9	10	11	12	13	14
Princess Elizabeth's anonymous army uniform	An avant-garde court presentation dress	Disguise worn by Jefferson Davis	Outfit worn by Oscar Wilde on his American tour	Wedding ensembles of Mick and Bianca Jagger	Empress Soraya of Iran's tulle ball gown	From Brooklyn to Buckingham Palace
1945	**1893**	**1865**	**1882**	**1971**	**1953**	**1896**
15	16	17	18	19	20	21
An escaped slave's clothes	Marie Antoinette's wedding jewels	A French couture gown fit for a queen	Ernest Shackleton's unfortunate boots	Marilyn Monroe's bedazzled birthday dress	Charles Lindbergh's transatlantic flight suit	Flight suit worn by Amelia Earhart
1803	**1770**	**1948**	**1916**	**1962**	**1927**	**1932**
22	23	24	25	26	27	28
Caps and gowns of Columbine grads	Hats worn by Bonnie and Clyde	The Sture family's fashion relics	Muhammad Ali's boxing robe	Melania Trump's Dolce & Gabbana coat	"Garabaldi Shirts" worn by Italian patriots	Men's clothes used to convict Joan of Arc
1999	**1917**	**1567**	**1965**	**2017**	**1860**	**1431**
29	30	31				
Boots that summited Mount Everest	A flowery French garden party gown	An iron slave collar in New Orleans				
1953	**1894**	**1862**				

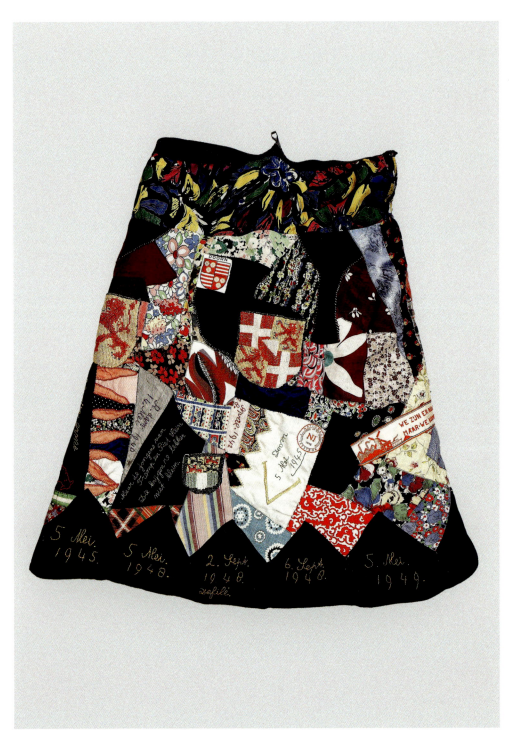

01

— **1851** —

Queen Victoria opened the Great Exhibition at the Crystal Palace in London, a landmark display of art and technology from around the world, wearing "a dress of pink and silver, with a diamond ray Diadem and little crown at the back, with two feathers, all the rest of my jewels being diamonds." The dress was made of silk woven in the Spitalfields neighborhood of London, thus patriotically promoting British manufacturing on a global stage.

MAY 2

2016

Actress Claire Danes wore a luminescent strapless ball gown to the Metropolitan Museum of Art's annual Costume Institute gala, whose theme was "Fashion in an Age of Technology." Designer Zac Posen partnered with Google's Made with Code initiative to create the ice-blue organza gown, lit up by fiber optics and thirty concealed battery packs. "I'm interested in that place where the past and the future meet," Posen explained.

MAY 3

1810

When he swam across the Hellespont—the narrow strait in Turkey known today as the Dardanelles—in one hour and ten minutes, Lord Byron wore "a pair of trowsers [*sic*], an accoutrement which by no means assists the performance," he recalled.

MAY

MAY 4

1970

Mary Ann Vecchio, a fourteen-year-old runaway, was participating in a student antiwar protest at Kent State University when the Ohio National Guard opened fire on the unarmed crowd, killing twenty-year-old Jeffrey Miller and three others.

OPPOSITE: *Feestrok celebrating Dutch liberation*

John Filo's Pulitzer Prize–winning photo of Vecchio kneeling over Miller's body has become an icon of the Vietnam Era, but Vecchio's T-shirt—reading "SLAVE"—is often overlooked and has received little attention from historians.

Cheap and mass-produced, graphic T-shirts were first used as marketing devices, but were quickly co-opted by idealistic young people as vehicles for political and personal expression. Vecchio's T-shirt, likely handmade, served as an all-purpose cry of oppression; it might refer to mental slavery, the draft, or the Civil Rights movement. Like her flared jeans (customized with "flower power" decorations) and ethnic-inspired sandals, it was an androgynous garment. Her long, lank hairstyle, too, was increasingly worn by men. Her antifashion fashion statement sums up what historian Jo Paoletti has described as the "do-it-yourself, anything-goes aesthetic" of 1960s and '70s counterculture.

MAY 5

1949

The *feestrok* or *bevrijdingsrok* ("celebration skirt" or "liberation skirt") on page 102 is one of more than four thousand made by Dutch women to commemorate the anniversary of the end of the German occupation of the Netherlands on May 5, 1945. The idea for the celebration skirt came from Mies Boissevain-van Lennep, a member of the Dutch resistance. When she was imprisoned by the Germans in 1943, her family and friends secretly sent her a scarf made up of small pieces of their own clothes. From this seed grew the idea of a patriotic patchwork skirt that could be worn on the anniversary of liberation and other important national occasions.

A committee of the International Information Centre and Archives for the Women's Movement developed guidelines for making the skirts. They had to begin with an old garment. Symbolically, the patchwork represented unity from diversity, and the new society rebuilt from the ashes of the war. Personal memories and important dates were embroidered on the skirt in colorful materials, making a new garment out of the old one. The hem of the skirt had to include upward-pointing triangles embroidered with the date of liberation and the dates on which the skirt was worn. Elsewhere on the skirt, dates and memories of personal or national importance could be added. (This one includes May 14, 1940—the date of the bombardment of Rotterdam.) Skirts made according to the committee's rules could be entered into a national archive, receiving a stamp and a number, which was duly stitched onto the skirt.

The registered skirt was worn on the anniversary of liberation in both 1948 and 1949, as well as for Queen Wilhelmina's Golden Jubilee parade in The Hague on

September 2, 1948, and Queen Juliana's coronation four days later. At one point during the Jubilee festivities, Queen Wilhelmina was serenaded by fifteen hundred women, all of them wearing celebration skirts. Dozens of these skirts have survived in museum collections. Each is unique but, at the same time, instantly recognizable as a badge of national pride and perseverance.

MAY 6

1954

Sir Roger Bannister wore a pair of black kangaroo leather shoes with spiked leather soles when he became the first man to run a mile in less than four minutes in Oxford, England. They weighed 4.5 ounces; he sharpened the spikes to make them even thinner. Christie's sold the shoes for $412,062 in 2015.

MAY 7

1915

Margaret Gwyer and her new husband, Herbert, a missionary in Saskatoon, Canada, were traveling second-class from New York to Liverpool aboard the Cunard passenger liner RMS *Lusitania* when it was attacked by a German U-boat. "We were at dinner when the torpedo struck," Herbert remembered. "I shall never forget the crash of all the crockery from the tables." The couple quickly decided against returning to their stateroom to retrieve their possessions and instead headed to one of the fifty lifeboats. Just as they reached it, Margaret looked up at the swiftly tilting ship. Thinking one of the enormous funnels was about to fall on the lifeboat, she climbed back on deck. Unawares, Herbert jumped into the lifeboat, which began to pull away from the ship.

As the *Lusitania* capsized, Margaret was thrown into the icy water and lost consciousness. She was sucked into a funnel, where she came to. Almost immediately, there was a massive explosion as the ship's boilers exploded, shooting Margaret out of the funnel. A fellow survivor, Oliver Bernard, remembered the look of "abject terror" on her face as she was expelled into the open water, coated in soot and oil. First Officer Charles Lauriat, who pulled her into his lifeboat, recounted: "Most of her clothes had been blown away and there wasn't a white spot on her except her teeth and the whites of her eyes. Marvellous to say she wasn't hurt and proved a great help in cheering us all by her bright talk." When she reunited with Herbert—who hardly recognized her—Margaret joked: "Never mind, we've lost those awful wedding presents."

The sinking of the *Lusitania*—which was neither a military nor a merchant vessel—prompted an international outcry. Although passengers on all ships sailing under the British flag did so at their own risk after February 18, when Berlin declared British waters a "war zone," no one had expected an attack on a passenger ship. Of the 1,959 people aboard, 1,195 died, including 128 US citizens. Wary of drawing the Americans into the war, the German High Command bowed to political pressure and banned direct attacks on passenger vessels. But they continued to get caught in the crossfire from time to time, stoking further outrage. A year after the *Lusitania* disaster, the Germans finally withdrew their U-boats from the Atlantic, but the rallying cry "Remember the *Lusitania!*" echoed until the end of World War I.

Margaret Gwyer would never forget the *Lusitania*; nonetheless, she kept her oil-stained, lace-trimmed, monogrammed cotton camisole undergarment as a reminder of her escape.

MAY 8

1945

At 5 o'clock on V-E Day, Princess Elizabeth—who had served as a driver and mechanic in the Auxiliary Territorial Service, the women's branch of the British Army, during World War II—waved to a jubilant throng from the balcony of Buckingham Palace wearing her uniform. Afterward, taking advantage of the chaos, the gathering darkness, and the anonymity her attire afforded, the future queen and some friends slipped into the crowd. "We were terrified of being recognized," she later recounted. "So I pulled my uniform cap well down over my eyes. A Grenadier officer among our party of about 16 people said he refused to be seen in the company of another officer improperly dressed. So I had to put my cap on normally." The group ended up at the Ritz Hotel, doing the conga. "I don't think people realized who was among the party," recalled Elizabeth's cousin, Margaret Rhodes, who was with her. "I think they thought it was just a group of drunk young people."

WORN ON
THIS DAY

MAY 9

1893

The bodice and skirt Mrs. W. G. Crum wore when she and her daughter were presented to Queen Victoria at Buckingham Palace was made by Sarah Fullerton-Monteith Young, a fashionable London dressmaker known for romantic,

OPPOSITE: Margaret Gwyer's camisole, worn on the *Lusitania*

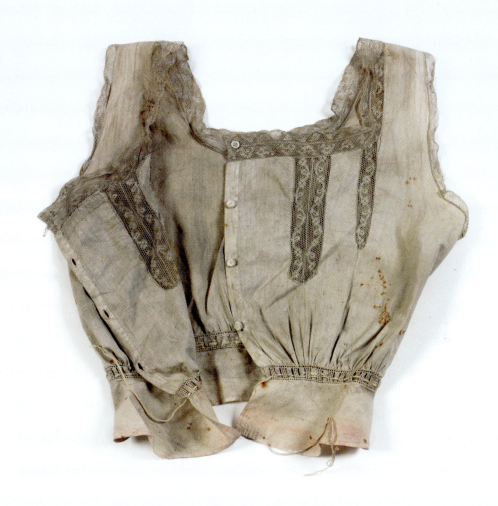

"WE WERE AT DINNER WHEN THE TORPEDO STRUCK"

unconventional gowns with exotic or historical overtones.

The handwoven silk brocade, in a pattern titled "Flower Garden," was created by the influential artist-designer William Morris. "I am in a whirlwind of dyeing and weaving, and . . . rather excited by a new piece just off the loom, which looks beautiful, like a flower garden," Morris wrote to a friend on March 4, 1879. Like other key figures in the Arts and Crafts Movement that transformed the English art world in the late nineteenth century, Morris championed traditional handcrafts over industrialized "progress," reviving historical printing, dyeing, and weaving techniques. Many of his designs for fabric, wallpaper, and carpets—including his famous "Strawberry Thief"—were inspired by his gardens at Kelmscott Manor in Oxfordshire.

Both Morris and Young had strong ties to Aestheticism, a related artistic movement that embraced classical and medieval-style clothing and rejected disfiguring emblems of modernity like corsets, crinolines, and high heels. This gown's soft, simple lines, gathered bodice, and historicized details (like the overskirt) betray the influence of Aestheticism. As Morris commanded in 1882: "Do not allow yourselves to be upholstered like armchairs, but drape yourselves like women."

For aristocratic women, presentation at court marked the beginning of adulthood: "Before that event, one was definitely and irrevocably in the schoolroom," Lady Angela Forbes remembered. Her own presentation to Queen Victoria took place around the same time as Mrs. Crum's. Forbes wore a "lovely white frock" copied from a Worth model by the fashionable London dressmaker Mrs. Mason. Forbes's nervousness at meeting the monarch was compounded by the unaccustomed formality of her clothes. "I was terrified of tumbling over my train, and I didn't like the feathers in my hair at all," she confessed. She became so flustered that she kissed the Queen on both cheeks instead of the hand, as etiquette demanded. After she had made the requisite number of curtsies, "I suddenly found my train flung over my arm by a gentleman-in-waiting, and I was out of the room. It was all over so quickly that it seemed a fearful waste of time to have dressed up for those few

WORN ON
THIS DAY

minutes." Mrs. Crum's elegant but "artistic" ensemble offers a comfortable, counterculture alternative to the ordeal of dressing for court.

MAY 10

1865

When he was captured by Union troops near Irwinville, Georgia, retreating Confederate President Jefferson Davis was disguised as a woman. "Knowing he would be recognized, I plead with him to let me throw over him a large waterproof wrap

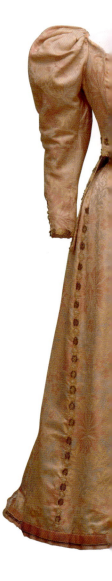

ABOVE: Mrs. W. G. Crum's court attire

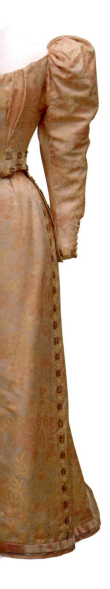

which had often served him . . . for a dressing gown and which I hoped might so cover his person that in the grey of the morning he would not be recognized," his wife, Varina, recalled. "I threw over his head a little black shawl which was around my own shoulders, seeing that he could not find his hat."

MAY 11

1882

On a lecture tour of America, Oscar Wilde appeared at Wallack's Theater in New York dressed in accordance with his Bohemian aesthetic principles. He wore "a suit of black velvet with . . . knee-breeches, . . . long black stockings, pumps with silver buckles, a drab kid glove on the left hand, lace ruffles at the wrist, and a lace ruffle around the neck, expanding in front into a little cataract of lace, that occupied the position usually belonging to a shirt-front," the *New York Times* reported. "Mr. Wilde's hair hung in graceful hanks over his neck and shoulders, and so concealed his ears that it was impossible to discover whether he wore ear-rings or not."

MAY 12

1971

For their wedding in Saint-Tropez, Mick and Bianca Jagger were both dressed by couturier Yves Saint Laurent. Mick wore a beige three-piece suit and sneakers. Bianca wore a large white hat with a veil and a white tuxedo jacket and a matching long skirt. She discovered that the shirt that went with the ensemble no longer fit her—unbeknownst to the public, she was four months pregnant with her daughter Jade—so she wore nothing underneath her jacket. Instead of a bouquet, she sported a corsage on her wrist. "My marriage ended on my wedding day," Bianca later said.

MAY 13

1953

Empress Soraya of Iran had a fitting for a strapless tulle ball gown with fashion designer Emilio Schuberth in his studio in Rome, Italy. Schuberth was known for his ultrafeminine designs for royalty and Hollywood stars. Soraya was both: the second wife of the Shah Mohammad Reza, the last Shah of Iran, she had a brief career as a film actress after their 1958 divorce. In 1979, the twenty-five-hundred-year-old Persian monarchy was overthrown and replaced by the Islamic Republic.

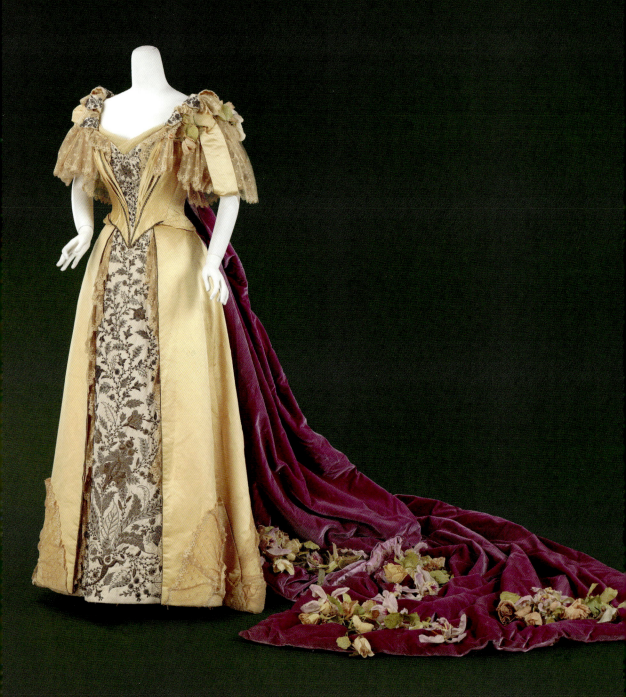

MAY 14

1896

When Emily Warren Roebling's father-in-law, John R. Roebling, the designer of the Brooklyn Bridge, died before his masterpiece was completed, her husband, Washington, took over the project as chief engineer. But Washington developed a debilitating case of cassion disease, or decompression sickness—a hazard of building deep bridge foundations—and Emily took his place. She was the first to walk across the bridge when it was completed in 1883.

Emily was adept at building metaphorical bridges, too. One gown, whose designer is unknown, took the American to the capitals of Europe in 1896. In London, she wore it when she was presented to Queen Victoria—an important rite of passage for any young woman, whatever her nationality. In Paris, Emily sat for her portrait by Carolus-Duran, again wearing this gown. And, in Moscow, she wore it to the five-hour coronation of Nicholas II and Alexandra Feodorovna on May 14.

The gown's historical details—including a stomacher and overskirt reminiscent of eighteenth-century gowns—and its lavish trimmings of metallic embroidery and lace must have looked at home in the venerable palaces it visited. The rich gold and purple textiles evoke the traditional trappings of royalty. The velvet train strewn with silk orchids is attached at the shoulders. Court protocol required a long train, but it could be removed back home in the republic. Participation in events such as these on the international stage both acknowledged and sealed one's social standing, particularly for Americans. You needed the right connections, but you also needed the right clothes.

MAY 15

1803

When Caesar, an eighteen-year-old slave, ran away from his owner, Samuel McClellan of Woodstock, Connecticut, he wore "a light colored sailor jacket, a mixed green and black swansdown vest, a pair of blue overalls, a Holland shirt, a pair of gray socks, a pair of thick shoes, a brown homemade great coat, and a large old Hat," according to a poster advertising a $10 reward for his capture. Such advertisements often contained lengthy descriptions of what runaway slaves were wearing when they escaped, as it was usually the only clothing they possessed.

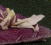

OPPOSITE: Emily Warren Roebling's court gown and train

MAY 16

1770

For her wedding to the future Louis XVI in the Royal Chapel at the palace of Versailles, fourteen-year-old Marie-Antoinette was "very fine in Diamonds," according to one guest, the Duchess of Northumberland. "She really had quite a Load of Jewels."

MAY 17

1948

When Princess Elizabeth and her new husband, the Duke of Edinburgh, visited Paris in 1948, Lady Alexandra Howard-Johnston, wife of the British naval attaché, was invited to attend a ballet performance in their honor. She wore a white satin gown embroidered in gold by Jacques Fath, her usual couturier. When she arrived at the Théâtre de l'Opéra with her husband, the Garde Nationale suddenly leapt to attention. "I realised they had mistaken us for the Princess and Duke," she remembered. "That was the effect made by my splendid Fath."

MAY 18

1916

Ernest Shackleton's failed expedition to the South Pole in 1914–16 was outfitted by Burberry. After his ship, the *Endurance*, sank, Shackleton and some of his crew made a desperate 800-mile voyage to South Georgia Island in one of its lifeboats, the *James Caird*. As he prepared to cross the island on foot, Shackleton complained: "I was unfortunate as regarded footgear, since I had given away my heavy Burberry boots on the floe, and now had a comparatively light pair in poor condition. The carpenter assisted me by putting several screws in the sole of each boot with the object of providing a grip on the ice." The screws came from the *James Caird*.

MAY 19

1962

It wasn't her birthday suit, but it was close. Marilyn Monroe took the stage at a Democratic Party fundraising gala at Madison Square Garden in a shimmering Jean Louis gown made of sheer, flesh-toned marquisette studded with twenty-five hundred rhinestones. From the audience, it looked like she was wearing nothing but rhinestones. The dress was so tight Monroe reportedly had to be sewn into it.

OPPOSITE: Lady Alexandra Howard-Johnston's Jacques Fath gown

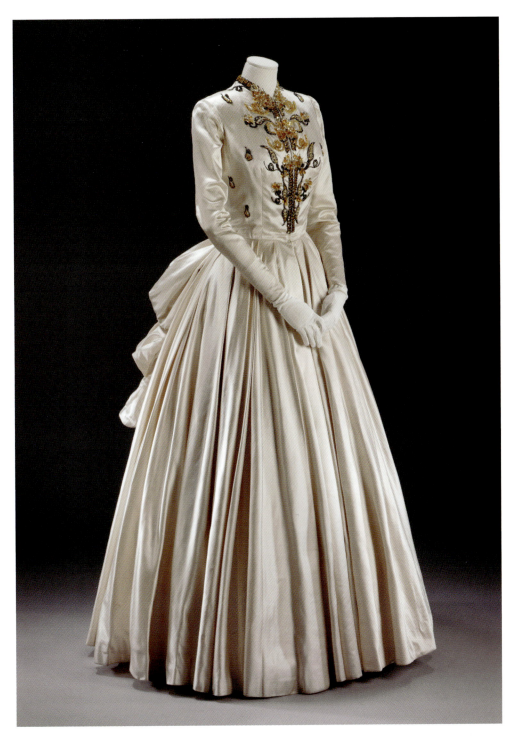

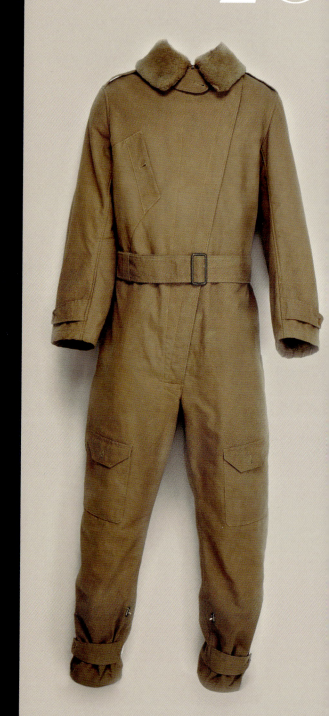

In her trademark breathy voice, she sang "Happy Birthday" to President John F. Kennedy, who would turn forty-five ten days later. "I can now retire from politics after having had Happy Birthday sung to me in such a sweet, wholesome way," Kennedy joked afterward. It wasn't just Marilyn's suggestive delivery; it was the dress. Originally purchased for $1,440.33, it sold for $4.8 million in a 2016 auction.

MAY 20

1927

Charles Lindbergh wore a one-piece brown cotton twill flight suit with a fur collar on the *Spirit of St. Louis* when he embarked on the first solo transatlantic crossing from New York to Paris. The $50 suit was made by A. G. Spalding & Bros., the sporting goods firm founded in 1876; the Spalding name can still be seen on basketballs, soccer balls, and footballs.

After flying for thirty-three-and-a-half hours straight, "Lucky Lindy" landed the next evening at Le Bourget Aerodrome, where he received a hero's welcome. Aware that his flight suit had traveled into history, Lindbergh signed the underside of the collar and wrote: "Worn on the following flights: San Diego–St. Louis, St. Louis–New York, New York–Paris."

MAY 21

1932

Amelia Earhart wore a one-piece flight suit over jodhpurs, a short jacket, and a collared shirt when she became the second person (and first woman) to fly solo across the Atlantic, exactly five years after Charles Lindbergh accomplished the same feat. She planned to land in Paris, but bad weather and technical problems forced her down in a field in Ballyarnett, Northern Ireland, after nearly fifteen hours in the air.

Later that year, Earhart parlayed her celebrity into a clothing collection, "Amelia Fashions." The wrinkle-free dresses, skirts, pants, and outerwear were designed for "active women" rather than pilots, but some incorporated parachute silk and the fabric used for airplane wings. Earhart also developed a line of flying apparel for women. For many years, she had lamented the dearth of options in aviation gear for women.

Earhart disappeared with her navigator on July 2, 1937, while attempting an around-the-world journey. Her fate remains a mystery.

OPPOSITE: Marilyn Monroe's Happy Birthday Mr. President dress, Charles Lindbergh's flight suit

MAY 22

1999

The graduating class of Columbine High School in Colorado wore caps and gowns in the school colors of blue and gold for a bittersweet ceremony held just one month after thirteen students and teachers were killed in a campus massacre. Academic regalia has its roots in menswear of the twelfth century, when the first English universities were founded, and it was retained for daily use by scholars and students. But it wasn't until the 1890s that it caught on in America, where it has always been reserved for commencement and other ceremonial events.

MAY 23

1917

When notorious bank robbers Bonnie Parker and Clyde Barrow died in a hail of bullets in a police ambush while driving their stolen getaway car near Sailes, Louisiana, Bonnie was wearing a blue knit cloche hat adorned with plastic sequins, and Clyde a tan fedora with a brown hatband.

MAY 24

1567

Privy Councilor Svante Sture and his sons, Nils and Erik, were murdered by King Erik XIV at Uppsala Castle in Sweden, along with two other men the monarch suspected of conspiring against him. In a fit of paranoia, the mad king attacked Nils with a dagger, leaving him and the others to be finished off by palace guards. Svante's widow put their bloodstained garments into an iron strongbox with eight locks, which she placed in the family chapel in Uppsala Cathedral, above the crypt where the men were buried. In the early 1970s, the clothes were removed and conserved for display in the Cathedral Museum.

All three costumes consist of doublets and voluminous breeches called *pluderhose*, from the German verb *pludern*, meaning "to puff." The baggy outer breeches of wool and silk had fitted inner breeches of chamois leather. The codpiece—originally a functional way of keeping a detached pair of leggings fastened—was, by this time, purely decorative, although it sometimes served as a pocket. Under their doublets, the men wore linen shirts decorated with embroidery, now extravagantly bloodstained.

OPPOSITE: Amelia Earhart's flight suit

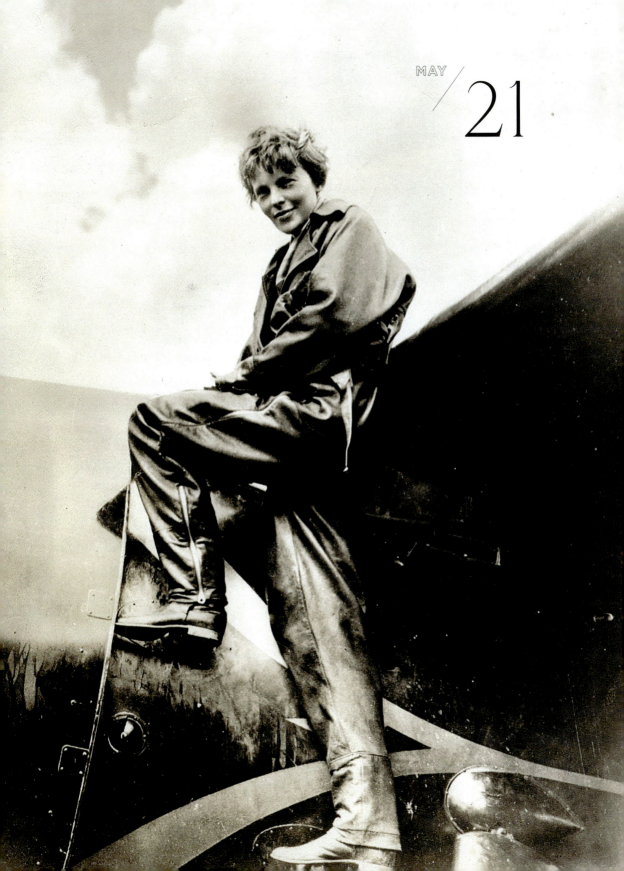

Nils Sture's chamois leather doublet was once painted black, with twenty silver buttons down the front. It has been pierced ten times by a sharp, pointed weapon; five of those blows were to the heart. Erik's black velvet doublet is decorated with three kinds of braid—originally yellow in color—applied in a diagonal pattern. It must have been a favorite, for it shows evidence of alterations during his lifetime, to enlarge it. He wore it with a matching cloak and a thin belt in a portrait of circa 1565, now in Gripsholm Castle. The black velvet doublet worn by Svante is slightly older in cut than those of his sons, with shoulder wings. Only fragments remain of their black felt hats.

Iron is conducive to the preservation of textiles. Sealed iron coffins—popular in mid-nineteenth century America for hygienic reasons, among those who could afford them—have acted as time capsules, preserving both the bodies of the dead and the clothes they wore for burial. Studies of these grim artifacts have revealed valuable details about social customs, dress, nutrition, medicine, and funeral practices, allowing the dead to speak from beyond the grave.

MAY 25

1965

When he knocked out Sonny Liston in under two minutes in Lewiston, Maine, the former Cassius Clay wore a white terrycloth robe emblazoned in red with the Muslim name he had adopted the previous year: Muhammad Ali. It was his first fight under the name that has gone down in history as that of the greatest boxer of all time.

MAY 26

2017

WORN ON THIS DAY

Accompanying her husband to the G7 summit in Sicily, Melania Trump wore a $51,500 Dolce & Gabbana coat covered in multicolored silk flowers. It was the first time her wardrobe choices as First Lady made headlines for being out of touch, but hardly the last. In August of the same year, she was widely criticized for wearing snakeskin Manolo Blahnik stilettos to visit a Hurricane Harvey–flooded Houston. In October 2018, she toured Africa wearing pith helmets, white linen suits, fedoras, and other colonialist clichés. And in June 2018, she boarded a plane to visit a camp for detained migrant children in Texas wearing a $39 Zara jacket with the phrase "I REALLY DON'T CARE, DO U?" scrawled on the back. The resulting outrage spawned the hashtag #MelaniaAntoinette.

OPPOSITE: Clothing belonging to Erik Sture

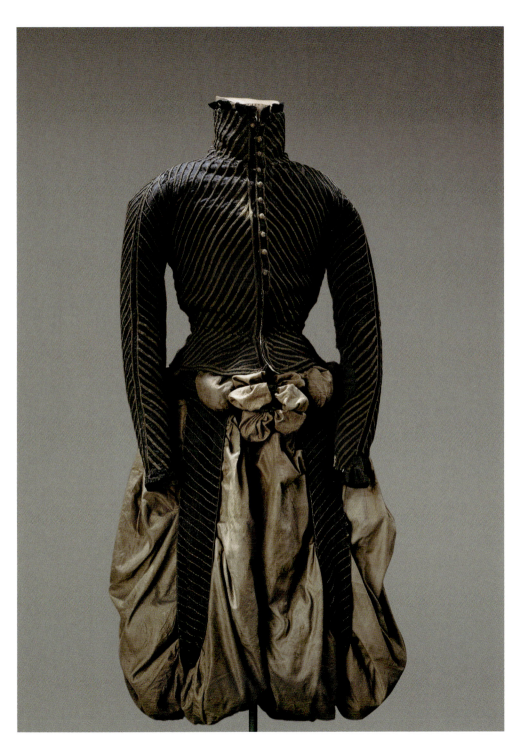

MAY 27

1860

At 3 a.m. on the Feast of Pentecost, General Giuseppe Garabaldi and his volunteer army of a thousand "Garabaldini" or "Redshirts"—named for the loose red shirts they wore in lieu of uniforms, which were too expensive for working-class patriots—launched an attack on Palermo, the capital of Sicily, with the aid of local rebels. They succeeded in driving out the occupying Neapolitan army, a key victory in the Risorgimento (or "Resurgence") that led to Italian unification. Women of fashion—including the French empress, Eugénie—adopted red "Garabaldi Shirts" in the general's honor. Decades later, Garabaldi's nationalist fervor was co-opted by the Fascist movement, and his Redshirts indirectly inspired Mussolini's Blackshirts and Hitler's Brownshirts.

MAY 28

1431

On trial for heresy in Rouen, France—then an English stronghold—Joan of Arc was caught wearing men's clothes in prison, after having been expressly forbidden to do so. According to one witness, it was a setup: the prison guards had taken her only feminine garments and she had nothing else to wear. But she had a history of wearing men's clothes into battle as well as in prison, because they were more convenient for fighting and for dressing herself, and a better defense against sexual molestation. Her short hairstyle, too, helped to convict her, despite her promise that "when I have done what God sent me to do I will resume wearing woman's dress." She was burned at the stake two days later.

WORN ON
THIS DAY

MAY 29

1953

At 11:30 a.m., Edmund Hillary and Tenzing Norgay became the first people to summit Mount Everest. Because previous expeditions to the Himalayas had found that footwear tended to absorb moisture and freeze solid, resulting in frostbitten feet, Hillary wore specially designed high-altitude boots made of glacé kid leather with nearly an inch of kapok fibers for insulation, a sweat-resistant liner, and soles made from a new type of lightweight microcellular rub-

ABOVE: Iron
slave collar

ber; it took thirty-five British firms to manufacture just one pair. Norgay wore traditional Sherpa reindeer-hide boots with canvas covers.

MAY 30

1894

On a perfect spring day, the stylish and eccentric Comte Robert de Montesquiou hosted a lavish garden party at his new house in Versailles, attended by Marcel Proust, Sarah Bernhardt, and the Comtesse Greffulhe, who "was delightfully attired in a pink lilac silk dress printed all over with orchids and covered in silk chiffon of the same shade," Proust wrote in his unsigned account of the party in *Le Gaulois*. "Her hat was in bloom with orchids surrounded by lilac gauze." The Charles Frederick Worth gown survives in the collection of the Musée Galliera.

MAY 31

1862

After the capture of New Orleans by Union troops, Captain S. Tyler Read of the Third Massachusetts Cavalry was ordered to seize arms from the plantations surrounding the city. Having heard that there were still some slaves at one plantation, he asked to see them. The overseer showed Read and his soldiers to a small outbuilding with a padlock on the door. The only windows were small and near the roof, and they were closed. "Captain Read entered first, and I followed," his sergeant told James Kendall Ewer, who wrote a history of the regiment. "But we withdrew immediately, as the stench was too strong for our nostrils.... There, crouched down in the darkness and filth, we found three female human beings, confined for the crime of trying to make their escape from slavery."

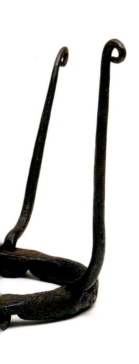

One woman—"whose skin was almost as white as my own"—wore an iron collar with three foot-long prongs riveted around her neck. "The ring had worn large sores upon her neck," the sergeant remembered. "I felt at that time as though I would like to have that overseer turned over to my tender mercies for about five minutes." Read ordered the overseer to open the windows while he and his men continued on their arms-collecting mission. When they finished, they retrieved the prisoners and took them back to their camp, where they removed the collar. General Benjamin Franklin Butler immediately gave the women their freedom. They had been locked up for thirteen weeks.

JUNE

1	2	3	4	5	6	7
Zoot suit worn by Malcolm X to avoid the draft **1943**	Queen Elizabeth II's coronation dress **1953**	Wallis Simpson's wedding gown **1937**	"Golden Slave" costume worn by Vaslav Nijinsky **1910**	Racing silks worn by Johnny Longden **1943**	An American Soldier's disfigured D-Day helmet **1944**	Jubilee Cope made for the Bishop of London **1977**

8	9	10	11	12	13	14
Coronation gown of Empress Elisabeth **1867**	Zoot suits worn in Los Angeles riots **1943**	Eliza Hussey Goodwin's century-old bridal shoes **1862**	Elizabeth Taylor's short miniskirt **1969**	Straitjacket escaped by Harry Houdini **1923**	Jewish refugee Lilly Joseph's celebratory gown **1939**	Fidel Castro's patriotic *guayabera* **1994**

15	16	17	18	19	20	21
From the ballroom to the battlefield **1815**	Thermal suit worn by Valentina Tereshkova **1963**	Napoleon's hooded Waterloo cloak **1815**	Cuirass worn during the Battle of Waterloo **1815**	Dior dress worn by Princess Margaret **1952**	*Bonnet rouge* worn by King Louis XVI **1792**	Suzanne Lenglen's tennis court chic **1926**

22	23	24	25	26	27	28
Queen Victoria dressed for her Diamond Jubilee **1897**	Elsa Schiaparelli's Eiffel Tower gown **1939**	Paul Poiret's "1002nd Night" costumes **1911**	Sir John Throckmorton's farm-to-table wool coat **1811**	Elaine Stritch's hazardous halter top **1951**	Clothes worn by Hyrum Smith when he was killed **1884**	Smocked dress worn by Shirley Temple **1938**

29	30					
"Revenge Dress" worn by Princess Diana **1994**	Elizabeth Leyman's debutante dress **1927**					

FROM ZOOT SUITS TO DEBUTANTE DRESSES

06 / 01

Determined to avoid military service, eighteen-year-old Harlem hustler Malcolm Little—later known as Malcolm X—arrived for his army induction appointment at New York's Local Draft Board #59 "costumed like an actor," he recalled in his autobiography. He wore one of his prized zoot suits, the flamboyantly broad-shouldered, high-waisted, and wide-legged suits favored by young, urban African American and Latino men. "With my wild zoot suit, I wore the yellow knob-toe shoes, and I frizzled my hair up into a reddish bush of conk." He greeted the white soldier at the receptionist desk: "Crazy-o, daddy-o, get me moving. I can't wait to get in that brown." Shortly thereafter, he wrote, "a 4-F card came to me in the mail, and I never heard from the Army anymore."

JUNE 2

1953

The second Elizabethan age began with the coronation of Queen Elizabeth II. It was the first coronation of a female British monarch since Queen Victoria in 1838, and there was no immediate precedent for what the sovereign should wear. The coronation would be televised, so the queen's attire had to be both timelessly regal and camera-ready.

For a solution, the twenty-six-year-old Elizabeth turned to British designer Norman Hartnell, who had made her wedding dress; she requested a similar silhouette for her coronation gown, with a sweetheart neckline and a full skirt. White satin—patriotically woven by Warner & Sons in Essex from fibers produced at an English silk farm in Kent—served as a blank canvas for emblematic embellishments. The gown was almost entirely covered in seed pearls, crystals, and embroideries of gold, silver, and silk threads depicting symbols of the realm: English roses, Scottish thistles,

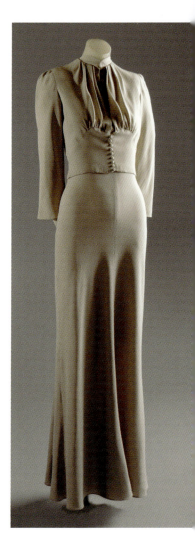

OPPOSITE, ABOVE:
Queen Elizabeth II's
coronation gown,
Wallis Simpson's
wedding dress

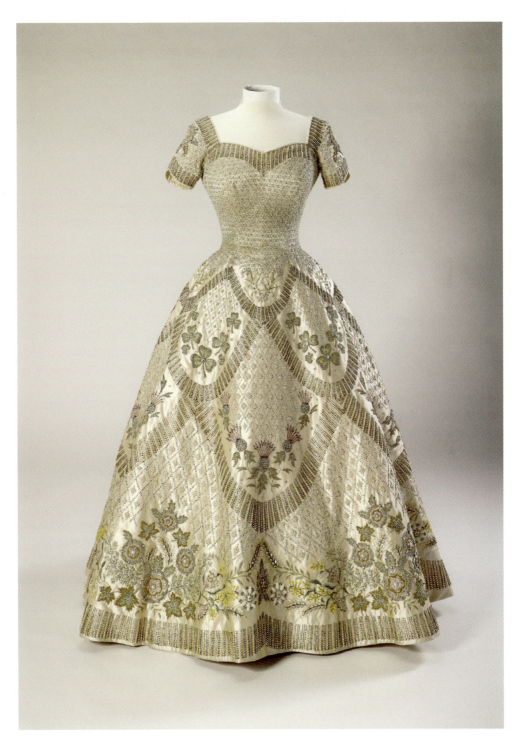

JUNE / O2

Welsh leeks, Irish shamrocks, Australian wattles, Canadian maple leaves, New Zealand ferns, South African protea, Indian lotus flowers, and Pakistani wheat, cotton, and jute. For good luck, Hartnell secretly added a four-leaf clover, positioned where the queen's left hand would rest on it during the ceremony. The gown took eight months to create; it was delivered just three days before the ceremony.

Cecil Beaton, who witnessed the ceremony and photographed the queen in her robes afterward, perceived how skillfully she turned the gown's physical and metaphorical stiffness to her advantage. "Her pink hands are folded meekly on the elaborate grandeur of her encrusted skirt; she is still a young girl with a demeanor of simplicity and humility," he recorded in his diary. "As she walks she allows her heavy skirt to swing backwards and forwards in a beautiful rhythmic effect. This girlish figure has enormous dignity; she belongs in this scene of almost Byzantine magnificence." In his autobiography, Hartnell said he'd designed it with "altar clothes and sacred vestments" in mind.

Like a wedding gown, a coronation gown may seem like a one-time-only outfit, too formal and too laden with symbolism for any other occasion. But, whether out of a desire to show it off or a lingering sense of wartime thrift, the newly minted queen wore the gown no fewer than seven times. She donned it for post-coronation receptions at Buckingham Palace and Holyrood House, her Scottish seat. Over the next four years, it traveled with her to Australia, New Zealand, Ceylon, and Canada, where she wore it to address the parliaments of those Commonwealth countries. As the joke goes, what does the queen do with her old clothes? She wears them.

JUNE 3

1937

Wallis Simpson wore this gown for her wedding to the former King Edward VIII. He had abdicated the British throne to marry her, an American divorcée, famously declaring: "I have found it impossible to carry the heavy burden of responsibility and to discharge my duties as king as I would wish to do without the help and support of the woman I love." The abdication crisis unexpectedly put his brother on the throne as George VI —and, later, George VI's daughter, Queen Elizabeth II.

"I'm not a beautiful woman," Simpson once said. "I'm nothing to look

at, so the only thing I can do is dress better than anyone else." Although she wore clothes by a who's-who of couturiers, including Elsa Schiaparelli, Hubert de Givenchy, and Madame Grès, legendary *Vogue* editor Diana Vreeland testified that "Mainbocher was responsible for the Duchess's wonderful simplicity and dash." It was he who made her trousseau and wedding ensemble: a simple, floor-length gown and matching long-sleeved jacket of silk crepe. The cornflower color was chosen to match her eyes. Mainbocher called it "Wallis blue." The dye has faded over time.

Modest without being prudish, the dress epitomized the duchess's understated elegance and struck a chord with women entranced by the "greatest love story of all time." Cheap knockoffs of "The Wally" went on sale in New York department stores within days, in a variety of colors and materials. From then on, the Duke and Duchess of Windsor would reign over fashion as the best-dressed couple in the world.

JUNE 4

1910

At the world premiere of the Ballets Russes' *Scheherazade* in Paris, Vaslav Nijinsky danced the role of the Golden Slave. (See page vi.) In the ballet—inspired by the opening tale of *The Thousand and One Nights*—a Persian king takes a hunting trip and returns to find the members of his harem engaged in an orgy, with his favorite wife in the Golden Slave's arms. (He slaughters everyone.)

Audiences were both scandalized and seduced by Leon Bakst's revealing, androgynous costumes: diaphanous trousers, turbans, tunics, sashes, bandeau tops, and nude (as well as nude-look) torsos for both sexes. Bakst was known for using "barbaric" colors like bright green and hot pink. Nijinsky, however, was entirely gold from head to toe, even wearing gold body paint. His gold harem pants were attached to a jeweled bandeau top by ropes of pearls; he also wore pearl earrings. With his gleaming turban and bulbous Turkish trousers, he resembled a solid-gold phallus.

In an art form long dominated by the female ballerina, Nijinsky's performance made the male dancer exciting and relevant again. He was not just a passive partner, but a virtuoso in his own right. Bakst's exotic, erotic costumes allowed a degree of movement unprecedented in ballet. "Nothing like Nijinsky's lithe and sensuous dancing had been seen before," Sonia Keppel testified in her memoir *Edwardian Daughter*.

Keppel recalled that "many of those who saw [*Scheherazade*] were powerfully affected by it, and some of the most unlikely people suddenly saw themselves as pagan gods and enchantresses"—a fantasy that spilled over into dress and interior décor. The Ballets Russes' impact on fashion was enduring. In 1976, Yves Saint Laurent showed a "Ballets Russes" collection, reviving extravagant Orientalism in fashion.

JUNE 5

1943

The racing colors or "silks" jockey Johnny Longden wore when he rode Count Fleet to capture the Triple Crown at the Belmont Stakes—only the sixth time a horse had won the Kentucky Derby, the Preakness Stakes, and the Belmont Stakes in the same year—were later auctioned for $50,000 in war bonds. The jockey's costume of brimmed cap, close-fitting silk jacket, breeches, and knee-high boots has changed little since the eighteenth century.

JUNE 6

1944

Lieutenant Clinton Gardner had a narrow escape after he was struck by shrapnel on Omaha Beach during the D-Day invasion. "You're lucky, Lieutenant," said the medic who finally got him to a field hospital, twenty-three hours after he had been hit. "That mortar fragment just ploughed through your scalp, right down to your skull, but the bone isn't fractured at all, just scarred." The medic administered a local anesthetic, all the morphine having been lost in the landing. "While the captain holds my head still, two majors twist and jerk my helmet for several minutes before it finally unhooks from my scalp," Gardner remembered in his memoir, *D-Day and Beyond*. "Not a comfortable process, but very little pain. They show me the helmet. Hole's as big as I thought it was." As sniper bullets whizzed through the tent overhead, the doctors dressed his wound. An hour later, Gardner was on his way back to England.

In a letter to his family dated June 13, 1944, written from a New

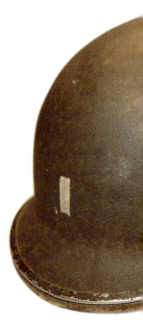

WORN ON
THIS DAY

ABOVE:
Damaged helmet
of Lieutenant
Clinton Gardner

York hospital on American Red Cross letterhead, Gardner joked: "No doubt the return address is raising some question in your minds as to my health. Don't worry: I have all arms & legs, fingers & toes & feel simply fine." He added: "I did, however, get hit, not at all seriously, in the head." He facetiously credited his thick skull for leaving him with "only a small scalp wound."

Gardner recovered quickly enough to earn a second Purple Heart in the Battle of the Bulge later that year. He donated his damaged D-Day helmet to his alma mater, Dartmouth University.

JUNE 7

1977

At the thanksgiving service held at St. Paul's Cathedral in honor of Queen Elizabeth II's Silver Jubilee, the twenty-fifth anniversary of her accession, the Bishop of London wore a cope designed by Beryl Dean, MBE, one of the foremost textile artists of the twentieth-century, who died in 2001. She and her needlework students at the Stanhope Institute stitched it over two years. It continues to be worn in services at St. Paul's, including the thanksgiving service for the Queen's Diamond Jubilee in 2012.

The cope depicts seventy-six churches of the Diocese of London with the cathedral itself at the center of the composition. Each individual church is embroidered in gold and silk thread on a silk organza ground, attached to a base of cream wool. A matching mitre—the peaked headdress worn by bishops—is embroidered with the façade of Westminster Abbey and, on the back, a ship, symbolizing the Church.

Ecclesiastical vestments are based on the everyday dress of the early Christian church and have changed little in the past twelve hundred years. The cope evolved from the byrrus, a semicircular hooded cape of ancient Roman origin. Many copes have a vestigial hood in the form of a shield-shaped panel at the back. By the medieval period, the cope was the most heavily decorated of all vestments, as the congregation spent most of the service staring at the back of it. Many early copes were embroidered with Biblical scenes; the Jubilee Cope encourages contemplation of London's long and distinguished spiritual, architectural, and artistic heritage.

JUNE 8

1867

For her coronation as Queen of Hungary at the Church of St. Matthew in Buda Castle, Empress Elisabeth of Austria wore a gown designed by Paris couturier Charles Frederick Worth but inspired by Hungarian national dress. The white and silver brocade gown with short, lace-edged sleeves was trimmed with oversized bows and strings of pearls across the breast, echoing the braid of Hussar uniforms. A black velvet over-bodice and a short lace apron completed the homage. "Sisi"—who had worn the Hungarian national colors of red, white, and green on a state visit to Budapest a decade earlier—used her thoughtful wardrobe choices and charismatic public image to smooth the divisions between the Hungarians and their Viennese overlords; as queen, she would prove to be a staunch champion of Hungarian liberation. Franz Liszt, who composed the mass for the coronation ceremony, called her "a celestial vision." Unfortunately, the gown does not survive; the Empress donated it to the church to be made into religious vestments.

JUNE 9

1943

A months-long period of civil unrest culminated in the Zoot Suit Riots, a week of violent clashes on the streets of Los Angeles between uniformed white sailors and soldiers awaiting deployment to the battlefields of World War II and gangs of Mexican American "zoot suiters," identifiable by their flamboyant knee-length jackets, baggy "ankle choker pants," broad-brimmed hats, and long, dangling watch chains.

The zoot suit was the most visible target of a larger conflict between whites and immigrants, soldiers and civilians, buzz cuts and slicked-backed ducktails. At a time when the War Production Board regulated the use of fabric—banning double-breasted jackets and vests in favor of single-breasted, two-piece "Victory Suits" with narrow trousers and no cuffs—the zoot suit was perceived as being rebellious, selfish, and unpatriotic.

OPPOSITE:
Jubilee cope, rioters
wearing zoot suits

Beginning on June 3, many zoot suiters were forcibly disrobed on the streets; others were beaten with clubs, belts, and bats. The nightly riots came to an end on June 8, when military personnel were barred from leaving their barracks. On June 9, the Los Angeles City Council unanimously passed a resolution banning zoot suits, as scores of young Mexican American men rounded up by police—many arrested for no other crime than their fashion choices—made their way to court.

JUNE 10

1862

Eliza Hussey Goodwin wore pink and white satin shoes when she married Charles Frothingham in Boston. They certainly counted as the bride's "something old," as well as her "something borrowed." Their original owner, Prudence Marion Jenkins, had worn them for her own wedding to Dr. John Chace in Providence, Rhode Island, nearly a century earlier, on December 12, 1778.

JUNE 11

1969

Richard Burton noted in his diary that his wife, Elizabeth Taylor, "looked very exciting in the shortest miniskirt. The slightest inclination from the vertical and her entire bum was revealed to the admiring gaze." The miniskirt, first sold in London designer Mary Quant's boutique Bazaar in 1958, graduated from clubs to college campuses and office buildings, getting shorter and shorter along the way. By 1967, one designer quipped to *Time*: "There is the micromini, the micro-micro, the 'Oh, My God' and the 'Hello, Officer.'"

JUNE 12

1923

Harry Houdini hung upside down from a crane forty feet above the ground in New York City wearing a straitjacket, from which he escaped in two minutes, thirty-seven seconds. Invented in the late 1700s as a humane alternative to chains for inmates of insane asylums, straitjackets are today primarily used in prisons, which house ten times more mentally ill people than state psychiatric hospitals.

OPPOSITE:
Eliza Hussey
Goodwin's century-
old wedding shoes

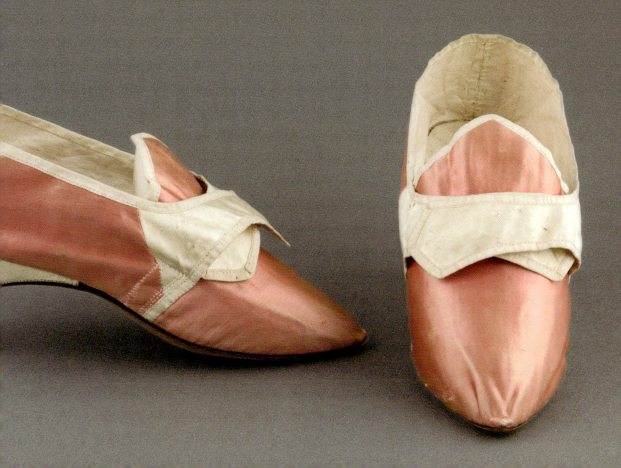

JUNE 13

1939

Lilly Joseph had an evening gown made for her voyage aboard the Hamburg-Amerika luxury liner the M.S. *St. Louis,* sailing for Havana, Cuba. She wore the floor-length sheer floral gown and its purple satin underdress only once, for the celebration held the evening the nine hundred passengers—most of them Jewish refugees—learned that they did not have to return to Germany.

But the celebration was premature. Cuban authorities denied entry to all but 29 of the 937 passengers. They were subsequently denied entry to the United States and Canada. While the passengers eventually found refuge in various European countries, about a quarter are estimated to have died in Nazi concentration camps as Hitler invaded Belgium, France, and the Netherlands. Lilly and her family were among the lucky ones: the *St. Louis* deposited them in England, where they obtained US visas, emigrating to New York in 1940.

JUNE 14

1994

At the 4th Ibero-American Summit of Heads of State and Government in Cartagena, Colombia, Cuban leader Fidel Castro swapped his customary olive green uniform for a white *guayabera*—a loose, lightweight shirt characterized by vertical rows of pleats, worn untucked. Controversially casual in the mid-twentieth century, *guayaberas* are now a proud symbol of Cuban identity across the political spectrum.

JUNE 15

WORN ON
THIS DAY

1815

Three days before the battle of Waterloo, the Duchess of Richmond—wife of a high-ranking British Army officer—threw a ball in Brussels. Around 11 p.m., the guest of honor, the Duke of Wellington, received word that the French forces had unexpectedly advanced to Quatre-Bras, less than fifty miles away, ruining the party. In his diary, Sergeant Thomas Morris recorded that "officers of some brigades appeared on the battlefield on the 16th in their ball dress," having "had no time to change." Like Nero fiddling as Rome burned, the Duchess of Richmond's ball is a metaphor for frivolity in the face of disaster.

OPPOSITE:
Lilly Joseph's
dress, Napoleon's
Waterloo cloak

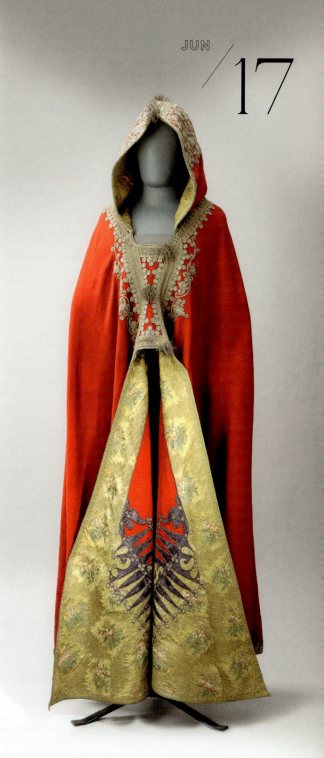

JUNE 16

1963

Russian cosmonaut Valentina Tereshkova became the first woman to travel to space on the *Vostok 6*. A textile worker before volunteering for the space program, she was also the first to wear a mission emblem patch on her blue thermal suit: a dove with an olive branch clutched in its beak against a background of sunrays. Tereshkova's call sign was "Seagull," which the suit's designers may have conflated with the symbol of peace, preservation, and renewal from the Biblical story of another trailblazing ship: Noah's Ark.

JUNE 17

1815

Napoleon wore a magnificent hooded cloak on the eve of the battle of Waterloo in Belgium, the site of his final defeat by the British Army. Although likely made in France, the red felt garment lined with flowered gold silk brocade is based on a burnous, an Algerian Berber garment. (Napoleon never invaded Algeria, but it had been on his to-do list since at least 1808.) The cloak was seized from the Emperor's baggage train during his retreat and is now in the British Royal Collection.

JUNE 18

1815

French *caribinier-à-cheval* (cavalry rifleman) Antoine Fauveau, twenty-three, wore a breastplate of brass-covered steel, called a cuirass, in the battle of Waterloo, where he lost his life. A British soldier who fought at Waterloo, Captain Gronow, testified: "I never shall forget the strange noise our bullets made against the breastplates of [the] Cuirassiers, six or seven thousand in number, who attacked us with great fury. I can only compare it, with a somewhat homely simile, to the noise of a violent hail-storm beating upon panes of glass." But their cuirasses were no match for British cannons.

After the clamor, British artillery officer Alexander Mercer described the eerie hush that fell over the battlefield at the end of the day: "It was a poignant sensation, standing in the nocturnal silence and gazing on the battlefield, which during the day had been a theatre of fighting and now was so calm and silent, the actors spread on the bloodied soil, their pallid faces

turned to the cold rays of the moon which reflected off the helmets and breastplates!"

JUNE 19

1952

Princess Margaret wore Christian Dior's "Rose Pompon" dress to Royal Ascot. Instead of the pink rosebud print shown on the runway, she had hers made in cream-colored chiffon, and paired it with a wide-brimmed hat. Much more than her older sister, Elizabeth—who tended to dress conservatively and patronize English designers—Margaret enjoyed indulging in the latest French fashions, including this romantic "New Look" dress.

JUNE 20

1792

On the third anniversary of the Tennis Court Oath—one of the precipitating events of the French Revolution—a peaceful (though heavily armed) crowd marched on the Château de Tuileries in Paris. There, they made King Louis XVI don a *bonnet rouge*, a soft red cap resembling those given to freed slaves in ancient Greece, symbolizing *liberté*. At the same time, they forced Queen Marie-Antoinette to put a tricolor cockade in her hair. Blue and red (representing the city of Paris) and white (representing the Bourbon monarchy) were adopted as the colors of the Revolution—and, later, the French flag.

JUNE 21

1926

To celebrate the fiftieth anniversary of the Wimbledon Championships, King George V and Queen Mary presented commemorative gold medals to thirty-four past champions, including French player Suzanne Lenglen. Lenglen had lost only one match between 1919 and 1926, winning a total of six Wimbledon championships as well as two Olympic gold medals.

Lenglen's winning streak made tennis history, but it also altered the course of fashion history. At a time when female players still wore ankle-length gored skirts, corsets, and high-necked, long-sleeved blouses, Lenglen had made her first Wimbledon appearance in 1919 in a flimsy dress with short sleeves and a calf-length pleated skirt, her white silk stockings rolled

above her knees and a floppy white hat on her head. She didn't wear a corset. She didn't even wear a petticoat.

Though the press dubbed her outfit "indecent," it marked the beginning of the end of restrictive clothing for sportswomen. Eventually, Lenglen would replace the short sleeves with sleeveless dresses, and the linen hat with a more practical and much-copied headband, dubbed "the Lenglen Bandeau." She curtsied to Queen Mary dressed for her doubles match in a short pleated skirt, sleeveless blouse, rubber-soled "Lenglen shoes" of white doeskin, and cropped hair anchored by her trademark bandeau—a sharp contrast to the queen's high-necked, long-sleeved, ankle-length gown, trimmed with lace and worn with a feathered toque, scarf, purse, gloves, and heels. It was the young athlete, not the venerable queen, who was the fashion influencer.

When she wasn't playing tennis, Lenglen wore fur coats and couture gowns by Jean Patou, who opened a dedicated sportswear shop, Coin des Sports, in 1925. (They were introduced by Patou's brother-in-law, Raymond Barbas, a member of the French national tennis team.) At the height of her career, Lenglen was the most famous female athlete in the world, a mainstay of the sports pages, the gossip columns, and fashion magazines alike.

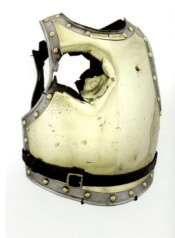

JUNE 22

1897

Queen Victoria celebrated her Diamond Jubilee—the sixtieth year of her reign—with a service of thanksgiving at St. Paul's Cathedral. It was a rare public appearance for the seventy-eight-year-old queen, who called it "a day never to be forgotten." Though she still wore mourning for her husband, who had been dead thirty-five years, the so-called Widow of Windsor took great care with her appearance. "I wore a dress of black silk, trimmed with panels of grey satin veiled with black net and steel embroideries, and some black lace, my lovely diamond chain . . . round my neck," she remembered. "My bonnet was trimmed with creamy white flowers, and white aigrette and some black lace." Mourning etiquette prohibited widows from wearing colored clothing or jewelry, though most only observed it for a year or two.

OPPOSITE, ABOVE:
Suzanne Lenglen's
Wimbledon attire,
Antoine Faveau's
damaged cuirass

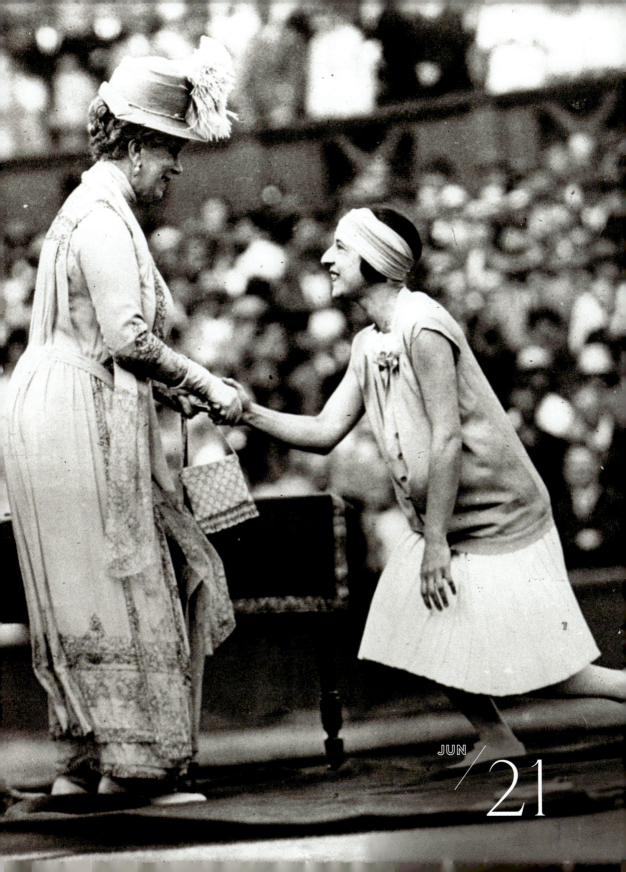

JUNE 23

1939

Italian-born, Paris-based designer Elsa Schiaparelli wore a gown of her own design to a charity ball celebrating the Eiffel Tower's fiftieth anniversary, held in the restaurant on the tower's second platform. One of the most inventive couturières in history, Schiaparelli is best remembered for her collaborations with Surrealist artists such as Salvador Dali and Jean Cocteau and her *trompe l'oeil* knitting and embroidery motifs. While her contemporary and rival Coco Chanel dismissed her as "that Italian artist who makes clothes," Christian Dior was more complimentary. "With her great talent, Mme Schiaparelli knew how to push the frontiers of elegance until it bordered on the bizarre," he wrote in his autobiography, adding: "Perhaps, from 1938 onwards, she even went a little too far."

Her playful gown certainly pushed the boundaries of *haute couture*. "Schiap" paired it with a matching short-sleeved jacket and a towering hat in the shape of the Eiffel Tower, made of black ostrich feathers. The whimsical fabric depicting swallows bearing letters sealed with red sealing wax was designed by the husband-and-wife team of Jean Peltier and Suzanne Janin for Ducharne, who provided many textiles exclusively to Schiaparelli.

The designer also provided four candy-colored bustled gowns and ostrich feather hats to the four young socialites who opened the ball with a quadrille. The bustles were both a throwback to 1889, the year of the Tower's debut, and a preview of the form-fitting silhouette with imaginatively gathered skirts that would dominate Schiaparelli's next collection. As *Vogue* had declared in March: "Paris has suddenly gone completely innocent, quaint, modest, girlish."

The summer of 1939 was notable for its extravagant high society balls, the last of their kind before World War II. *Vogue* fashion editor Bettina Ballard called that year's social season "the gayest I had yet seen. There were garden parties or big cocktail parties every day and balls or some sort of spectacle every night for all of June and well into July." Eight weeks after this party, France and Britain declared war on Germany, bringing the "frenzied frivolity" Ballard described to an abrupt end.

WORN ON
THIS DAY

OPPOSITE:
Elsa Schiaparelli's Eiffel
Tower anniversary dress

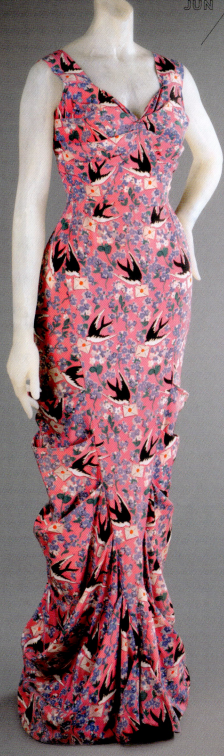

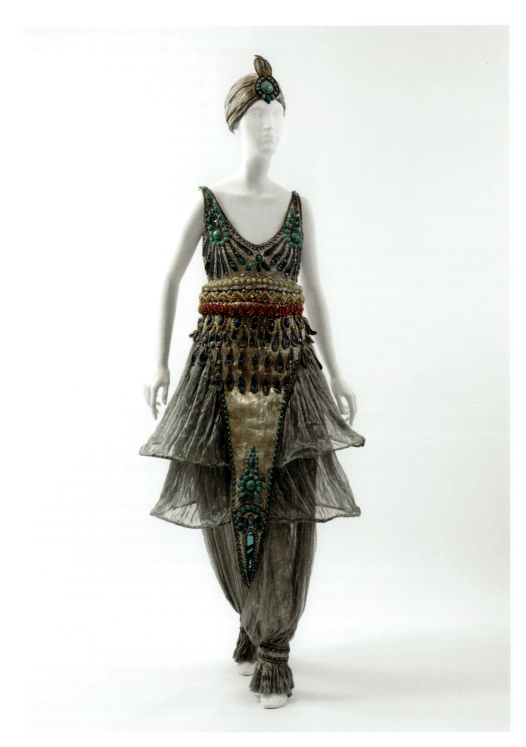

1911

Undoubtedly inspired by the exotic sets and costumes of the Ballets Russes' production of *Scheherazade* the previous year (see page 127), couturier Paul Poiret threw a lavish "1,002nd Night" masquerade party for three hundred guests at his Paris home. He created several of the costumes worn at the event, including a silk chiffon turban adorned with a turquoise cabochon and egret feathers for his wife, Denise, and an exquisitely embellished ensemble with daring diaphanous trousers, worn by an unknown guest.

The event launched Poiret's conical "lampshade" or "minaret" tunic, with a stiffened hem. This tunic—paired with a skirt rather than trousers—would soon become a staple of Poiret's couture collections. By April 1914, *Vogue* called it "a safe wager that every woman in the land possessed at least one" of these tunics.

Dressed as a pasha with Denise as his concubine, Poiret used the party (and many others like it) as a promotional device to advertise his avant-garde fashions in a setting that heightened the glamor and drama of the Orientalist aesthetic.

1811

As the Industrial Revolution began to transform England's economy and landscape, making it possible to produce clothing and other goods with greater speed and less expense than ever before, Sir John Throckmorton bet Newbury wool mill owner John Coxeter a thousand guineas that he couldn't make a coat in a single day. Confident in the abilities of his shearers, spinners, and weavers, Coxeter accepted the challenge. At sunrise on June 25, Throckmorton delivered two sheep to Coxeter. At sunset, he wore the finished coat to dinner, having lost his bet but gained the ultimate farm-to-table fashion statement.

1951

Actress Elaine Stritch was arrested in Central Park and fined $1 for wearing a midriff-baring halter top and shorts. Magistrate Emilio Junes told her:

OPPOSITE: "1002nd Night" costume

"A beautiful girl like you could cause a small riot and cause a large crowd to collect by removing your shirt." Stritch retorted: "Well, I was there all day and nothing happened."

JUNE 27

1884

Hyrum Smith was killed in Carthage, Illinois, where he and his younger brother Joseph—the founder and leader of the Church of Jesus Christ of Latter-Day Saints—were behind bars awaiting trial for destroying the press of a newspaper critical of Smith and his followers. A mob of two hundred armed men stormed the jail, their faces blackened with wet gunpowder. Hyrum was shot in the face, through the cell door; as he fell, another bullet struck him in the back. Joseph fell from a second-story window after being shot several times. Five men were arrested for their murders but later acquitted. Far from destroying the nascent church, their deaths turned the Smith brothers into religious martyrs. After their burials, the majority of the Mormons left Illinois and followed Joseph's successor, Brigham Young, to Utah.

The linen shirt, shawl-collar vest, and fall-front trousers Hyrum was wearing at the time of his death were preserved by his heirs, riddled with bullet holes and bloodstains. According to a fellow prisoner, Willard Richards, "the day was warm, and no one had his coat on but myself." The blood from Hyrum's face soaked his shirt and the right front of the vest, where part of the fabric has been cut away. The bullet that struck Hyrum in the back "lodged against his watch, which was in his right vest pocket, completely pulverizing the crystal and face, tearing off the hands and mashing the whole body of the watch," Richards wrote. Hyrum's trousers reveal more bullet holes in each leg, although no traces of blood remain there. His clothes are now in the Church History Museum in Salt Lake City, a memorial to his martyrdom.

WORN ON THIS DAY

JUNE 28

1938

During a promotional road trip across America, ten-year-old Shirley Temple wore a smocked silk dress with a Peter Pan collar on a visit to FBI headquarters in Washington, DC, where FBI director J. Edgar Hoover gave her a personal tour of the crime laboratory. It was the beginning of an unlikely life-

OPPOSITE:
Sir John Throckmorton's made-in-a-day coat, Hyrum Smith's attire

144

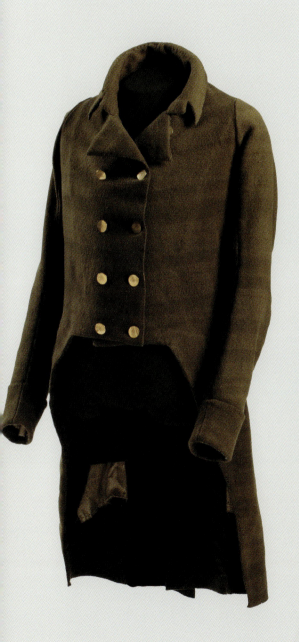

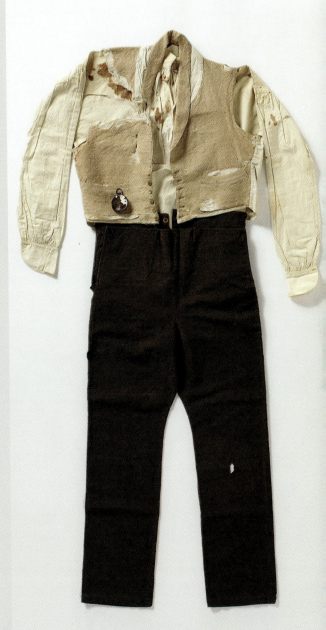

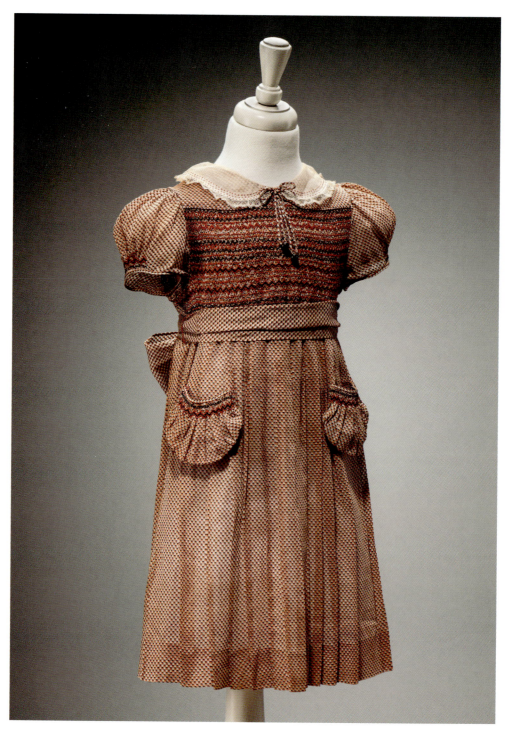

long friendship between America's sweetheart and America's number-one lawman. Years later, Hoover gave Temple a tear gas pen and performed a background check on her fiancé.

JUNE 29

1994

On the evening Princess Diana's estranged husband, Prince Charles, admitted his infidelity in a televised interview, she attended a party at London's Serpentine Gallery. She had been planning to wear a borrowed Valentino. Instead, she chose a short, sexy, shoulder-baring little black dress by Greek designer Christina Stambolian that she had bought three years earlier but never had the nerve to wear. The tabloids dubbed it her "Revenge Dress," and it dominated the news the following morning, pushing Charles and his mistress, Camilla Parker Bowles, off the front pages.

JUNE 30

1927

Elizabeth Leyman wore a peach gown with blue streamers for her debutante ball, an evening garden party held at her parents' home in Cincinnati. Her sister, Grace, wore an identical gown in the opposite colors, which, unfortunately, has not survived.

The gowns were created by couturier Jeanne Lanvin, in a silhouette known as the *robe de style*. Although more indicative of the fashions of the early teens than the twenties, the *robe de style*'s romantic elegance proved to be timeless, enduring even as fashion dictated shorter skirts and simpler lines. Combining a modern sleeveless, uncorseted bodice and dropped waistline with an extravagant, old-fashioned, long skirt buoyed by small panniers and often heavily beaded, beribboned, or beruffled, the *robe de style* proved to be especially popular for formal events like debutante balls and court presentations, where it gave its wearer a regal presence. Lanvin continued to sell *robes de style* as late as 1939.

Other couture houses—notably Boué Soeurs—also produced *robes de style*, but, for many, the silhouette remained synonymous with Lanvin. As Christian Dior reminisced: "The name Lanvin for me was bound up with the memory of girls in *robes de style* whom I danced my first foxtrots, charlestons and shimmies with."

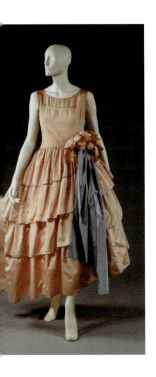

OPPOSITE, ABOVE:
Shirley Temple's dress, Elizabeth Leyman's debutante gown

FROM BRIDAL GOWNS TO DIVING SUITS

JULY

1	2	3	4	5	6	7
Frances Dodge's blue wedding dress	Costumes for the Devonshire House Ball	Jennie Wade's leather coin purse	Patriotic shorts from America's bicentennial	Bikini designed by Louis Réard	Anne Frank's wardrobe in hiding	A gown for the Blenheim Ball
1938	**1897**	**1863**	**1976**	**1946**	**1942**	**1939**
8	9	10	11	12	13	14
Poet Percy Bysshe Shelley's sailing clothes	First Lady Eva Perón's Dior ballgown	Lady Godiva's wild ride through Coventry	Duelling glasses worn by Alexander Hamilton	Jerkin worn by Hendrik Casimir I	Georgia O'Keeffe's vintage dress	Mismatched shoes worn by Olympian Jim Thorpe
1822	**1951**	**1040**	**1804**	**1640**	**1979**	**1912**
15	16	17	18	19	20	21
Olympic women take the plunge	Princess Alexandra's christening bodice	Women's Land Army uniforms on the march	Dom Pedro II's coronation *Traje Majestici*	Taking the leap in a parachute gown	Neil Armstrong's A7-L spacesuit	A suave Zouave uniform at Bull Run
1912	**1894**	**1915**	**1841**	**1947**	**1969**	**1861**
22	23	24	25	26	27	28
Beastly dress at the Marlborough House Ball	Sneaking to freedom in leather moccasins	Uncle Sam costume worn on the *Eastland*	The power of purple in the Roman Empire	"Cowboys" shirt that sparked a controversy	A ship-shaped headdress sets sail	Candidate Hillary Clinton's white pantsuit
1874	**1918**	**1915**	**306**	**1975**	**1778**	**2016**
29	30	31				
Princess Diana's wedding gown and shoes	Swapping shirts at the World Cup	A daring diver's undersea gear				
1981	**1966**	**1945**				

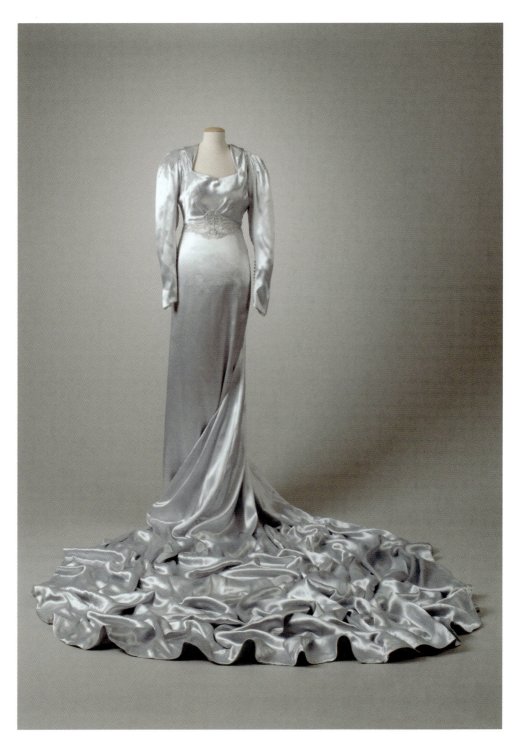

JULY / OI

07 / 01

— **1938** —

It wasn't just something blue. *Everything* was blue when automobile heiress Frances Dodge, twenty-three, married music magazine editor James B. Johnson in the drawing room of Meadow Brook Hall, her family's mansion near Rochester, Michigan.

It was a foregone conclusion that the wedding of "Detroit's No. 1 Glamour Girl" would "put another notch in that young woman's national reputation for glamour," the *Detroit Free Press* reported. After all, this was the same Frances Dodge who had carried black orchids with her silver debutante gown. The bridal party did not disappoint; they were a "rhapsody in blue" dressed in "every color and cadence of moonlight blue, from palest ciel to pale lapis lazuli."

The dresses were made by New York designer Peggy Hoyt, who milked the high-profile event for every last drop of publicity. The bride's gown was "inspired by the simplicity of ancient Grecian art"—apparently a reference to the acanthus leaf pattern of the seed pearl beading at the waistline. Much more than ancient Greece, however, it reflects the influence of Hollywood glamour on 1930s wedding fashions, with its thirteen-and-a-half-foot train and clinging fit created by bias cutting.

The bridesmaids were gowned in different shades of blue for an ombre effect. These "shimmering shafts of moonbeams and starlight" were "adroitly attuned to the hour of the ceremony," 8:30 p.m. Afterward, the nine hundred guests danced to a swing band under the stars.

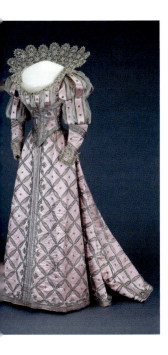

JULY 2

1897

In honor of Queen Victoria's Diamond Jubilee—the sixtieth anniversary of her ascension—the Duchess of Devonshire hosted a costume ball at her London home, Devonshire House. The seven hundred guests were instructed to come in allegorical or historical dress from before 1815.

"Rarely had the London social world been so stirred," Lady Randolph

OPPOSITE, ABOVE:
Frances Dodge's blue bridal gown, Princess Maud's masquerade costume

Churchill remembered. "For weeks not to say months beforehand it seemed the principal topic of conversation. The absorbing question was what characters were our friends and ourselves to represent?" Guests consulted old books, paintings, and engravings for inspiration. The men, who rarely got to wear anything but tailcoats, were even more excited about their costumes than the women, and paid just as dearly for them.

To bring their ideas to life, the guests turned to the most elite fashion designers of the day, including Charles Frederick Worth, Lucile, and the theatrical costumer Alias in Soho. The costumes had to be sufficiently impressive not just for the party, but for posterity: the society photographer Lafayette set up a tented studio in the garden to capture the costumes, which were eventually published in a commemorative album.

Although Queen Victoria herself did not attend, the Prince and Princes of Wales came as a Knight of Malta and Marguerite de Valois. Their daughter, Princess (later Queen) Maud of Norway, was lady-in-waiting to her mother in a pink Renaissance-style gown. The hostess was daringly bare-armed as Zenobia, Queen of Palmyra; her husband copied his costume from Titian's portrait of Emperor Charles V. Lady Tweedmouth, as Queen Elizabeth, brought a company of eight Yeomen of the Guard; the Princess of Pless, as the Queen of Sheba, was attended by an entourage in blackface. Churchill recorded that the Countess of Westmoreland, as "a charming Hebe, with an enormous eagle poised on her shoulder and a gold cup in her hand, made a perfect picture, but, alas! in one attitude only, which she vainly tried to preserve throughout the evening."

She was not the only guest to regret choosing an uncomfortable costume. Prince Alfred of Edinburgh wore a suit of armor; he had to remove his helmet to eat. As Joan of Arc, Lady Helena Gleichen borrowed a small suit of armor to wear over her tabard, but it was so heavy that she only wore the leg and arm pieces. "These last were agony as whenever I bent my arm they took pieces of flesh out," she remembered. Gleichen had three male attendants in full armor who carried her banner and helmet. "We made a very imposing cortege clattering up the marble stairs."

Many guests came as their own ancestors, copied from family portraits. Princess Victor of Hohenlohe-Langenburg dressed as an ancestress, "only discovering to her horror afterward that the lady was not at all respectable," her daughter revealed. The costumes were such well-kept secrets that some guests came in the same guise as others. Thus, there were the two Cleopatras and two Napoleons. "It was indeed a Waterloo for both of them," Churchill quipped.

OPPOSITE: Jennie Wade's coin purse, Fourth of July bicentennial shorts

JULY 3

1863

Seamstress Jennie Wade was kneading dough in her sister's kitchen in Gettysburg, Pennsylvania, making bread to distribute to the Union soldiers streaming into town, when she was struck in the back by a stray Confederate bullet, dying instantly. Of the more than seven thousand people killed in the Battle of Gettysburg—the bloodiest conflict of the Civil War—the twenty-year-old Wade was the only civilian. In her pocket was a small brown leather coin purse embossed with a paisley pattern.

JULY 4

1976

The bicentennial of the American Revolution was commemorated nationwide with fife-and-drum bands, Liberty Bells, and miles of red, white, and blue bunting. Parades, fireworks displays, tall ships festivals, and historical reenactments marked the year-long celebration of the two-hundredth anniversary of the Declaration of Independence. A fad for quasi-colonial clothing and a renewed interest in traditional handcrafts like quilting, spinning, and weaving grew out of equal parts excitement about the historic celebration and dissatisfaction with the economic malaise of the 1970s.

The stars and stripes bedecked a bewildering array of merchandise and wearable souvenirs. Richard Platz of Detroit, Michigan, wore a pair of patriotic cutoff denim shorts during the festivities. The print updates Revolutionary-era icons and slogans with a contemporary aesthetic for a crazy quilt of all-American style.

JULY 5

1946

At times, the language of fashion and the language of history are inextricably woven together. The bikini took its name from Bikini Atoll in Micronesia, where the United States tested the first atomic weapon on July 1, 1946—just days before the skimpy swimsuit made its public debut at a poolside press conference in Paris. Its designer, automotive engineer turned swimwear entrepreneur Louis Réard, felt that his new two-piece suit would be just as explosive as the bomb. But the fashion press suggested that it was

OPPOSITE: Louis Réard's bikini

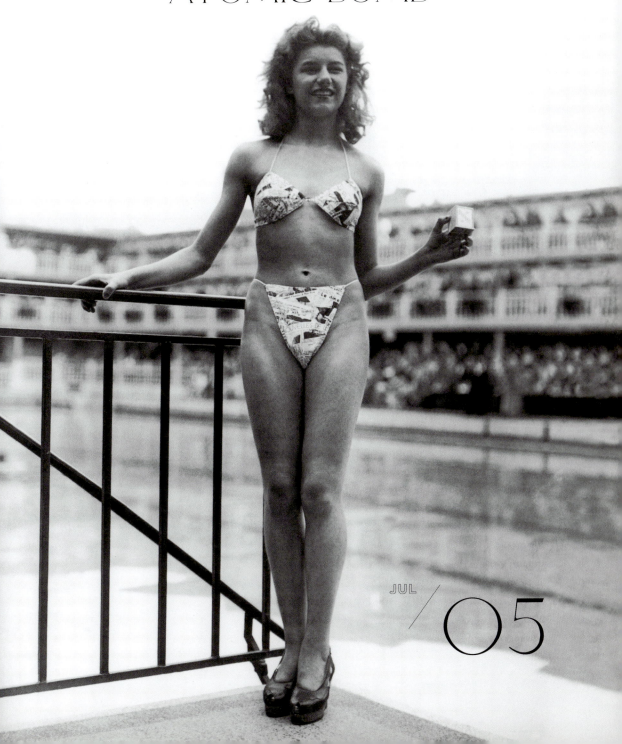

"THE MOST IMPORTANT
THING SINCE THE
ATOMIC BOMB"

JUL / 05

so named because the tiny triangles of fabric looked like scraps left over from a nuclear blast. A similar though slightly less revealing suit was marketed under the name "Atome" by designer Jacques Heim, but "bikini" is the one that stuck.

Because no respectable model would wear the bikini, Réard hired Micheline Bernardini, a showgirl at the Casino de Paris, where the dancers often wore even less. Although the bikini was not the first two-piece bathing suit, it was the first one to expose the belly button and the hips—a design Réard came up with after noticing women rolling up their suits at the sides to get a better tan. The suit was advertised as being small enough to pull through a wedding ring; to emphasize its diminutive size, Réard packaged it in a tiny box resembling a ring box, which Bernardini displayed for photographers. The bikini's newsprint pattern alluded to the headlines Réard expected the suit to make.

Diana Vreeland proclaimed the bikini "the most important thing since the atomic bomb," calling it "a swoonsuit that exposed everything about a girl except her mother's maiden name." But it took time for her enthusiasm to spread. The bikini was banned on many beaches; for several years it could only be seen in tony resorts on the French Riviera. Contestants who wore bikinis in the first Miss World beauty pageant in 1951 were disqualified. It wasn't until 1953, when nineteen-year-old Brigitte Bardot was photographed wearing one at the Cannes Film Festival, that the bikini went mainstream, although Americans continued to resist it until the early 1960s, perhaps swayed by the Catholic Church's subsequent boycott of Bardot's films. California swimsuit mogul Fred Cole dismissed the bikini as a suit for "diminutive Gallic women" with "short legs."

But the bikini crept into American pop culture through youth-oriented movies and music. In 1960, Brian Hyland immortalized the skimpy swimsuit in the novelty hit "Itsy Bitsy Teenie Weenie Yellow Polka-Dot Bikini." In 1965, the Beach Boys were still calling them "French bikinis" in "California Girls." Films like *Bikini Beach* (1964), *How to Stuff a Wild Bikini* (1965), and *The Ghost in the Invisible Bikini* (1966) capitalized on the titillating name though they rarely included bikinis that bared as much as Réard's.

Réard had a store on the Avenue de l'Opéra until his death in 1984. In 2017, his label was relaunched along with the original bikini in its iconic newsprint pattern. More than seventy years after its debut, the bikini is still making headlines.

OPPOSITE: Charles James gown for the Blenheim Ball

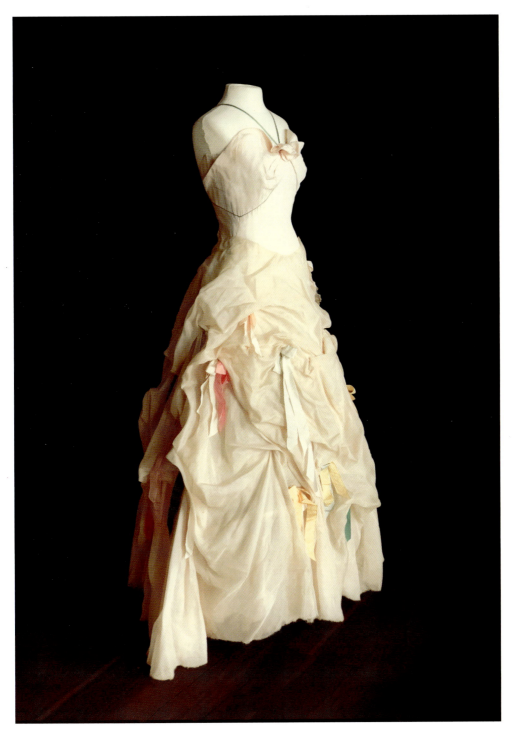

JULY / 07

1942

Thirteen-year-old Anne Frank and her family left their home in Amsterdam on a warm summer's day, "wrapped in so many layers of clothes it looked as if we were going off to spend the night in a refrigerator, and all that just so we could take more clothes with us," she wrote in her diary. They were going into hiding from the Nazis, and had no idea how long they might be away. "No Jew in our situation would dare leave the house with a suitcase full of clothes," Anne explained. "I was wearing two undershirts, three pairs of underpants, a dress, and over that a skirt, a jacket, a raincoat, two pairs of stockings, heavy shoes, a cap, a scarf and lots more." She added: "I was suffocating even before we left the house, but no one bothered to ask me how I felt." Anne was caught after more than two years in hiding and died in Bergen-Belsen concentration camp in 1945.

1939

Anne, Countess of Rosse, wore a pale pink Charles James gown with a skirt gathered up by wide ribbon rosettes—one of a series of ribbon gowns and capes the British-born milliner-turned-designer created—to the Blenheim Ball, a spectacular coming-out party for Lady Sarah Spencer-Churchill, the seventeen-year-old daughter of the Tenth Duke of Marlborough. The ball would go down in history as not just the social event of the season, but the last of the great English country house parties before World War II. The delicate, romantic gown—bedecked in bows like a gift—captures the fleeting beauty of that enchanted summer.

Blenheim was England's only privately owned palace, gifted to the First Duke of Marlborough by Queen Anne. On the night of the ball, "the palace was floodlit, and its grand baroque beauty could be seen for miles," remembered Chips Channon, one of the guests. "The lakes were floodlit too and, better still, the famous terraces, they were blue and green and Tyroleans walked about singing. . . . There were literally rivers of champagne." As dawn broke, the remaining guests wound up the party with coffee and hotdogs, served by footmen in powdered wigs and Marlborough livery.

"The whole summer seemed to be given up to having a good time," Lady Elizabeth Scott wistfully recalled. Julian Amery remembered "after the Blenheim Ball, standing on Westminster Bridge with a fair companion and watching Big Ben strike eight. We were both still in full evening dress. People were going to work all around but no-one seemed to think it odd." In a dazzling season, the Blenheim Ball stood out as

WORN ON
THIS DAY

the crown jewel. "Never had a better time," twenty-two-year-old John F. Kennedy told a friend. Channon was more poetic: "I have seen much, traveled far, and am accustomed to splendor, but there has never been anything like tonight. It was gay, young, brilliant, in short, perfection. Shall we ever see the like again?"

He had good reason to wonder. The Military Training Act had been passed in May, reinstating conscription; young men would soon swap their evening wear for uniforms, country houses would be mothballed, and London mansions would be bombed out of existence. Within two months, Hitler had invaded Poland, and England and France had declared war on Germany. Blenheim was turned into a school; its famous terraces were converted into victory gardens. Lady Sarah took a job at a munitions factory, driving an old Ford to work and calling herself "Sally Churchill." Charles James left London for New York, never to return.

It would be nearly a decade before British high society gathered together in all their finery again. On April 12, 1948, Cynthia Jebb attended a dinner at London's Savoy Hotel. "I wore my best, and the Jebb diamonds, and [my husband] wore his white tie and tail-coat for the first time since 1939," she wrote in her diary. "When I used to look at all those boiled shirts and white waistcoats put away all these years and yellowing rapidly, I often wondered whether we should ever see them worn again. . . . Lo and behold, here they were resuscitated, a bit tight, but nevertheless the genuine article." Anne's graceful gown, too, was worn again after the war—by her daughter.

JULY 8

1822

The poet Percy Bysshe Shelley, who had never learned to swim, drowned when his sailboat, the *Don Juan*, was caught in a squall off the coast of Italy. His body washed ashore more than a week later; he was identified by his white silk stockings and nankeen trousers with a volume of Keats's poems in the pocket.

JULY 9

1951

First Lady Eva Perón celebrated Argentina's Independence Day at a gala at the Teatro Colón in Buenos Aires wearing a strapless white tulle ball gown by Christian Dior. The gown was later immortalized in the balcony scene of Andrew Lloyd Webber's musical *Evita*. Although Perón made many public appearances on the balcony of the Casa Rosada, the presidential palace, she never did so in evening wear. Dior called Perón "the only queen I ever dressed."

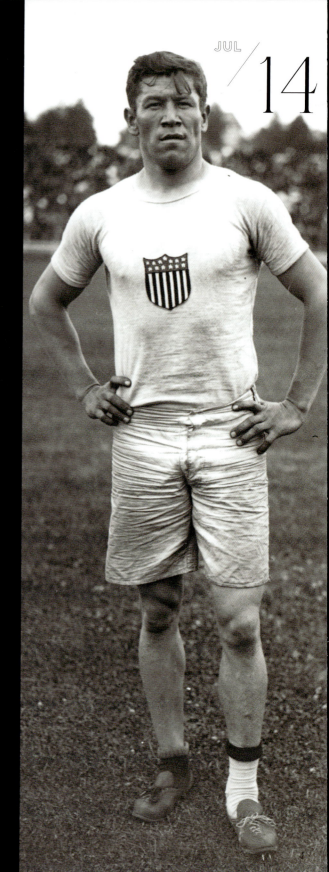

JULY 10

1040

It was on this day that Lady Godiva is supposed to have ridden naked on horseback through the streets of Coventry, England, covered only by her long hair, to persuade her husband, the Earl of Mercia, to lower taxes.

JULY 11

1804

The famous duel between Alexander Hamilton and Aaron Burr in Weehawken, New Jersey, was delayed when Hamilton halted the proceedings to put on his glasses. The sun was rising, and its light was bouncing off the Hudson River, affecting his eyesight. After fumbling in his pocket for his spectacles, Hamilton announced: "This will do. Now you may proceed." Scholars continue to debate whether Hamilton put on his glasses with the intention of killing Burr, wounding him without killing him, or simply evading Burr's shot. As it happened, he did none of those things. Burr shot Hamilton in the stomach; he died the next day.

JULY 12

1640

Hendrik Casimir I, Count of Nassau-Dietz, was wearing a leather jerkin when he was shot from his horse in the Battle of Hulst in the Netherlands. He died the next day, at the age of twenty-eight. These sleeveless jackets were not lined and could be turned inside out to prolong their life; in *Troilus and Cressida*, Shakespeare criticizes fickle public opinion, which "one may wear . . . on both sides like a leather jerkin."

Leather jerkins were designed to protect their wearers from blows and blades, not bullets. Guns were first used in battle in the fifteenth century, but it was the flintlock musket—widely adopted around 1630—that made them lethal from a distance. From then on, soldiers augmented their jerkins with iron cuirasses—breastplates in use since ancient times. Had Hendrik been wearing one, it might have deflected the bullet, whose entry point is still visible in the lower center back of his jerkin, now in the Rijksmuseum.

OPPOSITE: Georgia O'Keeffe's dress, Jim Thorpe's mismatched Olympic cleats

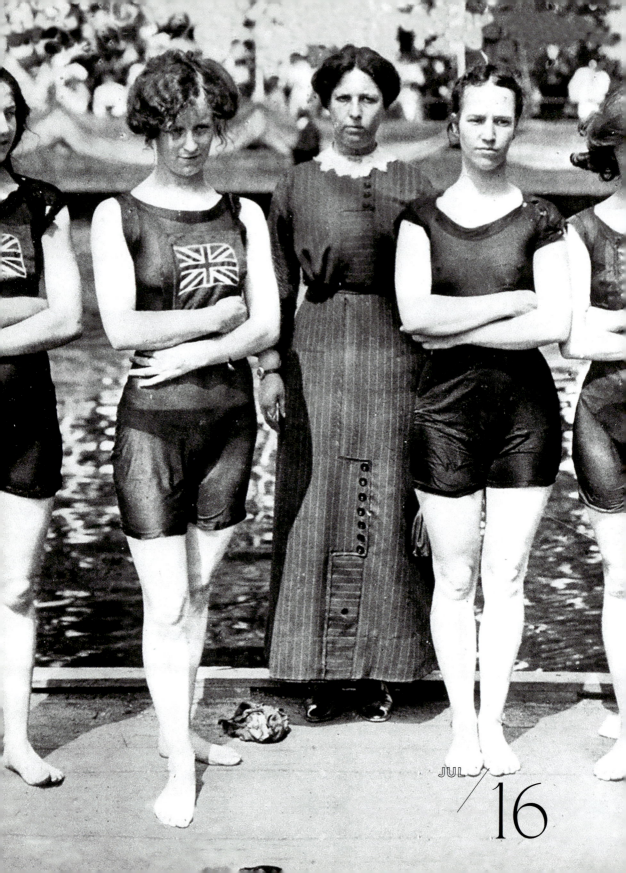

JULY 13

1979

Georgia O'Keeffe's personal assistant, Carol Merrill, visited the ninety-one-year-old artist at home in New Mexico and found her "wearing a dress designed by someone she said was the best woman designer we've ever had." Merrill described the garment: "The shoulders were cut away toward the neck where there is a collar with points. It is crisp looking and the material increases toward the hem, mid-calf, so it is a triangle in brownish-hued aqua. It was very cool-looking, a bluish color that was shaped so it didn't touch the body to restrain or warm." It was typical of the sculptural, monochromatic garments that characterized O'Keeffe's wardrobe her whole life, even in old age.

The talented "woman designer" was Claire McCardell, who had been dead for more than twenty years. McCardell's innovative sportswear—designed under the Townley Frocks label in the 1930s, '40s, and '50s—was so modern and wearable that it still looks fresh today. As designer Anna Sui has said of McCardell: "You look at some of the things she did and you can't believe it was the '40s." During World War II, when traditional fabrics were difficult to obtain, McCardell made dresses in denim, calico, and weather balloon cotton, pairing them with ballet flats to conserve leather. O'Keeffe—an expert seamstress who made many of her own clothes—recognized genius when she saw it, and kept wearing her McCardells until her death in 1986.

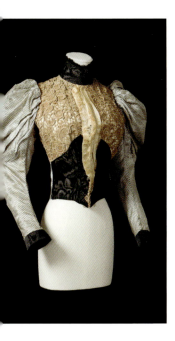

JULY 14

1912

On the second day of the first-ever Olympic decathlon competition in Stockholm, American track and field athlete Jim Thorpe discovered that his shoes had been stolen. He found two mismatched cleats in a trash can, but they were different sizes, so Thorpe wore them with extra socks on one foot. He won two of the four events that day—the 110-meter hurdles and the high jump—and took the gold medal by a huge margin of victory. Sweden's King Gustaf V, who presented it, proclaimed Thorpe "the greatest athlete in the world"—which he confirmed by going on to take the gold in the pentathlon as well.

A Sac and Fox Indian, Thorpe had grown up in the Oklahoma Territory,

OPPOSITE, ABOVE:
Olympic wool bathing suits, Princess Alexandra's bodice

which achieved statehood in 1907. Orphaned as a teenager, he was sent to a government-run boarding school, the Carlisle Indian Industrial School in Pennsylvania, where his astonishing athletic prowess attracted notice. Coached by the legendary Glen "Pop" Warner, Thorpe was a two-time All-American for the high school's football team, then led the Carlisle Indians to the NCAA Championship.

Thorpe didn't go to Stockholm to win medals alone. He hoped to win over the family of his sweetheart and classmate Iva Miller, who disapproved of him. His plan worked. He and Iva were married the following year in a lavish Catholic ceremony. Thorpe went on to play professional baseball, football, and basketball. He also worked as a Hollywood stuntman. He was stripped of his Olympic medals in 1913, when it was discovered that he had played minor league baseball, forfeiting his amateur status—a move that many perceived as being racially motivated. The medals were reinstated seventy years later, after Thorpe's death.

JULY 15

1912

Sports clothing often predicts the future of fashion, introducing high-tech materials and aerodynamic silhouettes that only much later appear in everyday dress. When women competed in swimming events for the first time at the 1912 Stockholm Olympics, the British team won the four-hundred-meter relay wearing one-piece wool bathing suits adorned with the Union Jack. The athletes were obviously uncomfortable being photographed in their skimpy suits, which became clingy and transparent when wet; photos of their opponents reveal similarly protective postures. Their reticence is not surprising considering that the woman standing behind the swimmers are dressed in what was, at the time, conventional daywear, with a high neckline, long sleeves, corset, ankle-length skirt, and boots.

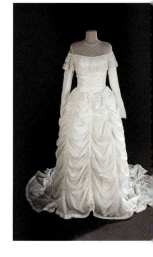

JULY 16

1894

Princess Alexandra wore a bodice by Madame Fromont of Paris to the christening of her grandson, the future King Edward VIII, better known today as the Duke of Windsor. Because she was in later stages of mourning for her eldest son, Eddy, who had died of influenza in 1892, it was half black; Alexandra would continue to wear muted colors for the rest of her life. The christening must have been an especially poignant event for her, because the child's mother, Mary of Teck,

OPPOSITE, ABOVE:
Dom Pedro II's regal
coronation attire, Ruth
Lengel's parachute
wedding gown

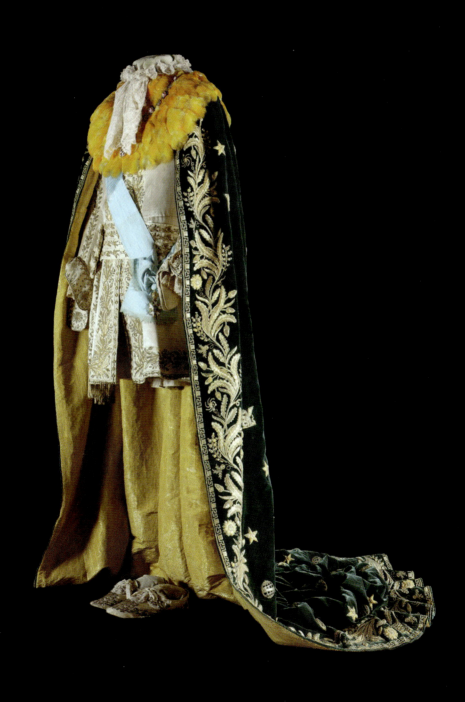

had been engaged to Eddy when he died and subsequently married his younger brother, George.

Alexandra is often compared to another Princess of Wales, Diana. Both were beautiful and beloved leaders of fashion trapped in unhappy marriages. Like Diana, the Danish-born Alexandra was not an edgy, avant-garde innovator, but her celebrity ensured that her sporty good taste set fashion trends. High necklines and, for evening, chokers became fashionable because she wore them to conceal a scar on her neck. She also popularized "tailor-mades": women's suits of wool or serge, made by menswear tailors. Women even copied her slight limp, a complication from the rheumatic fever she contracted in 1867. In the early 1870s, Charles Frederick Worth named the "princess line" after Alexandra, because the streamlined silhouette—cut without a waist seam—suited her tall, slim figure. The term "princess seam" is still used to describe a vertical shaping seam.

JULY 17

1915

The Women's Right to Serve March in London offered a rare urban sighting of the Women's Land Army, formed in 1914 to provide wartime agricultural labor. The "Land Girls" did not wear military-style uniforms but were instantly recognizable in their thigh-length smocks, belted over trousers or breeches and boots or gaiters. The WLA handbook described this as a "sensible" costume and pointed out: "You are doing a man's work and so you are dressed rather like a man." The uniform was a powerful recruiting tool in an age of corsets, high heels, and hobble skirts.

JULY 18

1841

WORN ON
THIS DAY

When he was crowned Emperor of Brazil, fifteen-year-old Dom Pedro II wore a *Traje Majestici*—literally "majestic outfit"—that combined Old World splendor with New World materials. Over a knee-length white satin tunic and leggings, he wore a green velvet mantle. Though clearly inspired by the ermine-lined blue velvet mantle embroidered with fleurs-de-lis worn by French kings, it was lined in golden silk and embroidered with native cacao and tobacco branches. Instead of a short ermine cape, he wore one of Guinean cock-of-the-rock feathers made by Tiriyo Indians. A crown, sword, scepter, and the chivalric orders of the Rose and the Southern Cross completed the costume. After the coronation, Dom Pedro wore the *Traje Majestici* twice a year, at the opening and closing of the Brazilian Parliament.

OPPOSITE: Neil Armstrong's space suit

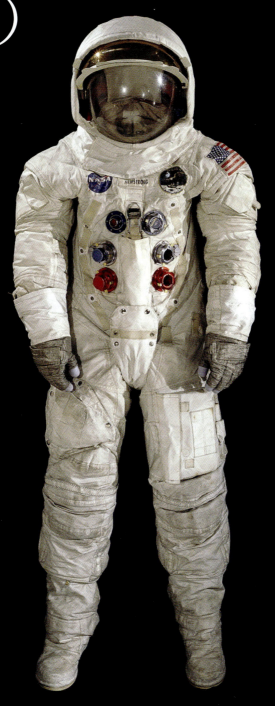

1947

Many World War II–era brides wore wedding gowns made from white silk or nylon parachutes, a readily available alternative to hard-to-find bridal fabrics. But when Ruth Lengel took the leap with Major Claude Hensinger in Neffs, Pennsylvania, she wore the same nylon parachute that had saved Hensinger's life. When the engine of the B-29 he was piloting caught fire after a bombing raid on Japan in 1944, Hensinger and his crew had to bail out. He sustained only minor injuries, then used his parachute as a pillow and blanket as he waited to be rescued. He kept the parachute, and when he proposed to Ruth, he offered her the material for her gown. Ruth hired a local seamstress to make the bodice. The skirt, which Ruth made herself, has a train created by adjusting the parachute strings. After Ruth and Claude's daughter and daughter-in-law both wore the gown at their own weddings, the family donated it to the Smithsonian.

JULY 20

1969

Neil Armstrong, commander of the *Apollo 11* mission, wore an A7-L spacesuit when he became the first man to walk on the moon. Conceived and constructed by the bra and girdle maker Playtex, a subsidiary of the International Latex Corporation, the A7-L "was not developed from military-industrial expertise, but rather from underwear," wrote Nicholas de Monchaux in *Spacesuit: Fashioning Apollo.* It was a fitting origin story for a suit that had to be comfortable as well as functional, allowing enough mobility for Armstrong not just to take "one small step" but also to gather soil samples and conduct scientific experiments.

After suffering through World War II in dowdy coveralls, uniforms, and hand-me-downs, American women embraced the hourglass silhouette of Christian Dior's "New Look" with its attendant petticoats, corsets, waspies, and girdles. But they insisted on comfort, achieved using high-tech, manmade textiles rather than the steel and whalebone of previous generations of shapewear. The bullet bras and merry widows of the 1950s were marvels of structural engineering; the Wonderbra was invented in 1961. To clothe the *Apollo 11* crew, NASA turned to the forefront of design technology and material science: the underwear industry.

Seamstresses seconded from the Playtex assembly line used "girdle-dipping techniques to produce convoluted joints" of latex and "couture techniques to fuse disparate layers at 64 stitches to the inch," Monchaux wrote. Most of the A7-L's

WORN ON THIS DAY

twenty-one thin layers were made from materials that could be found in any woman's lingerie drawer: nylon, Lycra, Neoprene, Dacron. Unlike underwear, however, the suit had to stand up to extreme heat and cold, ultraviolet radiation, and projectile micrometeorites, necessitating additional layers of reflective and flame-resistant Mylar, Kapton, and Teflon.

The out-of-the-world suit was, effectively, a wearable spacecraft, as Armstrong noted in a letter of appreciation he sent to NASA on the twenty-fifth anniversary of his moonwalk. The A7-L had "turned out to be one of the most widely photographed spacecraft in history," Armstrong wrote. "That was no doubt due to the fact that it was so photogenic." With typical self-deprecating humor, the astronaut added: "Equally responsible for its success was its characteristic of hiding from view its ugly occupant."

Designed to last six months, Armstrong's eighty-pound, twenty-one-layer suit underwent vital conservation work in anticipation of the moonwalk's fiftieth anniversary in 2019. The project was funded by the Smithsonian's first-ever Kickstarter campaign. "Reboot the Suit" raised half a million dollars in just four days— the same amount of time it took *Apollo 11* to go to the moon and back.

JULY 21

1861

While the Civil War is often mythologized as a conflict between the Blue (Union) and the Gray (Confederacy), the subject of uniforms was far from black and white. Some Rebels wore blue; some Yankees wore gray. As the war dragged on and fabric became scarce, soldiers on both sides made do with uniforms of yellowish-brown homespun. And then there were the Zouaves—or, as one regiment was nicknamed, the "Red-Legged Devils."

"Zouave"—which rhymes with "suave"—is a Frenchification of Zouaoua, an Algerian Berber tribe. The first Zoauves were French soldiers stationed in North Africa in the 1830s, who adopted the dashing dress, energetic marching drills, and bold tactics of their Algerian counterparts. They paired short blue tunics with voluminous white pantaloons in the summer and red wool pantaloons in the winter, accessorized with blue sashes, white puttees (leg wraps), and fez-like tasseled caps or turbans. Though their uniforms appeared eccentric—even by the exuberantly beplumed and braided standards of the nineteenth century—Zouaves were considered fierce fighters.

Inspired by tales of the Crimea, Colonel Elmer Ellsworth formed the first Zouave regiment in the United States in 1859. In peacetime, it functioned as a

sort of drill team, performing around the northern United States. One of its members described his uniform as "a bright red chasseur cap with gold braid; light blue shirt with moiré antique facings, dark blue jacket with orange and red trimmings; brass bell buttons, placed as close together as possible; a red sash and loose red trousers, russet leather leggings, buttoned over the trousers, reaching from ankle halfway to knee, and white waistbelt." Though more theatrical than authentically Algerian, this uniform would serve as a model for future American Zouave units, many of whom wore fancifully decorated jackets which, in turn, inspired women's fashions.

When the Civil War broke out, volunteer Zouave units formed on both sides. Ellsworth obtained permission from his friend Abraham Lincoln to raise a Zouave regiment comprised of the toughest men he could find: New York volunteer firefighters. On May 24, 1861—the day after Virginia seceded—Ellsworth led his "Fire Zouaves" into Alexandria, intending to secure the town's railroad station and telegraph office. He noticed a secessionist flag flying atop the Marshall House Inn and took four of his men to the roof to cut it down. As Ellsworth was returning downstairs, the inn's proprietor, James W. Jackson, ambushed him and killed him at point blank range with a shotgun blast to the chest, making Ellsworth the first Union officer to die in the Civil War. One of his men, Private Francis Brownell, immediately shot and killed Jackson, earning the Medal of Honor for his quick action.

The incident became a rallying point for the North, and Brownell became a minor celebrity. Mathew Brady photographed him in a swaggering contrapposto stance for a *carte de visite* titled "Ellsworth's Avenger." Brownell is armed with a knife, sword, and the bayonet he used to kill Jackson, with a mourning band for Ellsworth around his left arm and the flag taken from the Marshall House Inn beneath his feet. His belt reads "Premier 1" in metal lettering—part of the uniform of the Premier Engine Company Number One of Troy, New York, Brownell's hometown. A few weeks later, on July 21, Brownell wore this uniform in the Battle of Bull Run, the first major battle of the Civil War. (In the South, it was known as the Battle of Manassas.)

The uniform survives in the collection of Manassas National Battlefield Park. On a mannequin, stripped of its sword and swagger, it looks comical, like an old-timey bellhop uniform. It serves as a useful reminder that sometimes the man makes the clothes, and that not all Zouaves wore red pantaloons, which would have made them easy targets on the battlefield. Instead, Brownell's surviving uniform confirms that the Fire Zouaves wore red flannel firemen's shirts, red caps, gray jackets with red and black trim, and blue pantaloons.

OPPOSITE: Private Francis Brownell's Zouave uniform, the Duke of Connaught's beast costume

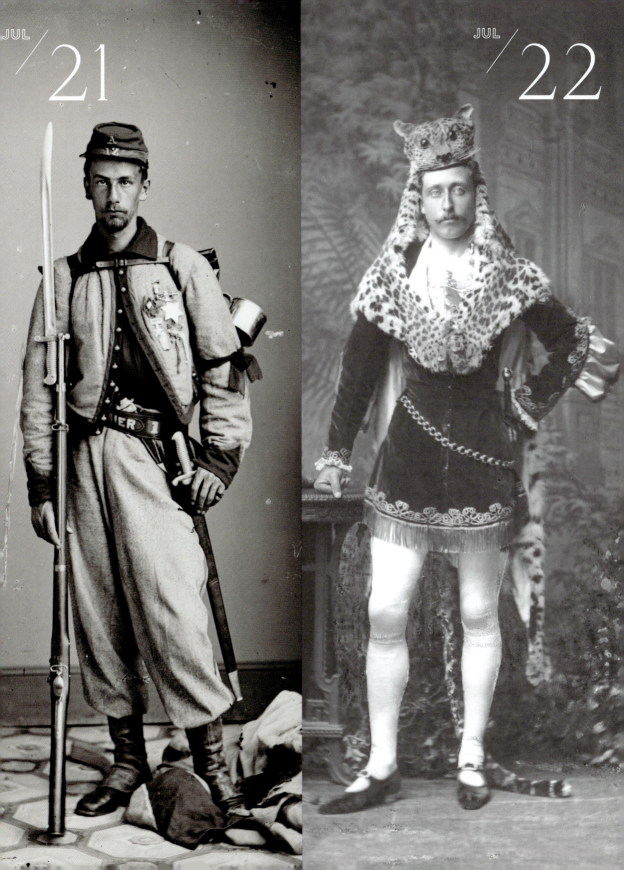

The Union lost the Battle of Bull Run, in part because some of the Confederate troops wore blue, and they failed to recognize them as the enemy until it was too late. In their unusual red, blue, and gray uniforms, the Fire Zouaves may have sown similar confusion among the Confederates. Unmoored by the loss of their leader, however, they disbanded, and never fought together again.

JULY 22

1874

Queen Victoria loved a good party, and she was especially fond of costume or "fancy dress" parties as they were (and still are) called in England. After the death of Prince Albert in 1861, however, the distraught queen withdrew from society, leaving the royal entertaining duties to her eldest son, the Prince of Wales. The historical fancy dress ball he and his wife, Princess Alexandra, hosted at Marlborough House in 1874 was the most coveted invitation issued by the younger royals.

While some criticized the frivolity of royal balls, most appreciated their contribution to the economy—especially costume balls, which required guests to purchase new, custom-made clothes, from head to toe. "In old days, those who did not go to her Majesty's fancy balls used still to be glad to hear of them, because they were 'so good for trade,'" the *Times* noted. With fourteen hundred invited guests, the Marlborough House ball "must have done trade a good turn too, for during the past fortnight scarcely a bit of old world finery, or so much as the print of a man in doublet and hose, was to be had at the shops." *Vanity Fair* concurred: "There is at the present moment among costumiers, tailors, barbers, bootmakers and dressmakers no more popular air than 'God bless the Prince.'"

The ball opened with a series of quadrilles performed by dancers dressed in coordinating costumes. The prince—costumed as Charles I—led the first group of dancers, who looked as if they had stepped out of Van Dyck's portraits of seventeenth-century courtiers. Princess Alexandra—dressed as a Venetian lady in a ruby velvet gown decorated with gold embroidery, jewels, and strings of pearls—led an Italian-themed quadrille. But it was the fairy tale quadrille that figured most prominently in accounts of the ball.

Alongside Cinderella and her Prince, Undine and her knight, Red Riding Hood and her huntsman, Little Bo Peep and Little Boy Blue, and Bluebeard and his wife, the Prince's brother Arthur, Duke of Connaught, played the Beast to Beauty. His show-stopping costume allowed him to transform into a handsome prince midway through the dance by swapping his beastly carapace—an entire leopard skin, complete with tail—for a feathered cap.

JULY 23

1918

Captain E. W. Leggatt and twenty-eight other British officers escaped the Holz-minden prisoner of war camp in Germany through a tunnel, which collapsed behind them. Traveling silently by night in a pair of makeshift leather moc-casins—probably fashioned out of a flight jacket—Leggatt was one of ten who reached the Dutch border safely.

JULY 24

1915

The Western Electric Company hired the steamer *Eastland* to take twenty-five hundred employees and their families from downtown Chicago across Lake Michigan to Indiana for a day of music and picnicking. As the flat-bottomed boat pulled away from the dock, it pitched to one side and capsized, throwing hun-dreds of passengers into the water and trapping many more below deck. Six-teen-year-old Herman Krause planned to march in a parade at the picnic; he was wearing a red, white, and blue Uncle Sam costume his mother had made for him. "When the boat rolled, he was in the water, and people started yelling, 'Save Uncle Sam! You have to save Uncle Sam!'" according to Krause's grandson, Karl Sup, the founder of the Eastland Memorial Society. "He figures it saved his life." More than eight hundred fellow passengers were not so lucky.

JULY 25

306

When the Roman co-emperor (or Augustus) Constantius I died suddenly in Eboracum—modern-day York, England—during a military campaign against the Picts, his son, Constantine, accepted the army's demand that he succeed him and put on his father's purple robes. Tyrian purple—a reddish-purple dye produced by sea snails—was a rare and remarkably colorfast hue, and its use was restricted by law. Senior Roman officials wore white togas edged with purple stripes, but the phrase "donning the purple" was synonymous with becoming emperor. The other Augustus, Galerius, was furious when he heard the news, but signaled his acceptance of Constantine's unorthodox accession by person-ally sending him a new set of purple robes, thus making it clear that he alone conferred legitimacy.

JULY 26

1975

Alan Jones was arrested while walking along Piccadilly in London wearing Malcolm McLaren's notorious "Cowboys" T-shirt, which had just gone on sale that day. The shirt featured gay pornographer Jim French's 1969 illustration of two cowboys in profile, naked from the waist down apart from their boots. Jones was charged with "showing an obscene print in a public place" under the Vagrancy Act of 1824. The next day, police raided McLaren's seminal King's Road punk boutique, Sex, seizing eighteen of the shirts. Both Jones and McLaren were fined, sparking a public debate over free speech and the selective enforcement of centuries-old laws.

JULY 27

1778

The Battle of Ushant was the first major naval conflict between the French and English after France sided with England's rebellious colonists in the American Revolution. Though the battle was not decisive and both sides would claim victory, the French fleet suffered far fewer casualties, and one French frigate in particular, *La Belle Poule*, badly damaged the Royal Navy's *Arethusa*. "All Paris was enflamed by the news," the Vicomtesse de Fars recorded, "and for a month the ladies enshrined its memory with an object of fashion of bad taste, called the *coiffure à la Belle Poule*. This represented, more or less, a ship in full sail." The style had another name explicitly referencing its political context: the "Independence Coiffure, or the Triumph of Liberty." It was one of many ship-shaped headdresses that celebrated specific French naval victories in the American Revolution and, more importantly, advertised their female wearers' patriotism and political acumen.

JULY 28

2016

Hillary Clinton became the first woman to win a major party's presidential nomination on the last night of the Democratic National

Princess Diana's wedding gown

Convention in Philadelphia. Her white Ralph Lauren pantsuit evoked both the white garb of the suffragettes—signifying purity—and Olivia Pope, the take-no-prisoners heroine of the Washington, DC–set television drama *Scandal*.

JULY 29

1981

With one hundred yards of tulle, twenty-five yards of silk taffeta, ten thousand pearls, a twenty-five-foot-long train, gigantic puffed sleeves, and more ruffles, bows, and antique Carrickmacross lace than could comfortably fit into the bride's horse-drawn carriage, Princess Diana's wedding gown inspired the term "meringue." Its fairy-tale romanticism may look over-the-top today, but the style—designed by the husband-and-wife team of David and Elizabeth Emanuel—was cutting-edge in the era of Gunne Sax and Laura Ashley. The bride's 153-yard tulle veil was anchored by the Spencer family tiara. Although the media made much of the fact the Prince of Wales was marrying a "commoner," Diana was the daughter of an earl, and her family's lineage went back much farther than that of the Windsors.

Diana's shoes could not be seen under her voluminous skirts, but they were equally ornate. Covered in 542 sequins and 132 pearls, they took custom cobbler Clive Shilton six months to create. An embroidered heart ringed by a ruffle of lace decorated each toe. The soles were suede to provide grip on the red-carpeted aisle of St. Paul's Cathedral, and the shank was hand-painted, with a tiny "C" and "D" on either side of a heart. Because Diana stood 5'10"—the same height as the groom—she requested a low heel.

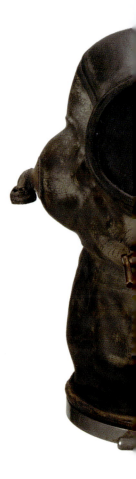

JULY 30

1966

At the end of England's only World Cup final victory, fullback George Cohen exchanged jerseys with Lothar Emmerich, a winger with the losing West German team. Christie's auctioned Cohen's red jersey for £32,000 in 2006. The tradition of soccer players swapping shirts with their opponents dates back to 1931 and has recently spread to other sports, including American football.

ABOVE: James Magennis's diving helmet

JULY 31

1945

James Magennis was just fifteen when he joined the Royal Navy in 1935. Ten years later, in the final weeks of World War II, he was the diver on a midget submarine that entered the Johor Strait, the shallow waterway separating mainland Malaysia from Singapore, where the Japanese heavy cruiser *Takao* was guarding the entrance to Singapore harbor. His mission: to attach six explosive charges to the ship's hull and sink it. He wore a frogman mask and suit made by the Dunlop Rubber Company, the British firm that had invented the first pneumatic tire in 1888.

From the beginning, the mission was fraught with peril and misadventure. The sub's journey to the target area took eleven hours, in sweltering heat and humidity. It passed through a known minefield to avoid detection and had to dive to avoid a patrol boat. Traveling blind, it rammed into the side of the *Takao*'s hull and nearly ran aground. Miraculously, no one on board the ship heard the crash.

When Magennis opened the diver's hatch, he discovered that the space between ship and sub was so tight that he could not open it all the way. But the tide was going out and there was no time to reposition the sub. Instead, Magennis stripped off his breathing equipment so he could squeeze through the narrow opening, replacing it once he was outside the sub.

The ship's hull was so grimy that the explosives wouldn't stick; Magennis had to scrape away seaweed and barnacles with his knife, rubbing his hands raw in the process. It took him half an hour to attach all six charges, the risk of discovery ever-present. Finally, he squeezed back through the diver's hatch only to find that the sub was trapped beneath the Takao, which had sunk with the tide.

After an hour of maneuvering, the crew managed to work the sub free, but when they tried to drop their final payload—two two-ton explosive charges, that had to be positioned under the ship—one of them failed. It needed to be released by hand. Magennis volunteered to venture outside the sub again to free it with a heavy wrench. At last, the sub made its escape. Six hours later, the charges tore a hole in the *Takao*'s hull, immobilizing the cruiser for the remainder of the war. Magennis was awarded the Victoria Cross—Britain's highest military honor—for his "great courage and devotion to duty and complete disregard for his own safety."

AUGUST

1	2	3	4	5	6	7
Roses worn by British Army regiments	Sir Walter Tirel's cumbersome cloak	A "New Look" wedding corset	Playboy Bunny costumes in the wild	Tiger Woods's red Sunday shirt	Nobuko Oshita's high school uniform	A pilot's multi-purpose muffler
1759	**1100**	**1957**	**1966**	**2007**	**1945**	**1942**
8	9	10	11	12	13	14
Hijab worn by Olympic fencer Ibtihaj Muhammad	An Olympian's racy racerback swimsuit	Queen Marie-Antoinette's lost shoe	Facial hair that charmed Charles Dickens	Influential ambassadors from India	The first female Marine Corps uniform	A tapestry purse in Times Square
2016	**1932**	**1792**	**1844**	**1788**	**1918**	**1945**
15	16	17	18	19	20	21
Prime Minister Jawaharlal Nehru's jacket	"Siren suit" worn by Winston Churchill	Pink bonnet for a tiny prisoner	Jimi Hendrix's Woodstock look	Louis O'Soup's beaded beaver-skin shirt	Matthäus Schwarz's book of clothes	Frida Kahlo's wedding wear
1947	**1942**	**1945**	**1969**	**1881**	**1535**	**1929**
22	23	24	25	26	27	28
Gown worn to welcome the Marquis de Lafayette	Falconry accessories of James I of England	Disguises donned by Danish saboteurs	A patriotic Parisian's embroidered blouse	Lewis and Clark expedition footwear	Hunting shirt worn by Abraham Duryea	Tan suit worn by President Barack Obama
1825	**1614**	**1943**	**1944**	**1805**	**1776**	**2014**
29	30	31				
Funeral attire worn by Aretha Franklin	Shoes of a Hurricane Katrina survivor	A sensational split skirt for riding				
2018	**2005**	**1902**				

FROM FLOWERED CAPS TO SPLIT SKIRTS

08/01

The Anglo-German forces decisively defeated the French at the Battle of Minden in Prussia (modern-day Germany), turning the tide of the Seven Years' War. As the British troops advanced to meet the enemy, soldiers picked wild roses from the hedgerows and wore them in their buttonholes. To this day, members of British Army regiments that participated in the battle wear "Minden roses" on their caps and lapels on August 1.

AUGUST 2

1100

King William II of England was shot by an arrow and killed while hunting in the New Forest. Though his companion, Sir Walter Tirel, was suspected of murder, he claimed he'd misfired when his foot caught in his long cloak.

AUGUST 3

1957

When Christian Dior launched his ultra-feminine "New Look" in 1947, he declared: "There can be no fashion without foundation." In his autobiography, Dior proclaimed that he "designed clothes for flower-like women, with rounded shoulders, full feminine busts, and handspan waists above enormous spreading skirts. . . . I moulded my dresses to the curves of the female body, so that they called attention to its shape. I emphasized the width of the hips, and gave the bust its true prominence."

Of course, few women had naturally full busts and handspan waists. The foundation garment industry responded with an arsenal of underpinnings: corsets, girdles, waspies, corselettes, merry widows, bustiers, and bullet bras. Vivian Williams wore this corset

WORN ON THIS DAY

OPPOSITE: "New Look" corset

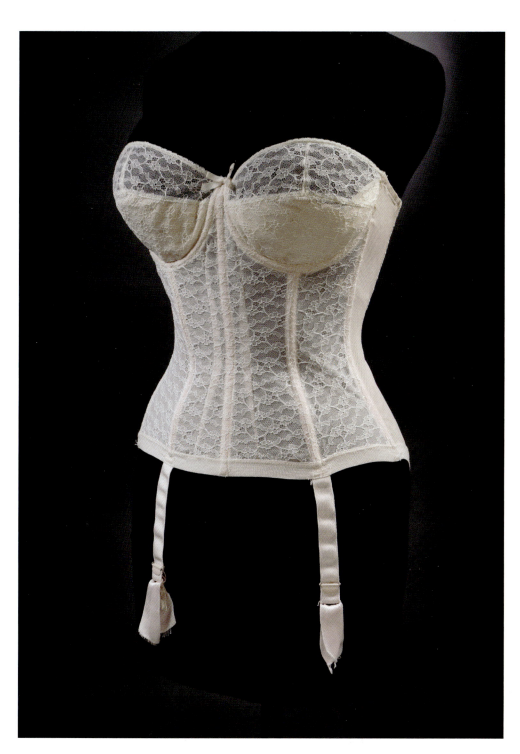

AUGUST / 03

under her wedding dress, a Vogue Patterns edition of a gown by Dior's rival, Jacques Fath, who had died in 1954. The corset was made by Berlei and purchased from the London department store Dickins & Jones.

While bras had largely replaced corsets during World War II—to conserve materials as much for the comfort of women employed in war work—the New Look revived them; however, modern manufacturing and materials made them more attractive and comfortable than previous generations of foundation garments. This one has boning made of wire rather than steel or whalebone, and it closes with hooks and eyes instead of laces or slots and studs. Because she bought it off the rack, Williams took the corset in at the waist—something that would have been difficult before the introduction of elasticized nylon.

The corset is equipped with built-in garters (or "suspenders," in British parlance) for holding up stockings. As hemlines got higher and higher in the late 1950s, threatening to expose the garters, stockings began to be replaced by one-piece pantyhose or tights. When avant-garde designer Mary Quant—the inventor of the mini-skirt—opened her London boutique, Bazaar, in 1955, she struggled to find tights to go with her clothes. "Stocking manufacturers did not have the right machinery so I persuaded theatrical manufacturers to make us tights to go with the short skirts," she wrote in her autobiography.

When Quant designed a collection for J. C. Penney in 1960, she "persuaded them that providing a full range of tights/pantyhose, which they previously barely stocked, was vital for the company if they wanted mini-skirts to sell in a big way." This was so successful that "they turned all their hosiery buying power towards pantyhose, and were so well positioned to persuade American hosiery manufacturers that tights were the future that they reaped the rewards of this decision alone for years. They made millions."

WORN ON THIS DAY

Today, corsets, garters, and stockings are relics of the past, worn as fashion or fetish items rather than practical ones. While push-up bras and shapewear brands like Spanx have their devotees, fashion's foundations are just as likely to be laid in the gym—or the plastic surgeon's office.

AUGUST 4

1966

To promote the opening of the London Playboy Club—the first such establishment in Europe—the so-called Bunnies who staffed the club made a rare appearance in the wild, visiting the quaint village of Bunny in Nottinghamshire.

Playboy publisher Hugh Hefner chose a rabbit as his magazine's mascot "because of the humorous sexual connotation," he explained, but dressed him in a tuxedo for "sophistication." When he opened the first Playboy Club in Chicago in 1960, Hefner adapted the concept for his female employees. The blend of overpriced cocktails and underdressed waitresses proved to be a winning formula. Clubs multiplied like rabbits; eventually, there would be more than thirty worldwide, as well as casinos and resorts.

Since its debut, the Bunny suit—a strapless bodysuit paired with rabbit ears and a fluffy tail—has become a cartoonish cliché of female sexuality, serving as a visual punchline in *Bridget Jones's Diary, Legally Blonde, Mean Girls, The House Bunny*, and a host of other rom-coms. But the Bunny's erotic allure was as much of a tease as her skimpy suit, which promised further revelations that never came. Feminists still argue over whether the Bunny suit was constricting or liberating because it was designed to be both. The prototype—a satin one-piece worn over a prefab merry widow corset—looked too much like a bathing suit. A few snips of the scissors raised the leg opening, elongating the legs and accentuating the crotch. Hefner himself insisted on adding crisscross lacing at the top of the leg; though it was purely decorative and couldn't be untied, it suggested the tantalizing possibility of a wardrobe malfunction. The suit only came in two cup sizes, 34D and 36D, but those cups were equipped with pockets to facilitate stuffing.

Though the Bunny's cleavage was served up on a plate, she was cinched in and covered up from the chest down, her legs encased in sheer black Danskin pantyhose over nude tights. A rosette name tag at the right hipbone, ears, tail, and dyed-to-match satin pumps completed the outfit. But it was the addition of a man's tuxedo collar, bow tie, and cuffs that pushed the Bunny suit into pop-culture legend.

In 1963, Norman Mailer described the Bunny suit as "a Gay-Nineties rig which exaggerated their hips, bound their waist . . . and lifted them into a phallic brassiere—each breast looked like the big bullet on the front bumper of a Cadillac. . . . To the back, on the curve of the can, as if ejected tenderly from the body, was the puff of chastity, a little white ball of a bunny's tail which bobbed as they walked." The Bunnies may have been eye candy, but they were literally untouchable; petting a Bunny was grounds for expulsion from the club.

AUGUST 5

2007

Golfer Tiger Woods won his third consecutive World Golf Championships–Bridgestone Invitational title wearing a red Nike polo shirt, his usual garb for the final round of a tournament. "I wear red on Sundays because my mom thinks that that's my power color, and you know you should always listen to your mom," Woods explained on his website.

AUGUST 6

1945

Nobuko Oshita was a freshman at First Hiroshima Prefectural Girls High School when an American B-29 bomber dropped an atomic bomb on the city, bringing World War II to its endgame. Japanese students were expected to contribute to the war effort. On the morning of August 6, thirteen-year-old Nobuko and her classmates were demolishing a building to create a fire break in Dobashi, Hiroshima's western business district, when the bomb was dropped at 8:15 a.m. Dobashi was just half a mile from ground zero. Nobuko and a few other survivors took refuge in a nearby elementary school. With the help of rescue workers, she made it home to her parents and sister in Otake, twenty miles away, but died later that night.

Nobuko's diary chronicled the storm clouds gathering over Japan in 1945. School days were consumed by war work and frequently interrupted by air raid alarms and the boom of antiair-

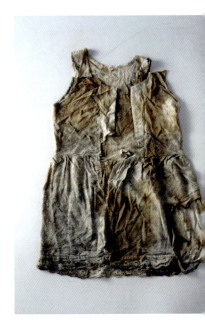

OPPOSITE, ABOVE:
Nobuko Oshita's high school uniform

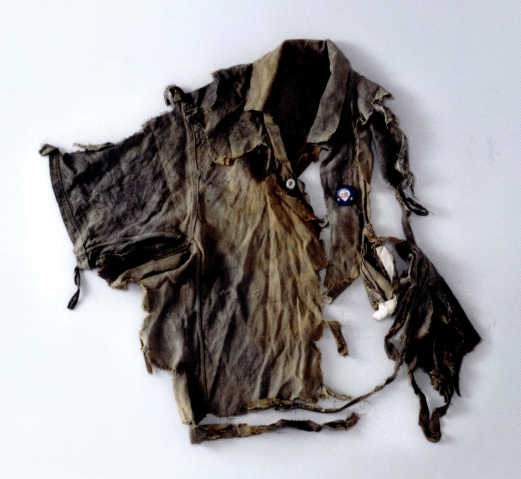

"WE HAD ANOTHER AIR-RAID DRILL DURING FIRST PERIOD"

craft guns. On April 13, Nobuko wrote: "Today we had another air-raid drill during first period at school. We practiced, doing everything as we had been told yesterday. At the start of the second period, even though no air-raid alert had been issued, B-29s were invading the air over Hiroshima." Between April and July, Nobuko would record thirty-two air-raid alerts.

On the day she and tens of thousands of others died, Nobuko was wearing her school's summer uniform, which she had made herself in her second-period sewing class. On June 13, she'd noted: "Up to last year, our uniforms were white, but this year they are khaki-colored or grayish. The reason for the change is that white uniforms stand out in an air attack. So, today we made patterns for our uniforms." The blast incinerated one side of Nobuko's uniform, although a metal badge bearing the name of her school is still attached to the lapel. Since it was first worn in the 1920s, the Western-style schoolgirl's uniform, or *seifuku*, has become an iconic symbol of Japanese culture, whether honored or fetishized. This mangled, burnt, and stained survival is both instantly recognizable and horribly changed.

Another student who witnessed the horrors in Hiroshima was seven-year-old Issey Miyake, who lost his mother to radiation poisoning a few years later. In a 2009 *New York Times* op-ed piece, he attributed his career choice to the events of that day. "I gravitated toward the field of clothing design, partly because it is a creative format that is modern and optimistic," he wrote. It was a rare moment of reflection and revelation for the designer. "I tried never to be defined by my past," he explained. "I did not want to be labeled 'the designer who survived the atomic bomb,' and therefore I have always avoided questions about Hiroshima." Instead, he has focused on "things that can be created, not destroyed, and things that bring beauty and joy."

While Miyake has avoided references to Hiroshima, other Japanese designers who grew up in its shadow and suffered postwar poverty and devastation—including Rei Kawakubo and Yohji Yamamoto—have won acclaim for their distressed and deconstructed clothing, often in relentless black, which the fashion press has dubbed "post-atomic" and "Hiroshima chic."

AUGUST 7

1942

Imperial Japanese Navy Zero pilot Saburo Sakai credited his silk muffler with saving his life during the Battle of Guadalcanal, when he used it to stop the bleeding from severe head wounds that left him blind in one eye. Silk mufflers became part of the naval uniform in the late 1930s, after fighter pilots began making their own out of salvaged parachutes. While Warrant Officer Takeo Tanimizu confessed that pilots were "dandies," the mufflers offered warmth as well as other practical benefits. One pilot remembered being told in flight school that he should trail his silk muffler in the water in the event of a crash landing at sea, to deter sharks; another used his as a tourniquet when he was wounded in the leg over Burma.

AUGUST 8

2016

Fencer Ibtihaj Muhammad became the first American Olympian to compete in a hijab. With her help, the US women's sabre team won the bronze medal. In 2018, Mattel released its first head-scarf-wearing Barbie doll in her image as part of its "Sheroes" collection.

AUGUST 9

1932

Australian swimmer Clare Dennis won the gold medal in the two-hundred-meter breaststroke at the Olympic Games in Los Angeles, wearing a racerback silk swimsuit by Australian brand Speedo. Although she set a new Olympic record in her semifinal race, she was almost disqualified for showing "too much shoulder blade." Following protracted official negotiations, the charge was dismissed. Speedo's innovative, V-shaped back strap design, first created for men in 1928, facilitated upper body motion and reduced drag.

1792

For three years after the French Revolution of 1789, the deposed King Louis XVI and Queen Marie-Antoinette were kept under virtual house arrest in their Paris residence, the Château des Tuileries. The new government could not agree on the fate of the royal family. Although stripped of power and prestige, the court continued to function as usual, adhering to its ancient rituals and etiquette. But the people of Paris were impatient for action, and, in the hot summer of 1792, they took matters into their own hands, storming the château and slaughtering hundreds of soldiers, bodyguards, and courtiers.

The royal family managed to escape as the palace was ransacked and looted. In the chaos, Marie-Antoinette lost her watch, purse, locket, and a high-heeled silk shoe trimmed with ribbons. Reimprisoned in a medieval fortress not far from the ruins of the Bastille prison, the royal family found themselves in desperate need of clothes. The royal wardrobe had been decimated, the scraps carried off by the mob.

Though not a single complete outfit belonging to Marie-Antoinette has survived, several of her shoes have. Portable, ornamental, and even fetishized, shoes are not as likely to be recycled as garments, which can be altered to fit new figures and new fashions. Recently, the queen's shoes have made headlines by drawing record prices at auctions. A pair of white silk mules with faded tricolor ribbons that the queen reputedly wore to the first-ever Bastille Day celebration in 1790 fetched $57,600 in Toulon in 2012. Later that same year, a pair of her green-and-pink-striped silk pumps sold for $65,000 in Paris.

WORN ON THIS DAY

The creator of these royal relics cannot be identified conclusively; however, the queen's principal shoemaker was Monsieur Charpentier, an eccentric artisan who lived in a fine house decorated with portraits of his aristocratic clients, where he would entertain guests with philosophical readings after supper. Though his shoes were fit for a queen, they were not fit for much else. When a client complained that her new shoes fell apart within twelve hours, he chided her for walking in them.

OPPOSITE: Marie-Antoinette's shoe

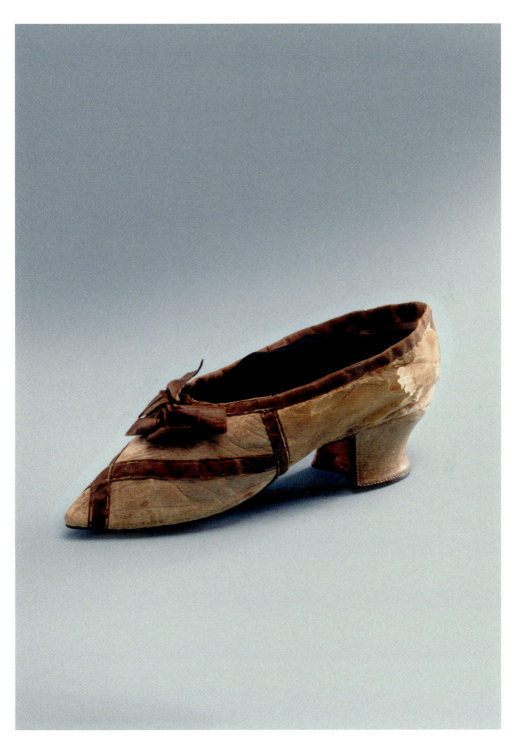

AUGUST / 10

With its rejection of luxury, formality, and elitism, the French Revolution decimated the fashion trades. Even the populist politician Marat, the self-proclaimed "friend of the people," was alarmed, declaring: "I would not be surprised if in twenty years not a single worker in Paris will know how to make . . . a pair of shoes." Just a year after losing this shoe, Marie-Antoinette went to the guillotine wearing a pair of plum-colored shoes she had carefully kept pristine during her imprisonment.

AUGUST 11

1844

Charles Dickens—vacationing near Genoa, Italy—wrote to a friend in England with an update on the progress of his fashionably groomed facial hair: "The moustaches are glorious, glorious. I have cut them short, and trimmed them a little at the ends to improve their shape. They are charming, charming. Without them, life would be a blank."

AUGUST 12

1788

A delegation of ambassadors from Tippoo-Sahib, Sultan of Mysore, arrived at Versailles for their presentation to King Louis XVI and Queen Marie-Antoinette. The entire court assembled to greet and gawk at the visitors, along with a large crowd that had traveled from Paris. According to the Comte d'Hézecques, a page at the palace, the Indians' dress was "composed of loose trousers and gowns of muslin or cotton cloth, fairly fine. I have not seen any gold embroideries except on their shawls, with which they wrap themselves more or less, according to the temperature." With the jaded air of a veteran courtier, the fourteen-year-old added: "Their turbans are not as high as those of the Turks, but they are much wider."

<div style="float:left">WORN ON
THIS DAY</div>

AUGUST 13

1918

Opha May Johnson, thirty-nine, was the first woman to be sworn into the Marine Corps, which decided to admit women to fill gaps left by men fighting overseas in World War I. Though she worked as a clerk in Arling-

ton, she had to train and drill like male Marines. Her uniform was a jacket with four flap pockets, a shirt, and a necktie, worn with a calf-length skirt and a flat-folding garrison cap identical to those worn by enlisted men. Johnson and other female recruits were let go at the end of the war in 1919. But women returned to the Marine Corps—again, temporarily, and in a strictly administrative capacity—during World War II. It was not until September 21, 2017, that the Marine Corps announced that the first woman in the service's 250-year history had passed the physically grueling eighty-six-day Infantry Officer Course.

AUGUST 14

1945

For many years, the nurse and sailor captured kissing in Times Square on V-J Day in Alfred Eisenstaedt's iconic *LIFE* magazine photo went unidentified. When the image was republished in 1980, former dental assistant Greta Zimmer recognized herself. "The seams in my stockings were perfectly straight—I was always careful about that," she explained, adding: "I was carrying this little tapestry purse that I owned."

AUGUST 15

1947

On India's first Independence Day, Jawaharlal Nehru was inaugurated as the country's first prime minister. He wore an *achkan*, single-breasted, knee-length coat with a short Mandarin collar. Originally Mughal court dress, it remained a formal garment. Around the time Nehru left office in 1964, a hip-length version of his signature style entered Western fashion as a "Nehru jacket," often accessorized with beads or medallions. It was one of several tie-free menswear options popular in the 1960s.

AUGUST 16

1942

Sir Archibald Clark Kerr, the British ambassador to Moscow, was dismayed when Prime Minister Winston Churchill arrived for a gala dinner at the Kremlin wearing "a dreadful garment that he claimed to have

designed himself to wear during air raids." Indeed, Churchill had commissioned several zip-front, one-piece "rompers," as he called them, from his tailors, Turnbull & Asser, in fabrics ranging from gray pinstriped wool to green velvet with matching slippers, for evening. (The blue version he wore to the Kremlin banquet looked like "mechanic's overalls" or "a child's romper," Kerr complained. "Siren suits"—so named because they could be put on quickly when air raid sirens sounded—were a necessary evil in wartime, but Churchill wore his all the time, and continued to wear them long after the war ended.

AUGUST 17

1945

Sandra Roche was born in a Japanese civilian internment camp in Weihsien in northeast China. When World War II broke out in 1941, the Japanese had forced thousands of Allied citizens living in occupied Asian countries—including businessmen, missionaries, and teachers—into such camps. On the day the camp was liberated, seven-month-old Sandra was wearing a pink baby bonnet made from café curtains by another internee, using a hand-cranked sewing machine. Sandra and her parents—along with fourteen hundred other prisoners—were rescued by a seven-man team put together by the US Office of Strategic Services. Two of her rescuers, Tad Nagaki and Stanley Staiger, signed Sandra's bonnet, as did several Roche family friends.

AUGUST 18

1969

On the final day of Woodstock, Jimi Hendrix took the stage wearing a red headscarf in his Afro, bell-bottomed jeans, a silver Navajo concho belt, moccasins, and a white leather cropped shirt decorated with fringe and blue beads. The American Indian Movement (AIM) had been founded the previous year, and Hendrix was proud of his Cherokee heritage. Other festival fashion statements included Janis Joplin's tie-dyed jumpsuit, American flag print jeans, peasant blouses, ponchos, and outright nudity.

OPPOSITE:
Louis O'Soup's shirt

AUGUST 19

1881

Louis O'Soup, leader of the Plains Ojibwa people, wore a shirt decorated with beadwork, beaver skin, and dyed horsehair when he addressed the Marquess of Lorne, the Governor General of Canada, at Fort Qu'apelle in Saskatchewan. His speech drew attention to the poor treatment of his people by the Canadian government; however, his words were incompletely translated to soften their message. After he spoke, Lorne presented O'Soup with a Waltham watch. O'Soup, in turn, gave Lorne the shirt off his back and its matching leggings, which Lorne subsequently sold to the British Museum. O'Soup would devote most of his life to trying to persuade Canada's government to honor its treaty obligations to indigenous peoples.

AUGUST 20

1535

The impulse to catalog, classify, and, ultimately, communicate one's fashion choices through Instagram selfies, vlogs, and "haul videos" is nothing new. Like most everything in fashion, it's been done before—in Renaissance Germany. Between 1520 and 1560, Augsburg accountant Matthäus Schwarz compiled a *Klaidungsbüchlein* or "book of clothes" cataloging his extensive and flamboyant wardrobe in a series of hand-drawn portraits, rendered in rich tempera colors accentuated with costly gilding. The images and their calligraphed captions chronicle changing male fashions down to the last codpiece, even recording minutiae like the weight of the heavily padded, pumpkin-like nether garments called hose. But they also illustrate how one Renaissance man advanced politically and socially through careful image management.

At a time when people effectively designed their own clothes with the help of tailors, dressmakers, and shoemakers, Matthäus boasted of his savvy color and fabric choices as he planned spectacular new outfits for a bewildering variety of occasions, from weddings and sledding parties to falcon hunts and funerals. Fashion served as a visible barometer of unprecedented cultural exchanges and technological advances.

When Martin Luther complained that Germans spent too much money on imported luxury goods, he may well have been thinking of Matthäus, who often noted the cost of his garments and seems to have taken pride in

OPPOSITE: Illustration from Matthäus Schwarz's *Klaidungsbüchlein*

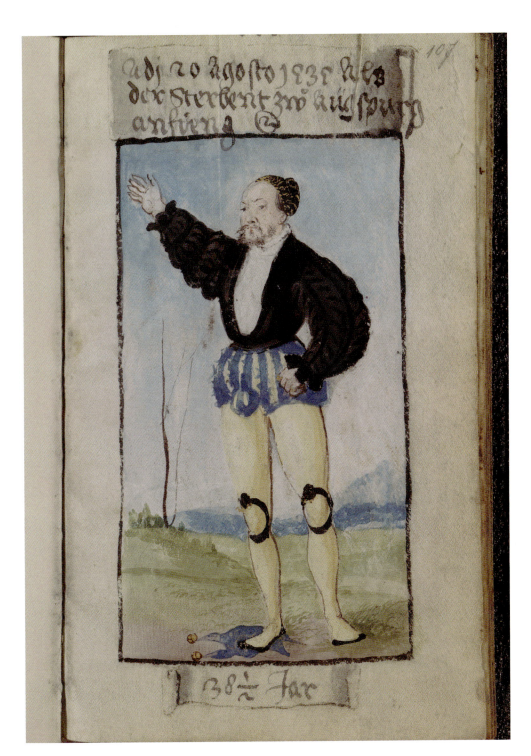

recording tailoring bills in excess of the materials, a new and important benchmark of luxury at the time. The ensemble of open-fronted, slashed doublet and short, paned and pinked trunk hose paired with cross-gartered yellow hose he wore on August 20 epitomizes the body-conscious and brilliantly ornamental male fashions of the pre-Reformation period. (By the time Shakespeare wrote *Twelfth Night* in 1602, though, Malvolio's cross-gartered yellow stockings were a ridiculous, outdated pretension.)

This jaunty outfit has a grim caption: "On the 20th August, 1535, when people in Augsburg began to die." The plague stayed in Augsburg until March 1536. Matthäus survived but the artist responsible for this and most of the other images in the *Klaidungsbüchlein* died.

AUGUST 21

1929

Artists Frida Kahlo and Diego Rivera were married at the town hall in Coyocán, Mexico. Kahlo wore a traditional Mexican blouse, skirt, and *rebozo* (shawl) she had borrowed from her maid. Normally, she preferred the plain, functional work wear favored by young Communists, sometimes even wearing men's clothing. But she appreciated how the long, full skirt hid her legs, shriveled by childhood polio, and the brace she wore on her right foot, damaged in an accident. After the wedding, with Diego's encouragement, she began wearing colorful, traditional Mexican-Indian costumes with flowing skirts, elaborate hairstyles, and dramatic jewelry, immortalized in her many self-portraits. When the couple moved to San Francisco in 1930, the photographer Edward Weston said of Frida: "Dressed in native costume even to huaraches, she causes much excitement on the streets of San Francisco. People stop in their tracks to look in wonder."

AUGUST 22

1825

To celebrate the fiftieth anniversary of the American Revolution, the US government invited the sixty-six-year-old Marquis de Lafayette, the French aristocrat who had served valiantly as a commander in the Continental Army, to take a year-long tour of America, beginning in August 1824. Lafayette reconnected with the people and places he had come to know during the war and visited all twenty-four states of the Union, discovering how

much the nation had grown and prospered in his absence.

Everywhere he went, the "nation's guest" was welcomed with balls, banners, and parades, as well as wearable merchandise like ribbons, handkerchiefs, gloves, fans, and even waistcoats printed with his portrait. One Philadelphia newspaper commented: "Everything is Lafayette, whether it be on our heads or under our feet. We wrap our bodies in Lafayette coats during the day, and repose between Lafayette blankets at night." In 1832, Frances Trollope joked in *Domestic Manners of the Americans* that "the reception of General Lafayette is the one single instance in which the national pride has overcome the national thrift."

From New York to New Orleans, Lafayette was wined and dined, lauded and lavished with praise. Because many of the dinners and meetings he attended were for men exclusively, evening receptions and balls were the only opportunities for women to indulge in patriotic display and hero-worship. At one ball, "more than four hundred ladies were introduced to Lafayette," his secretary, Auguste Levasseur, recorded.

Guests at many of these events carried fans or wore white kid gloves (available in men's and ladies' styles) stamped with Lafayette's portrait and the phrase "Welcome Lafayette." One night in Philadelphia, the Marquis started to kiss the hand of a lady and found himself gazing into his own eyes. Politely protesting that he did not care to kiss himself, he made a low bow instead.

Several garments and other artifacts associated with Lafayette's tour have survived, an indication of the excitement surrounding the once-in-a-lifetime chance to meet the hero of the Revolutionary War, including a brocaded satin gown trimmed with gauze ruffles and dog-tooth edging that was worn to a ball at Mason's Hall in Culpeper, Virginia. Captain Philip Slaughter recorded that dinner was served "under a tent in a garden . . . covered with five hundred yards of brown linen. We had an elegant dinner, and drank thirty toasts" before the dancing began at 9 p.m. Lafayette and his companions left town at 6 o'clock the next morning for another long day of travel followed by similar evening entertainments.

Culpeper was one of the last stops on Lafayette's tour, and Levasseur noted that "although in all these towns the progress of Lafayette was marked by popular festivals, he could not avoid feeling pained by the recollection that in a few days he was about to leave, perhaps for ever, a country which contained so many objects of his affection." Lafayette died in 1834 without ever returning to America.

AUGUST 23

1614

When he visited Sir William Pope at Wroxton Abbey in Oxfordshire during one of his "progresses" around his kingdom, James I of England (James VI of Scotland) left behind a matched set of falconry accessories, including a velvet-lined leather gauntlet, a pouch, and a lure trimmed with tassels and gold braid and beautifully embroidered in silk, gold, and silver threads with a pattern of blackberries and mistletoe, which were considered protective talismans in Scottish folklore. According to Thomas Warton's *Life of Sir Thomas Pope*, Pope "entertained the king with the fashionable and courtly diversions of hawking and bear-baiting."

AUGUST 24

1943

Disguised as construction workers, two members of the Danish resistance group Holder Danske smuggled explosives into the Copenhagen Forum, Scandinavia's largest exhibition hall, which the Nazis were converting into barracks. Later that night, the city awoke to the sound of a massive explosion that destroyed the building just one day before it was scheduled to reopen. It was the most spectacular of many daring acts of sabotage against the occupying Germans.

AUGUST 25

1944

WORN ON
THIS DAY

On the day that Paris was liberated by General Philippe Leclerc and his Second French Armored Division, along with American infantry, a member of the French resistance added the final inscriptions to a crepe blouse embroidered with patriotic symbols and slogans.

The embroidered motifs include French, English, and American flags (which conveniently shared the same blue, white, and red color scheme); the two-barred Cross of Lorraine, the symbol of General Charles de Gaulle's Free French forces; and, on the cuffs, "Honneur" and "Patrie" ("Honor" and "Country"). Bouquets hold asters, cornflowers, and poppies—native wildflowers symbolizing memory and loss.

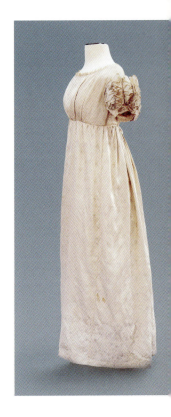

OPPOSITE, ABOVE:
Blouse with patriotic motifs, gown made for Lafayette's tour of America

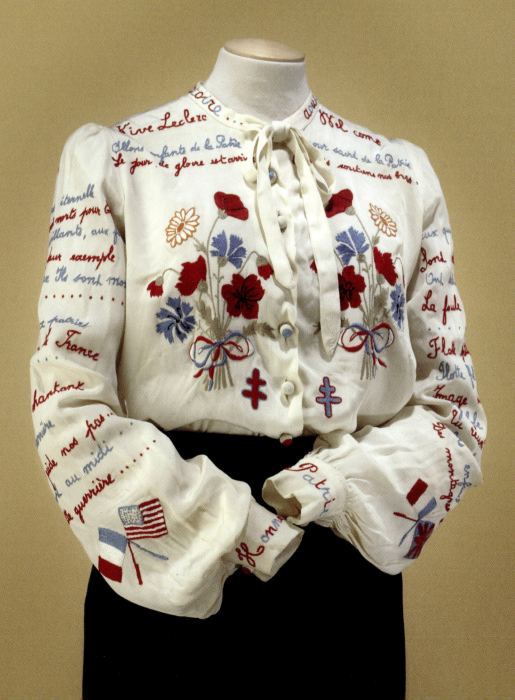

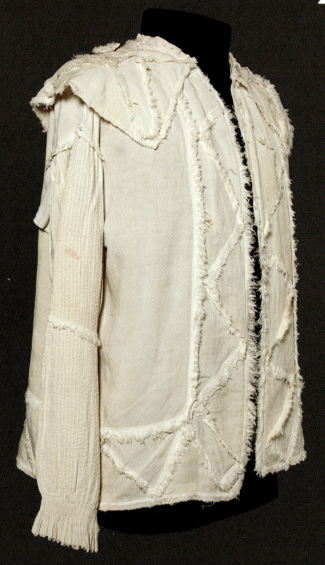

"A COMPLETE
MARKSMAN"

Much of the embroidered text consists of verses from patriotic songs, including the popular World War I songs "It's a Long Way to Tipperary" and "La Madelon"; Victor Hugo's "Hymne," written in honor of the victims of the July Revolution of 1830; and the Marseillaise, the French national anthem.

The couturier Pierre Balmain spent the evening of August 25 at his colleague Cristóbal Balenciaga's apartment. "We all knew that Paris was about to become free again," he wrote in his memoirs. "Suddenly police cars arrived, announcing through loudspeakers that General Leclerc had reached the city. At that moment, in spite of the curfew and the blackout, all the windows of the Avenue Marceau lit up and everyone came out on to the balconies." All over the city, church bells began to ring. "As if with one mind, the whole avenue began singing the Marseillaise." Undoubtedly, this blouse was worn proudly at the victory celebrations.

AUGUST 26

1805

On "a clear cold morning," the Corps of Discovery Expedition "set out at Sunrise and proceeded with our big coats on," reaching the head of the Columbia River in Idaho, according to the journal of Sergeant John Ordway. Lieutenant William Clark—of Lewis and Clark fame—"derected [*sic*] the men to mend their Mockessons [*sic*]" so they could go out hunting early the next morning, as they had run out of meat. Earlier in the expedition, Ordway had observed that "one pair of good mockins [*sic*] will not last more than about 2 days. Will ware [*sic*] holes in them the first day and patch them for the next."

AUGUST 27

1776

In the Battle of Long Island, Captain Abraham Duryea wore a fringed linen hunting shirt instead of a uniform. A uniquely American garment first worn in the Virginia backcountry, the hunting shirt was sometimes called an "Indian shirt," indicating a possible link to Native American dress. When expert riflemen from Pennsylvania, Maryland, and Virginia arrived in Boston to join the Continental Army in the summer of 1775, many of them wore similar shirts. Unlike standard men's shirts, which

OPPOSITE: Fringed linen hunting shirt

were open only at the neck and went on over the head, hunting shirts were often open all the way down the front, like coats, with large cape collars and decorative geometric patterns in raveled strips of linen (likely inspired by Native American adaptations of European-style linen shirts). They were easy to put on, remove, and layer, and could be belted tight for a close fit.

As the fame of the backcountry riflemen spread, General George Washington encouraged his troops to wear the distinctive shirts, believing they gave the Continental Army a psychological advantage. On July 24, 1776, Washington wrote that he "earnestly encourages the use of hunting shirts," which were "justly supposed to carry no small terror to the enemy, who think every such person a complete marksman." He also found them "cheaper and more convenient" than wool uniforms, as they could be layered over warm waistcoats in winter.

Duryea's shirt has lost its left sleeve, possibly as a result of damage sustained in battle. It is a rare surviving example of the Continental Army's secret weapon in the American Revolution.

AUGUST 28

2014

President Barack Obama wore a tan suit to a White House press conference, during which thousands of comments disparaging the suit were posted on Twitter. Although he had worn the same suit (with a different tie) on Easter Sunday, it now went viral. After the *Washington Post* covered the reaction in a story headlined "Twitter Nation distracted by president's tan suit," White House Press Secretary Josh Earnest announced: "The president stands squarely behind the decision he made yesterday to wear his summer suit." In certain circles, the tan suit controversy is still jokingly referred to as the biggest scandal of "No-Drama Obama's" presidency.

WORN ON
THIS DAY

AUGUST 29

2018

"Queen of Soul" Aretha Franklin, who died August 16, lay in state in Detroit for a two-day public viewing in appropriately regal garb:

a full-skirted, tea-length, beaded red lace and chiffon dress, red lip-stick, and five-inch red patent-leather Christian Louboutin stiletto heels, followed by an overnight wardrobe change into a shimmering baby blue dress with silver heels. Thousands of fans stood in line for hours to pay their R-E-S-P-E-C-Ts.

AUGUST 30

2005

Having lost everything when Hurricane Katrina destroyed his home in the Ninth Ward of New Orleans the previous day, survivor Jeremiah Ward fashioned a pair of makeshift shoes out of a cigar box. Photos of Ward's cardboard-clad feet and other scenes of Katrina's devastation shocked Americans and won a Pulitzer Prize for the *Dallas Morning News*.

AUGUST 31

1902

Wealthy widow Emily Stevens Ladenburg caused a sensation in the fashionable resort town of Saratoga Springs, New York, when she went horseback riding in an ankle-length split skirt rather than the usual skirted riding habit. While adventuresses like Annie Oakley had worn split skirts and eschewed ladylike side-saddles, Ladenburg was the first to do so in polite society.

FROM YELLOW STARS TO NAVY UNIFORMS

SEPTEMBER

1	2	3	4	5	6	7
A German Jew's "badge of shame"	The Prince of Wales's sailor suit	Disguise worn by Frederick Douglass to escape slavery	A big, fat, and wide bridal gown	Peter the Great's beard tax levied	Reversible Royal Flying Corps officer tunic	Gabrielle "Coco" Chanel does Dallas
1941	**1846**	**1838**	**1759**	**1698**	**1917**	**1957**

8	9	10	11	12	13	14
A Liberty of London wedding gown	An infant queen is crowned	Madeleine Albright's peace process pins	Shoes worn by a World Trade Center survivor	Raw meat dress worn by Lady Gaga	Minimalist motorcycle gear makes history	Isadora Duncan's deadly scarf
1891	**1543**	**1997**	**2001**	**2010**	**1948**	**1927**

15	16	17	18	19	20	21
Hot-air balloon launches fashion trends	Dressing for nighttime Zeppelin raids	An immigrant family gets tagged	The red dress that caught President Reagan's eye	Belgian beauty pageant ballgowns	Tennis dress worn by Billie Jean King	Carolyn Bessette's wedding gown
1784	**1916**	**1950**	**1985**	**1888**	**1973**	**1996**

22	23	24	25	26	27	28
"The best way of seeing the coronation"	Crash helmet worn by an airmail ace	Queen Victoria's "smart" new bonnet	"No ordinary first day of school"	Tear gas sparks an Umbrella Revolution	Prosthetic legs worn on the runway	Wrapping up for wing-walking
1761	**1911**	**1854**	**1957**	**2014**	**1998**	**1980**

29	30					
Eyewear for unprecedented altitudes	Fashion designer makes WAVES					
1921	**1942**					

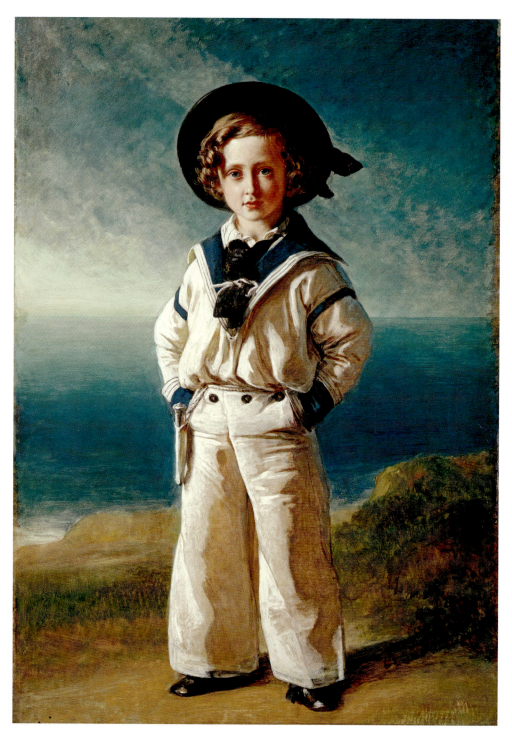

SEPTEMBER / 02

09 / 01

— **1941** —

From this day, Jews in Germany were required to wear a yellow Star of David sewn to their clothes. "That badge of shame had in German eyes branded me for four years as an outcast to society," wrote Inge Auerbacher in her memoir *Beyond the Yellow Star to America*. When she was liberated from the Theresienstadt concentration camp on May 8, 1945, she "tore the yellow Star of David with the word 'Jude,' meaning Jew in German, off. . . . On that day I was reborn. May 8 became my second birthday."

SEPTEMBER 2

1846

Sailing on the royal yacht off the coast of Jersey, four-year-old Bertie, Prince of Wales "put on his sailor's dress, which was beautifully made by the man on board who makes for our sailors," his mother, Queen Victoria, recorded in her diary. "When he appeared, the officers and sailors, who were all assembled on deck to see him, cheered, and seemed delighted with him."

Bertie's sailor suit, which survives in the National Maritime Museum as well as being immortalized in Franz Xaver Winterhalter's 1846 portrait, consists of a white linen frock (or middy, for "midshipman") with blue twill-tape "strips of the watch" on the sleeves and fall-front linen trousers, with a miniature rigging knife on a rope belt. The frock's collar and cuffs of blue jean have three stripes of white tape in imitation of the uniforms of the royal yacht's crewmen. Since the early nineteenth century, sailors had worn frocks, with their distinctive square-cut open collar. But it was only in 1857 that this tradition was formalized in the uniforms of the Royal Navy.

Bertie's suit was a novelty at the time, but it soon became fashionable to dress children of both sexes in British-style sailor suits.

OPPOSITE: Bertie's sailor suit

The same factors that made them practical as uniforms—they were washable, comfortable, and could be mass-produced to outfit entire ship's crews without precise sizing—made them ideal for growing children. Sailor suits worn by everyone from the Romanov and von Trapp children to modern-day Japanese schoolgirls have inspired iconic pop-culture counterparts like *Sailor Moon*, a Japanese manga series.

SEPTEMBER 3

1838

Frederick Douglass escaped slavery in Baltimore by disguising himself as a sailor. After a previous escape attempt had failed, his master had hired him out to work in the city's shipyards, and he drew on his knowledge of "ships and sailor's talk" to pass as a free black sailor. "I had on a red shirt and a tarpaulin hat and black cravat, tied in sailor fashion, carelessly and loosely about my neck," Douglass wrote in his autobiography. He borrowed a sailor's protection pass from a friend, though he bore little resemblance to the physical description given on the paper. Had the conductor on the train that carried him to freedom examined it closely, "he could not have failed to discover that it called for a very different looking person from myself," Douglass wrote.

SEPTEMBER 4

1759

For her wedding to Aelbrecht, Baron van Slingelandt, at the Kloosterkerk in the Hague, twenty-two-year-old Helena Slicher wore a hooped gown more than six feet wide. Its cut is based on an English mantua, a coat-like gown draped and pleated on the body and worn with a matching underskirt. But the overskirt has a long, pleated train in the continental court style, giving it a more dramatic and formal appearance.

The hoop petticoat supporting this bridal behemoth was probably made of linen ribbed with whalebone, meaning baleen, the strong but lightweight and flexible material that takes the place of

OPPOSITE:
Helena Slicher's wedding gown

teeth in some species of whales. The gown's sleeves are fitted with two small round lead weights, and the folds of the train are reinforced with thick paper, ensuring that it kept its smooth, stiff lines.

The plain white silk combined with the enormous hoop, triple sleeve ruffles, and train act as a vast blank canvas for the gown's chief attraction: an embroidered garden of parrot tulips, auricula, dianthus, and Oriental poppies rendered in polychrome silk. With a wedding dress like this, who needs a bouquet?

SEPTEMBER 5

1698

In an effort to bring Russia in line with its cleanshaven Western European neighbors and simultaneously finance his war with Sweden, Peter the Great imposed a tax on beards. Men who paid a hundred rubles per year received a "beard token," which they were required to carry at all times. The unpopular tax was abolished in 1772.

SEPTEMBER 6

1917

After being shot down and captured on December 14, 1915, Second Lieutenant Gilbert Insall escaped from the Strohen prisoner of war camp in Germany with the help of his reversible Royal Flying Corps officer's uniform tunic, which could be turned inside-out to resemble a civilian jacket. Nine days after tunneling out of Strohen, he reached neutral Holland, a feat for which he was awarded Britain's Military Cross.

SEPTEMBER 7

1957

It really was her first rodeo. When Gabrielle "Coco" Chanel visited Texas as a guest of Stanley Marcus, the founder of the Neiman Marcus department store in Dallas, he entertained her with a Western-style hoedown at his brother's farm, where the festivities included a cow fashion show. Seated under the stars on folding chairs at tables covered in red-checkered tablecloths, guests watched as "a pair of unlikely newlyweds sud-

denly appeared in the converging beams of a number of spotlights," Chanel remembered. "A very young bull stuffed into evening clothes and wearing a top hat between his horns, and an equally young heifer in white Chanel with a long veil."

Today, Chanel is a fashion legend, but, at the time, she was at a low ebb in her career. With her business and reputation ruined by World War II—which she had spent holed up in her suite at the Ritz with a German officer thirteen years her junior—Chanel had staged a comeback in 1954. But her first collection was a dud; few French editors or clients were ready to forgive and forget. It was Chanel's successful conquest of America, orchestrated by Marcus, that put her back in fashion in France.

In 1938, Marcus had established the Neiman Marcus Award for Distinguished Service in the Field of Fashion. Dubbed the "Oscars of the Fashion Industry," the award gave Marcus an excuse to bring top fashion designers and style-setters to Dallas. With the company's fiftieth anniversary approaching in 1957, Marcus needed a headline-grabbing guest of honor. Who was more Oscar-worthy than Chanel? On September 6, he collected a white-gloved, pearl-draped Chanel from Love Field in a white Rolls Royce, one of a fleet the company had provided for the anniversary celebrations. She would spend three weeks in Dallas, later telling the *New Yorker*: "I liked very much Texas. The people of Dallas, ah, je les aime beaucoup. Très gentils, très charmants, très simples. [Ah, I love them a lot. Very nice, very charming, very simple.]"

If Chanel's early success depended on the indispensable little black dress—the "Ford" of dresses, as *Vogue* called it in 1926—her unlikely second act was propelled by the iconic Chanel suit she wore to the hoedown. As Diana Vreeland wrote in her autobiography, *DV*: "These postwar suits of Chanel were designed God knows *when*, but the tailoring, the line, the shoulders, the underarms, the *jupe*—never too short, never making a fool of a woman when she sits down—is even today the right thing to wear." Typically made of humble, masculine textiles like tweed and bouclé, they were feminized with gold buttons and luxurious linings, the hems weighted with chains for a smooth line. Although many attempted to knock them off, Chanel's exacting standards could not be mass-produced. This precursor of the power suit signaled women's entry into the workplace and Chanel's reentry into the upper echelons of the fashion pantheon.

1891

For her marriage to Barrow Cadbury in Birmingham, Geraldine Southall wore what the *South Birmingham News* described as "a Grecian gown of white Pongee silk." Also known as Shantung, Pongee is a fine, undyed silk. Though the gown gives the impression of toga-like looseness and comfort, its soft folds conceal a tight-fitting bodice.

The gown came from the Liberty of London department store, founded in 1875 by Arthur Lasenby Liberty. The son of a Buckinghamshire draper, Liberty worked in the family business, but he was more interested in painting, literature, and history and felt stifled by the mercantile world. Inspired by the International Exhibition of 1862—a display of artistic and industrial marvels from around the world, held in London—Liberty began selling textiles, porcelain, and curios imported from the Far East.

Among the buyers of the supple, softly colored Asian textiles Liberty popularized were artists and dress reform advocates, who saw them as refreshing antidotes to modern machine-made textiles and garish aniline dyes. He counted among his friends and clients the avant-garde painters James McNeill Whistler, Lawrence Alma Tadema, Edward Burne-Jones, and Dante Gabriel Rossetti. These men rejected contemporary fashion and looked to the past—especially antiquity and the Middle Ages—for a more attractive, handcrafted alternative, dressing their wives and models in loose, flowing dresses and hairstyles inspired by historical artworks.

Liberty recognized that his exotic wares would appeal not just to artists and radical dress reformers, but also to middle- and upper-class women who wanted to emulate—within reason—this so-called Aesthetic look. But before Liberty could reach the masses, he needed a better product: textiles that combined the muted tints and superior draping properties of Asian imports with the strength and colorfastness of industrialized Western manufactures. He worked with British weavers and dyers to develop textiles using raw materials imported from Asia. His "Liberty Art Fabrics" were more durable, more responsive to trends, and better suited to the British climate than the delicate Asian imports they imitated.

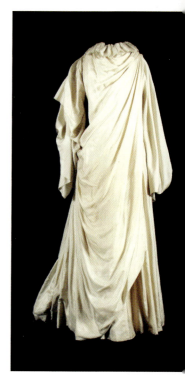

OPPOSITE, ABOVE:
Dressed for a cow fashion show, a Grecian-inspired wedding gown

WORN ON THIS DAY

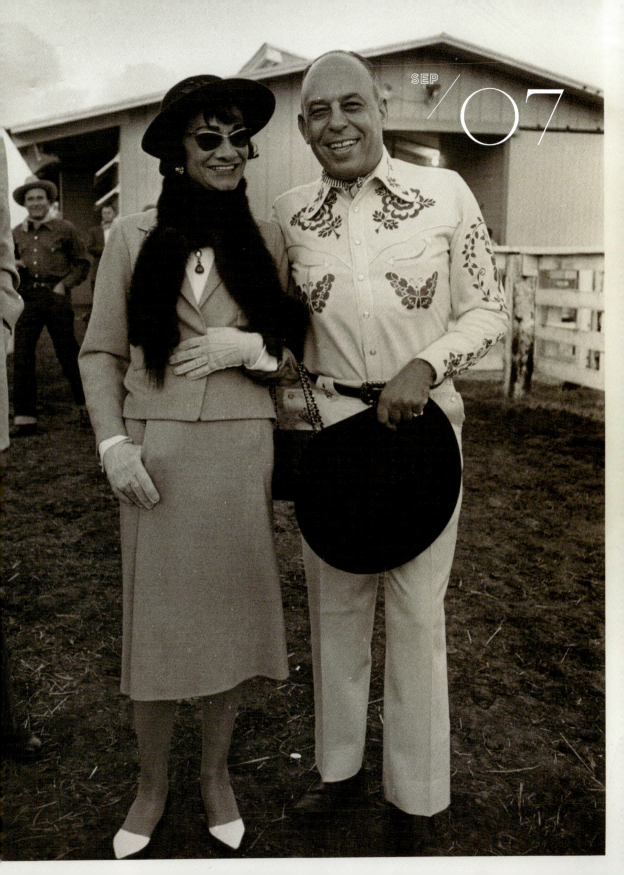

To showcase his textile offerings, Liberty opened a costume department selling gowns in the firm's distinctive textiles, produced in-house or by small commercial studios. Although they evoked classical or pastoral simplicity, this effect was often achieved through time-consuming handcrafted details like embroidery or smocking. Oscar Wilde declared Liberty to be "the chosen resort of the artistic shopper." In a 1905 catalog, Liberty boasted of emancipating women "from slavish subjection to passing fashion," adding that "Classic, Renaissance, and Empire styles" had been "absorbed into each other, reincarnated, but never lost, because they were good and true in principle."

SEPTEMBER 9

1543

At her coronation in the Chapel Royal at Stirling Castle, nine-month-old Mary, Queen of Scots, was too tiny to wear the crown, so Cardinal Beaton held it over her head instead. Sir Ralph Sadler, the English ambassador to Scotland, reported to Henry VIII that "the ceremony was carried out with such solemnity as they do use in this country, which is not very costly."

SEPTEMBER 10

1997

Madeleine Albright began her first tour of the Middle East by meeting with Israeli prime minister Benjamin Netanyahu in hopes of restarting the regional peace process. America's first female secretary of state had amassed a large collection of pins during her years as US ambassador to the United Nations, which she deployed strategically when dealing with other world leaders. "I devoted more time to the Middle East than to any other region," Albright wrote in her 2009 memoir *Read My Pins: Stories from a Diplomat's Jewel Box.* "Although I often wore the dove, I found cause—when displeased with the pace of negotiations—to substitute a turtle, a snail, or, when truly aggravated, a crab." During a meeting with Yasser Arafat in Gaza City in 1999, Albright wore a pin in the shape of a bee. "I spent many hours wrangling with the Palestinian leader about the need for compromise in the Middle East," she remembered. "My pin reflected my mood."

ABOVE: Shoes worn on 9/11

2001

Linda Raisch-Lopez was at her desk on the ninety-seventh floor of the World Trade Center's South Tower at 8:46 a.m., when hijackers aboard American Airlines Flight 11 crashed the plane into the North Tower, directly opposite her window. "We heard a loud boom and we saw flames and paper by the windows," Raisch-Lopez told the *Hudson Reporter*. "When we saw that, some people started screaming." The intense heat of the explosion was "coming through the glass."

As she evacuated the building, Raisch-Lopez took off her new yellow heels to navigate the crowded stairwells. She had almost reached the sixtieth floor at 9:03 a.m., when a second plane struck the South Tower between the seventy-seventh and eighty-fifth floors, throwing her against the wall. Once on the ground, she put her shoes back on to flee north to the Hudson Pier through the debris-strewn streets of Lower Manhattan. It wasn't until she got off the ferry in New Jersey, where she lived, that she realized they were covered in blood. "I just wanted to get home to my kids," she explained.

The 9/11 Memorial Museum on the former site of the World Trade Center has more than thirty pairs of survivors' shoes, much more than any other category of artifact. Most of them are damaged and dirty, scuffed and scratched; some are partially melted, blistered, or bloodstained, like these. When their wearers put them on the morning of September 11, they could not have known that their choice of shoes could mean the difference between life and death as they fled the burning (and, finally, collapsing) Twin Towers. Survivors reported seeing piles of abandoned heels in the stairwells. Some of those who descended in their stocking feet had to borrow shoes or put on a stranger's abandoned shoes. The Battery Park tunnel connecting Lower Manhattan to Brooklyn was blanketed by shoes left behind by commuters who were told to abandon their cars and run for their lives. Local residents found dusty shoes and firemen's boots scattered around Ground Zero for weeks afterward.

World Trade Center survivors saved their shoes for a number of reasons: as reminders of their escape, or as relics of the 2,606 who died. Many forever changed their footwear buying habits, choosing

practical, comfortable shoes that won't slow them down in an emergency. Today, these artifacts allow us to imagine what it must have been like to be in their shoes on that dark day.

SEPTEMBER 12

2010

Lady Gaga wore a dress, hat, purse, and boots made of raw meat to the MTV Video Music Awards, where she accepted the award for Video of the Year. Created by designer Franc Fernandez out of flank steaks from his family butcher, it was her third and final outfit of the night, accessorized with blue-streaked hair, diamond bracelets, and a visible thong. Though the dress was immediately condemned by PETA, Gaga defended it as a reminder that "if we don't fight for our rights, pretty soon we're going to have as much rights as the meat on our own bones." The ensemble was carefully taxidermied for display at the Rock and Roll Hall of Fame.

SEPTEMBER 13

1948

Roland "Rollie" Free set a new land speed record of 150.3 miles per hour after stripping down to a bathing suit, shower cap, and a borrowed pair of sneakers to race his Vincent motorcycle across the Bonneville Salt Flats in Utah, lying in a prone position along the machine's spine to minimize wind resistance.

SEPTEMBER 14

1927

The famous American dancer Isadora Duncan was riding along the Promenade de Anglais in Nice in her chauffeured convertible. "Affecting, as was her habit, an unusual costume, Miss Duncan was wearing an immense iridescent silk scarf wrapped around her neck," the *New York Times* reported (incorrectly—it was not iridescent, but hand-painted in an Asian-inspired design). The trailing red fringe of the scarf caught in the car's wheel, snapping Duncan's neck. When Gertrude Stein heard of the accident, she quipped: "Affectations can be dangerous."

SEPTEMBER 15

1784

Accompanied by a cat, a dog, and two pigeons, Vincenzo Lunardi made the first successful hot-air balloon voyage in England in front of thousands of spectators, including the Prince of Wales. His feat instantly launched a fashion craze. On October 23, London's *Morning Post* reported that "the *Lunardi bonnet* and the *Lunardi garters* are presently to be followed by the *Lunardi chemise*."

SEPTEMBER 16

1916

During World War I, Londoners took shelter from a nighttime Zeppelin raid in the Tube's underground tunnels. "People were in there in all sorts of queer clothes," Hallie Eustace Miles recorded in her diary. "Some had rushed from their beds to the nearest Tube, carrying their wraps and even their boots in their hands. . . . Women were dressing on the platforms, and pulling on their stockings." Although there was no raid that night, a week later, on September 28, Miles had to grab the long coat, "Zeppelin hat," and "alarm trousers" she kept by her bedroom door and flee to the cellar as bombs fell around her flat.

SEPTEMBER 17

1950

When nine members of the Thiessen family arrived at the port of Halifax from the Ukraine, paper tags indicating their destination were attached to their coats. Immigrants to Canada were issued these tags until the 1960s. Though they served a practical purpose as many of the newcomers did not speak English or French, their resemblance to luggage tags was considered humiliating.

SEPTEMBER 18

1985

White House correspondent Jo Ann Rowe wore "a bright red dress" for a rare press conference with President Ronald Reagan in the early days of

the Iran-Contra scandal. "Red had been declared the favored color of the President, because the First Lady considered it her 'go-to' color," she explained in her memoir, *Not for Public Consumption*. "We who endeavored to attract the President's attention had begun to wear red at every opportunity. Men were lucky and needed to only sport a red tie. Women who chose to display more creative forms of red were rewarded for their efforts by President Reagan, who would then call on them and comment favorably on their color choice." To Rowe's "great delight," the President called on her. But "before I could ask my question, he looked around at his audience and . . . blurted, 'I didn't call on you because you were wearing red! You just caught my eye!' He got the laugh he was aiming for."

SEPTEMBER 19

1888

The first beauty pageant took place in the resort town of Spa in Belgium. A jury of twenty-two men judged nineteen female contestants, "who were all dressed in ballroom costume," the *London Graphic* reported. Eighteen-year-old Marthe Soucaret won the first prize of 5,000 francs. "The announcement caused great wrath among many of the disappointed damsels, some of whom vented their ire in a not wholly becoming manner."

SEPTEMBER 20

1973

Billie Jean King defeated Bobby Riggs in the "Battle of the Sexes," an exhibition match staged at the Astrodome in Houston, Texas. King won $100,000—and the gratitude of women everywhere.

King wore a dress designed for her by Ted Tinling, who had transformed the traditional white palette of tennis clothes (thought to combat unsightly sweat stains) by introducing color, trimmings, and flattering silhouettes. After King declared his original design to be too scratchy, Tinling substituted this backup dress. On the morning of the match, he added rhinestones around the neckline, worried that the harsh lights of the indoor stadium would wash King out. He wanted the thirty thousand spectators and television audience of

ABOVE: Tennis dress worn by Billie Jean King

fifty million to pay attention. King wore blue suede shoes Adidas had made to match the dress.

King won easily in straight sets, proving not just that a woman could beat a man, but that women's tennis was a commercial draw. Though she eventually became friends with Riggs, King continued to fight for Title IX, and she was an early champion of equal purses for male and female tournament players—something only instituted in 2007 at Wimbledon, where the dress code still stipulates that players wear "suitable tennis attire that is almost entirely white."

SEPTEMBER 21

1996

America's most eligible bachelor, John F. Kennedy Jr., married Calvin Klein publicist Carolyn Bessette in an intimate, top-secret ceremony on Cumberland Island, off the coast of Georgia. The bride wore a bias-cut silk crepe slip dress by Narciso Rodriguez, a former Calvin Klein colleague, with a tulle veil, sheer elbow-length gloves, and beaded high-heeled sandals. The couple died in a plane crash on July 16, 1999.

SEPTEMBER 22

1761

When King George II died, his grandson George III put off his own coronation until he could find a suitable bride. When it was finally announced that both a wedding and a coronation would take place in September 1761, the news set off a frenzy of speculation among young ladies of the peerage, who could expect to play a role in the ceremonies. "I wonder if they will name me for train-bearer," Lady Sarah Lenox wrote to a friend. "I wish they would. . . . I think it's the best way of seeing the Coronation."

Lenox ended up being a bridesmaid in the royal wedding instead, but Lady Mary Douglas was one of six train-bearers chosen for the coronation. She wore a bodice made of cloth of gold, decorated with silver embroidery and fully boned with baleen. It originally formed part of a stiff-bodied gown or "royal robe"—England's answer to the *grand habit* worn as court dress elsewhere in Europe. The stiff-

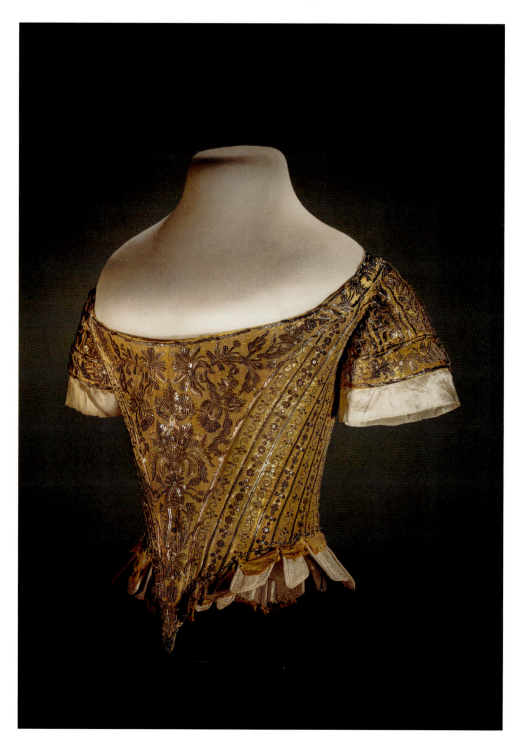

bodied gown was worn only on extremely formal occasions, and generally reserved for female members of the royal family. But there were rare circumstances in which lesser mortals were allowed to don this royal attire. Though there must have been a certain amount of discomfort and inconvenience involved in wearing the heavily boned, off-the-shoulder bodice during the six-hour ceremony in Westminster Abbey, the train-bearers likely relished the opportunity to play queen for the day.

The bodice originally had lace trimmings; tiny holes and loose threads are still visible where they were sewn around the sleeves and neckline. Crude gores have been added at the front and under one arm to enlarge it. The new queen, Charlotte of Mecklenburg-Strelitz, had sent her measurements to the London dressmakers ahead of her arrival in England on her wedding day, and it is likely that the train-bearers—assembled from all over the kingdom—did the same, resulting in an imperfect fit and hasty alterations. The floral embroidery is appliquéd—another time-saving measure. The unfinished hem of the bodice would have been hidden by Lady Mary's skirt, which has not survived.

SEPTEMBER 23

1911

Earle Ovington wore a French-made Roold leather crash helmet when he piloted the first airmail flight over Long Island. Airmail pilots quickly developed a reputation as the daredevils of the skies, flying in all kinds of adverse weather conditions to deliver the mail on time. A regular airmail service between Washington, DC, Philadelphia, and New York City was established in 1918. During its first nine years, there were more than sixty-five hundred forced landings.

SEPTEMBER 24

1854

Queen Victoria was caught in a "pelting" Scottish shower while riding to church at Balmoral in an open carriage. "The Queen said she knew the rain came out of spite because she had on a new

OPPOSITE: Lady Mary Douglas's coronation bodice

bonnet—a very pretty white silk capote with feathers," recorded Eleanor Stanley, one of her ladies-in-waiting. "We all agreed most cordially with H.M. that it did always rain when one was smart."

SEPTEMBER 25

1957

In 1954, the landmark Supreme Court case *Brown v. Board of Education* mandated the integration of public schools. Carlotta Walls was the youngest of the "Little Rock Nine" who volunteered to be Little Rock Central High School's first black students. On her first day of school, Walls had to be escorted past protesting segregationists by the army and the national guard. Once inside, she and her fellow black students were banned from participating in extracurricular activities. They were taunted in the hallways and pushed in the lunch line. Eventually, the Arkansas governor closed the school for a year to circumvent the court. But Walls returned for her senior year in the fall of 1959. In February 1960, her family home was bombed. Nevertheless, a few months later, she got her diploma.

In her 2009 memoir *A Mighty Long Way: My Journey to Justice at Little Rock Central High School*, Walls remembered how her "great-uncle Emerald Holloway stopped by the house with a surprise gift for me: cash to buy a brand-new dress for my first day at Central." Though Walls's mother usually made her clothes, "this was no ordinary first day of school, Uncle Em said. The integration of the finest high school in Arkansas would happen just once in our lifetime, and I had to have a dress to match the occasion." She found "the perfect outfit" in a downtown Little Rock department store, a matching blouse and dirndl-style skirt by Sportswear by Sheinberg. The puffed sleeves and tiny waistline accentuated Walls' youth; she was just fourteen years old. The alphabet print is so subtle that it's barely visible in the many black and white photos of that historic day. But it captured Carlotta's love of learning, at any cost.

WORN ON THIS DAY

SEPTEMBER 26

2014

A series of pro-democracy protests began in Hong Kong, dubbed the Umbrella Movement (or the Umbrella Revolution) because demonstrators used umbrellas to shield themselves from pepper spray and tear gas fired

OPPOSITE: Carlotta Walls's first day of school dress

"THIS WAS NO ORDINARY
FIRST DAY OF SCHOOL"

by the Hong Kong Police. As tens of thousands occupied the financial district and solidarity protests erupted on college campuses and around the world, the yellow umbrella became a symbol carried by protestors, emblazoned on banners, and transformed into memes. Though the protests ended December 15, China's leaders remained wary of umbrellas. Journalists covering President Xi Jinping's arrival in Macau on December 19 were banned from holding them, even though it was raining.

SEPTEMBER 27

1998

In Alexander McQueen's Spring/Summer 1999 runway show in London, Aimee Mullins—model, athlete, and double amputee—walked the runway in prosthetic legs made of hand-carved elm wood, complete with high heels and pointed toes. The three-dimensional pattern of grapevines resonated with the romantic naturalism of McQueen's "No. 13" collection.

SEPTEMBER 28

1980

Czech daredevil Jaromir Wagner became the first wing-walker to cross the Atlantic, completing a seven-hour flight from Greenland to Labrador strapped atop a twin-engine plane. As protection against the elements, he wore leather overalls, a skin diver's suit, and woolen underwear.

SEPTEMBER 29

1921

WORN ON
THIS DAY

When he broke the flight altitude record, reaching 40,800 feet, test pilot Lieutenant James Macready "was clothed in the heaviest of furs with special helmet and goggles," according to the *New York Times*. "To insure [*sic*] clear vision a special gelatin was used on the goggles to prevent collection of ice." Macready knew that success depended on protective eyewear; the previous record holder's eyeballs had frozen and suffered permanent damage when he removed his iced-over goggles to change his oxygen tank. A few years later, Macready helped Bausch & Lomb design the first Ray-Ban flight goggles, which inspired the antiglare "Aviator" sunglasses that went on sale to the public in 1938.

1942

When the first class of 119 officers in the US Women's Naval Reserve—better known as the Women Accepted for Volunteer Emergency Service (WAVES)—graduated from the Naval Reserve Midshipmen's School at Smith College, they wore, for the first time, the shipshape uniforms they'd received the previous day.

Hoping to avoid the negative press that had greeted the army's ill-fitting and unattractive Women's Auxiliary Corps (WAC) uniforms issued earlier that year, the navy had recruited Chicago-born couturier Main Rousseau Bocher—known in Paris as Mainbocher—to design uniforms that were both fashionable and functional. "One thing we have kept in mind," explained Lieutenant Commander Mildred H. MacAfee, "is that there should be no effort to dress the women up to look like men."

This was not just an aesthetic imperative but a cultural one. The United States had been fighting World War II for almost a year, and women's service branches were sorely needed to allow more men to fight overseas. But the idea of putting women in uniform remained controversial, and the last thing anyone wanted to do was invite comparisons to their male counterparts. "We did not have double-breasted suits like the navy men, which are unattractive on women," Captain Winifred Quick Collins remembered. "Our black ties—unlike a man's—were knotted to form a bow."

With its navy blue hue, brass buttons, and embroidered propeller and anchor, the officer's uniform drew upon naval tradition without mimicking men—or sacrificing style. The padded shoulders, pinched waists, and shapely collars—Mainbocher's signature—were fashion details that set the WAVES apart from the WACs. "We . . . loved those uniforms, as did the public," Collins testified. "My earlier concern about wearing a man's uniform vanished the moment we received our attractive, feminine Mainbocher designs."

After spending much of his career in Paris dressing socialites like Daisy Fellowes, Millicent Rogers, and Wallis Simpson, Mainbocher had relocated to New York at the outset of the war. He viewed designing the WAVES uniform as his patriotic duty and did it on a volunteer basis; he would go on to design uniforms for the US Coast Guard Women's Reserve (SPARS), the American Red Cross, and the Women Marines.

SEPTEMBER

Mainbocher's chic uniform was the navy's secret weapon for recruiting women to its new service branch. In January 1943, the *New York Times Magazine* declared: "The 'best dressed women of the year' are the women who are wearing uniforms." And syndicated fashion columnist Dorothy Roe quipped: "Uncle Sam's sailor girls can now look the Duchess of Windsor in the eye and say: 'I believe we have the same dressmaker.'"

Mainbocher's uniforms continued to make WAVES after the war ended. "My Navy uniforms were too good to discard," Lieutenant Helen Clifford Gunter remembered. "I ripped the two lieutenant stripes off my jacket, removed insignia from lapels, and changed the brass buttons. Worn under my all-weather raincoat, a civilian beret replacing my officer's hat, the uniforms were transformed into tailored serge suits, appropriate for a New York business woman."

OPPOSITE:
WAVES uniform

OCTOBER

1	2	3	4	5	6	7
Ottowa ornamentation at Fort Pitt	Queen Sirikit of Thailand's Balmain gown	"Trial of the Century" courtroom suit	Battle of Mogadishu combat boots	Mae Belcher's opening night evening cape	Alexander McQueen's "Armadillo" boots	Lady Emma Hamilton's antique "attitudes"
1775	**1969**	**1995**	**1993**	**1912**	**2009**	**1800**
8	9	10	11	12	13	14
Helmet worn in the Great Chicago fire	Malala Yousafzai's school uniform	Writer Mary Wollstonecraft's buoyant clothes	Eleanor Roosevelt's souvenir of Pakistan	Dress worn for a dance with a prince	Disguise worn by Angela Davis on the lam	Al Capone's criminally chic wardrobe
1871	**2012**	**1795**	**1954**	**1860**	**1970**	**1931**
15	16	17	18	19	20	21
The first three-piece suit is worn	An Olympic podium protest	The dress that got derailed	Century-old redingote worn by Louise Six	Bloody sock worn by Red Sox pitcher Curt Schilling	Ball and chain worn by Private John Cook	Admiral Nelson's Trafalgar uniform
1666	**1968**	**1888**	**1881**	**2004**	**1809**	**1805**
22	23	24	25	26	27	28
Twiggy's historical hippie chic	A military chaplain's camouflage kippah	A good luck charm that wasn't	Charge of the Light Brigade uniform	A prime minister's palace protocol	Dress and cape worn by Olympic hostesses	Paper dresses worn by "Nixon Girls"
1970	**1983**	**79**	**1854**	**1973**	**1968**	**1968**
29	30	31				
An escapee's "grimly respectable" disguise	Muhammad Ali's "Rumble in the Jungle" robe	Andy Warhol's uncomfortable Halloween costume				
1943	**1974**	**1977**				

FROM NOSE RINGS TO DIAMOND NECKLACES

'01

— **1775** —

At Fort Pitt (modern-day Pittsburgh), English traveler Nicholas Cresswell witnessed treaty negotiations between the Ottawa and Delaware tribes. "The dress of the [Ottawa] men is short, white linen or calico shirts which come a little below their hips without buttons at neck or wrist and in general ruffled and a great number of small silver brooches stuck in it," he wrote in his journal. "Silver plates about three inches broad round the wrists of their arms, silver wheels in their ears, which are stretched long enough for the tip of the ear to touch the shoulder, silver rings in their noses." They were hairless except for a single lock on the crown of the head, which was uncovered. The Ottawa women wore "the same sort of shirts as the men and a sort of short petticoat that comes no lower than the knee, leggings and Mockeysons [sic], the same as the men."

OCTOBER 2

1969

A short stopover in Bangkok on a trip to Australia inadvertently introduced couturier Pierre Balmain to his best customer, Queen Sirikit of Thailand. After returning to Paris, he received a letter bearing the royal Thai coat of arms. "A high official told me that the Queen wished to order some dresses, and asked me to call at the Palace in the course of my next voyage," Balmain wrote in his autobiography.

In fact, King Rama IX and Queen Sirikit were planning a six-month visit to America and Europe, and the queen "wanted a full wardrobe in the European style"—half a year's worth of clothes, for every occasion, destination, and season. "Thus began for me the most marvelous assignment that a couturier could hope to have," Balmain wrote. He did not just make all of Queen Sirikit's clothes, hats, and furs for the trip, but hired François Lesage to do the embroidery, ordered her shoes from René Mancini, and commissioned twenty-four custom-made Louis Vuitton trunks to carry it all.

WORN ON THIS DAY

OPPOSITE: Queen Sirikit's Balmain dress

OCTOBER / O2

Though their coronation had taken place in 1950, the young royal couple had not yet visited the West. Their 1960 tour of fifteen countries would be their formal debut on the global stage. Queen Sirikit was anxious to establish a distinct national identity, showcasing Thai silks in her Western-style clothes. Balmain was just the man for the job.

"A Queen's wardrobe goes with her into her country's history," he wrote. "Her dresses must carry the stamp of enduring elegance, and guard against the risk of becoming antiquated." In practice, that meant giving Queen Sirikit simple lines and a consistent, instantly recognizable silhouette. There were also practical considerations. Her clothes "must be ready to withstand gusts of wind. The fact that she is also obligated to wear rich jewelry makes it imperative that her clothes carry the stamp of luxurious simplicity." Balmain dressed her in his trademark uncluttered style but used bright Thai silks, so she'd be visible at public events. His strategy worked. Queen Sirikit was instantly catapulted to the International Best Dressed List.

In 1963, Queen Sirikit presented Balmain with a new challenge. Thailand did not have a national dress; it had been slowly westernized over the years, until, in 1941, the government simply issued a decree mandating western clothing. The queen asked Balmain to help her devise a new form of national dress, incorporating Thai silks and traditional garments like hip wrappers and shoulder cloths. Drawing on surviving court textiles and nineteenth-century photographs, Balmain created eight styles evoking traditional wrapped and draped garments, but constructed using Western dressmaking techniques. The queen wore this beautifully embroidered gown to a performance at the National Theatre in Bangkok on October 2, 1969. Called a Thai Chakri, it honors Thailand's past while forging a modern national identity.

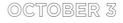

OCTOBER 3

1995

The so-called Trial of the Century came to its dramatic conclusion in a Los Angeles courtroom on October 3, 1995. Former football hero and sometime actor Orenthal James "O. J." Simpson stood accused of brutally murdering his ex-wife, Nicole Simpson, and waiter Ron Goldman on June 12, 1994. The trial was a perfect storm of fame, race, violence, and scandal, and the televised proceedings captivated the public. After sixteen months of lurid

testimony, outsized personalities, and incessant media coverage, the verdict came: as more than one hundred million viewers watched live, Simpson was declared innocent. *Washington Post* media critic Howard Kurtz called it "the most dramatic courtroom verdict in the history of Western civilization."

While the case turned on a bloody leather glove, the sharply tailored Italian suits worn by Simpson and his sprawling "Dream Team" of male lawyers conveyed the impression of successful businessmen from Brentwood, the tony, celebrity-friendly neighborhood where Simpson lived. Though Simpson's public persona had been honed by his suit-clad Hertz commercials as much as by his cleats-wearing NFL career, his courtroom wardrobe was carefully vetted by a team of jury consultants.

On what would be his final day in court, Simpson donned a custom-tailored tan suit by Ermenegildo Zegna, worth more than $2,000. Simpson's white and gold diamond-patterned tie, also by Zegna, closely resembled the one sported by F. Lee Bailey, one of his lawyers, on the same day. Tie sales hit a record high of $1.3 million annually in the United States in 1995, before entering a steep decline as "casual Fridays" and the rise of the youth-driven tech industry introduced a laid-back ethos to the American workplace.

Ironically, Simpson's acquittal suit itself became the subject of a lawsuit when Fred Goldman, father of one of the victims, tried to block Simpson's former manager from selling it for a profit. A thirteen-year legal battle ended in the suit being donated to the Newseum in Washington, DC, after the Smithsonian declined it, deeming it "inappropriate" for their collection.

OCTOBER 4

1993

In the Battle of Mogadishu in Somalia—the deadliest firefight US forces had faced since Vietnam—Army Ranger Specialist Shawn Nelson, like other soldiers in his unit, wore desert combat boots with his blood type ("O-NEG") inked on the collar in case of injury. "You didn't want to jinx yourself," wrote *Philadelphia Inquirer* correspondent Mark Bowden in his account of the battle, *Black Hawk Down.* "But prudence dictated preparing for the worst." In this case, the worst happened: what began as a routine special ops operation estimated to take forty-five minutes ended fifteen hours later, with the loss of eighteen Americans, two Black Hawk helicopters, and hundreds of Somalis. Nelson survived the disastrous mission, and the United States ultimately withdrew from Somalia.

OCTOBER 5

1912

The opening of Adolphus Hotel—the first grand hotel in downtown Dallas—was the social event of the season. Mae Belcher wore a stunning, sable-trimmed sequined evening cape to the opening of the Beaux-Arts building, still a Dallas landmark today. "Clothes are my weakness," Belcher often said. As the wife of a much older man who had made a fortune in mining, it was a weakness she could afford to indulge. She was an early customer of Neiman Marcus, which opened in Dallas in 1907. It was there that she purchased this cape, which she wore with a mocha-colored dress embellished with embroidery and a fringe. Belcher continued to drape herself in mink, jewels, and sequins after her husband's death, as she built a Texas oil empire of her own. She died in 1983, having made, lost, and recovered several fortunes.

OCTOBER 6

2009

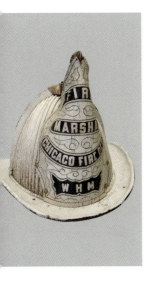

Alexander McQueen presented his Spring/Summer 2010 collection, titled "Plato's Atlantis," at the Palais Omnisports in Paris. It was the first catwalk show to be live-streamed, and the website crashed due to the demand. Among the many wonders on display—digitally printed fabrics, scale-like beading—were the twenty-one pairs of "Armadillo" platform booties simultaneously evoking a lobster's claw, a horse's hoof, and a ballerina's pointe shoe. Each pair was custom-made for the runway, hand-carved from wood and sheathed in leather and iridescent sequins. Though they were not commercially produced, some loyal clients—including Lady Gaga—managed to obtain them. It would be McQueen's last runway show before his suicide on February 11, 2010.

OCTOBER 7

1800

In Dresden, Lady Emma Hamilton performed her famous "attitudes"—a series of dramatic poses inspired by classical art, which became famous in part because she performed them scantily clad in diaphanous robes. "Several Indian shawls, a chair, some antique vases, a wreath of roses, a tambourine, and a few children are her whole apparatus," Melesina St. George recorded in her diary. "Her hair (which by-the-bye is never clean), is short, dressed like an

OPPOSITE, ABOVE:
Mae Belcher's evening cape, Fire Marshal William H. Musham's helmet

antique, and her gown a simple calico chemise, very easy, with loose sleeves to the wrist. She disposes the shawls so as to form Grecian, Turkish, and other drapery, as well as a variety of turbans. Her arrangement of the turbans is absolute sleight-of-hand, she does it so quickly, so easily, and so well."

OCTOBER 8

1871

Fire Marshal William H. Musham wore a metal helmet bearing his initials on the night of the Great Chicago Fire. The blaze started around 9 p.m. in a small barn belonging to the O'Leary family; allegedly, Mrs. O'Leary's cow knocked over a lantern as she was milking it. Unusually dry and windy conditions caused the fire to burn out of control for thirty-six hours, killing an estimated three hundred people and leaving more than one hundred thousand homeless as it tore through Chicago's predominantly wooden structures and sidewalks.

Musham was the first officer to respond to the alarm, out of a force consisting of just 185 firemen and seventeen horse-drawn engines. He would become head of the Chicago Fire Department in 1901, but he was forced to resign in 1904—on the twenty-ninth anniversary of the Great Chicago Fire—after more than six hundred people died in the "fireproof" Iroquois Theatre when it burned down, just weeks after being allowed to open with numerous fire code violations.

OCTOBER 9

2012

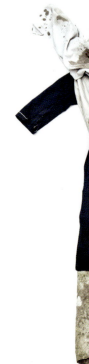

WORN ON THIS DAY

Malala Yousafzai was wearing her school uniform—a traditional *salwar kameez* consisting of a tunic, trousers, and shawl—when she was shot in the head by a Taliban gunman as she took the bus home from Khushal Girls High School in Swat, Pakistan. Though she was only fifteen, she was already an outspoken activist for female education, which the Taliban had banned. "To me, October 9th is not the day I was shot," she said in an interview. "It is the day I survived." Exactly two years and one day later, following multiple surgeries, Yousafzai was awarded the Nobel Peace Prize, making her the youngest (and only the second Pakistani) Nobel laureate.

ABOVE: Malala Yousafzai's school uniform

1795

Distraught over an unfaithful lover, Mary Wollstonecraft—the feminist author of *A Vindication of the Rights of Women*—attempted suicide by throwing herself off Putney Bridge into the icy Thames. Though she first spent half an hour walking on the bridge in the pouring rain to drench her gown, "her cloaths [*sic*] buoyed her up & she floated, & was taken up senseless abt. 200 yards from the bridge, and by proper applications restored to life," her neighbor, Joseph Farington, recorded in his diary. Without naming the "elegantly dressed" woman rescued from the river, the *Times* reported that "about two hours afterward, her coach came, with her maid, and a proper change of apparel, when she was conveyed home, perfectly recovered." Nearly two years later, Wollstonecraft died shortly after giving birth to her daughter, *Frankenstein* author Mary Shelley.

OCTOBER 11

1954

For a dinner celebrating her seventieth birthday, former First Lady Eleanor Roosevelt wore a dress she'd had made from a diaphanous cream-colored silk embroidered with silver purchased in Pakistan on her 1952 trip around the world. During her weeklong stay, she received gifts including a *dupatta* (shawl), a six-foot-long gold-plated necklace, and a handgun. "The spirit of the people of Pakistan is something one does not soon forget," Roosevelt wrote in her 1961 autobiography. "There is courage and great vitality."

OCTOBER 12

1860

When the Prince of Wales, the future King Edward VII, visited New York, America instantly forgot its republican values and welcomed him with open arms. The prince was still a bachelor, and would-be Cinderellas flocked to the ball given in his honor at the Academy of Music. Sarah Didoti Gardiner commissioned a gown from the Paris couture house Worth & Bobergh, where Charles Frederick Worth got his start, for the occasion. Although New York was developing into an international shopping capital, those who could afford to still traveled to Paris to do their shopping. The gown is made

of Lyon silk; the cut velvet has a coral pile on a ground of silver gauze. According to family legend, only two lengths of the fabric were woven, and the other one went to the Tsarina of Russia.

1970

Activist, feminist, former UCLA philosophy instructor, and fugitive Angela Davis was captured at the Howard Johnson Motor Lodge in midtown Manhattan. Wanted by the FBI for murder in connection with an August 7 shootout, she was almost unrecognizable when she was apprehended, wearing a blue button-down shirt, a dark blue miniskirt, and glasses, her famous "Black Power" Afro straightened and pulled back under a short wig. Her arrest triggered a nationwide "Free Angela Davis" movement; John Lennon and the Rolling Stones wrote songs about her. She was acquitted on June 5, 1972.

1931

"Eight shinyshoed gamblers" took the witness stand to testify against Al "Scarface" Capone, who was on trial in Chicago for income tax evasion, according to the *New York Times*. One witness, bookie George Lederman, wore "a diamond-studded belt buckle, looking very much like one of the thirty buckles costing $275 each which Capone bought at one time in 1928." In a fore-echo of political consultant Paul Manafort's 2018 conviction, prosecutors cited Capone's lavish spending on cars, furniture, gambling, and clothes—including "silk shirts at $30 each, silk underwear at $14 a set, sack suits at $135 apiece, . . . ties at $5 (by the dozen)"—as evidence that his income was much greater than he reported to the tax authorities. Several of Capone's clothiers testified in court, drawing gasps and laughter from the solidly middle-American jury, and the media breathlessly chronicled the endless array of colorful suits and pocket squares the dapper don sported during the eleven-day trial. When Capone was sentenced to eleven years in Leavenworth, the *Times* noted that "Capone's obscurity in prison will be in sharp contrast with the figure cut by the flashily dressed gang overlord at his trial," pointing out that he "will have only one suit."

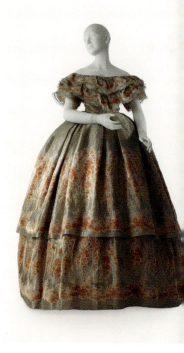

OPPOSITE, ABOVE:
Al Capone at his trial, Louise Six's century-old gown, Sarah Didoti Gardiner's gown

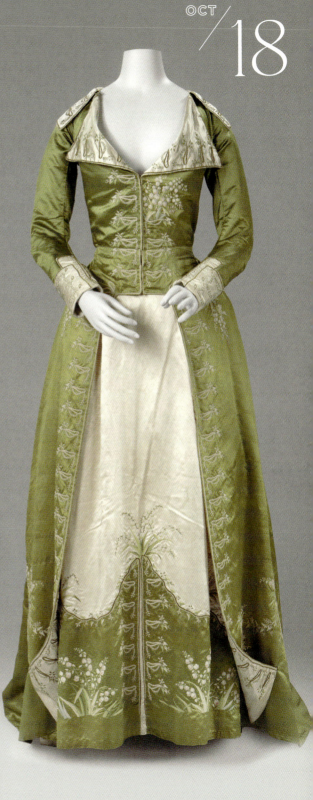

1666

On October 7, 1666, King Charles II "declared his resolution of setting a fashion for clothes, which he will never alter," Samuel Pepys recorded in his diary. The men of his court would no longer wear French fashions, but adopt a new, uniquely English costume: the three-piece suit, with a long coat and vest in place of a doublet. On the 15th, Pepys noted: "This day the King begins to put on his vest, and I did see several persons of the House of Lords and Commons too, great courtiers, who are in it; being a long cassocke close to the body, of black cloth, and pinked with white silke under it, and a coat over it, and the legs ruffled with black riband like a pigeon's leg." He added: "Upon the whole, I wish the King may keep it, for it is a very fine and handsome garment."

1968

At the Olympics in Mexico City, African American sprinters Tommie Smith and John Carlos (who won the gold and bronze medals, respectively) raised black-gloved fists and bowed their heads on the podium at the medals ceremony, as "The Star-Spangled Banner" played. Because Carlos had forgotten to bring gloves to the event, Smith wore his right glove and Carlos wore the left one. While the gesture was widely interpreted as a Black Power salute, Smith later explained that it was a "human rights salute." Both athletes—along with Australian silver medalist Peter Norman—wore human rights badges on their jackets. They took off their shoes, to draw attention to the poverty that plagued black communities. Carlos unzipped his jacket, and wore a black T-shirt to cover the "USA" on his uniform shirt. Smith and Carlos were booed as they left the podium, stripped of their medals, expelled from the team, and subjected to death threats.

WORN ON THIS DAY

1888

While carrying the Tsar and his family home from a tour of the Caucasus, the luxurious Imperial train derailed. Tsarina Maria Feodorovna was in the dining car, which lost its wheels and part of its roof. She survived, bruised and bleeding from flying glass, but twenty-one people died in the accident,

and thirty-five were wounded. The Tsarina spent the next five hours helping the injured in the rain, wearing a blood-splattered and dirt-caked beige silk traveling dress made by Charles Frederick Worth.

OCTOBER 18

1881

Louise Six wore an eighteenth-century *redingote*—a coat-like gown based on a man's riding coat—in a *tableau vivant* at her aunt and uncle's silver wedding anniversary party, the low neckline filled in with a thin shawl. The gown had belonged to a Six family ancestor, who likely first wore it around 1786.

The one-hundred-year-old garment was probably preserved for its exquisite embroidery in a lily-of-the-valley motif, which echoes the decoration found on men's coats of the late eighteenth century, complete with *trompe l'oeil* buttonholes, one stuffed with an embroidered bouquet. The combination of moss green and pale pink was popular in the 1780s. While many historic garments have been preserved for centuries in family's dressing-up boxes, such use often results in alterations and damage, making this rare survival all the more unique.

OCTOBER 19

2004

As he warmed up before Game 6 of a tense league championship series, Boston Red Sox pitcher Curt Schilling tore the sutures in his recently repaired right ankle tendon. His white sock turned red as blood seeped through. Schilling pitched anyway, and the Sox won the "Bloody Sock Game," going on to win the league championship and Boston's first World Series since 1918. Schilling threw the sock away at the end of the game, but he sold another bloodstained sock worn in Game 2 of the World Series for $92,163 in 2013.

OCTOBER 20

1809

At Fort Bellefontaine in Missouri, Private John Cook was allowed to remove the ball and chain that had been attached to his ankle for eighteen days—a form of punishment the US Army introduced in the late eighteenth century as an alternative to flogging, which had proved ineffectual.

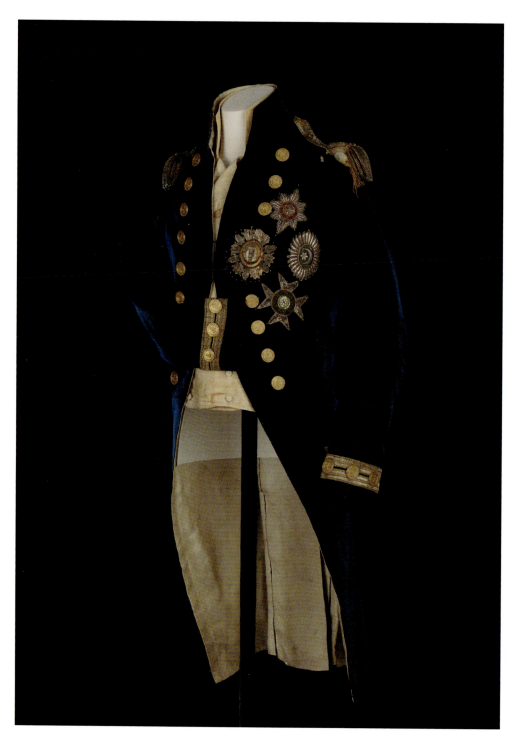

1805

The Battle of Trafalgar was a bittersweet victory for the English. The formidable Royal Navy defeated the combined French and Spanish fleets, foiling Napoleon's ambitions to invade England. But the heroic Admiral Horatio Nelson was fatally wounded by a musket ball to the shoulder. "We do not know whether we should mourn or rejoice," the *Times* of London reported. "The country has gained the most splendid and decisive Victory that has ever graced the naval annals of England; but it has been dearly purchased."

Nelson died wearing his vice-admiral's undress uniform. The hole made by the fatal bullet is visible close to the damaged left epaulette. A small loop on the right sleeve of the coat attaches the end to a lapel button; Nelson had lost his right arm in the disastrous Battle of Santa Cruz de Tenerife in 1797. The coat is made of wool in the deep blue-black color used in Royal Navy uniforms, which had only recently become known as "navy blue" thanks to Nelson's well-publicized exploits.

The impressive insignia sewn to the left breast of Nelson's coat—the "perfect constellation of stars and orders" described by Melesina St. George—included the Order of the Bath, the Order of the Crescent, the Order of Ferdinand, and the Order of St. Joachim. But these glittering decorations may have inadvertently led to his death, as they would have reflected the sunlight and identified the admiral to the enemy. According to one account of the battle, Nelson refused to take them off despite the risk, saying: "In honor I gained them; in honor I will die in them."

After he was wounded, Nelson was carried below the deck of his ship, the H.M.S. *Victory*. He supposedly had the presence of mind to cover his face and decorations with his hand or handkerchief, so his men would not recognize him and lose morale. He lived just long enough to learn that England had won the day, commenting: "Thank God I have done my duty." Instead of being buried at sea, Nelson's body was preserved in a barrel of brandy so it could be transported back to London for a four-hour state funeral in St. Paul's Cathedral.

Today, a statue of Nelson looks down on Trafalgar Square in London, and Nelson's signal to begin the battle—"England expects every man will do his duty"—has passed into popular parlance. October 21 is still celebrated as "Trafalgar Day" in the United Kingdom, and Nelson's Trafalgar

OPPOSITE: Horatio Nelson's Battle of Trafalgar uniform

uniform is proudly displayed in the National Maritime Museum at Greenwich. After visiting the museum in 1926, Virginia Woolf wrote in her diary: "Behold if I didn't burst into tears over the coat Nelson wore at Trafalgar with the medal which he hid with his hand when they carried him down, dying, lest the sailors might see it was him. . . . I read it all when I came in, & could swear I was there on the *Victory*."

OCTOBER 22

1970

Lesley Hornby, the stick-thin model nicknamed "Twiggy," wore a Renaissance-style evening gown to the *Daily Mirror* Fashion Celebrity Dinner in London. Made by Scottish designer Bill Gibb from pastel panels of silk brocade and glazed cotton furnishing fabric, it was inspired by German artist Hans Holbein's circa 1520 drawing of the wife of a prosperous citizen of Basel.

Gibb's clothes transported their wearers into realms of fantasy, perfecting the artful mash-up of ethnic and historical influences that characterized the hippie era. In contrast to the sleek surfaces of the Space Age, his pieces were unabashedly decorative and tactile, mixing patterns and textures in a kaleidoscope of color. Gibb used exuberantly patterned textiles designed by his then-boyfriend Kaffe Fassett and intricate, chunky knits crafted by Mildred Bolton. After graduating from art school, Gibb worked as a freelance designer for Baccarat. Harrods, the London department store, opened a "Bill Gibb Room" in 1970. Shortly thereafter, Twiggy got in touch.

Twiggy is often associated with the mod, miniskirted 1960s. The impish, androgynous teenager with the huge eyes ringed by false lashes exploded onto the fashion scene when she was discovered at a hair salon and named the "Face of '66" by the *Daily Express*. But she continued to be a fashion leader in the era of maxi dresses and hippie chic, growing out her famed pixie cut and wearing her blond hair long and crimped like a pre-Raphaelite maiden.

Twiggy was Gibb's best advertisement. She would wear his

WORN ON
THIS DAY

billowing, bohemian gowns to the London and New York premieres of her 1971 film debut *The Boyfriend*. She also modeled them for fashion magazines. In April 1970, *Vogue* reported that "Twiggy brought her long looks to New York and they look irresistible here, too." She was pictured wearing Gibb's patchwork suede jacket and pleated tartan midi skirt for Baccarat with lace-up boots against the backdrop of the Russian Tea Room.

In 1972, Gibb launched his own label, but he was a better designer than businessman, and never achieved the success his talent promised before his untimely death in 1988.

OCTOBER 23

1983

At dawn on a Sunday morning, a suicide attacker detonated a truck bomb outside a barracks housing American Marines and other international military personnel in Beirut, Lebanon, killing 241 military personnel and wounding dozens more. It was the single deadliest day for the Marines since the Battle of Iwo Jima.

Rabbi Arnold E. Resnicoff, assistant chaplain for the US Sixth Fleet, had arrived in Beirut two days earlier to conduct a memorial service for a Jewish Marine killed in action. He'd had an opportunity to leave on Saturday, but refused to travel on the Sabbath. As a result, he was just one hundred yards from the truck when it exploded. "Bodies and pieces of bodies were everywhere," he wrote later that night. "Screams of those injured or trapped were barely audible at first, as our minds struggled to grapple with the reality before us—a massive four-story building, reduced to a pile of rubble; dust mixing with smoke and fire, obscuring our view of the little that was left."

Resnicoff and his Catholic colleague, Father George "Pooch" Pucciarelli, were among the first on the scene and spent the next several hours rescuing and ministering to survivors. When Resnicoff lost his kippah or skullcap after using it to mop an injured Marine's brow, Pucciarelli cut a circle out of his own camouflage cap to make him a new one. "Somehow he wanted those Marines to know not just that we were chaplains, but that he was a Chris-

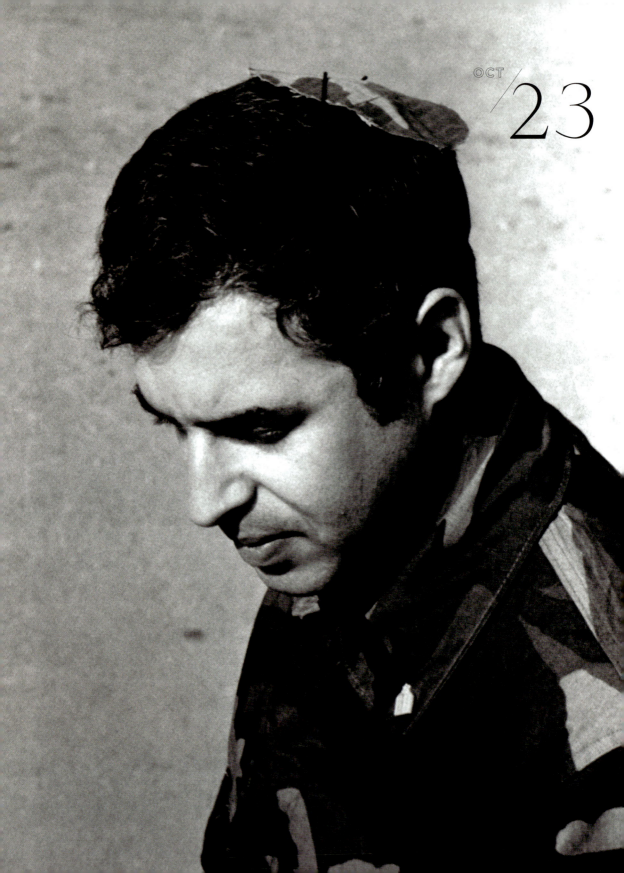

tian and that I was Jewish," Resnicoff remembered. "Somehow we both wanted to shout the message in a land where people were killing each other—at least partially based on the differences in religion among them—that we, we Americans still believed that we could be proud of our particular religions and yet work side by side when the time came to help others, to comfort, and to ease pain."

Chaplains conducting outdoor services in camouflage vestments had become a familiar sight during the Vietnam War, in which Resnicoff served. But the right of Jewish military personnel to wear kippahs was at that very moment under attack. In 1986, the Supreme Court would rule against a constitutional right to wear a kippah in *Goldman v. Weinberger*.

Jewish congressman Stephen Solarz spearheaded a campaign to pass an amendment allowing "neat and conservative" religious garments to be worn while in uniform. To prove how unobtrusive the kippah was, he distributed camouflage kippahs to congressmen, also sending one to Justice William J. Brennan, who had dissented in the case. Brennan later confessed that he put it on at work and forgot to remove it until he arrived home and his wife asked him what he had on his head.

The widely reported story of Resnicoff's kippah made its way into President Ronald Regan's keynote address at the 1984 Baptist Fundamentalism convention. It was credited with easing the passage of Solarz's amendment into law.

OCTOBER 24

79

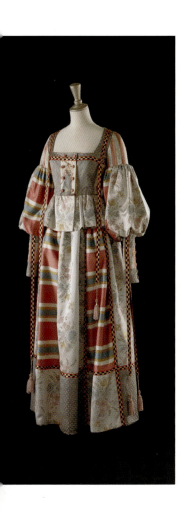

OPPOSITE, ABOVE:
Rabbi Arnold E. Resnicoff's makeshift kippah, Twiggy's Renaissance-inspired evening gown

This snake-shaped gold bracelet was recovered from the ruins of Pompeii more than a thousand years after it was buried by the eruption of Mount Vesuvius in the first century. In ancient Italy, snakes signified good luck. Many of the bodies found in the ashes wore similar good luck charms, possibly in an attempt to protect themselves from the increasingly active volcano. They were of little help; the city was destroyed, and with it an estimated two thousand men, women, and children.

OCTOBER 25

1854

Sergeant Frederick Peake was a member of the Thirteenth Light Dragoons at the Battle of Balaklava during the Crimean War; he took part in the doomed Charge of the Light Brigade against the unexpectedly well-armed Russian forces. When Peake's arm was broken by canister shot, medics cut off the right sleeve of his dark blue uniform coatee. Despite this damage, the coatee was so precious to Peake that he continued to wear it for the rest of his life, altering it as his girth expanded.

OCTOBER 26

1973

Hoping to strengthen ties with one of Australia's biggest trading partners, Prime Minister Edward Gough Whitlam had lunch with the Emperor and Empress of Japan in the Imperial Palace in Tokyo. The Labor Party leader wore a morning suit he'd had made for the occasion—and never wore again. In contrast to Australia's casual ethos, Japanese court protocol demanded formal attire.

OCTOBER 27

1968

The dress-and-cape combo on page 251 was worn at the closing ceremonies of the 1968 Summer Olympics in Mexico City by an *edecán* or "aide de camp"—one of 1,170 multilingual young women recruited to act as hostesses for athletes, organizers, and visitors.

WORN ON
THIS DAY

It was the first Olympic Games held in Latin America, or in a "developing" country. The organizing committee, headed by architect Pedro Ramírez Vázquez, was eager to present Mexico as a modern nation with a rich cultural tradition, both ancient and up-to-the-minute. Instead of sombreros and serapes, visitors would be welcomed by "pretty girl guides in psychedelic miniskirts," in the words of the *Los Angeles Times*. Even the city's slums were sparkling clean, freshly painted, and brightly lit for the occasion.

OPPOSITE: Gold bracelet from Pompeii

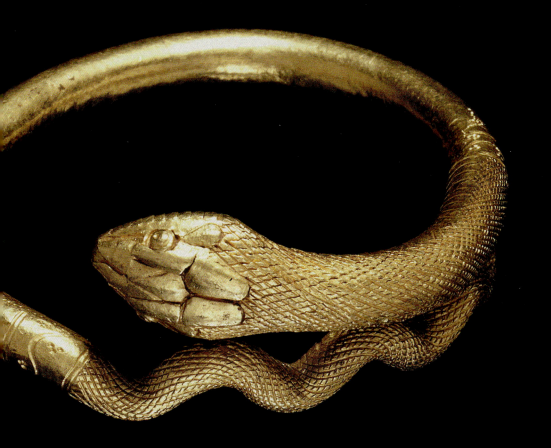

British-born, Mexico-based Julia Johnson-Marshall created the *edecán* uniforms, incorporating American graphic designer Lance Wyman's instantly iconic "Mexico '68" logo. The numbers encompass two of the five Olympic rings; the font, characterized by concentric circles, evokes pre-Columbian art as well as contemporary Op Art. This iconography—used throughout the Games—was both distinctive and easily legible. Ramirez Vázquez explained that the uniform "looks good on a girl who's chubby, or one who's skinny, or tall. . . . All the world will recognize that, well, she is an *edecán*."

For further clarity, the uniforms were color-coded. *Edecáns* who worked for the National Olympic Committee wore black and white, but the International Olympic Committee aides wore hot pink and white, and media escorts wore orange and white. All the *edecáns* received six months of practical and cultural training. Along with a dress and cape, each was issued two white mock turtlenecks, worn under the dress, and a pair of orange heels.

By the closing ceremony, however, it was clear that the optimism and patriotism embodied by the organizing committee's ambitious design program had not exactly come to fruition. Just days before the Games began, the Mexican army and police massacred unarmed students demonstrating in Tlatelolco. Striking students at the University of Mexico whistled derisively at foreign athletes as they trained. Some painted bleeding hearts on the snow-white peace doves decorating the city. Halfway through the Games, US track and field athletes Tommie Smith and John Carlos staged a divisive civil rights salute on the medal podium. Given the precarious socioeconomic climate, much of the Mexican public viewed the Olympics as a waste of money.

OCTOBER 28

1968

"Nixon Girls" in red, white, and blue paper dresses lined up at Pittsburgh's Civic Arena to greet Richard Nixon as he arrived at a campaign rally. Disposable paper dresses enjoyed a brief vogue in the turbulent 1960s, when young people literally wore their politics on their sleeves—but were prepared to discard them just as easily as a piece of paper.

OPPOSITE: Dress and cape for hostesses at the Olympics, "Nixon Girls"

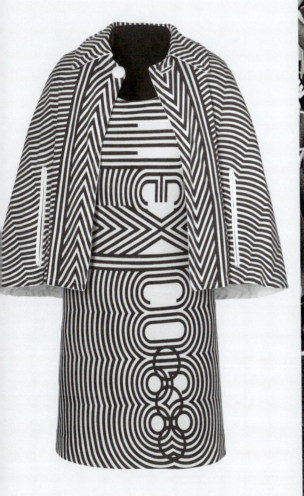

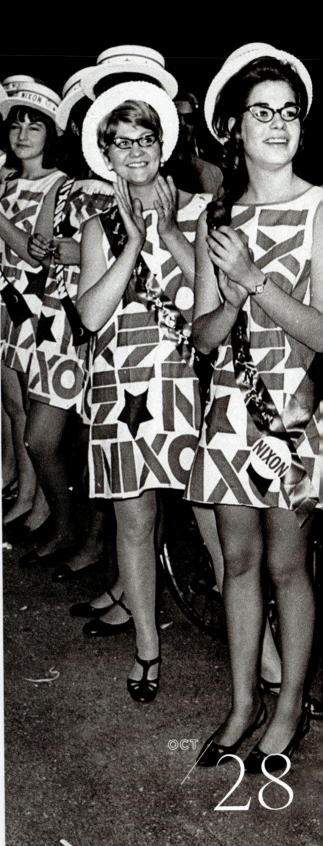

1943

Royal Air Force Flight Lieutenant Oliver Philpot was shot down off the coast of Norway in 1941, captured, and held in Stalag Luft III, a German prisoner of war camp in Poland. The camp's site was selected because the sandy soil made it difficult for POWs to tunnel out. Nevertheless, over several months, Philpot and two other prisoners dug a tunnel and meticulously planned their escape, gathering forged identity papers, maps, compasses, cash, and civilian disguises.

Knowing that he could never pass for a German, Philpot planned to pose as Jon Jörgensen, a Norwegian businessman, and obtained forged travel papers in that name. He went to great lengths to assemble his businessman's wardrobe, detailed in his memoir *Stolen Journey*. A chest of "illicit civilian clothing" buried in one of the camp's huts provided a formal black Homburg hat and "a short little double-breasted jacket" of "curious black material," patched under one arm. "Civilian buttons were put on it and appeared in serried ranks down the front as if to shout 'genuine civilian,'" Philpot remembered. A pair of black uniform trousers borrowed from a fellow prisoner created a suit. Philpot converted a uniform greatcoat into credible civilian outerwear by removing the epaulettes and adding "a really smart set of buttons." He replaced his English shoelaces with German ones. "They were leathery things—quite unmistakable." He trimmed his moustache "in the best Hitler style."

The escape plan depended on avoiding German patrols and catching trains. "Punctuality was not a luxury; it was a necessity," Philpot reflected. A friend lent him his Rolex, with instructions to return it to his father when he reached England.

Finding a tie, however, "caused untold trouble," Philpot recalled. "There just wasn't one, nor was there suitable material. And then, when I was at the point of despair, a Fleet Air Arm pilot took away a nice new black R.A.F. tie of mine, and reappeared a day later with it covered with parallel, but intermittent, white lines placed diagonally across it, these made by the simple method of using a needle and white thread." It was just the "grimly respectable" touch his civilian costume needed. Philpot concluded: "Jon was not going to look too bad."

To keep his disguise clean while crawling through the tunnel, Phil-

WORN ON THIS DAY

ABOVE: POW Oliver Philpot's tie, part of a disguise

pot used two sets of Red Cross long underwear, painstakingly dyed black—one pulled over his clothes, the other wrapped around his greatcoat and the attaché case containing his hat, a clean shirt and handkerchiefs, and toiletries of German manufacture. He and his fellow escapees also fashioned balaclavas, gloves, and shoe coverings out of the dyed material. "All these preparations gave me confidence," Philpot remarked. "It was all the difference between going on parade with a new uniform on, or one with buttons falling off."

Once outside the camp, Philpot traveled by train to Danzig, where he stowed away on a ship to neutral Sweden, arriving in Stockholm on November 4. The British legation treated him to a handsome new wardrobe at the Nordiska department store. But he kept his escapee's jacket and tie, now in the Imperial War Museum.

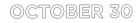

OCTOBER 30

1974

At the height of the Black Pride movement, the "Rumble in the Jungle" brought American boxing to Kinshasa, Zaire (now the Democratic Republic of the Congo). Promoters Lloyd Price and Don King billed the fight between George Foreman and Muhammad Ali as a metaphorical journey "from the slave ship to the championship." James Brown, B. B. King, and a who's-who of black musicians were flown in to perform a prefight concert.

But it was Ali—outspoken and larger than life—who was the biggest celebrity in Kinshasa. He landed before Foreman and took advantage of his early arrival to trash-talk his opponent. Although both men were African American, Ali derided Foreman as "a Belgian"—a damning insult in the former Belgian colony. And, on fight night, the former Cassius Clay declared his solidarity with his African fans by donning a one-of-a-kind boxing robe made for the occasion.

According to Norman Mailer, who chronicled the event in his book *The Fight*, "it was a long white silk robe with an intricate black pattern, and [Ali's] first comment was, 'It's a real African robe.'" Ali's trainer had brought the heavyweight a conventional white satin robe piped in red, green, and black—the national colors of Zaire—with a map of the country stitched over the heart. But Ali rejected it, saying: "This one's more beautiful. It's really prettier than the one you brought."

Though it may have been pretty, Ali's choice was hardly "a real African robe." Nor was it the work of a specialist athletic outfitter. It had been made by London tailor Mr. Fish, one of the leading proponents of the so-called Peacock Revolution in 1960s menswear. David Bowie and Mick Jagger were fans of his flamboyant suits, and Ali commissioned him to create a robe that was ready to rumble.

Fish enlisted a young art history student, Anna Gruetzner-Robins, to weave the "African" cloth for the garment, which evoked the geometric, dichromatic Kuba textiles native to Zaire. Ali's name was spelled out in beads on the back; beaded fringe danced at the ends of the sash. Fish delivered the finished robe to Ali at his training camp in Philadelphia. "He was a bit fazed by an effete youngish Englishman, but he certainly appreciated the robe," Fish remembered. "Seeing him at his camp, standing there naked, it was like God had come to earth. He was like Adonis." Back in London, Gruetzner-Robins had to watch the fight in a pub because she had no television. The bold, black-and-white pattern of Ali's robe stood out in a way that delicate piping and embroidery never could.

Ali defeated Foreman in one of the greatest fights of all time, debuting his "rope-a-dope" strategy to exhaust Foreman before knocking him out in the eighth round. In the aftermath of his victory, Ali left the robe behind in the locker room, but he insisted on going back for it, Mailer reported. It was sold by Christie's in 1997 for $140,000, setting a new record for boxing memorabilia.

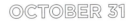

OCTOBER 31

1977

After a Halloween party at Studio 54, Andy Warhol cryptically complained to his diary: "My diamond choker was pinching my neck—I hate jewelry. How do ladies wear it? It's so uncomfortable."

OPPOSITE: Muhammad Ali's African-inspired boxing robe

FROM DARING DISGUISES TO MEN'S MUFFS

NOVEMBER

1	2	3	4	5	6	7
Casanova's bloody jailbreak clothes	Queen Marie-Antoinette's birthday makeover	Jane Fonda's iconic mug shot haircut	Princess Sofia Magdalena's wide wedding gown	Guy Fawkes's suspicious spurs	Gabrielle d'Estrées's bejeweled gown	Women's trousers, outlawed in Paris
1756	**1785**	**1970**	**1766**	**1605**	**1594**	**1800**

8	9	10	11	12	13	14
Tom Dempsey's controversial kicking shoe	Dissent collar worn by Ruth Bader Ginsburg	The fall of the Berlin Wall	POW/MIA bracelet campaign launched	Jules Léotard's revealing trapeze costume	F. Scott Fitzgerald's Brooks Brothers uniform	Comtesse Greffulhe's "Byzantine empress" gown
1970	**2016**	**1989**	**1970**	**1859**	**1917**	**1904**

15	16	17	18	19	20	21
Ballerina Emma Livry's deadly tutu	Kate Middleton's engagement dress	Empress Eugénie's yachting suit	Kurt Cobain's *Unplugged* cardigan	"Shabby" overcoat worn for Gettysburg Address	Tank mask of Lieutenant Gordon Hassell	Wedding suit worn by the Duke of York
1862	**2010**	**1869**	**1993**	**1863**	**1917**	**1673**

22	23	24	25	26	27	28
Jackie Kennedy's pink suit	Oliver Cromwell's fancy funeral procession	Mobutu Sese Seko's "dictator chic"	Thanksgiving "ragamuffin party" costume	Dressing for the "Glorious Revolution"	Rhett Hutchence's candy-striped funeral attire	Costume worn to Truman Capote's Black and White Ball
1963	**1658**	**1965**	**1943**	**1688**	**1997**	**1966**

29	30					
The first Army-Navy football game uniforms	Samuel Pepys's first muff					
1890	**1662**					

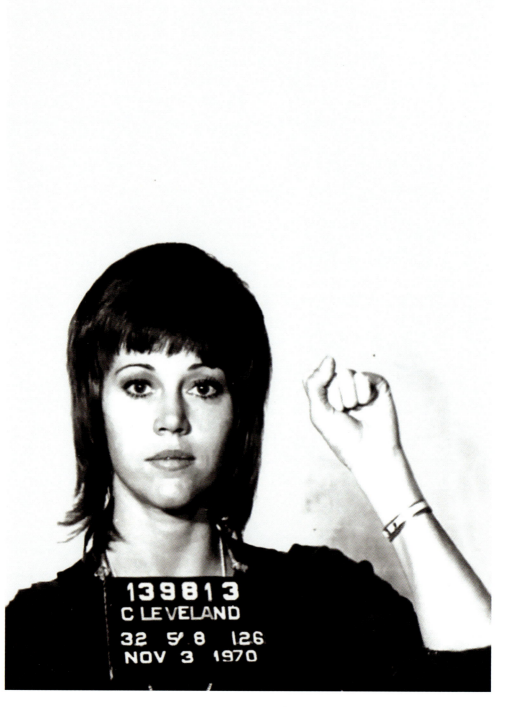

139813
C LEVELAND
32 5'8 126
NOV 3 1970

NOVEMBER / 03

11 / 01

— **1756** —

After a daring midnight escape across the rooftops of Venice from the attic cells of the Doge's Palace, where he had been imprisoned by the Inquisition, the legendary seducer Casanova's "first task was to change my clothes," he wrote in his memoirs. "My figure could only inspire pity or terror, so bloodstained and tattered was I. I took off my stockings, and the blood gushed out of two wounds I had given myself on the parapet, while [splinters] had torn my waistcoat, shirt, breeches, legs and thighs." After bandaging himself with handkerchiefs, he tied up his hair and put on a "fine suit," a lace-trimmed shirt, and white stockings. But despite his "exquisite hat trimmed with Spanish lace and adorned with a white feather," he confessed: "I must have looked like a man who has been to a dance and has spent the rest of the night in a disorderly house."

NOVEMBER 2

1785

On her thirtieth birthday, Queen Marie-Antoinette planned to give up "the ornaments that could only be those of extreme youth," a newspaper reported. "Consequently she would no longer wear flowers or feathers" in her hair or hats. In the eighteenth century, thirty was considered the threshold of middle age, and many women reformed their wardrobes accordingly, giving up rouge, the color pink, and other youthful accoutrements. The report, however, may have been wishful thinking; the queen continued to indulge her controversial passion for fashion.

NOVEMBER 3

1970

In the fall of 1970, actress and activist Jane Fonda went on a North American lecture tour to denounce the Vietnam War. When she landed in Cleveland on November 2, after speaking at a college in Canada, police

OPPOSITE, ABOVE:
Actress Jane Fonda's mug shot

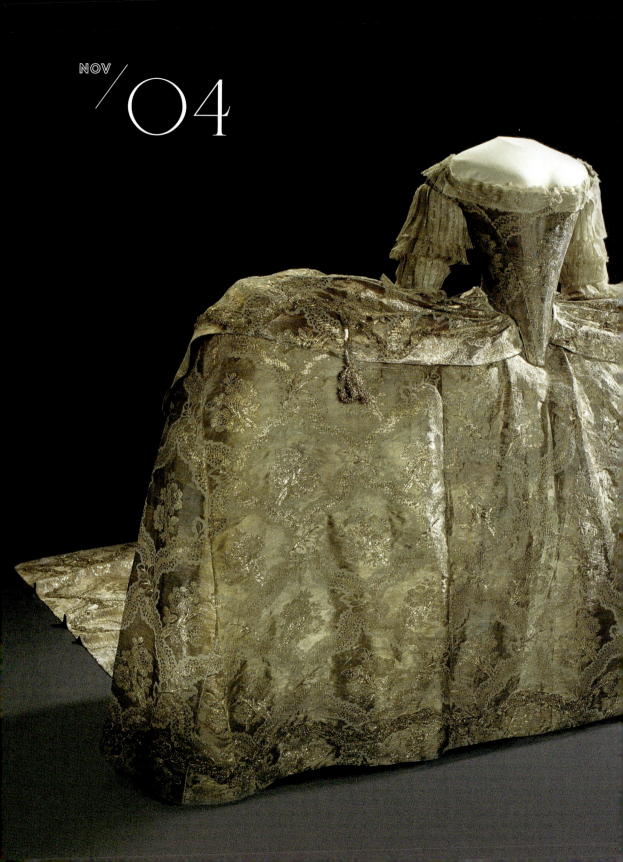

searched her luggage and found vitamins. "I told them what they were, but they said they were getting orders from the White House," Fonda recalled. She was arrested on drug smuggling charges. "I think they hoped this 'scandal' would cause the college speeches to be canceled and ruin my respectability."

Fonda had just finished making *Klute*, although it wouldn't be released until the following June. She usually wore her hair long and blond (think *Barefoot in the Park* and *Barbarella*). Before filming, however, stylist Paul McGregor had cut it into a shag and dyed it back to Fonda's natural brunette. The artsy, angled, shoulder-length cut with choppy bangs and face-framing sideburns transformed Fonda from a blond bombshell into a punk princess. For the first time in her adult life, she said, "I looked like me! I knew right away that I could do life differently with this hair."

Fonda's edgy new haircut was photographed once on November 2 at the Cuyahoga County Sherriff's Office and again the next day when she was booked for a separate crime of kicking a local cop during her airport arrest. In the second mug shot, she raised her clenched fist in defiance. The image instantly became iconic. To President Nixon's dismay, Fonda's hair got more attention that the arrest itself. Fonda was quickly released on bond and the charges were dismissed after the vitamins were tested and proved to be just that: vitamins.

Klute was a critical and commercial success. Fonda won her first Oscar for her portrayal of a high-class Manhattan call girl in jeopardy. And the shag haircut—now known as "the *Klute* haircut"—became a nationwide phenomenon. Today, Fonda's website sells mugs, clutches, tote bags, and other merchandise with her mug shot plastered on them, and the activist once derided as "Hanoi Jane" continues to take a stand on issues like the Dakota Pipeline and #MeToo.

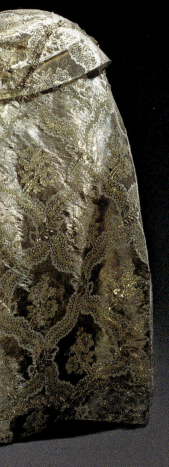

ABOVE: Princess Sofia Magdalena's wedding gown

NOVEMBER 4

1766

As royal wedding gowns go, it's hard to top the one worn by Princess Sofia Magdalena of Denmark when she married the future

King Gustave III of Sweden at Stockholm Palace. With her hoop petticoat measuring six feet across and a ten-foot train, the bride was wider—and longer—than she was high.

White satin, lace, orange blossoms, and veils would not become standard issue for brides until the mid-nineteenth century, when Queen Victoria helped to popularize the white wedding gown as we know it today. Fashion plates of the 1700s depict wedding gowns of red, blue, and other vivid hues. It was perfectly acceptable and, indeed, expected for women to wear their wedding gowns again and again.

Royal weddings, however, demanded cloth of silver, an extremely expensive fabric woven with real silver thread that had been reserved by law for the nobility since the seventeenth century. Along with Sofia Magdalena, both Catherine the Great (in 1744) and Marie-Antoinette (in 1770) wore cloth of silver for their weddings. This textile is further embellished with a woven floral and lace pattern. In total, twenty-seven yards of the precious fabric were required to make this glittering gown fit for a future queen.

Royal weddings required the bride, groom, and guests alike to wear court dress. For women, this meant the *grand habit*, loosely translated as "formal dress." King Louis XIV personally invented this costume in the 1670s. Even at its first appearance at the court of Versailles, it was a hybrid of new and old, as the aging king tried to revive the female fashions he had admired in his youth. The bare shoulders and back-laced bodice stiffened with ribs of whalebone (the contemporary name for baleen, the rigid, hairlike substance that takes the place of teeth in some whales) harked back to the fashions of the 1660s. By 1700, the *grand habit* had been adopted as formal female court dress throughout Europe, from Spain to Russia, with only minor regional variations—a powerful testament to French fashion's dominance. This gown and the groom's matching suit were ordered in Paris by the Swedish ambassador.

The *grand habit* was not intended to make women look young, slim, or attractive; it was intended to make them look rich, and it remained in use for more than a hundred years because it did so very successfully. The stiffer the bodice, the wider the hoop, and the longer the train, the more costly the textiles, trimmings, embroidery, and jewels the *grand habit* could show off. But when the French Revolution of 1789 upended the monarchy, the *grand habit* gradually fell out of use, not just in France but across Europe. Many were likely destroyed, or cut up and the precious fabric reused to make other garments. As a result, only a handful of *grands habits* have survived in museum collections.

NOVEMBER 5

1605

Guy Fawkes was arrested in the early hours of the morning when, acting on a tip, Thomas Knyvett, a member of Parliament, searched the cellars under the House of Lords. Knyvett noticed Fawkes leaving a cellar wearing a cloak, boots, and spurs, as if dressed for a journey, and became suspicious. He searched the cellar and found thirty-six barrels of gunpowder hidden among piles of coal and firewood. The so-called Gunpowder Plot to blow up the House of Lords during the State Opening of Parliament later that day—launching a Catholic revolt—had been foiled. Fawkes and his treasonous co-conspirators were hanged, drawn, and quartered. British schoolchildren are still encouraged to "remember, remember the fifth of November" with bonfires, fireworks, and burning effigies of Fawkes.

NOVEMBER 6

1594

For a baptism ceremony at the Church of Saint-Germain l'Auxerrois in Paris, Gabrielle d'Estrées, King Henri IV's mistress, wore a black satin gown "so ornamented with pearls and precious stones that she could scarcely move under its weight," Pierre de L'Estoile recorded in his diary.

NOVEMBER 7

1800

In response to overenthusiastic expressions of *liberté*, *égalité*, and *fraternité* by female supporters of the French Revolution, the city of Paris made it illegal for women to wear trousers without a permit. Over time, exceptions were introduced for riding horses or bicycles. The law was last applied in 1928, when the French Olympic Committee banned lesbian track and field athlete Violette Morris from competing, ostensibly due to her penchant for wearing pants. The ban remained on the books until 2013, when it was declared unconstitutional.

NOVEMBER 8

1970

Tom Dempsey, kicker for the New Orleans Saints, was born with no toes on his right foot and no fingers on his right hand. He was wearing a modified black

leather kicking shoe that looked more like a football than a shoe when he made a sixty-three-yard field goal against the Detroit Lions at Tulane Stadium, winning the game in the final seconds. It was the longest field goal in history at the time. When a reporter asked him if he thought the enlarged toe surface of his shoe gave him an unfair advantage, Dempsey replied: "Unfair, eh? How 'bout you try kickin' a 63 yard field goal to win it with 2 seconds left an' yer wearin' a square shoe, oh yeah, and no toes either." Nevertheless, in 1977, NHL introduced a rule stating that "any shoe that is worn by a player with an artificial limb on his kicking leg must have a kicking surface that conforms to that of a normal kicking shoe." It is informally known as the "Tom Dempsey Rule."

NOVEMBER 9

2016

On the day after Donald Trump's election, Supreme Court Justice Ruth Bader Ginsburg wore her jeweled "dissent collar" with her black judicial robe. Ginsburg—who became the second woman appointed to the Supreme Court in 1993—has several decorative collars and jabots. "The standard robe is made for a man because it has a place for the shirt to show, and the tie," Ginsburg told the *Washington Post* in 2009. "So Sandra Day O'Connor and I thought it would be appropriate if we included as part of our robe something typical of a woman." Ginsburg wears her dissent collar when she dissents from a decision being handed down from the Supreme Court. The famous neckwear has been made into necklaces and pins worn by fans of the "Notorious RBG."

NOVEMBER 10

1989

At midnight, East Germany officially opened its borders to the West. Thousands of people congregated at the Berlin Wall for an impromptu street party. Uniformed East German soldiers watched as young Berliners clad in blue jeans and leather jackets—the uniform of the West—used hammers and picks to tear down the barrier, erected in 1961. As the French philosopher Jules Régis Debray observed: "There is more power in rock music, videos, blue jeans, fast food, news networks and TV satellites than in the entire [Soviet] Red Army."

NOVEMBER 11

1970

On Veterans Day—the anniversary of the end of World War I in 1918—the Los Angeles–based student group Voices in Vital America (VIVA) launched the POW/MIA Bracelet Campaign to call attention to Americans lost or captured in the Vietnam War. The idea came from television talk show host (later Congressman) Bob Dornan, who wore a bracelet from Vietnam as a way of remembering the suffering caused by the war. Each metal POW/MIA bracelet was inscribed with the name, rank, and loss date of a missing serviceman. At the height of the campaign, VIVA received twelve thousand requests for bracelets per day; the group distributed nearly five million in total before shuttering in 1976. "By then the American public was tired of hearing about Vietnam and showed no interested in the POW/MIA issue," lamented Carol Bates, the campaign's national chairman.

NOVEMBER 12

1859

Jules Léotard, the son of a Toulouse gymnasium owner, performed the first "flying trapeze" act at the Cirque Napoleon in Paris, wearing a skintight, one-piece costume of his own design that showed off his enviable physique. According to one of his fans, "he was beautiful to look upon; being admirably made & proportioned; muscular arms shoulders & thighs; and calf ankle and foot as elegantly turned as a lady's." Another described his black silk bodysuit, "its deep V-neck showing off his bulging chest." The outfit—now known as a "leotard"—was so revealing that, when Léotard was invited to perform for Tsar Alexander II, he was instructed to wear a formal suit, which was torn to shreds during his act. Léotard's celebrity inspired George Leybourne to write the music hall song "The Daring Young Man on the Flying Trapeze."

NOVEMBER 13

1917

Having just received his commission as a second lieutenant in the Army, Princeton senior F. Scott Fitzgerald went directly to Brooks Brothers, the New York men's clothier founded in 1818, to order custom-tailored uniforms. He wrote to his mother the next day: "My uniforms are going to cost quite a

bit so if you havn't [*sic*] sent me what you have of my own money please do so." Although the war ended before his Brooks Brothers uniforms saw battle, Fitzgerald was wearing one when he met his future wife, Zelda Sayre, at a dance in Montgomery, Alabama, the following July. In her 1932 autobiographical novel *Save Me the Waltz,* Zelda wrote: "He smelled like new goods. Being close to him with her face in the space between his ear and his stiff army collar was like being initiated into the subterranean reserves of a fine fabric store exuding the delicacy of cambrics and linen and luxury bound in bales."

NOVEMBER 14

1904

When the Comtesse Greffulhe appeared at her daughter Elaine's wedding in Paris, people in the congregation reportedly exclaimed, "Mon Dieu! Est-ce là le mère de la mariée?" ("My God, is that the mother of the bride?"). Press accounts of the ceremony were so taken by Greffulhe's gown that they hardly mentioned the bride's. The gown has a Worth label, but it was probably created for the countess by Worth's protégé, Paul Poiret. The magazine *La Femme d'aujourd'hui* described it as "a sensational Byzantine empress outfit: a silver brocade gown covered with artistic embroideries with sparkling mother-of-pearl embellished with gold and dainty pearls, with a band of sable at the hem." With her gown, the countess wore a "splendid dog collar and *sautoir* of fine pearls" and an "immense hat of silver tulle bordered with sable, with, on each side, voluminous birds of paradise, between which stood straight and proud, an enormous brilliant diamond shining like a huge tear of joy, bathed in the colors of the rainbow by the sun."

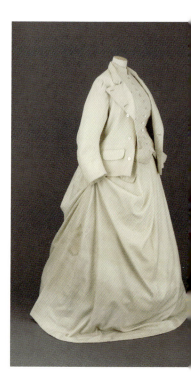

NOVEMBER 15

1862

Ballerina Emma Livry's tutu caught fire on a gas light during a dress rehearsal at the Paris Opéra. Although theaters had been required to fireproof costumes and sets to prevent such accidents since 1859, Livry refused to wear chemically treated costumes.

OPPOSITE, ABOVE:
Comtesse Greffulhe's
mother of the bride
gown, Empress Eugénie's
"guardian angel" gown

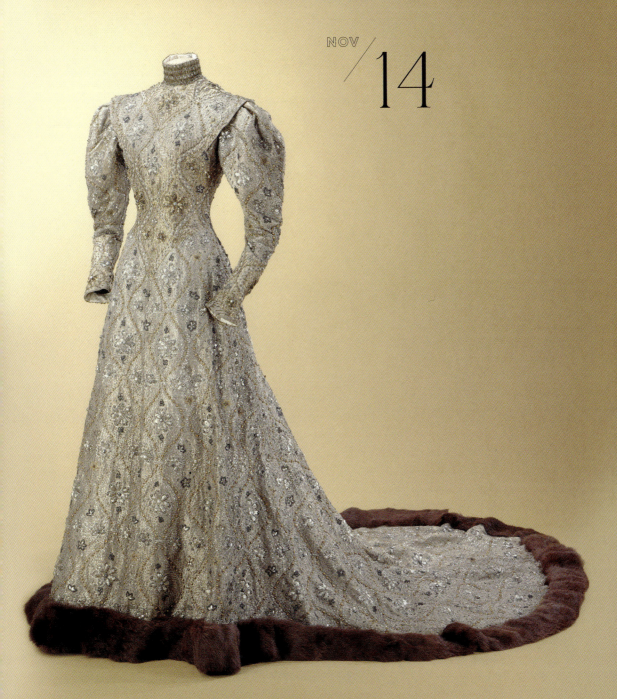

"MY GOD, IS THAT THE
MOTHER OF THE BRIDE?"

Burned over 40 percent of her body, she lived in agony for eight more months before dying of sepsis at the age of twenty-one. Her childhood dance teacher preserved the charred remains of her costume in a small wooden sarcophagus, now in the Musée-bibliothèque de l'Opéra.

NOVEMBER 16

2010

It was the press conference that launched a thousand knockoffs. In the gilded halls of St. James's Palace, just after 11 a.m., Prince William—elder son of Princess Diana and grandson to Queen Elizabeth II—announced his engagement to his girlfriend, Kate Middleton, to a throng of reporters and photographers. Though the engagement had long been rumored and expected, the announcement came as a surprise to both the press and the palace staff, who had been directed to arrange the press conference just two hours earlier—around the same time the prince broke the news to the royal family.

The couple, who had become engaged on a trip to Kenya the previous month, delayed the announcement due to the death of Middleton's grandfather. Middleton clearly had time to put careful thought into her outfit for the press conference. Her blue silk jersey wrap dress was chosen to match her twelve-carat blue Ceylon sapphire engagement ring, the same one Prince Charles had presented to William's late mother nearly thirty years earlier. (Diana reportedly chose it from a selection of rings because its enormous size made it easily visible to the public.) The ladylike, knee-grazing style of the dress—paired with nylons and closed-toe black suede heels by Episode—declared Middleton's transition from commoner to queen-in-waiting, and set a precedent for her chic but conservative wardrobe as Duchess of Cambridge. The label, Issa, was a longtime favorite, however; she already had Issa dresses in a variety of colors, lengths, and prints, including one she was photographed in on the eve of her April 29, 2011, wedding.

The press conference was a triumph for Middleton, whom the British tabloids had dubbed "Waity Katie" during her eight-year, on-again-off-again royal relationship. But it was an equally significant moment for Daniella Helayel, Issa's Brazilian-born designer. Middleton's dress sold out within minutes, and new orders poured in. The company—already struggling to keep up with its success—found that it couldn't afford to produce enough stock to meet the demand. Meanwhile, cheap, hastily produced knockoffs of the dress threatened to steal Issa's thunder.

In 2011, Helayel was forced to sell 51 percent of her company. The buyer, her friend Camilla Al-Fayed, was the daughter of businessman Mohamed Al-Fayed, a

vocal critic of the royal family, and sister of Princess Diana's lover, Dodi Al-Fayed. Instantly, Middleton stopped wearing Issa. Though the partnership saved the company, it eventually soured. Helayel quit in 2013, and the business closed two years later. The "Kate Effect" continues to be both a blessing and a curse for designers, as the duchess formerly known as Kate Middleton sets trends that are followed around the world.

NOVEMBER 17

1869

The Suez Canal linking the Red Sea to the Mediterranean was a marvel of both engineering and diplomacy. When it finally opened to ships after ten years under construction, the first vessel to navigate it was the French Imperial yacht *L'Aigle*. On the bridge, clad in a celestial white sailing ensemble, was the woman the canal's developer had dubbed its "guardian angel," Empress Eugénie.

Egypt's political alliance with France dated back to the sixteenth century. Napoleon had first proposed the idea of a canal connecting Europe to the Far East in the 1790s, and it was a French diplomat, Ferdinand de Lesseps, who saw the project to completion. Eugénie—de Lesseps's distant cousin—helped smooth the delicate negotiations between the French and Egyptian governments. De Lesseps likened the Spanish-born Empress to Queen Isabella, and himself to Christopher Columbus.

As the guest of honor at the canal's opening, Eugénie assembled her wardrobe for the journey carefully, commissioning special garments suitable for the rigors of traveling, for the arid Mediterranean climate, and for the many official events and entertainments she would attend along the way. In October, she left Paris and traveled to Port Said via Venice, Athens, Constantinople, and Alexandria. Baron Samuel Selig de Kusel's steamer happened to leave Alexandria at the same time as *L'Aigle*. He remembered seeing Eugénie "standing on the bridge, surrounded by her suite, and I may safely say that all eyes were centered upon her."

At 8 a.m. on November 17, the canal officially opened to ships. "There was a true Egyptian sky, that enchanting sunlight that has an almost hallucinating clarity," Eugénie reminisced years later. "Fifty vessels, all flying their flags, were waiting for me at the entrance. . . . The sight was one of such magnificence and proclaimed the grandeur of the French Empire so eloquently that I could scarcely control myself—I rejoiced, triumphantly."

For the historic voyage, she wore an appropriately angelic ensemble of jacket, vest, and skirt in sturdy but lightweight beige serge with mother-of-pearl buttons,

created by the tailoring firm of Henry Creed & Co. Tailors generally dressed men, but they also created specialized sporting garments for women, including riding habits, yachting clothes, and "tailor-mades," menswear-inspired ensembles of jackets and long skirts. Founded in London in 1760, Creed relocated to Paris in 1854 at Eugénie's behest; today, it makes fragrances exclusively.

An American eyewitness, Dr. Thomas Evans, testified: "I can never forget her radiant figure as she stood on the bridge of *L'Aigle*, while the Imperial yacht slowly passed by the immense throng that had assembled on the banks of the canal to greet her Majesty." Cannons fired, flags waved, and the crowds shouted "*Vive l'Impératrice!*" and "*Vive Eugénie!*" Overwhelmed, Eugénie lifted her handkerchief to her eyes, "to suppress her tears."

It would be the last time Eugénie represented France on the world stage. Less than a year later, the Second Empire was overthrown, and the Imperial family exiled to England.

NOVEMBER 18

1993

The olive green "granddad cardigan" Nirvana frontman Kurt Cobain wore for a taping of MTV's *Unplugged*—a shaggy blend of acrylic, mohair, and Lycra, accented by a cigarette burn—embodied the grunge fashion aesthetic: lived-in thrift store finds, layered for protection against the soggy climate of Seattle, dubbed by one critic "the worst dressed town with the best music scene in the world." Cobain committed suicide four months later. In 2015, the sweater sold for $137,500 at an auction.

NOVEMBER 19

1863

Asked to make "a few appropriate remarks" at the dedication of the Soldiers' National Cemetery in Gettysburg, Pennsylvania, President Abraham Lincoln delivered—in less than three hundred words—one of the most famous speeches in history. Because recording technology did not exist, scholars continue to debate which of several drafts of the speech Lincoln actually read from. Folds are still evident on the pages of one version, suggesting that it is the copy Lincoln took from the interior breast pocket of a "rather a shabby overcoat," as one eyewitness described it.

NOVEMBER 20

1917

In the First World War, modern and ancient weaponry and tactics shared the same battlefields. The tank mask—both medieval and futuristic in appearance—embodies the evolution of warfare in the early twentieth century.

Several of these masks have survived, which is not surprising considering that they were designed to withstand flying shrapnel. The one pictured on page 273 was worn by Second Lieutenant Gordon Hassell, who commanded one of 378 tanks that participated in the Battle of Cambrai. It was the first time the British Army deployed their tanks en masse—a controversial tactic for the unproven technology.

After floundering in the mud at Ypres, the Tank Corps was determined to show what it could do on favorable terrain. The surprise attack, which began at 6:20 a.m., was over within an hour. The tanks' job was to clear the way for the cavalry and infantry along a six-mile front; thirty-nine of them were put out of action, including Hassell's, which had its tracks ripped off. Stuck, his tank was hit by German fire, and immediately transformed from offensive weapon into defensive shelter. "Slivers of hot red steel began to fly in the tank—bullets hitting the armoured plates melted and the splash was dangerous to the eyes," Hassell remembered. "For protection, we used a small face mask."

At Cambrai, "tanks at last came into their kingdom," Captain Stair Gillon remembered of the battle. Hassell wrote to his parents the next day: "Have come through yesterday's glorious success perfectly well and without hurt. Have had a good time." But the good time didn't last; the Germans rebounded quickly, and, by November 30, Britain had lost all the territory its mighty tanks had gained.

NOVEMBER 21

1673

When the Duke of York, the future King James II, married Mary of Modena at Dover Castle, the wedding was a subdued affair, as the bride's Catholicism made her unpopular in Protestant England. Nevertheless, the groom dressed to impress in a wool suit embroidered with silver-gilt thread, a transitional style between the doublet and hose and the three-piece suit. After the ceremony, James gave the suit to Sir Edward Carteret, one of the few courtiers brave enough to attend the Catholic service.

1963

After her husband was assassinated in Dallas, First Lady Jackie Kennedy refused to remove her bloodstained pink and navy bouclé suit—an authorized Chanel copy made by New York's Chez Ninon—until she returned to the White House. (See image on this book's cover.) "Let them see what they've done," she said. The suit is now in the National Archives, where it is embargoed from public view until the year 2103. In 2011, a senior archivist told the *Washington Post*: "It looks like it's brand new, except for the blood." In fact, Kennedy had worn the suit several times, beginning in November 1961; it was reportedly a favorite of her husband's.

NOVEMBER 23

1658

Oliver Cromwell, Lord Protectorate of England, had died on September 3. Because a state funeral required several weeks to plan, the deceased was often buried quickly and quietly, then represented in the ceremony by a life-sized wax or wooden effigy, lavishly dressed in his or her own clothes. Though Cromwell had been instrumental in abolishing the English monarchy, even signing King Charles I's death warrant in 1649, he was buried with all the pomp and circumstance of a monarch.

Giovanni Bernardi, the Genoese ambassador, described how Cromwell's effigy "with regal vestments, a crown on the head, and in one hand a scepter and in the other a globe" was placed on an open hearse drawn by six horses "adorned with many feathers, all covered, except the eyes, with black velvet, which almost trailed on the ground." The coachmen wore "long robes of the same material," and the hearse itself was draped in black velvet and plumes. The funeral procession was led by noblemen "dressed in the finest cloth, the shortest of whose trains trailed two spans on the ground, some eight spans, some twelve, and some sixteen, carried by the gentlemen of their suite. The shortest train of the ordinary people touched the ground." Bernardi estimated that the cloth alone—paid for by Cromwell's son and successor, Richard—"cannot have cost

WORN ON
THIS DAY

OPPOSITE: Lieutenant Gordon Hassel's WWI tank mask

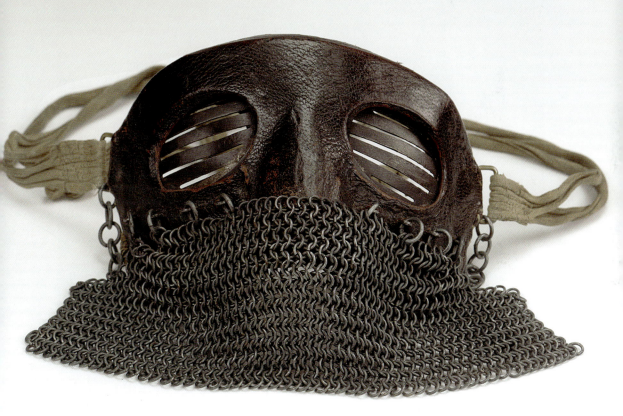

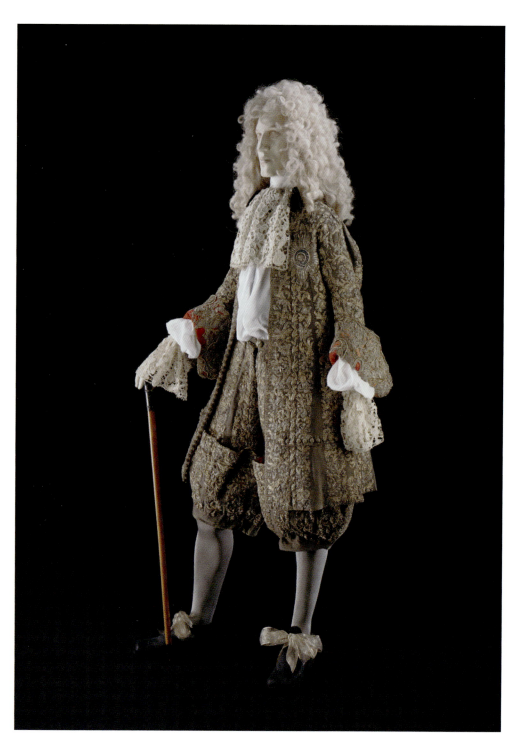

less than £30,000 sterling." The effigy was thus escorted through the streets of London to Westminster Abbey, where it remained on public view an additional three months.

The reverence for Cromwell was short-lived: when the monarchy was restored in 1660, his body was disinterred, posthumously hung for treason, and beheaded.

NOVEMBER 24

1965

Mobutu Sese Seko seized control of the Democratic Republic of the Congo. He would become known for his trademark outfit: a leopard skin toque; a tieless, Mao-style suit called an *abacost* (for "à bas le costume," or "down with the suit"); oversized, thick-framed glasses; and a silver-tipped ebony cane. In 1970, as part of a widespread Africanization program, he renamed the country the Republic of Zaire and banned Zairians from wearing Western-style dress, to distance them from their colonial past. British author Peter York coined the term "dictator chic" in 2006 to describe the flashy, militaristic, pseudo-historic style of the dictator's homes and wardrobes, which often invoke "the power and aggression symbolism of Animal Heroes."

NOVEMBER 25

1943

On Thanksgiving Day, an army veteran was arrested for attempted robbery "attired in an ill-fitting assortment of women's clothing over khaki Army trousers peeping from under a drab, gray dress," according to the *New York Times*. In court, he explained that he was dressed for a ragamuffin party—a Thanksgiving tradition dating back to the 1870s, when children would dress in costumes and masks and beg for coins and candy. Ragamuffins in tattered, oversized garments were common in New York, especially, but one also saw "Fausts, Filipinos, Mephistos, Boers, Uncle Sams, John Bulls, Harlequins, bandits, sailors, soldiers in khaki suits, Deweys, and Columbines," the *Times* reported in 1899. Boys often raided their sisters' wardrobes for disguises. By the 1960s, the annual dressing-up ritual was extinct, supplanted by Halloween.

OPPOSITE:
King James II's
wedding suit

NOVEMBER 26

1688

King James II's two daughters, Mary and Anne, were instrumental in plotting his downfall, the bloodless coup known as the Glorious Revolution. In the early hours of November 26, Anne fled Whitehall Palace "in nightgown and slippers," according to the Earl of Marchmont, after hearing that Mary's Dutch husband, William, had arrived in England with his army to seize the throne. Anne escaped London with the help of her former tutor Henry Compton, the Bishop of London, who had swapped his ecclesiastical robes for a buff coat, jackboots, sword, and pistol. When James heard the news, he reportedly cried: "God help me. My own children have forsaken me."

NOVEMBER 27

1997

At the Sydney, Australia, funeral of his older brother, INXS lead singer Michael Hutchence, pallbearer Rhett Hutchence stood out among the black-clad mourners in a red, black, and white candy-striped suit that had been a gift from Michael.

NOVEMBER 28

1966

Candice Bergen wore a Halston gown and Bergdorf Goodman bunny mask to Truman Capote's star-studded Black and White Ball at the Plaza Hotel. The author had planned the event for more than a year, assembling the guest list like a cast of characters in one of his novels, mixing socialites and celebrities, artists, and power brokers: Tallulah Bankhead, Lauren Bacall, Lee Radziwill, Frank Sinatra, and Mia Farrow were all in attendance. As with modern awards shows, the arrivals were broadcast on television. "They rolled off the assembly line like dolls newly painted and freshly coiffed, packaged in silk, satin and jewels and addressed to Truman Capote, the Plaza Hotel," the *New York Times* wrote.

Inspired by Cecil Beaton's costumes for the Ascot scene in 1964's *My Fair Lady*, Capote specified a black-and-white dress code with masks, and fans for the ladies. In addition to creating a striking tableau, the pal-

ABOVE: Candace Bergen's Black and White Ball costume

ette would unify the diverse crowd, while the masks would encourage mingling. At midnight, the masks would come off.

After the year-long buildup, though, the actual party was a bit of a snooze. Bergen was reportedly so bored that she left early.

NOVEMBER 29

1890

When the first Army-Navy game was played at West Point, the visiting Navy team, clad in striped knitted stocking caps, beat the Army team, in solid knitted stocking caps, 24-0. Apart from their hats, both teams dressed similarly in turtleneck sweaters, knickers, and dark stockings. Early football uniforms were rudimentary; most players simply wore coordinating colors or matching hats to indicate team membership. By the early 1880s, knitted stocking caps had replaced skull caps as the preferred headgear.

As the game has evolved from a combination of rugby and soccer to the modern sport, uniforms have adapted accordingly. Helmets were optional in college football until 1939; facemasks were added in the 1950s, by which time hard plastic helmets had replaced leather ones. Growing concerns about chronic traumatic encephalopathy—a degenerative brain disorder associated with repetitive head trauma—have spurred recent advances in football helmet technology, including helmets with soft outer shells and "smart" helmets equipped with impact sensors.

NOVEMBER 30

1662

On a day of "bitter cold frost," the English diarist Samuel Pepys recorded: "This day I first did wear a muffe, being my wife's last year's muffe, and now I have bought her a new one, this serves me very well." Though there was no firm distinction between men's and women's muffs in the early years of their vogue, the man's muff became gendered by the eighteenth century, distinguished by its larger size and distinctive materials, including the skins of predatory animals.

DECEMBER

1	2	3	4	5	6	7
Soldiers in ice skates and khaki	Mario Savio's fleece-lined coat	The "hatpin peril" strikes New York	Jean Bedel Bokassa's coronation regalia	Betsy Bloomingdale's Bal Oriental costume	Wedding gowns worn in protest	The watch that survived Pearl Harbor
1916	1964	1896	1977	1969	2016	1941

8	9	10	11	12	13	14
Yellow vests for Paris protests	Salome's seven veils striptease onstage	Mainbocher's marvel of engineering	Mary Lowry Warren's much-worn wedding gown	Santa Claus costume worn by Mr. T	Traditional Scandinavian St. Lucia costume	The birth of women's running gear
2018	1905	1948	1895	1983	1906	1963

15	16	17	18	19	20	21
Margaret Mitchell's *Gone with the Wind* premiere coat	Dressing for the Boston Tea Party	The Wright brothers' first flight outfits	Katharine Hepburn's costume for *Coco*	Lindy Chamberlain's mommy-and-me dress	Harry Styles's Yves Saint Laurent fur coat	Marlene Dietrich's Christian Dior suit
1939	1773	1903	1967	1981	2016	1950

22	23	24	25	26	27	28
Protest prison uniforms worn by British suffragettes	Mourning at the court of Versailles	Corseted costumes for the opera *Aida*	President Gerald Ford's ugly Christmas sweater	Riding outfits worn on the feast of St. Stephen	The dress that survived an English avalanche	Burial gown of Eleanora di Toledo
1908	1780	1871	1974	2006	1836	1562

29	30	31				
Ellen Terry's Lady Macbeth costume	Boston bans masks from balls	New Year's Eve at Stuio 54				
1888	1809	1977				

FROM SOLDIERS ON ICE TO DISCO NIGHTS

12 / 01

— **1916** —

At a time when many professional athletes were enlisting, a group of soldiers from Canada's 228th Battalion played their first game as an official team in the National Hockey Association, wearing ice skates with their khaki military uniforms. They led the league in scoring by the time they shipped out in mid-February.

DECEMBER 2

1964

What do you wear to a revolution? Mario Savio, a twenty-one-year-old student at the University of California at Berkeley, unexpectedly found himself on the world stage as the leader of the Free Speech Movement when the university tried to ban students from promoting political causes on campus. Savio, who had spent the "Freedom Summer" of 1964 registering black voters in Mississippi, was one of many activists who would not be silenced. Though he suffered from depression and a stammer, the earnest, lanky math major became the face of student protest in the early years of the counterculture movement.

Savio is best remembered for the rabble-rousing "machine" speech he delivered at a noon rally on the steps of the university's Sproul Hall on December 2, 1964—the climax of three months of demonstrations and protests. "There's a time when the operation of the machine becomes so odious, makes you so sick at heart, that you can't take part, you can't even passively take part," he cried. "And you've got to put your bodies upon the gears, and upon the wheels, upon the levers, upon all the apparatus, and you've got to make it stop, and you've got to indicate to the people who run it, the people who own it, that unless you're free, the machine will be prevented from working at all."

WORN ON THIS DAY

OPPOSITE: Activist Mario Savio delivering a speech

DECEMBER / 02

At the rally, Savio wore a short, fleece-lined coat, which had become "a sort of personal trademark" during that turbulent fall, according to the *New York Times Magazine*. While he sometimes swapped it for a professorial sports jacket and tie, it was the sheepskin coat that was pictured in newspapers, referenced in interviews, and imitated by young firebrands across the country. Along with Savio's unruly mop of curls, it signaled a deliberate departure from the clean-cut, buttoned-up aesthetic of the 1950s and presaged the shaggy street style of the counterculture movement. The far-out fashions of the late 1960s were not just a colorful backdrop to the period's political struggles, but an integral element of them.

DECEMBER 3

1896

As New York Police Department Officer F. J. Driscoll was arresting "a flashily dressed woman" for loitering on a street corner in the Bowery, she "used unseemly language" and "drew her hatpin from her hat and made a vicious blow at his face," the *New York Times* reported. The eight-inch steel spike just missed his eye. Hatpins, "dreaded of policemen," were responsible for a wave of injuries and even deaths in the late nineteenth and early twentieth centuries—some accidents, some crimes, and some in the name of self-defense. Several politicians tried to outlaw hatpins, but it was World War I and the ensuing fashion for bobbed hair that finally ended the "Hatpin Peril."

DECEMBER 4

1977

Jean Bedel Bokassa crowned himself Emperor of the Central African Republic in Bangui. The ceremony and its red, gold, and white regalia were inspired by Napoleon's 1804 coronation. A brutal dictator and alleged cannibal, Bokassa was deposed in 1979. He died in 1996, leaving seventeen wives and sixty-two children.

WORN ON
THIS DAY

DECEMBER 5

1969

One of the most coveted invitations among the twentieth-century "jet set" was to Baron Alexis de Redé's Bal Oriental. An update of Paul Poiret's

1002nd Night party and countless other Oriental-themed entertainments, it drew celebrities, socialites, and fashion plates to the aristocratic aesthete's seventeenth-century mansion on the Île St. Louis in Paris.

Servants in magenta silk carrying enormous pink and gold parasols escorted guests through the courtyard, where they were greeted by Indian sitar players and drummers perched atop two life-sized *papier-mâché* white elephants, "richly jeweled and caparisoned," according to *Vogue* editor Diana Vreeland, who reported on the festivities. Sixteen "Nubian guards" in turbans, their bare chests "gleaming with oil," stood sentry on the stairs, holding torches aloft. The scent of jasmine and myrrh wafted from perfume burners.

The baron, dressed as a Kirghiz huntsman in a giant fur hat with a dagger at his waist, received his guests in a gallery overlooking the gardens and the Seine, "where musicians dressed in red-and-gold Chinese costumes played under an immense red-and-gold parasol hung with bells," Vreeland noted. Another room had been transformed into a Turkish-themed discothèque, with "low divans strewn with Turkish cushions around the dance floor." In yet another room "lighted by huge pink-and-gold Chinese lanterns," a buffet was arranged on tables around "seventeenth-century Chinese cloisonné elephants holding flowers."

Baron Eric de Rothschild was a Tartar horseman; Madame Michel Weil was a Turkish odalisque. Brigitte Bardot came as a belly dancer. The Duc and Duchesse de Cadaval wore "Chinoiserie in the mood of *Turandot*." Jaqueline de Guitot's forehead was studded with amber beads. One guest, dressed as a Maharajah, carried a live lion cub. Fu Manchu mustaches, bare midriffs, kohl eye makeup, and over-the-top jewelry were *de rigueur*.

Los Angeles socialite Betsy Bloomingdale wore the James Galanos ensemble on page 285. With its bra top and peekaboo silver lace, it exudes California hippie chic. Bloomingdale may have commissioned it for a costume party, but it was so in tune with the daring, Eastern-inspired fashion aesthetic of the late 1960s and early 70s that she could easily have worn it again. She couldn't wear it out to dinner, though—at the time, women were still banned from wearing trousers in many restaurants, as well as office buildings. But they had long been a part of Occidental fantasies of "Oriental" dressing, referencing the trousers historically worn by Chinese and Middle Eastern women. For centuries, Asian-inspired fancy dress had given Westerners an excuse to experiment with conspicuously luxurious textiles and, often, daring or revealing styles; however, Galanos lined Bloomingdale's

trousers and top with nude fabric, so they didn't reveal as much as they appeared to.

Photos of the event indicate that Bloomingdale accessorized with a towering silver turban. *Vogue* revealed how "several of the elder belles of the ball contrived to look so wonderfully serene, their faces so smooth and unlined": their on-theme turbans, fur Cossack hats, and Balinese headdresses hid pink Scotch Hair Set Tape, pulling their skin taut at the hairline. If Bloomingdale, forty-seven, had any such beauty secrets, she kept them under her hat.

DECEMBER 6

2016

A dozen Lebanese women wearing white wedding gowns, veils, and bandages stained with fake blood gathered outside the government building in Beirut to protest Article 522, a law dating to the 1940s allowing rapists to escape prosecution if they married their victims. The law was finally repealed on August 16, 2017.

DECEMBER 7

1941

It was "a date which will live in infamy," in President Franklin D. Roosevelt's famous words, but Roy S. "Swede" Boreen didn't know that when he put on his Bulova watch along with his US Navy uniform on the morning of December 7.

Boreen was the son of Swedish immigrants. His father had served in the Swedish Navy. In 1938, Boreen followed in his footsteps, enlisting just after his eighteenth birthday. He was assigned to the battleship the USS *Oklahoma*, where he worked his way up from scrubbing decks to the ship's Pay Office. "The Okie" was part of the Pacific Fleet, based at Pearl Harbor on the island of Oahu in Hawaii.

On December 7, Boreen rose at 7, ate breakfast, and reported to his desk. At 7:55, he heard an alarm and the call to battle stations. Glancing out a porthole, he spotted a Japanese Kate torpedo bomber overhead, so close that Boreen could see the pilot's grin.

The first torpedo struck the *Oklahoma* as Boreen ran to his battle station on the third deck. As he hurriedly closed the watertight doors

OPPOSITE, ABOVE: Jean Bedel Bokassa's coronation, Roy S. Boreen's Pearl Harbor watch, Betsy Bloomingdale's Bal Oriental costume

to the compartment, a second torpedo slammed into an adjacent compartment, rupturing a fuel tank. "I was completely covered with oil and had to clear my eyes," Boreen remembered. "I turned around and noticed water was pouring down from the second deck ladder hatch." A third torpedo blast, and the order came to abandon the ship, which was already listing. Boreen climbed the ladder to the second deck, where the water was waist-deep, then escaped to the main deck. He looked up and saw a group of Japanese bombers overhead, closing in on Battleship Row "like a flock of ducks."

A direct hit from an armor-piercing shell detonated the powder magazine of the USS *Arizona*. Boreen couldn't see the ship from his position, but the fireball that shot hundreds of feet in the air told him that she was lost, along with 1,177 of her crew. A Zero fighter aircraft was heading straight for the *Oklahoma*. Boreen dove fifty feet into the water, which was slicked with oil and aflame, and took cover behind one of the ship's external flotation tanks. From there, he watched as the Zero fired on the sailors still clinging to the sides of the *Oklahoma*. Less than twelve minutes after the attack began, the ship capsized, trapping many crewmen in the hull to suffocate slowly over the coming days. Of the seven sailors who worked in the Pay Office, Boreen was the only survivor; in total, 443 of the ship's 1,379 crew members died.

A second wave of attacks followed at 8:45 a.m. When it was over, Boreen swam to the USS *Maryland*, which was moored alongside the *Oklahoma* and largely protected by her during the attack. "The sailors opened their lockers and got some towels to get the oil off my face and body, and handed me a clean set of clothing," he remembered. "I sat down and had a cup of coffee, my first cigarette." It was then that he glanced at his watch and noticed that it had stopped at 8:04 am, the moment Boreen hit the water.

DECEMBER 8

2018

For the fourth consecutive weekend, Paris virtually shut down as police clashed with working-class activists protesting rising fuel prices, taxes, and income inequality. The protestors wore *gilets jaunes,* or yellow vests—inexpensive yet highly visible fluorescent safety garments worn by construction workers, airport ground staff, and other blue-collar workers, which French motorists have been required by law to carry in their vehicles since

2008. "The yellow vest is immediately visible in all of the pictures of the protests, peaceful or not, and impossible to miss even on the small screens of social media," the *New York Times* reported. "There hasn't been such a compelling sartorial symbol of revolt since the sans-culottes seized on their trousers as the point of visual difference with the aristocracy during the French Revolution." Two days later, President Emmanuel Macron gave a televised speech promising an increased minimum wage and other economic reforms.

DECEMBER 9

1905

At the Dresden premiere of Richard Strauss's opera *Salome*, the leading lady refused to perform the scandalous Dance of the Seven Veils, protesting: "I'm a decent woman!" A ballerina served as her body double. Audiences were both shocked by the nine-minute striptease and amused that "Salome's complicated sexual inhibitions had in a moment caused her to lose several stone in weight," as the composer Arnold Bax noted.

DECEMBER 10

1948

Socialite Jean Schweppe Armour, wife of the heir to a Chicago meatpacking empire, wore a strapless red velvet Mainbocher evening gown to the "400 Party" at the Casino Club. (The exclusive club, still in operation today, limits itself to four hundred members.) The heart-shaped neckline and matching choker and bracelets were trimmed with silver-beaded red velvet balls resembling Christmas ornaments. Chicago-born, Paris-based Mainbocher claimed to have invented the strapless dress, a marvel of engineering at the time. "Away with shoulder-straps—decrees Mainbocher," *Vogue* proclaimed in July 1934. "Whalebone sewed strategically into the bodice removes all cause for alarm." The trend caught on quickly, but World War II intervened, and, by 1942, Mainbocher was back in the United States designing sensible suits and military uniforms. It wasn't until the war ended that fashion returned to the ultra-feminine silhouette of the 1930s and strapless dress sales surged, with a boost from Rita Hayworth. In the 1946 film *Gilda*, Hayworth sang—and danced—in a strapless black satin Jean Louis gown inspired by John Singer Sargent's portrait *Madame X*, memorably paired

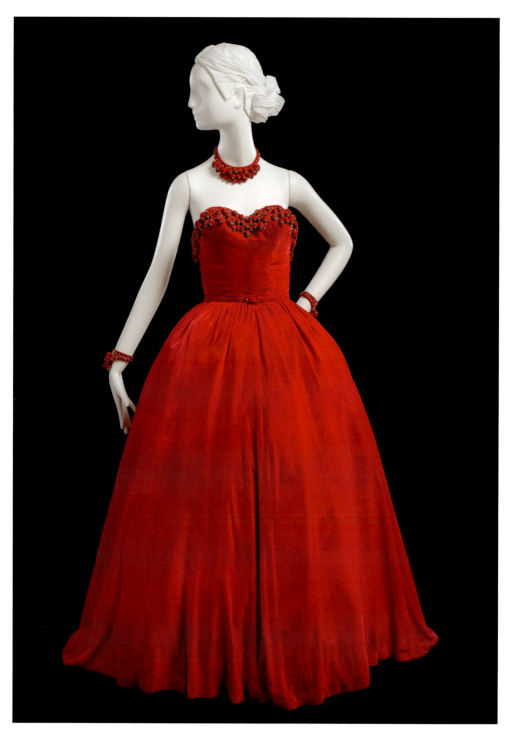

with long satin gloves that ended right at the gown's neckline. When Hayworth threw her arms over her head without losing her top, she gave women everywhere the confidence to unstrap.

DECEMBER 11

1895

The ivory silk and lace gown Mary Lowry Warren wore for her wedding in Buffalo, New York, was subsequently altered and worn by ten of her descendants, most recently in 2015.

DECEMBER 12

1983

At the annual press preview of the White House Christmas decorations, wrestler-turned-actor Mr. T. played Santa, wearing a fur-trimmed red suit, the sleeves and lower legs cut off, with his trademark Mohawk, gold chains, and combat boots. First Lady Nancy Reagan sat on his lap. He gave her a Mr. T. doll and air fresheners.

DECEMBER 13

1906

On December 13—near the winter solstice—young Scandinavian girls (like those in Lima, Sweden, pictured on page 291) have traditionally dressed up as St. Lucia in white gowns with red sashes and crowns of candles in their hair to wake their families with freshly baked saffron buns.

DECEMBER 14

1963

Merry Lepper became the first woman to complete a marathon in the US after crashing the all-male Western Hemisphere Marathon in Culver City, California. She wore gym shorts, a button-front blouse, and New Balance Tracksters—ultralight leather running shoes designed for men. "I felt really slick in my shoes," Lepper remembered years later. Introduced in 1960 with a price tag of $15.65, Tracksters

OPPOSITE: Jean Schweppe Armour's strapless dress

were the first running shoes made in multiple widths, ensuring a comfortable fit. Their rippled outsoles provided traction and shock absorption, while a red saddle cinched and supported the upper.

Today, athletic clothing is a multibillion dollar industry; in 1963, however, women's running gear did not exist. Marathons were not open to women, who were thought to be too frail for distance running. New Balance would not design a running shoe for women until 1978.

DECEMBER 15

1939

Margaret Mitchell was the belle of the ball at the star-studded gala premiere of the film adaptation of *Gone with the Wind* in her hometown of Atlanta, Georgia, where much of her Pulitzer Prize-winning novel takes place. For the occasion, she wore a full-length, cream-colored velvet evening coat brocaded with gold and silver leaves from Rich's, an Atlanta department store founded in 1867, amid the events described in her novel.

An estimated one million people converged on Atlanta for three days of festivities in honor of the film, including a costume ball. The city was bedecked in Confederate flags for the occasion. A ten-year-old Martin Luther King Jr. sang at one charity ball with the Ebenezer Baptist Church choir—dressed as a slave in front of a mock-up of Tara, Scarlett O'Hara's plantation.

Racial tensions were high in Atlanta and the premiere was not without controversy. Clark Gable threatened to boycott the event because Georgia's Jim Crow laws prevented the film's black actors from sitting in the same theater as the white actors. (Hattie McDaniel, who would win an Oscar for her portrayal of Mammy, convinced him to attend anyway.) Although it became one of the most successful films of all time, *Gone with the Wind*'s stereotyped portrayals of slaves and its nostalgic depiction of the Antebellum South (a way of life "gone with the wind") sparked protests across the country. The president of the National Baptist Convention condemned it as a "disgrace"; the National Association for the Advancement of Colored People organized demonstrations outside theaters.

Gone with the Wind would be Mitchell's only published novel.

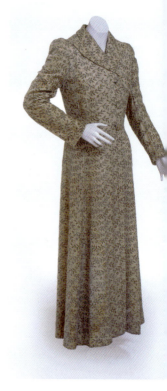

OPPOSITE, ABOVE:
Traditional St. Lucia costume, Margaret Mitchell's premiere evening coat

She died August 16, 1949, at the age of forty-eight, five days after being struck by a car while crossing Peachtree Street. In the 1990s, researchers discovered that she had secretly made several donations to Morehouse College, a historically black men's university in Atlanta.

DECEMBER 16

1773

On the night of the Boston Tea Party, many of the Sons of Liberty who dumped crates of tea into the harbor in protest of the unpopular Tea Act were disguised as Mohawks. "To prevent discovery we agreed to wear ragged clothes and disfigure ourselves, dressing to resemble Indians," one of the participants, Joshua Wyeth, revealed. Another, George Hewes, was "equipped with a small hatchet" and "painted my face and hands with coal dust in the shop of a blacksmith." Benjamin Russell remembered seeing his father and a neighbor smearing each other's faces with soot and red ochre. Although there was not much time to prepare elaborate costumes, the ruse helped the conspirators recognize each other and hid their identities. Symbolically, it declared that they were no longer British subjects, but Americans.

DECEMBER 17

1903

For their famous twelve-second flight near Kitty Hawk, North Carolina, the Wright brothers wore dark caps and coats over their customary white shirts, starched collars, and dark ties. Although it was a cold winter's day, neither the plane's altitude nor speed was sufficient to necessitate protective gear.

DECEMBER 18

1967

On the opening night of *Coco*, the Broadway musical about Coco Chanel, costume designer Cecil Beaton complained about Katharine Hepburn, whom he considered miscast and "mechanical" in the title role: "She appeared in her own hat instead of the one that went with

ABOVE:
Lindy Chamberlain's
black court sundress

the blue on her costume. Instead of Chanel jewellery she wears a little paste brooch. . . . She is suspicious and untrustworthy."

DECEMBER 19

1981

The case of Azaria Chamberlain—the nine-week-old baby who disappeared from a tent on a family camping trip in the Australian outback on August 17, 1980—gripped the media, the nation, and the world. Although her parents, Michael and Lindy Chamberlain, insisted from the outset that a wild dog or dingo had dragged Azaria into the bush, it would take seven years to solve the mystery, which continues to evoke strong feelings in Australia.

Suspicion immediately fell on the baby's parents. Lindy was photographed wearing a black sundress as she entered court on December 19, and appeared in it several times during the inquest. She wore it in memory of Azaria; it was part of a matching mommy-and-me set that she and Azaria had worn to her six-week check-up. "It was the first time I had ever taken her out publicly in a little black cotton dress," Lindy wrote in her memoirs. "It caused quite a bit of comment. People either loved it or hated it."

During the inquest, many observers took the fact that Lindy had dressed her baby in such "unnatural" colors as evidence of her guilt. (It was said—wrongly—that Azaria was "always" dressed in black.) Lindy's own extensive wardrobe, combined with her oddly emotionless affect, also condemned her in the court of public opinion. The baby's unusual name and the Chamberlains' Seventh-Day Adventist religion gave rise to rumors born of ignorance and prejudice, fanned by the prosecutors and the media.

In court, dingo experts, forensic scientists, and fellow campers testified to the events surrounding Azaria's disappearance. On October 29, 1983, Lindy was found guilty of murder and sentenced to life in jail, with Michael named as an accessory after the fact. (He was immediately released on bond.) The conviction was based on a stain found in the family car that was presumed to be blood—a conclusion later disproved.

Lindy served three years in prison—giving birth to her fourth child in jail—before being released due to new evidence: Azaria's

missing jacket was found near a dingo lair. The Chamberlains were officially acquitted in 1988, but it took two more inquests in 1995 and 2012 to establish beyond a doubt that Azaria had, indeed, been killed by a dingo.

DECEMBER 20

2016

Harry Styles was photographed wearing a Yves Saint Laurent fur coat in London. Fans complained that the One Direction singer was endorsing animal cruelty.

DECEMBER 21

1950

Marlene Dietrich stepped off the RMS *Queen Elizabeth* in New York wearing chic sailing attire: a gray suit by Christian Dior. Dior had been brought in to design all of Dietrich's outfits for Alfred Hitchcock's 1950 thriller *Stage Fright*, and the pair had worked together closely to create Dietrich's character's tailored yet sultry suits. The partnership continued off screen. With its "New Look" hourglass silhouette and peplum jacket, this suit announced better than any passport that one was fresh off the boat from Paris.

Transatlantic travel was an elegant affair, requiring chic sportswear for deck tennis and shuffleboard and formal dress and jewels for dinner. Boarding and disembarking were opportune moments for seeing and being seen. "For the woman who goes to Europe," *Vogue* advised in 1925, "first, a suit, of tweed, perhaps, classically and mannishly tailored." With commercial jet travel to Europe in its infancy, the ocean liner gangway photo was the contemporary equivalent of paparazzi shots of celebrities arriving at airports, and stars dressed accordingly, albeit with much less emphasis on comfort.

DECEMBER 22

1908

British suffragettes who had been imprisoned for their activism often wore replica prison uniforms to demonstrations and fundraising

OPPOSITE: Marlene Dietrich's traveling suit, British suffragettes' symbolic prison uniforms

events, in order to highlight the harsh conditions under which they had been held. In the photo on page 294, taken at the Women's Social and Political Union headquarters in London, Emmeline Pankhurst and her daughter Christabel wore the uniform of Holloway Prison, where they had just served three-month sentences.

According to Emmeline's daughter Sylvia, who did her own stint in Holloway in 1908, prison clothes were "badly sewn and badly cut" of "harsh woolen stuff" with "innumerable strings to fasten around one's waist"—a primitive solution to the problem of mass-producing clothes that could fit a variety of body types. "A strange-looking pair of corsets was supplied to each of us, but these we were not obliged to wear unless we wished," Sylvia remembered. "The stockings were of harsh thick wool, and had been badly darned. They were black with red stripes going around the legs, and as they were very wide, and there were no garters or suspenders to keep them up, they were constantly slipping down and wrinkling around one's ankles." Every article of prison clothing was conspicuously stamped with the broad arrow, a heraldic device historically used to indicate the king's or the government's property. From the 1820s, it appeared on convict uniforms, including those worn by Emmeline and Christabel.

Emmeline described her prison experience as "like a human being in the process of being turned into a wild beast." But in a speech delivered to American suffragists in Connecticut in 1913, she revealed the upside of incarceration: "When they put us in prison at first, simply for taking petitions, we submitted; we allowed them to dress us in prison clothes; we allowed them to put us in solitary confinement; we allowed them to put us amongst the most degraded of criminals; we learned of some of the appalling evils of our so-called civilization that we could not have learned in any other way. It was valuable experience, and we were glad to get it."

The lesson hit home. In the United States, the National Woman's Party began awarding silver pins in the shape of iron-bar prison doors with heart-shaped locks—designed by artist Nina Allender—to suffragettes who had been imprisoned. More subtle and more elegant than a prison uniform, these pins were worn proudly, as badges of honor.

OPPOSITE: Sketch for *Aida* costume

DECEMBER 23

1780

As the mother of Queen Marie-Antoinette of France, Empress Maria Theresa of Austria was entitled to a six-month period of mourning by the French court when she died on November 29. The Marquis de Valfons described the elaborate ritual of the official condolences at Versailles on December 23. Nearly six hundred mourners paraded silently through the palace, the women "in long mantles" and veils of black, and the men "in long mantles of black cloth with cravats, . . . ribbons on their coats, crosses on their mantles, walking one by one, at three paces distant," each pausing to bow or curtsy to the king and queen.

DECEMBER 24

1871

Giuseppe Verdi's opera *Aida* premiered at the Khedivial Opera House in Cairo on Christmas Eve. The historically inspired costumes and sets were designed by French Egyptologist Auguste Mariette, founder of the Egyptian Museum, who also conceived the story. Both the music and the mise-en-scène were intended to be authentic representations of ancient Egypt—specifically, the reign of Ramses III—although Mariette had considerably more historical evidence than Verdi to draw upon for inspiration.

"What the Viceroy wants is a purely ancient and Egyptian opera," Mariette testified. "The sets will be based on historical accounts; the costumes will be designed after the bas-reliefs of Upper Egypt. No effort will be spared in this respect." Mariette even harangued Paul Draneht, the Khedivial's manager, about the cast's facial hair. "I need to speak to you very seriously about the business of the moustaches and beards of your actors," he wrote. "Since I am taking such extraordinary pains to create costumes that will be elegant as well as correct, according to the period, they must not fail because of a question of moustaches." Indeed, he added, one might as well dress the hero, Radames, depicted in this costume sketch, "as a Chinaman."

While Mariette's sketches evoked the stylized poses and flat

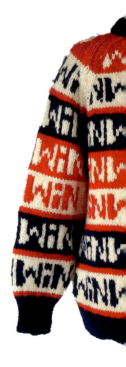

ABOVE:
Gerald Ford's ugly
Christmas sweater

appearance of Egyptian bas-reliefs, the finished costumes incorporated some obvious anachronisms, including corsets for the female characters.

DECEMBER 25

1974

On a Christmas ski trip with his family in Vail, Colorado, President Gerald Ford donned a hand-knitted red, white, and blue pullover sent to him by a supporter. Its "WiN" motif was not a reelection slogan, but an acronym for "Whip Inflation Now," Ford's campaign to boost the stagnant economy, launched that fall. Despite the president's much-photographed Yuletide fashion statement, however, enthusiasm for the program waned by the New Year as the promised results failed to materialize, and the initiative quickly went the way of a dried-out Christmas tree.

DECEMBER 26

2006

The feast day of St. Stephen—the patron saint of horses—has long been celebrated with fox hunts. Each year, hunt clubs assemble on the morning of December 26 in their riding boots, buff breeches, and scarlet wool tailcoats, called "pinks." Though protective helmets have largely replaced top hats, and women have swapped skirted riding habits and sidesaddles for more masculine equestrian gear, hunting dress has changed little since the early 1800s.

Indeed, with its idyllic background of rolling hills and the historic village of Lacock in Wiltshire, this scene could represent virtually any Boxing Day hunt in the previous two centuries. However, an important change to the annual social and sporting ritual took place in 2004, when the British Parliament banned hunting foxes with hounds on the grounds of animal cruelty. The riders and hounds in the photo on page 304 are "drag hunting"—that is, following an artificial scent trail rather than a live fox. For some, the law represented a misguided attack on a cherished tradition. To others, it was an overdue check on the elite pastime Oscar Wilde called "the unspeakable in full pursuit of the uneatable."

DECEMBER 27

1836

After three days of incessant snow beginning on Christmas Eve, the deadliest avalanche in English history buried five cottages in Lewes, Sussex, killing eight people between the ages of eleven and eighty-two. "The mass appeared to strike the houses first at the base, heaving them upwards, and then breaking over them like a gigantic wave," the *Sussex Weekly Advertiser* reported. "There was nothing but a mound of pure white." The white dress worn by two-year-old Fanny Boaks, one of the survivors rescued from the debris, is still on display in the town's Anne of Cleves Museum. Her mother, Jane, was among the dead.

DECEMBER 28

1562

Eleanora di Toledo, the Duchess of Florence, died unexpectedly on December 17, 1562, at the age of forty. She had insisted on accompanying her husband, Cosimo I de Medici, and three of their five sons on a visit to Pisa, where malaria had broken out. Two of the boys—sixteen-year-old Don Garzia and nineteen-year-old Don Giovanni—contracted it and died; Eleanora, who nursed them, succumbed days later.

The bodies were returned to Florence for burial in the Medici family chapel at the Basilica of San Lorenzo, where Eleanora was interred on December 28. At some point between her death and her burial, she was dressed in a gown of white satin ornamented with bands of velvet and metallic embroidery. Her clothes were put on carelessly, whether out of haste or because no one would see them; one stocking was inside out, and her bodice was only partially laced up the sides.

These intimate details are known only because Eleanora was disinterred in 1857. Her body was not embalmed, probably out of fear of contagion, and the bodily fluids in the wooden coffin helped to preserve the textiles. Pieces of her gown, painstakingly conserved in the 1980s, are now displayed flat in a dimly lit chamber in the Galleria del Costume at the Palazzo Pitti in Florence,

ABOVE: Eleanora di Toledo's burial gown

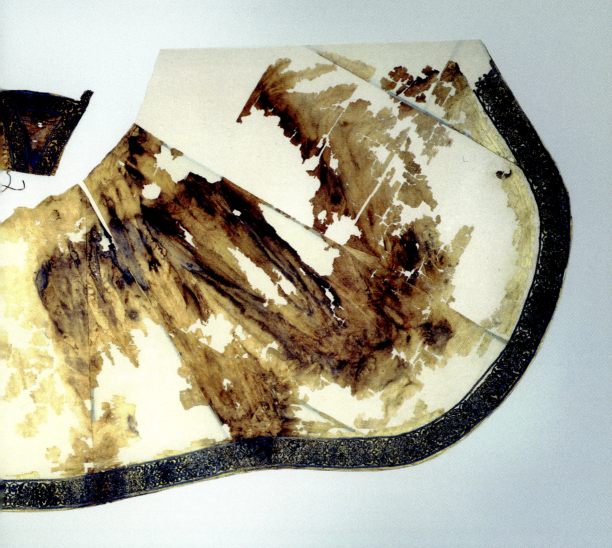

alongside the fragmentary burial clothes of Don Garzia and Cosimo, who died in 1574.

Archival evidence suggests that Eleanora was buried in the last dress made for her. The Medici wardrobe records describe a gown delivered in August 1562, "with bodice and skirt in white satin with a band of brown *sfondato* velvet embroidered in gold and silver with narrow gold braid." This gown is not listed in the posthumous inventory of Eleanora's possessions, suggesting that it was buried with her.

This rare surviving Renaissance gown is a haunting tribute to a Medici duchess, whose wardrobe was so lavish that, while she was alive, she was said to keep ten gold and silver weavers continually employed.

DECEMBER 29

1888

It was opening night of Sir Henry Irving's new production of *Macbeth* at the Lyceum Theatre in London; Irving starred alongside his frequent stage partner, Ellen Terry. In the audience sat the American painter John Singer Sargent. Inspiration struck on all fronts, and, by January 1, Sargent was at work on a monumental portrait of Terry in her spectacularly innovative costume.

Oscar Wilde, who saw the actress arrive at Sargent's Chelsea studio for one sitting, mused that "the street that on a wet and dreary morning has vouchsafed the vision of Lady Macbeth in full regalia magnificently seated in a four-wheeler can never again be as other streets: it must always be full of wonderful possibilities." He added: "Lady Macbeth seems to be an economical housekeeper and evidently patronises local industries for her husband's clothes and servant's liveries, but she takes care to do all her own shopping in Byzantium."

Terry's costume was not quite Byzantine, but neither was it the contemporary dress most Shakespearean actresses wore, whether they were playing Cordelia or Cleopatra. Irving was known for his historically and geographically accurate productions, and Terry's medieval dress evoked the thirteenth century with its hanging sleeves, low-slung metal girdle, and headdress of false red braids, bound in gold.

The costume was created by Alice Comyns-Carr, who made many of Terry's clothes. Comyns-Carr was a leading figure in the Aesthetic movement, an antifashion campaign to return art and fashion to the

OPPOSITE: Ellen Terry's *Macbeth* costume

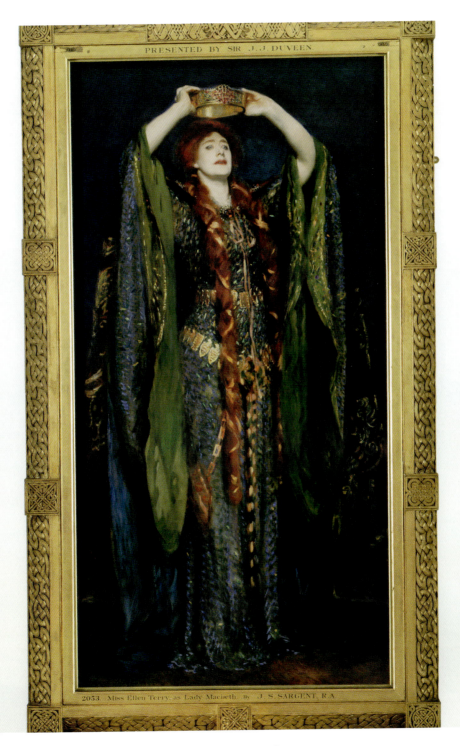

PRESENTED BY SIR J.J. DUVEEN

2053. Miss Ellen Terry, as Lady Macbeth. By J. S. SARGENT, R.A

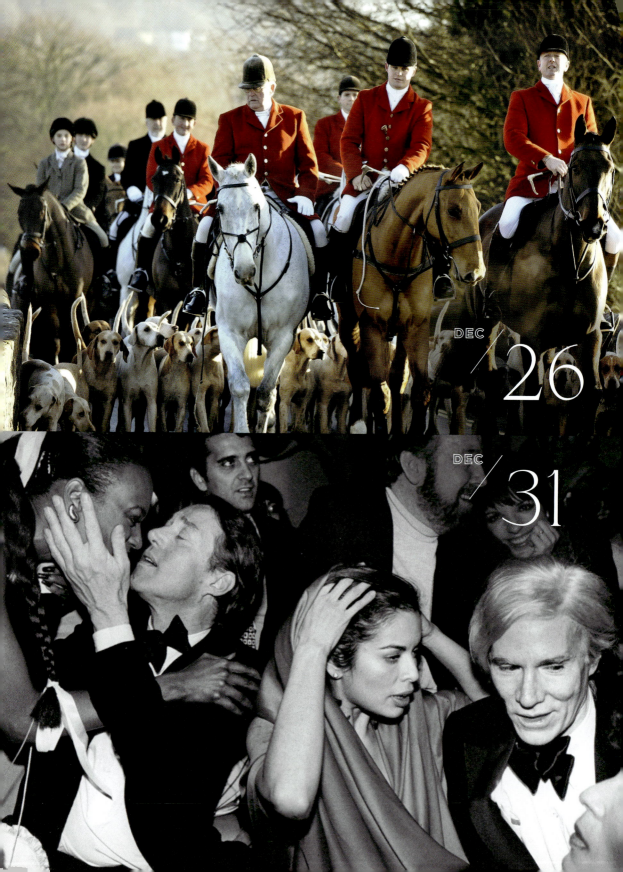

DEC /26

DEC /31

glories of its Medieval and Renaissance past, as if the Industrial Revolution had never happened. Comyns-Carr wanted the dress to look "like soft chain armour . . . and yet have something that would give the appearance of the scales of a serpent," she wrote in her *Reminiscences*. Seamstress Ada Nettleship crocheted the overgown using green and blue yarn, then covered it with 1,000 iridescent blue-green beetle wings. A border of red and white gemstones in a Celtic design adorned the hem.

Terry's costume may have been intriguingly and unusually ancient in inspiration, but—like most iconic stage costumes—it was, in its own way, perfectly in tune with contemporary tastes. Aesthetic dress increasingly influenced mainstream fashion, notably that sold by the Liberty of London department store, which opened in 1875. Beetle wing embroidery was a thoroughly modern fashion touch, which Comyns-Carr was inspired to use after seeing a similarly embellished gown on the socialite Lady Randolph Churchill—hardly a fashion maverick.

"I wish you could see my dresses," Terry wrote to her daughter. "They are superb, especially the first one: green beetles on it, and such a cloak! The photographs give no idea of it at all, for it is in colour that it is so splendid." Irving's hit production ran for six months, and Terry wore the costume on several later tours. Sargent's portrait was equally successful; in her *Memoirs*, Terry described it as the sensation of 1889 when it was shown at the New Gallery. Irving himself bought it for the Beefsteak Room of the Lyceum.

DECEMBER 30

1809

The wearing of masks at balls was banned in Boston, Massachusetts; it was thought that the anonymity permitted by masks was detrimental to public morals. The law was not repealed until April Fool's Day, 1963.

DECEMBER
removed

DECEMBER 31

1977

The Studio 54 nightclub opened on April 26, 1977, and instantly became the celebrity epicenter of the Disco Decade when Bianca Jagger—the wife of Rolling Stones frontman Mick Jagger and an international style icon—held her twenty-seventh birthday party there a week later. Dressed in a

OPPOSITE: Fox hunt on Boxing Day, New Year's Eve at Studio 54

305
removed

floor-length, off-the-shoulder red gown and gold Manolo Blahnik sandals, she memorably climbed atop a live white horse on the dance floor.

Jagger donned another daring red gown—this one with a dramatic cowl—to celebrate New Year's Eve at the club later that year. Both were designed by Halston, another regular at Studio 54; he had hosted her notorious birthday party. While Seventh Avenue fashion designers had once worked behind the scenes—their names known to industry insiders but rarely to the public—they had recently emerged into the public eye, socializing with their well-heeled clients, and appearing in magazine features and gossip columns. Halston was one of the first American designers to become a celebrity in his own right, and his slinky, minimalist clothes were the uniform of the Studio 54 set.

In a photo taken that night, Jagger is flanked by Halston and artist Andy Warhol; behind them are producer Jack Haley and his wife, Liza Minnelli. The eclectic gathering was typical of Studio 54, where, on any given night, one might bump into Elizabeth Taylor, Steven Tyler, Truman Capote, Donna Summer, or Diana Vreeland. (Warhol once described the club as "a dictatorship at the door and a democracy inside.") Their clothes capture the anything-goes atmosphere of the club, and, by extension, the nonconformist spirit of fashion in the late 1970s, an era of liberation for women, gays, and African Americans. Halston wore a tuxedo, but Warhol paired his jacket and bow tie with blue jeans. Pop star Michael Jackson was there that night, too, dressed in an argyle sweater that forecast the preppy trend of the early 1980s, albeit accessorized with an enormous collar, belt, and Afro. Haley and Minnelli both wore turtlenecks and trousers, a nod to the unisex trend. At the time, turtlenecks for men and trousers for women were still banned in some New York restaurants. But at Studio 54, only the most stylish got past the velvet ropes.

There would be just one other New Year's Eve at Studio 54 before the IRS raided the club on December 14, 1979, and owners Steve Rubell and Ian Schrager were jailed for tax evasion. Studio 54 reopened the following year under new ownership and continued to operate until 1986, but the party was over.

SELECTED
BIBLIOGRAPHY

Agassi, Andre. *Open: An Autobiography*. New York: Knopf, 2009.

Albright, Madeleine, et al. *Read My Pins: Stories From a Diplomat's Jewel Box*. New York: Melcher Media, 2009.

Alexander, Kimberly S. *Treasures Afoot: Shoe Stories from the Georgian Era*. Baltimore: Johns Hopkins University Press, 2018.

Amery, Julian. *Approach March: A Venture in Autobiography*. London: Hutchinson, 1973.

Anonymous. *A Memento of the Marriage of Albert Edward Prince of Wales with the Princess Alexandra of Denmark*. London: C. J. Cribb, 1863.

Antonelli, Paola, and Michelle Fisher, eds. *Items: Is Fashion Modern?* New York: Museum of Modern Art, 2017.

Ashelford, Jane. *The Art of Dress: Clothes and Society, 1500–1914*. London: National Trust Enterprises, 1996.

Auerbacher, Inge. *Beyond the Yellow Star to America*. Unionville, NY: Royal Fireworks Press, 1994.

Balmain, Pierre. *My Years and Seasons*. Trans. Edward Lanchbery and Gordon Young. London: Cassell, 1964.

Balsan, Consuelo Vanderbilt. *The Glitter and the Gold*. New York: Harpers and Brothers, 1952.

Baumgarten, Linda. *What Clothes Reveal: The Language of Clothing in Colonial and Federal America*. Williamsburg, VA: The Colonial Williamsburg Foundation in association with Yale University Press, 2002.

Blum, Dilys. *Shocking! The Art and Fashion of Elsa Schiaparelli*. Philadelphia: Philadelphia Museum of Art, 2003.

Busch, Hans. *Verdi's Aida: The History of an Opera in Letters and Documents*. Minneapolis: University of Minnesota Press, 1978.

Casanova, Giacomo. *The Memoirs of Jacques Casanova de Seingalt*. Trans. Arthur Machen. New York: Dover, 1961.

Chaney, Lisa. *Coco Chanel: An Intimate Life*. New York: Viking, 2011.

Chernow, Ron. *Alexander Hamilton*. New York: Penguin, 2004.

Chrisman-Campbell, Kimberly. *Fashion Victims: Dress at the Court of Louis XVI and Marie-Antoinette*. London: Yale University Press, 2015.

Collins, Winifred Quick, and Herbert M. Levine. *More Than a Uniform: A Navy Woman in a Navy Man's World*. Denton: University of North Texas Press, 1997.

Cornwallis-West, Mrs. George. *The Reminiscences of Lady Randolph Churchill*. London: Edward Arnold, 1908.

Craig, Mary W. *A Tangled Web: Mata Hari: Dancer, Courtesan, Spy*. Stroud, UK: The History Press, 2017.

Dalby, Liza. *Kimono: Fashioning Culture*. New Haven, CT: Yale University Press, 1993.

De Marly, Diana. *Costume on the Stage, 1600–1940*. New York: Barnes & Noble, 1982.

–––. *Worth: Father of Haute Couture*. New York: Holmes & Meier, 1980.

Delorme, Eleanor, ed. *Joséphine and the Arts of the Empire*. Los Angeles: J. Paul Getty Museum, 2005.

Dexter, Walter, ed. *The Letters of Charles Dickens*. London: Nonesuch Press, 1938.

Dior, Christian. *Dior by Dior: The Autobiography of Christian Dior*. Trans. Antonia Fraser. London: V&A Publishing, 2015.

Downey, Lynn. *Levi Strauss & Co.* Mount Pleasant, SC: Arcadia Publishing, 2007.

Evans, Thomas W., and Edward Augustus Crane. *Memoirs of Dr. Thomas W. Evans: The Second French Empire.* New York: D. Appleton, 1905.

Fitzgerald, F. Scott, and Matthew J. Bruccoli. *F. Scott Fitzgerald: A Life in Letters.* New York: Scribner, 1995.

Fortune, Brandon Brame. "'Studious Men Are Always Painted in Gowns': Charles Willson Peale's *Benjamin Rush* and the Question of Banyans in Eighteenth-Century Anglo-American Portraiture." *Dress* 29:1 (2002): 27–40.

Garfield, Simon. *Mauve: How One Man Invented a Color That Changed the World.* New York: W. W. Norton, 2001.

Geller, Judith B. *Titanic: Women and Children First.* New York: W. W. Norton, 1998.

Gleichen, Lady Helena. *Contacts and Contrasts.* London: John Murray, 1940.

Goto, Zoey. *Elvis Style: From Zoot Suits to Jumpsuits.* Faringdon, UK: Redshank Books, 2016.

Gunter, Helen Clifford. *Navy WAVE: Memories of World War II.* Fort Bragg: Cypress House Press, 1992.

Hancock, Joy Bright. *Lady in the Navy: A Personal Reminiscence.* Annapolis, MD: Naval Institute Press, 1972.

Harlow, Barbara, and Mia Carter, eds. *Archives of Empire: Volume I. From the East India Company to the Suez Canal.* Durham, NC: Duke University Press Books, 2003.

Harper, Ida Husted. *The Life and Work of Susan B. Anthony.* Indianapolis, IN: The Hollenbeck Press, 1908.

Haslip, Joan. *The Lonely Empress: Elizabeth of Austria.* London: Weidenfeld & Nicolson, 1965.

Haugland, H. Kristina. *Grace Kelly Style.* London: V&A Publishing, 2010.

———. *Grace Kelly: Icon of Style to Royal Bride.* Philadelphia: Philadelphia Museum of Art, 2006.

Hawksley, Lucinda. *Moustaches, Whiskers & Beards.* London: National Portrait Gallery, 2015.

Hobhouse, John Cam, and Lady Dorchester. *Recollections of a Long Life, Volume 1: 1786–1816.* Cambridge: Cambridge University Press, 2011.

Holzer, Harold, and Eric Foner. *The Civil War in 50 Objects.* New York: Viking, 2013.

Homans, Jennifer. *Apollo's Angels: A History of Ballet.* New York: Random House, 2009.

Hoover, Catherine, and John Ho Voorsanger. *Art and the Empire City: New York, 1825–1861.* New York: Metropolitan Museum of Art, 2000.

Hudson, Derek. *Munby: Man of Two Worlds: The Life and Diaries of Arthur J. Munby, 1828–1910.* London: J. Murray, 1972.

Jaivin, Linda. *Confessions of an S & M Virgin.* Melbourne: Text Publishing, 2012.

Kaeppler, Adrienne. *Hawaiian Featherwork.* Berlin: Nationalgalerie, 2010.

Kaplan, Wendy, ed. *Found in Translation: Design in California and Mexico, 1915–1985.* Los Angeles: Los Angeles County Museum of Art, 2017.

Keogh, Pamela Clarke. *Elvis Presley: The Man. The Life. The Legend.* New York: Atria Books, 2004.

Keppel, Sonia. *Edwardian Daughter.* London: Hamish Hamilton, 1958.

Kershaw, Robert. *24 Hours at Waterloo: 18 June 1815.* Philadelphia: Casemate, 2015.

Kurin, Richard. *The Smithsonian's History of America in 101 Objects.* New York: Penguin, 2013.

Lambert, Angela. *1939: The Last Season of Peace.* New York: Grove Press, 1989.

Leventon, Melissa. *Fit for a Queen: Her Majesty Queen Sirikit's Creations by Balmain.* Bangkok: Queen Sirikit Museum of Textiles, 2016.

Leventon, Melissa, and Dale Carolyn Gluckman. *In Royal Fashion: The Style of Queen Sirikit of Thailand.* Bangkok: Queen Sirikit Museum of Textiles, 2013.

Liliuokalani, Queen of Hawaii. *Hawaii's Story by Hawaii's Queen.* Boston: Lothrop, Lee & Shepard, 1898.

Lipsner, Benjamin B., and Leonard Finley Hilts. *The Airmail: Jennies to Jets.* Chicago: Wilcox & Follett, 1951.

Logan, Anne-Marie, and Liam M. Brockey. "Nicolas Trigault, SJ: A Portrait by Peter Paul Rubens." *Metropolitan Museum Journal* 38 (2003): 157–167.

Lovejoy, Bess. *Rest in Pieces: The Curious Fates of Famous Corpses.* New York: Simon & Schuster, 2013.

Lyon, Joseph L., and David W. Lyon. "Physical Evidence at Carthage Jail and What It Reveals about the Assassination of Joseph and Hyrum Smith." *BYU Studies Quarterly* 47:4 (2008): 5–47.

MacCarthy, Fiona. *Last Curtsey: The End of the Debutantes.* London: Faber and Faber, 2006.

Maierjin, Thomas. *When Lions Roar: The Churchills and the Kennedys.* New York: Crown, 2014.

Mathews-David, Allison. *Fashion Victims: The Dangers of Dress, Past and Present.* New York: Bloomsbury Visual Arts, 2015.

McCullough, David. *The Wright Brothers.* New York: Simon & Schuster, 2015.

Merrill, C. S. *Weekends with O'Keeffe.* Albuquerque: University of New Mexico Press, 2010.

Minnich, Helen Benton. *Japanese Costume: And the Makers of Its Elegant Tradition.* North Clarendon, VT: Charles E. Tuttle, 1986.

Mock, Jerrie. *Three-Eight Charlie.* Philadelphia: J. B. Lippincott, 1970.

Monchaux, Nicholas de. *Spacesuit: Fashioning Apollo.* Cambridge, MA: The MIT Press, 2011.

Montgomery-Massingberd, Hugh. *Blenheim Revisited: The Spencer-Churchills and Their Palace.* New York: Beaufort Books, 1985.

Morgan, Lady Sydney. *France in 1829–30.* London: Saunders and Otley, 1830.

Mulvagh, Jane. *Vivienne Westwood: An Unfashionable Life.* London: HarperCollins, 1998.

National Palace Museum of Korea. *The King at the Palace: Joseon Royal Court Culture at the National Palace Museum.* Seoul: National Palace Museum of Korea, 2015.

Newman, Terry. *Legendary Authors and the Clothes They Wore.* New York: Harper Design, 2017.

Nila, Gary. *Japanese Naval Aviation Uniforms and Equipment, 1937–45.* Oxford: Osprey Publishing, 2002.

Pankhurst, Estelle Sylvia. *The Suffragette: The History of the Women's Militant Suffrage Movement, 1905–1910.* New York: Source Book Press, 1970.

Paoletti, Jo. *Sex and Unisex: Fashion, Feminism, and the Sexual Revolution.* Bloomington: Indiana University Press, 2015.

Pastoureau, Michel. *The Devil's Cloth: A History of Stripes & Striped Fabric.* Trans. Jody Gladding. New York: Columbia University Press, 2001.

Pepper, Terence. *High Society: Photographs, 1897–1914.* London: National Portrait Gallery, 1998.

Picardie, Justine. *Coco Chanel: The Legend and the Life.* New York: HarperCollins, 2010.

Preston, Diana. *Lusitania: An Epic Tragedy.* New York: Walker & Company, 2002.

Quant, Mary. *Quant by Quant: The Autobiography of Mary Quant.* London: Cassell, 1966.

Ramsay, David. *Lusitania: Saga and Myth.* New York: W. W. Norton, 2012.

Rangström, Lena. *Kläder för tid och evighet: Gustaf III sedd genom sina dräkter.* Stockholm: Livrustkammaren, 1997.

———. *Modelejon: Manligt Mode, 1500-tal 1600-tal 1700-tal.* Stockholm: Livrustkammaren, 2002.

Roosevelt, Eleanor. *The Autobiography of Eleanor Roosevelt.* New York: HarperCollins, 2014.

Rose, Roger G. *Hawai'i: The Royal Isles.* Honolulu: Bishop Museum Press, 1980.

Rowe, Jo Ann, and Dale Robin Rowe. *Not for Public Consumption: My Octopusiacal Life.* 2016.

Rubenstein, Hal. *The Looks of Love: 50 Moments in Fashion That Inspired Romance.* New York: Harper Design, 2015.

Rublack, Ulinka, and Maria Hayward, eds. *The First Book of Fashion: The Books of Clothes of Matthäus & Veit Konrad Schwarz of Augsburg.* London: Bloomsbury Academic, 2015.

Scheips, Charlie. *Elsie de Wolfe's Paris: Frivolity Before the Storm.* New York: Abrams, 2014.

Sheffield, Gary. *The First World War in 100 Objects: The Story of the Great War Told Through the Objects That Shaped It.* London: Carlton Books, 2014.

Sherr, Lynn. *Failure Is Impossible: Susan B. Anthony in Her Own Words.* New York: Times Books, 1996.

Sherwood, Mary Elizabeth Wilson. *Here & There & Everywhere: Reminiscences.* Chicago: Herbert S. Stone, 1898.

Slinkard, Petra. *Making Mainbocher: The First American Couturier.* Chicago: Chicago History Museum, 2016.

St. George, Melesina. *Journal Kept During a Visit to Germany in 1799, 1800.* London: Savill and Edwards, 1861.

Staniland, Kay. *In Royal Fashion: The Clothes of Princess Charlotte of Wales and Queen Victoria 1796–1901.* London: Museum of London, 1997.

Steele, Valerie. *Paris Fashion: A Cultural History.* Oxford: Oxford University Press, 1988.

Steele, Valerie, ed. *Dance and Fashion.* New Haven, CT: Yale University Press, 2014.

Stone, Brian, ed. *Millennium Eyewitnesses: A Thousand Years of History Written by Those Who Were There.* London: Piatkus, 1997.

Tate, Sheila. *Lady in Red: An Intimate Portrait of Nancy Reagan.* New York: Crown Forum, 2018.

Taylor, Lou, and Amy de la Haye. *A Family of Fashion: The Messel Dress Collection, 1865–2005.* London: Philip Wilson Publishers, 2005.

Thomas, Nicholas. *Entangled Objects: Exchange, Material Culture, and Colonialism in the Pacific.* Cambridge, MA: Harvard University Press, 1991.

Turkle, Sherry, ed. *Evocative Objects: Things We Think With.* Cambridge, MA: The MIT Press, 2007.

Vreeland, Diana. *D.V.* New York: Knopf, 1984.

Ward, Robert D. *An Account of General La Fayette's Visit to Virginia, in the Years 1824–'25.* Richmond, VA: West, Johnston & Co., 1881.

Warhol, Andy, and Pat Hackett. *The Andy Warhol Diaries.* New York: Warner Books, 1989.

Wilson, Frances. *How to Survive the Titanic or The Sinking of J. Bruce Ismay.* London: Bloomsbury, 2012.

X, Malcolm, and Alex Haley. *The Autobiography of Malcolm X.* New York: Grove Press, 1965.

PHOTO CREDITS

PHOTO
CREDITS

**PHOTO
CREDITS**

INDEX

ACKNOW- LEDGMENTS

Survival of any garment for many decades or centuries depends on a combination of luck and love. I must begin by acknowledging my profound debt to the people who wore and loved these pieces, the families and heirs who cared for and shared them, and the dealers, collectors, and curators who acquired, safeguarded, and researched them, allowing their fascinating stories to be preserved and passed down to instruct and inspire future generations.

I am grateful to the many museums, archives, historical societies, libraries, auction houses, and private collectors who provided the images in these pages as well as information about their collections. Several of the surviving garments featured in this book are objects of deep personal, national, or religious significance. I am particularly obliged to Her Majesty Queen Elizabeth II for allowing me to reproduce an image of her coronation gown and to the Church of Jesus Christ of Latter-day Saints for permission to illustrate Hyram Smith's clothing. The Chapter of St. Paul's Cathedral and the Beryl Dean Education Trust kindly gave their blessing to the inclusion of the Jubilee Cope, which has been a personal favorite since I saw it in action during a Sunday service as a graduate student. The Hiroshima Peace Memorial Museum graciously provided images of Nobuko Oshita's school uniform, donated by her family in the hope of conveying the cruelty of nuclear weapons and promoting peace. My special thanks also go to the Queen Sirikit Museum of Textiles, the Auschwitz Memorial, the National Palace Museum of Korea, the United States Holocaust Memorial Museum, the 9/11 Memorial Museum, and the Museu Imperial.

Among the many archivists, curators, and collectors who shared their time and expertise, I want to recognize Olivia Anastasiadis, Alice Christophe, Cynthia Cooper, Ronna Dixson, Meghan Hansen, Kristina Haugland, Kevin Jones, Mike Juen, Nadine Lees, Melissa Leventon, Adam MacPharlain, Nora Ochoa, Jen Roger, Alison Rosse, Madelyn Rzadkowolski, Joshua D. Shaw, Petra Slinkard, Kristen E. Stewart,

ACKNOW- LEDGMENTS

323

Morgan R. Swan, and Charles Ulmann. Susan Holloway Scott, Dennita Sewell, Heather MacDonald, Cally Blackman, and Annette Becker pointed me to wonderful objects and images that I never would have found on my own.

While this book could not have been written without the miracle of digitized collections, documents, and oral histories, I am grateful to the staffs of the Huntington Library, the Getty Research Institute, the Los Angeles Public Library, the Pasadena Public Library, and the Glendale Public Library for their IRL assistance.

This book began as @WornOnThisDay, an occasional Twitter feed. Thousands of followers have shaped it with their comments, questions, and corrections, and I truly appreciate their enthusiasm and encouragement. I am so thankful to Laurie Fox at the Linda Chester Agency for seeing the book potential in posts of 280 characters and for helping *Worn on This Day* find its way to the perfect editor, Cindy Sipala at Running Press, who has been a joy to work with. It was Cindy who had the vision to expand this from a highlights reel of fashion history to a full 365 days, which made my life harder but made the book that much better. Also at Running Press, Michael Clark, Martha Whitt, and Celeste Joyce have been instrumental in shepherding this visually and thematically complex project to completion.

For patiently supporting my sartorial obsessions and inveterate book hoarding, and bringing luck and love into my life, I am immensely grateful to my husband, Ian; our boys, Rory and Ramsay; and my parents, Chris and Dianne, to whom this book is dedicated.

**ACKNOW-
LEDGMENTS**